BEHIND THE SCENES AT THE BBFC

FILM CLASSIFICATION FROM THE SILVER SCREEN TO THE DIGITAL AGE

EDITED BY EDWARD LAMBERTI

ASSOCIATE EDITORS
JASON GREEN, DAVID HYMAN, CRAIG LAPPER, KAREN MYERS

First published in 2012 by
PALGRAVE MACMILLAN

on behalf of the

BRITISH FILM INSTITUTE
21 Stephen Street, London W1T 1LN
www.bfi.org.uk

There's more to discover about film and television through the BFI. Our world-renowned archive, cinemas, festivals, films, publications and learning resources are here to inspire you.

Palgrave Macmillan in the UK is an imprint of Macmillan Publishers Limited, registered in England, company number 785998, of Houndmills, Basingstoke, Hampshire RG21 6XS. Palgrave Macmillan in the US is a division of St Martin's Press LLC, 175 Fifth Avenue, New York, NY 10010. Palgrave Macmillan is the global academic imprint of the above companies and has companies and representatives throughout the world. Palgrave® and Macmillan® are registered trademarks in the United States, the United Kingdom, Europe and other countries.

Cover design: Mark Swan
Cover images: (front) *Casino Royale* (Martin Campbell, 2006), © Danjaq LLC/© United Artists Corporation/ © Columbia Pictures Industries Inc.; *Dracula* (Terence Fisher, 1958), © Hammer Film Productions; *Monty Python's Life of Brian* (Terry Jones, 1979), Python (Monty) Pictures/HandMade Films; *Room at the Top* (Jack Clayton, 1959), Remus Films; (back) *Indiana Jones and the Temple of Doom* (Steven Spielberg, 1984), Lucasfilm Ltd/Robert Guenette Productions; *Battleship Potemkin* (Sergei M. Eisenstein, 1925), First Studio Goskino; *The Killer Inside Me* (Michael Winterbottom, 2010), © LLC Kim Productions.
Designed by couch
Set by Cambrian/couch
Printed in China

This book is printed on paper suitable for recycling and made from fully managed and sustained forest sources. Logging, pulping and manufacturing processes are expected to conform to the environmental regulations of the country of origin.

British Library Cataloguing-in-Publication Data
A catalogue record for this book is available from the British Library
A catalog record for this book is available from the Library of Congress
10 9 8 7 6 5 4 3 2 1
21 20 19 18 17 16 15 14 13 12

ISBN 978–1–84457–476–6

CONTENTS

ACKNOWLEDGMENTS

The editorial team would first of all very much like to thank all the writers, both for their contributions and for their friendly (and super-efficient) collaboration. It has been an absolute pleasure working with them all.

Many colleagues at the BBFC have helped in this project. We would like to thank in particular the Director, David Cooke, and the Presidential tier of Sir Quentin Thomas, Alison Hastings and Gerard Lemos, for giving us the space to tackle the project our way. Sue Clark and Emily Fussell helped significantly at the book's inception; they have our considerable thanks too. Fiona Liddell assisted the project by tirelessly providing our writers with access to our film files. Jen Evans was a great help in unearthing rare archived materials. Amy Brooks researched and sourced many of the images. Caroline Nicholson and Shaun Cobb kept so much else going when the demands of the project took us away from our desks. Catherine Anderson, Lucy Brett, Mark Dawson, Rebecca Mackay and Thomas Westwood gave key input. David Austin and Dave Barrett were very accommodating and supportive at the Senior Management level.

We would also like to thank BFI Publishing and Palgrave Macmillan, and in particular Rebecca Barden for her encouragement of the project and for overseeing our progress so amicably, and Anna Coatman, Sophia Contento, Chantal Latchford and Claire Morrison for their hard work. And for various kinds of advice, help and support, we must thank Stacey Abbott, Louis Bayman, James Chapman, Sarah Cooper and Sue Harper.

NOTES ON CONTRIBUTORS

SIAN BARBER is a Postdoctoral Researcher in the Department of Media Arts at Royal Holloway, University of London. She completed her PhD at the University of Portsmouth as part of the AHRC-funded 1970s project and has published on British cinema, cinemagoing and film censorship. Her latest work is Censoring the 1970s: The BBFC and the Decade That Taste Forgot (2011). Her other research interests include cultural history in an online environment and the challenges posed by websites and the internet to methods of research. She is currently working on the EUscreen project which aims to provide online access to Europe's television heritage.

SIMON BROWN is Principal Lecturer and Director of Studies for Film and Television at Kingston University. He has published widely on a range of topics including the Titanic on film, early cinema, British cinema, colour cinematography and American Quality Television. A 3D fan at heart, he is currently working on an article on 3DTV and a book on 3D cinema in the twenty-first century.

JOHN CARR is one of the world's leading authorities on children's and young people's use of the internet and associated new technologies. He is a key government adviser on internet safety and is on the Executive Board of the UK Council for Child Internet Safety (UKCCIS). He is also on the Advisory Council of the Family Online Safety Institute in Washington, DC and Beyond Borders, Canada, and is a member of the BBFC's Advisory Panel on Children's Viewing. His publications include 'The Role of the Internet in the Commission of Crime' and 'Out of Sight, Out of Mind – Global Responses to Dealing with Online Child Pornographic Images' and, in 2009, he co-authored (with Dr Zoe Hilton) 'The Digital Manifesto'. He was awarded an OBE in 2010.

STEVE CHIBNALL is Professor of British Cinema and Director of the Cinema and Television History (CATH) Research Centre at De Montfort University, Leicester. He is author or editor of a dozen books, including Quota Quickies (2006) and The British 'B' Film (the latter with Brian McFarlane, 2009). His current research projects include The Historical Dictionary of British Cinema (with Alan Burton), Anglo-Italian co-productions and the life of the ill-fated British actress Belinda Lee.

DAVID COOKE has been Director of the BBFC since September 2004. Prior to that, he held six government Director-level posts, in the Cabinet Office, Northern Ireland Office and Home Office, working on topics such as the Northern Ireland Peace Process, devolution, asylum, criminal justice performance and broadcasting.

ROBIN DUVAL was Director of the BBFC from 1999 to 2004. He began his career in BBC radio and worked as a writer and producer of television commercials at J. Walter Thompson. He later worked at the Central Office of Information, becoming Head of Television and Film Production. Prior to his appointment at the BBFC he spent seven years as Deputy Director of Programmes at

the Independent Television Commission. He was awarded a CBE in 2005 'for services to the film industry'. He is the author of the novel *Bear in the Woods* (2010).

JASON GREEN works in the policy and research department at the BBFC.

TRACY HARGREAVES is a Senior Lecturer in the School of English at the University of Leeds. She has written a monograph, *Androgyny in Modern Literature* (2005), and has co-edited (with Alice Ferrebe) an edition of 1950s and 1960s writing for *The Yearbook of English Studies* (2012). Her most recent essays have looked at cultural representations of the Queen's Coronation, the BBC's *The Forsyte Saga*, Richard Hoggart, John Braine and the British New Wave and the fiction of Doris Lessing and B. S. Johnson. She is currently working on a monograph, *Intimacy and the English Imagination: 1945–1969*.

GEOFFREY HAWTHORN was formerly Professor of International Politics at Cambridge. He has edited Bernard Williams's political essays in *In the Beginning Was the Deed: Realism and Moralism in Political Argument* (2005).

DAVID HYMAN has been employed as a BBFC examiner since 1999.

ROBERT JAMES is Senior Lecturer in Cultural and Social History at the University of Portsmouth. His book *Popular Culture and Working-Class Taste in Britain, 1930–39: A Round of Cheap Diversions?* was published in 2010. He is currently researching the impact of the Navy on leisure provision in Portsmouth and Plymouth during the early twentieth century.

Writer and broadcaster MARK KERMODE is resident film critic for BBC Radio 5 live and the BBC News Channel. He is the author of *It's Only a Movie* (2010) and *The Good, the Bad and the Multiplex* (2011) and two BFI Modern Classics volumes on *The Exorcist* and *The Shawshank Redemption*. He writes a weekly column for the *Observer,* and is a contributing editor to *Sight and Sound*. He has written and broadcast extensively on film censorship, with documentaries for BBC and Channel 4 television, and in the pages of *Time Out*, *Index on Censorship*, *Fangoria*, the *Independent* and *Video Watchdog*.

EDWARD LAMBERTI is Information Services Manager at the BBFC and a PhD candidate in the Film Studies department at King's College London.

CRAIG LAPPER joined the BBFC in 1997 and has served in a variety of positions at the Board, including Assistant to the Director under James Ferman and Robin Duval, Chief Assistant (Policy) under Robin Duval and David Cooke, and Senior Examiner since 2005. He has contributed accompanying notes and booklets for various DVD and Blu-ray releases, including *Salò*, *Trash*, *Flesh for Frankenstein*, *Straw Dogs* and *The Devils*, and has appeared in documentaries on censorship, including *Walking with Pasolini* (2008), *Video Nasties: Moral Panic, Censorship & Videotape* (2010) and *Time Shift – Dear Censor …* (2011).

GERARD LEMOS is Vice President of the BBFC. He also writes about social policy. His latest book is *The End of the Chinese Dream: Why Chinese People Fear the Future* (2012). He is Chairman of the Money Advice Service and chaired the Board of the British Council between 2008 and 2010 after many years as Deputy Chair.

AIDAN MCDOWELL is an examiner at the BBFC. He was formerly a Senior Policy Executive at the UK Film Council and Senior Executive Officer with the Department for Culture, Media and Sports' Media Division, where he was part of the Secretariat for the Film Policy Review Group and Observer to the BFI Film Education Working Group. He has a BA in American Studies from the University of Leicester and an MA in Film and TV Studies from the University of Westminster.

KAREN MYERS has been a film and video examiner at the BBFC since 2004. She previously worked in media education for the British Film Institute and in theatre production in the West End and at the Open Air Theatre, Regent's Park. She has an MA in English Literature from the Open University.

CAITLIN O'BRIEN has been a BBFC examiner since 2004 and previously worked in television production. She has a BA in English and German from the University of Oxford.

GUY OSBORN is Professor of Law at the University of Westminster. He is co-author of *Film and the Law* (2010) and a Founding Editor of the *Entertainment and Sports Law Journal*.

MURRAY PERKINS joined the BBFC as an examiner in 2000, and has held the post of Senior Examiner since 2005. He has contributed to various articles and documentaries on censorship and pornography in both print and broadcast, recently providing a chapter for the book *Policing Sex* (2012). Prior to coming to the UK, he worked for the New Zealand Office of Film and Literature Classification.

JULIAN PETLEY is Professor of Journalism and Screen Media in the School of Arts at Brunel University, Chair of the Campaign for Press and Broadcasting Freedom, and a member of the advisory board of Index on Censorship. He is the author of *Film and Video Censorship in Modern Britain* (2011) and co-editor with Stevie Simkin of the *Controversies* series.

ANN PHOENIX is Co-director of the Thomas Coram Research Unit, Institute of Education, University of London and joint head of the Department of Childhood, Families and Health. Her research is mainly about social identities and the links between psychological experiences and social processes. She is currently the Principal Investigator on NOVELLA (Narratives of Varied Everyday Lives and Linked Analyses), an ESRC-funded node of the National Centre for Research Methods. Her books include *Young Mothers?* (1991), *Black, White or Mixed Race?* (with Barbara Tizard, 1993/2002), *Young Masculinities* (with Stephen Frosh and Rob Pattman, 2002) and *Parenting and Ethnicity* (with Fatima Husain, 2007). She is a member of the BBFC's Advisory Panel on Children's Viewing, and she co-directs the Childhood Wellbeing Research Centre funded by the Department for Education.

STEPHEN SEDLEY served as a Lord Justice of Appeal at the Court of Appeal of England and Wales from 1999 to 2011. He became a QC in 1983 and a High Court Judge in 1992; he was knighted the same year. A collection of his writings, *Ashes and Sparks: Essays on Law and Justice*, was published in 2011.

STEVIE SIMKIN is Reader in Drama and Film, Faculty of Arts at the University of Winchester. His previous publications include *A Preface to Marlowe* (1999), *Revenge Tragedy: A New Casebook* (2001), *Early Modern Tragedy and the Cinema of Violence* (2005), *Straw Dogs* (2011), *Basic Instinct* (forthcoming 2013) and *Cultural Constructions of the Femme Fatale: From Pandora's Box to Amanda Knox* (forthcoming 2013). He is co-editor with Julian Petley of the *Controversies* series.

ALEX SINCLAIR, LLB, LLM, Barrister is an Associate Fellow at the Centre for the Study of Law, Society and Popular Culture, at the University of Westminster. He lectures in Media Law, Film and the Law and Entertainment Law at the School of Law.

QUENTIN THOMAS was appointed President of the BBFC in August 2002. His career was spent in Whitehall: in the Home Office, dealing with criminal law, criminal justice policy and with the broadcasting system and its regulation; as Secretary to the Royal Commission on Gambling under Lord Rothschild; in the Northern Ireland Office (1988–98) as Political Director; and in the Cabinet Office dealing with constitutional reform. He was knighted in 1998 'for services to peace in Northern Ireland'.

FOREWORD

Mark Kermode

From its birth at the end of the nineteenth century, cinema has attracted the attentions of authorities who have recognised the medium's popularity and potency, and have feared for the safety of its patrons. In the early days it was the flammability of nitrate film stock which first gave local authorities in Britain the power to regulate picture houses, with the Home Secretary acting against fire hazards rather than moral mazes through the introduction of the Cinematograph Act in 1909. Soon, attention turned from the volatile substances from which film was made to the allegedly 'dangerous' messages they contained, and the regulation, classification and censorship of movies became an integral part of the cinema business.

There is an age-old adage, familiar to those in the classification trade, which states that it is the inevitable fate of any censor to appear ridiculous to subsequent generations. Public tastes move quickly, and what appears shocking today can all too soon seem mundane and unremarkable, leaving any specific regulation with an extremely short shelf-life. More than any other branch of the film industry, censorship (in all its many forms) will always be distinctly of its time, and it is for precisely this reason that we can learn much about the movies – their production, their distribution, and their audiences – from the study of their regulation.

Over its hundred-year history the BBFC has undergone a series of seismic changes, all of which represent significant shifts in the public and political perception of the nature of cinema, and which broadly speaking represent a century-long movement from restriction to regulation. As long ago as the early 1970s, retiring chief censor John Trevelyan was floating the radical idea that the BBFC should no longer cut films for adults; in the 80s, the Board significantly changed its name from the 'British Board of Film Censors' to the 'British Board of Film Classification', apparently declaring a move away from the cutting room; and in 2000, the BBFC embarked upon an extensive survey of public opinion which concluded that adults should be allowed to choose for themselves what they can watch – within the confines of the law.

Today, the BBFC stands as the most open and accountable film regulation body anywhere in the world, an organisation which views the provision of information as being of paramount importance, and which strives to strike a balance between the strictures of UK law, and the still controversial principles of 'harm', and the freedoms of expression now legally enshrined in the Human Rights Act. You may not always agree with the BBFC's decisions, but today that disagreement can be part of a debate which will help define the future of the Board. And where better to start that debate than in understanding its history?

PREFACE

Quentin Thomas

The BBFC's centenary in 2012 marks a significant record of achievement. Although a private body, established because the government of the day did not want to take on the responsibility of regulating film content, something the industry believed needed to be done centrally, the BBFC secured a central place in the regulation of the most exciting, influential and powerful of the mass media. Though its decisions are always open to challenge, and some have inevitably proved controversial, it has secured a high level of public confidence.

The BBFC has proved adaptable, as it needed to do. Since 1912, the grounds for intervention, and the nature of its oversight, have changed markedly. This can be illustrated by comparing its present published Guidelines with earlier statements about the Board's approach. In 1916 the then President set out forty-three grounds for 'deletion', drawn from the Board's practice at that time. These included:

- Indecorous, ambiguous and irreverent titles or subtitles;
- Drunken scenes carried to excess;
- Cruelty to young infants and excessive cruelty and torture to adults, especially women;
- Unnecessary exhibition of feminine underclothing;
- Relations of Capital and Labour;
- Scenes tending to disparage public characters and institutions;
- Scenes holding up the King's uniform to contempt or ridicule;
- The drug habit, e.g., opium, morphia, cocaine, etc.[1]

Some of these clearly reflect the attitudes and social and political context (in the middle of war) and would seem incongruous as grounds for intervention today. Others express concern about issues which are reflected in the current Guidelines – for example, the treatment of violence, sex and drug misuse. Nowadays they are more likely to be considered as relevant to the age classification, rather than as grounds for 'deletion'.

Similarly, in 1948 the then President and Secretary formulated new terms of reference for the Board based on three principles:

- Was the story, incident or dialogue likely to impair the moral standards of the public by extenuating vice or crime or depreciating moral standards?
- Was it likely to give offence to reasonably minded cinema audiences?
- What effect would it have on children?[2]

Again, while the issues would be expressed somewhat differently today, some if not all of these points are reflected in the current Guidelines.

Over its hundred-year life, the Board, and its regime, has evolved considerably. In so doing, it has reflected profound changes in our society and culture; changes in cinema, in the availability of

film and in the technology which brings it to the viewer; and changes in our understanding and appreciation of film and of its impact.

But a number of fundamentals remain constant. These include:

- The need for sensitivity to the medium: regulation must reflect a deep appreciation of the nature of film, its power to entertain, inform, enrich and illuminate and its potential for harm as well as for benign influence;
- The need to retain the confidence of the public and other interests in striking the right balance between some independent scrutiny and creative and commercial freedom to maximise the benefit society derives from the medium;
- The need to protect against the risk of harm, most conspicuously in respect of children;
- The need for regulation to reflect and be consistent with contemporary culture and prevailing social attitudes.

All this is consistent with the principal statutory provisions: the Video Recordings Act (VRA) 1984 for video works and the Licensing Act 2003 for cinema. Under the 1984 Act, when considering whether to award a classification certificate to a work, or whether to classify a work at a particular category, the Board is required to have special regard (among other relevant factors) to the likelihood of works being viewed in the home, and to any harm that may be caused to potential viewers or, through their behaviour, to society by the manner in which the work deals with criminal behaviour, illegal drugs, violent behaviour or incidents, horrific behaviour or incidents, or human sexual activity.

The objectives of the Licensing Act, under which cinemas require a licence from the relevant local authority, are the prevention of crime and disorder, public safety, the prevention of public nuisance and the protection of children from harm.

Over the Board's life, but particularly in recent years, there has been a shift from restriction and prohibition towards regulation that is transparent, objective and therefore more accountable, alongside the increased provision of relevant information so that informed decisions can be made by potential viewers and their parents. (In addition to the brief consumer advice provided on each film or video work, the Board's website and its apps provide more detailed information, for parents in particular, about individual classified works, explaining why each was given its age classification.)

While the Board makes no claim to infallibility, it has developed machinery to ensure a systematic and consistent approach within the law. Moreover, its procedures and policies are open and accountable. And its decisions are based on declared policies reflected in published Guidelines which are themselves the product of extensive experience, study of research findings and successive rounds of public consultation.

In addition, the Board has a dedicated, experienced and professional staff. It also benefits from the advice of two standing consultative bodies, the Advisory Panel on Children's Viewing and the Consultative Council, which bring together people of relevant experience and expertise. Furthermore, it has a culture of openness and explanation, with a track record of responsiveness, and as the history demonstrates, a capacity to change and adapt.

The legal framework, established by Parliament, in which the Board operates, requires pre-publication regulation: that is, the film or video work is examined and, if appropriate, classified before it may be shown in a cinema or sold as a DVD or Blu-ray disc. While pre-publication scrutiny was once more widespread, for example in broadcasting, the theatre, even in the case of the printed word, it is now unusual for non-film media content.

Internationally, however, pre-publication oversight remains the norm for films. Its justification is straightforward: if the object of regulation is the prevention of harm then, to achieve its objective, it must apply before publication. And nowadays such compulsory prohibitions, as distinct from raising the age classification, as the Board makes almost always derive from an assessment of the risk of harm or are otherwise expressly proscribed by law (for example, in respect of animal cruelty or indecent images of children). In short, the system of regulation reflects and depends upon an appreciation of the nature of the medium and its potential impact.

In this, the Board's policy broadly follows the approach advocated by the Departmental Committee on Obscenity and Film Censorship under Professor Bernard Williams which reported in 1979 (Cmnd 7772). Recommendation 3 states:

> The law should rest partly on the basis of harms caused by or involved in the existence of the material: these alone can justify prohibitions; and partly on the basis of the public's legitimate

interest in not being offended by the display and availability of the material: this can justify no more than the imposition of restrictions designed to protect the ordinary citizen from unreasonable offence.

As to classifying films for persons under eighteen, recommendation 44 (a) says this 'should take account of the protection of children and young persons from influences which may be disturbing or harmful to them, or from material whose unrestricted availability to them would be unacceptable to responsible parents'.

Pre-publication classification also remains the norm in the suite of voluntary, best-practice initiatives the Board has set up outside its statutory responsibilities in partnership with industry. The Board is increasingly examining and classifying content for distribution online. It is also involved in advising, setting up and running other bespoke voluntary classification services for specific sectors whose involvement in creating or distributing content is relatively new and not required by any law. It is the BBFC's expertise and experience, built up over the last hundred years, which continues to encourage new partners to seek it out and work with it as they look to exploit emerging distribution platforms. And it is creating and managing these sorts of self-regulatory regimes which are likely to play an ever growing part in the BBFC's future story.

INTRODUCTION: A CENTENARY BOOK

Edward Lamberti

When the idea of a book to celebrate our centenary was first mooted, we thought it was a great idea. But then the question was, A book saying what? I think it's fair to say that the editorial team was, from the off, more interested in the idea of a volume that told us – and you – things we/you *don't* already know than a book that would merely retread existing ground on censorship and classification, and on several decades of film culture in Britain.

Also, we didn't want the book to be just 'our' take on 'us'. Of course we wanted the book to cover the past, bring the story up to the present and look to the future, but we also wanted it to be a multifaceted thing, igniting interest rather than settling into a single groove. We wanted it to be cohesive, but we also wanted it to comprise a range of views, voices and takes on the organisation.

The idea of a single author, then, was ruled out very early on. We didn't want someone who would just become a mouthpiece for what 'we' wanted to say. And even if that writer had not succumbed to such a role, we wanted to offer a wider perspective than any single author could give to the project.

So we invited a range of writers from outside our walls to produce brand new pieces which, together with contributions from internal staff, would make up the book and form a picture of what we're about.

When approaching people to contribute, we were anxious not to be too prescriptive. We gave our contributors an overview of our hopes for the project, a list of what we considered some of the key moments, issues and 'beats' in the century of activity in question, and as much access to our files as we could make possible. Beyond that, we were happy to let them come at their respective eras however they saw fit.

This book, then, *isn't* an official history. The authors have been free to write as individuals, to tell it as they see it. They have not been bound by official BBFC doctrine: for that, readers need to consult the Board's classification Guidelines and other official publications. The book is a history, a commentary, a survey – and more. And there is, of course, continuity. As one contributor passes the baton to the next, so the story develops. Themes recur, certain films make multiple appearances, footage gets cut and then, decades (and chapters) later, put back in. The social context and societal attitudes change. As do laws. So, for example, *Battleship Potemkin* goes from being banned to being a 'PG'.

Simon Brown kicks things off with a carefully charted account of how, and why, the BBFC came into being, and how it established itself in the eyes of the government, the local authorities and the film industry. In Robert James's survey of the Board's scenario reports in the 1930s and World War II, a picture emerges of an organisation aware of its role regarding the leisure habits of the general public and keen to promote a system of censorship that would instil a certain sense of public morality.

Moving into the post-war years, Steve Chibnall sorts through a succession of films and decisions that brought the organisation in line with a gradually more permissive society; while Tracy Hargreaves's coverage, in Chapter 4, of a number of key decisions from the late 1950s to the end

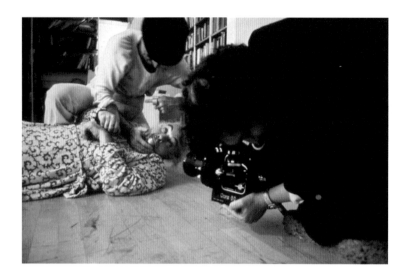

Director Stanley Kubrick
filming the controversial
home-invasion scene
from *A Clockwork
Orange* (1971)

of the 60s shows how that permissiveness came on in leaps and bounds during this period of enormous social upheaval.

Picking up the story in the early 1970s, Stevie Simkin scrutinises the BBFC's activities in this highly contentious period when a number of major films proved instantly controversial and created headache after headache for the Board (and for plenty of other organisations in British society). Here, *The Devils*, *Straw Dogs* and *A Clockwork Orange* are the starting point for an examination of a wide range of movies subject to intervention for a variety of reasons, and Simkin considers the ways in which many of the issues of the time still resonate today. Guy Osborn and Alex Sinclair's perspective on the latter half of the decade in Chapter 6 pinpoints the ways in which matters of legislation were weighing particularly heavily on the Board's activities and decisions. Their chapter highlights the significant role the then new man in charge, James Ferman, assumed in enabling the Board to re-establish its authority amid various voices of dissent in the era.

In Chapter 7, Sian Barber's handling of the 1980s eschews the well-covered territory of the 'video nasty' and concentrates rather on many high-profile mainstream titles that the Board dealt with in this period. Her account analyses the implications of the Board's decisions with regard to, among others, teenage viewers, family entertainment, homosexuality and the war film. Turning to the 1990s, Julian Petley shows how the Board's considerations of harm fed into its decisions with regard to, principally, a sex-education work (*The Lovers' Guide*), a video game (*Carmageddon*) and a feature film (*Crash*). Petley argues that in this era, scrutiny of BBFC decisions by various competing interests even endangered the organisation itself. This is discussed further in Chapter 9, in which Robin Duval, former Director of the BBFC, offers a relaxed and very personal account of his five years at the helm, a time in which the Board extended its drive to be more open and accountable.

David Cooke, the Board's current Director, brings us up to date in Chapter 10 by taking us through key developments in classification policy, greater empowerment of consumers and the creation, in partnership with industry, of best-practice self-regulation for online content. And in Chapter 11, BBFC Vice President Gerard Lemos introduces a collection of short essays that give individual takes on the landscape in which the Board sits, and in which moving-image culture itself is unfolding.

Interspersed with the chapters are case studies on individual works. These are written by BBFC staff, who, like our external collaborators, come at the films and the events in their own ways. These case studies supplement other in-depth looks at particular films that you'll find in the chapters themselves; but we've designed them also as stand-alone items. There are, of course, hundreds (even thousands) of BBFC decisions that we could have chosen to look at, and indeed, getting our longlist down to a mere twenty titles involved some of the Board's most ruthless cutting of recent times! But we think that each of the decisions we have chosen to discuss says something important about the Board's work, and adds to the portrait presented here.

Finally, a note on the text: in the offices of the organisation, 'the BBFC' and 'the Board' are used interchangeably – and it's the same in this book.

1

CENSORSHIP UNDER SIEGE: THE BBFC IN THE SILENT ERA

Simon Brown

From the very beginning, the British Board of Film Censors found itself under siege. Its early years were categorised by considerable uncertainty as its motives and decisions were questioned and its very existence challenged. As an organisation it sat at the centre of a maelstrom of powerful, combative and competing institutions, each with their own agenda and each regarding the BBFC with varying degrees of suspicion, indifference and, at times, contempt. These institutions form the major players in the story of the origins and development of the BBFC during the silent era. First was the Home Office, the government department responsible for public order in the UK. Second were the hundreds of local authorities around the country, each of which was responsible for granting licences to cinemas that allowed them to operate within their boundaries. The third was the film trade itself, made up of the three separate areas of production, exhibition and distribution (here in the form of renters). Each of these was represented by separate and often warring trade organisations, respectively the Kinematograph Manufacturers' Association (KMA), the Cinematograph Exhibitors' Association (CEA) and, later, the Kinematograph Renters' Society (KRS). Between them the Home Office, local authorities and the trade brought issues of public safety, legal authority and economic necessity to bear on what was a young, small and often powerless organisation, making its formative years ones of insecurity. The story of the BBFC in the silent era is the story of a struggle for recognition, respect and validation.

The Origins of the BBFC, 1909–12

The origins of the BBFC initially lay in the Cinematograph Act 1909, which was designed primarily to regulate film shows for the purpose of public safety. At that time cinema shows were a combustible mixture of dangerous ingredients. First, the strip of film was made of cellulose nitrate, which was highly flammable, burned extremely quickly and was very difficult to put out. Second, this dangerous material ran through a projector which had to produce a strong beam of light in order to project the image on the film strip onto a screen. One common source of illumination for early film projectors was limelight, in which a piece of lime was heated by a gas jet to produce a bright white light. The heat produced by the lime was intense, and while normally a strip of nitrate passing through the gate of the projector at around sixteen frames per second was exposed to the heat for too short a time to catch alight, if the film got stuck in the gate for only a few seconds it would be enough for it to burn.[1] The third danger element was the venue itself. Up until around 1906 the main venues for showing films were music halls and travelling shows in fairgrounds. From 1906 onwards, there was a proliferation of fixed-site cinema shows, commonly referred to nowadays as 'penny gaffs' and generally considered to be akin to the more famous early American cinemas known as Nickelodeons. Recent research by film historian Jon Burrows suggests, however, that the term 'penny gaff' was nowhere near as ubiquitous as has been frequently suggested, and that the term 'penny cinema' was more common, 'gaff' being a more derogatory term.[2]

Regardless of the name, penny cinemas tended to be small and cheap, often located in empty shops that were crudely converted for the purpose of film shows, with a few seats, a screen or sheet at one end and a projector at the other. More often than not there was only one door, which doubled as both entrance and exit and next to which the projector would be located. In the event of a projector fire, this one door and only route of escape could easily be cut off by the swiftly burning film and the resulting large amounts of toxic smoke. Reports of fires in penny cinemas were actually few and far between, but the potential for public-safety disasters did not go unnoticed. There were some high-profile catastrophes, including an appalling fire at a film show in Paris in 1897 in which around 140 people lost their lives. Other examples of the dangers of nitrate film included a fire in 1907 in Cecil Court, a small alleyway between St Martin's Lane and Charing Cross Road in London which was home to many early British film businesses, a fatal fire at the Hepworth Manufacturing Company studios in Walton-on-Thames, also in 1907 and a fire at Newmarket Town Hall in September the same year.[3] While only one of these was a public venue, incidents such as these served to highlight the dangers.

The London County Council (LLC), one of the hundreds of local councils in Great Britain, had already drawn up a series of rules to regulate cinema shows in the capital, including placing the projector in a fireproof box and banning the use of certain illuminants. The regulations, drawn up initially in January 1898 shortly after film shows began and revised in 1906, were enforceable under the Disorderly Houses Act 1751. They specifically related to venues featuring music and dancing (such as music halls), which distinguished such venues from the so-called legitimate theatres (where plays were put on) regulated by central government through the Lord Chamberlain's Office.[4] The problem was that while the regulations specifically related to cinema exhibition, they could only be enforced where the premises were actually licensed. The LCC only had authority over venues which had a music and dancing licence and it was not clear whether cinemas required a licence or not, since cinemas did not always involve live music and rarely, if ever, involved dancing. While it was common for a pianist to accompany the films, many other options were also available, including a lecturer who would speak alongside the films, as well as mechanical pianos that would play standard pieces without the need for a pianist, and even sound effects machines. There was some debate around the issue of whether the presence of a mechanical piano would mean a venue required a licence and thus make it eligible for prosecution under the law.

None of this, however, detracted from the basic principle of public safety. The LCC's main expert on cinematograph shows, Walter Reynolds, strongly advocated new national legislation specifically targeting film shows, stating that, as noted by David R. Williams, 'Twentieth-century amusements needed twentieth-century regulations.'[5] As unlicensed cinematograph shows spread throughout the country, many local councils around Britain moved to impose their own regulations. The desire for national legislation grew to the point that an announcement was made in February 1909 that such legislation would be drawn up and presented to Parliament.[6] The Cinematograph Act 1909 was passed by both Houses and received Royal Assent in November, coming into force on 1 January 1910. The enforcement of the Act was given over to the various local authorities that were to be responsible for licensing premises under their jurisdiction.

While certain clauses in the Act did cause concern among film exhibitors, in general the trade supported its implementation because the main target was not the growing exhibition chains or circuits but rather the small-scale penny operations which were, in Reynolds's own words, run by 'rapacious, unscrupulous manager(s) [...] wilfully placing [...] exploited patrons in danger'.[7] As much as this Act was about public safety, bringing in a formal system for licensing cinemas that required a minimum set of standards to be met was also therefore about ridding the trade of opportunist businessmen out to make quick money by charging low prices for poor-quality films – often scratched prints bought cheaply through secondhand sales companies – in grubby, unsuitable premises. The Act was therefore very welcome for an industry struggling not only with an apparently undesirable subgroup of entrepreneurs but also with a poor reputation as a working-class form of largely sensationalist entertainment that for many in society was a cause for concern. The Daily Telegraph in March 1908 published a letter by a vicar in Whitechapel who complained about a film called The Life of Charles Peace (1905). Peace was a burglar who had been executed for murder in 1879 and whose exploits, including a daring escape from a moving train, had been widely reported by the press. The film, made by William Haggar in South Wales, recounted key moments of Peace's life and was considered, by the vicar at least, to be violent and sensationalist.[8] In February 1909, the Commissioner of Police asked for tighter control over films that glorified crime, while more controversially in July 1910, the LCC banned a film of the famous

The Life of Charles
Peace (1905), one of a
number of early films
accused of glorifying
crime

prizefight between Jack Johnson and James Jeffries. Johnson was a black man, and at the time was the heavyweight champion. Jeffries came out of retirement to win back the title for white America and his defeat caused race riots throughout the US. The film was banned in the US and concern that it could spark similar violence in the UK prompted the LCC's decision.[9] Thus not only did the Act encompass issues of public safety, indirectly it also addressed the question of low-quality working-class film shows, as well as the morality of the subject matter of films playing, often to children, in these penny cinemas.

Concerns over what were seen to be controversial films playing to working-class audiences led a number of local authorities to request the power to prohibit exhibition of films they disliked and, in early 1911, legal precedent made this possible. The LCC commonly stipulated in its music-hall licences that venues could not open on Sunday and this condition was transferred to the licensing of cinema shows under the 1909 Act. In early 1910, the LCC issued a summons to the Bermondsey Bioscope Company for breach of the licence, having discovered they were showing films on Sundays. The Bermondsey Bioscope Company claimed that the LCC exceeded the bounds of the Act by including the Sunday stipulation. Having lost the case initially, the LCC appealed and won in December 1910. The Divisional Court scrutinised the Act and focused on section 2, which allowed that any county council could grant a licence 'under such restrictions as [...] the council may by the respective licences determine'. In the judgment of the court, this phrase permitted the LCC to impose any conditions it wanted in granting a licence, regardless of whether or not they related to safety. This decision formed the legal structure under which film censorship was, and continues to be, based, because it enshrined in law the fact that county councils could, if they wished, restrict the types of films which were shown as a condition of granting a licence.

It did not take long for some local authorities to add to any licence the condition that the films shown must not be improper or indecent. Beyond statutory legislation such as obscenity and libel laws, the concept of indecency was left largely to matters of individual taste, which made the

situation very difficult for exhibitors who, with perhaps a few obvious exceptions, could not be certain if a film would attract complaints. This gave rise to a potential situation in which any exhibitor showing a film which just happened to offend one of the council members or a number of influential patrons could find themselves in court and fined for a breach of licence, while another exhibitor within a few miles might have no problems at all.

Faced with a tarnished public image, and this unworkable situation for exhibitors, the film-makers' trade body, the KMA, met and agreed that they should approach the Home Office and suggest a form of self-regulated censorship. They approached a number of influential film renters who also agreed and, in February 1912, a deputation met with the Home Secretary, Reginald McKenna, to put forward their proposal.[10] The stakes were high, and so to demonstrate both its seriousness and its commitment to the concept of an independent body, the trade approached George A. Redford to be the President of the new organisation. Redford had no connection to the film industry but had been Examiner of Plays at the Lord Chamberlain's Office. Thus he brought with him knowledge and experience of censorship and ties to government but not of the film business.[11] He also had a certain middle-class respectability due to his links with the theatre; this would add an air of authority and responsibility to the proposed body. In addition, the trade suggested that while the censors would be independent of government, the Home Office could appoint a referee to act as a kind of appeal court in the event of disputes. McKenna was broadly supportive but firmly rejected the idea of either involving the Home Office directly or offering its formal support, since it had no actual authority over the process as it was envisaged and suggested by the trade.[12] The power to regulate film content was held by the local authorities as a condition for granting a cinema licence under the 1909 Act, and was further established by the legal precedent of the judgment in the *LCC* v. *Bermondsey Bioscope* ruling. If the authorities agreed to recognise and uphold the advice and decisions of the new organisation, then the decisions would have legal power and the Home Office need not be involved. It was the struggle to obtain this approval from the local authorities that would mark the early years of the soon-to-be-named British Board of Film Censors.

Trials and Tribulations: The Redford Years, 1912–16

In November 1912, the formation of the BBFC was announced in the House of Commons.[13] The Board started operations on 1 January 1913 under the Presidency of Redford, who was paid £1,000 per year, with four examiners each on a salary of £300 per year, and the imposing figure of Joseph Brooke Wilkinson, former Secretary of the KMA, as Secretary. The BBFC aimed to view around 120 films per week.[14] The four examiners all sat in the same room, and two films were projected simultaneously, next to each other, with two examiners watching one and two the other. Where a film raised issues, all four examiners would watch it, and then, if the film was particularly problematic, the President would view the film and have the final say. The President was responsible for all correspondence with whoever submitted the film. These working practices remained in place throughout the silent era, and well into the sound era.[15] From March 1913, the Board began to issue certificates that confirmed not only that the film had been passed but also in which category it had been placed. Initially there were only two categories – 'U', which was universal for all, and 'A', which imposed no age restriction but which contained material considered generally more suitable for adult audiences.

During the Board's first year of operation an unforeseen problem emerged: it was not made entirely clear to the trade whether the responsibility for submitting a film to the Board lay with the producer of the film or with the distributor. This resulted in the Board having swiftly to negotiate and clarify the situation to the effect that films had to be submitted before the rights were sold.[16] Despite this initial hiccup, in their first year the examiners saw an impressive 7,510 films. Of those, 6,861 were passed with a 'U' certificate while 627 received an 'A' certificate. Cuts were made to 166 films while only twenty-two were banned outright, due mainly to sexual content such as 'Indelicate or suggestive sexual situations', 'Indecent dancing' and 'Impropriety in conduct and dress'. Other reasons for banning films included excessive drunkenness and, as is still the case after the Cinematograph Films (Animals) Act of 1937, cruelty to animals, but perhaps more surprising reasons included 'Holding up a Minister of Religion to ridicule', 'Materialisation of Christ or the Almighty' and 'Native customs in foreign lands abhorrent to British ideas'.[17] Between them these reasons offer an indication of the types of moral thinking underpinning the work of the BBFC, which reflected a very middle-class view of Britain and, more importantly perhaps, a middle-class view of the working class, which constituted at this time the main audience for

The BBFC's first President, George A. Redford

cinemas. The list therefore suggests an attempt to repress immoral behaviour including sex and public drunkenness, while the issues raised around religion point to an attempt to avoid the demystification of the church, which was a guardian of public morals and opinions.[18] Finally, the objection to foreign customs implies a patronising attitude to other cultures as well as a protectionist attitude towards the British film industry. Thus, while in the first year the BBFC began with only two 'official' rules, which were no nudity and no depiction of Christ, these were quickly augmented by others which suggest a paternalistic and patronising attitude towards cinema audiences, as well as a general sense of British superiority in terms of taste. The Annual Report for 1913 ends with the assertion that 'the Board has had a salutary effect in gradually raising the standard of subject and eliminating anything repulsive or objectionable to the good taste and better feelings of English audiences'.[19]

Despite the seemingly rosy picture presented in the Annual Report, 1913 saw controversies arise over certain films, and these more importantly demonstrated the relative powerlessness of the Board. In many cases complaints about films were directed not at the BBFC but directly to government which was forced to intervene. In July 1913, for example, the Colonial Office received a complaint from the South African government about a film which showed images of the so-called Rand Riots, violent disturbances that took place in Johannesburg and which were quelled by British government troops supporting the local police, resulting in the deaths of a number of protesters. The Colonial Office approached the Home Office, which arranged with the BBFC to see the film and then suggested to the BBFC what cuts should be made.[20] The title of the film is unknown but quite possibly it was a British Pathé News film entitled *Rand Strike Riots* (1913). Closer to home, in August 1913 British Pathé News was denied the opportunity to show a film of prisoners at work on Dartmoor. The BBFC responded to Pathé saying that it was

> directed by the Secretary of State to say that he has consulted the Directors of Convict Prisons [and] regrets that on full consideration he is unable to give the permission asked for [due to] their regular practice which is not to allow any photographs of convicts to be taken.[21]

It is notable here that this is not a question of law but rather a question of policy, and strongly suggests that the BBFC was being directed by, and acceding to, government policy as dictated to it by the Home Office. By 1914, Pathé, at that point one of the more powerful international film companies and one of the biggest companies operating in Britain, had stopped submitting its fiction films to the BBFC altogether, a clear indication of just how weak the authority of the Board actually was, given that Pathé films were still widely shown regardless of the fact that they had no BBFC certificate.[22]

A further prison-related issue arose in November 1913 when the Anchor Film Company produced a film called *£1,000 Reward* which told the fictional story of an escape from Portland Prison, located on the Isle of Portland just off the coast of Dorset. The film was to be shot on the island itself and was sold on the basis that at that time no prisoner had ever escaped from Portland Prison. The Prison Commissioner wrote to the Home Office asking if there were any way that the film could be banned, given that it was filmed on or near the actual locations and, more importantly, that it showed scenes of the guards being bribed. The Commissioner's fear was that this would prompt copycat attempts by prisoners to bribe the guards and escape. The Home Office went to the BBFC which agreed to pass the film provided that any reference to Portland and any scenes showing the bribing of the guards were removed. The producers assented, but grumbled that by the time the cuts were made, the film was virtually unshowable.[23]

This deferral to the Home Office was a feature of the BBFC's first year of operation, to the extent that Brooke Wilkinson sent the BBFC Annual Report for 1913 to the Home Office for approval before it was published. The response clearly indicates the attitude towards the BBFC. It asked that a statement that the Board was 'recognised' by the Home Office be removed 'as it would be likely to give rise to misconception'. Official recognition was therefore denied and the Annual Report instead contains the much less emphatic assertion that 'the objects of the Board have the approval of the Home Office', meaning that it supported the idea behind the Board rather than the organisation itself, and that the Home Secretary 'very much appreciates' its work. Furthermore, the Home Office insisted that the phrase 'when the scheme [by which they meant the industry scheme for setting up its own censorship body] was originally discussed in detail with the Home Office' was replaced with 'when this scheme was placed before the Home Office', the former suggesting that the Home Office was actively involved in discussions while the latter indicated that it merely approved a package which the trade had already put in place. Even more

telling is the request to delete the statement that 'it is satisfactory to be able to report that the Home Office is in accord, so far as religious films are concerned, with the views of the Board'. The argument was that 'this reference to the Home Office would be almost certain to give rise to public discussion and controversy, and this, as I am sure you will agree, it is most desirable to avoid'.[24] This clearly indicates that the Home Office was keen to avoid being seen to align itself with, or support, the BBFC except in the most general terms of suggesting that it was, at least, fit for purpose. The BBFC was powerless to do anything but agree, Brooke Wilkinson meekly replying that, 'I can assure you your wishes in this matter will be carried out.'[25]

This submissive attitude towards the government was hardly surprising given that the BBFC was set up as an alternative to government censorship, which the Home Office did not want to initiate but which remained a threat hanging over the fledgling organisation. Thus the BBFC was powerless in the face of Home Office pressure, and was equally powerless in the face of the licensing authorities. While it had been set up by the industry as a voluntary body to censor film content and classify films, the decision whether a film could be shown or not still lay with the designated licensing authorities as enshrined by the 1909 Act. In other words, the BBFC had no legal authority at all, and so its influence was only remotely viable if, as was suggested by the Home Office, the licensing authorities agreed to abide by the decisions made by the Board. The take-up was far slower than had been hoped. While the BBFC's Annual Report for 1914 confidently stated that

> [S]o far as can be ascertained between forty and fifty Licensing Authorities have, during the year, shown their confidence in the Censorship by making a rule that only such films as have been passed by the Board are to be exhibited

it also acknowledged that only twenty-three had officially included this in their licences.[26] By the time the Annual Report for 1915 was published in early 1916, this had risen only very slightly so that just thirty-five out of the several hundred local authorities actually committed to abiding by the BBFC's decisions in the first three years of its existence.

At the same time a large number of the remaining local authorities quickly began to call for government-run censorship in place of the BBFC. In June 1914, the Magistrates of Penzance passed a resolution calling for state censorship of films on the grounds that cinema shows were largely attended by children, who needed government protection from indecent or improper films. Similar resolutions were passed around the same time by, among others, Durham City Council, Leamington Spa Town Council, Scarborough Town Council, Central Somerset Church Council and Huddersfield Town Council.[27] In December 1915, Manchester City Council followed suit and the same month the Chief Constables of several towns in Lancashire visited the Home Office to request that an official censor be appointed and uniform rules adopted. The deputation came after difficulties had arisen over the film *Five Nights* (1915), a romantic melodrama based upon a racy novel written by Victoria Cross published in 1908. This had been passed by the BBFC but banned by the LCC and other local authorities, including Preston, Birmingham and Leicester; the producers sued the Chief Constable of Preston for libel.[28] It was argued that some local authorities were allowing films to be shown amid concerns that a ban might lead to a legal challenge. The trade was also becoming disillusioned with the BBFC, seeing it as an organisation whose authority was not recognised by the government and whose decisions were not adhered to by the majority of local authorities. By November 1915, the trade papers were calling for the Home Office to act and either take on the business of censorship or give the BBFC official powers.[29]

Even the War Office was expressing dissatisfaction with the Board. The outbreak of World War I undoubtedly proved difficult for the BBFC; in 1914, it agreed to censor newsreels in consultation with the government Press Bureau, but in 1915 the situation became more complex.[30] The War Office insisted that all films containing scenes related to the armed forces be looked at carefully, since representations which may be acceptable in peacetime may not be at a time of war. While the BBFC Annual Report for 1915 states that the War Office and its Press Bureau worked with the BBFC to ensure all decisions were 'satisfactory',[31] in April 1915, the War Office sent a letter to the Home Office noting that the BBFC did not censor films for export. It suggested that an arrangement should be made with Customs to the effect that any film not passed by the BBFC should not be exported. It furthermore recommended that a military advisor from the Press Bureau join the Board to advise on military matters.[32] At the end of the year, the War Office wrote back to say that an advisor had been made available but the BBFC had not used them, and stated furthermore that BBFC censorship on military matters was 'very lax'.[33] The response from the

Home Secretary of the time, John Simon, was to agree that 'censorship needs to be made more thorough'.[34]

Simon resigned shortly afterwards, in January 1916, to be replaced by Herbert Samuel who, in his role as Chairman of the Joint Select Committee of the House of Lords and House of Commons, was one of the instigators of the Cinematograph Act 1909 and therefore took a much more active interest in issues of film censorship than his predecessors. Amid this groundswell of criticism from the War Office, the clergy, the police and the local authorities, Samuel took the notion of official censorship far more seriously. On 14 April 1916, he held a conference in which representatives of the key local licensing authorities met to discuss the idea of government censorship. The conference agreed to the setting-up of an official censor and the following week Samuel took the idea to the trade, who broadly agreed to the idea but with the proviso, as was being mooted in the latter part of 1915, that the existing BBFC be used.[35] On 11 May, the Home Office sent a letter to all the local authorities asking if they would accept the formation of an official censorship body. It also asked if they would accept as a condition of granting a licence the requirement that no film prohibited by this body would be shown and that if a film had not been passed the local authority could only allow it to be shown if the authority itself had approved it in advance. A final condition was that the local authority would object to no film passed by the government censor.[36] This was a delicate balancing act on behalf of the Home Office which, like the BBFC itself, had no legal right to force the local authorities to comply. Their right to decide what could and could not be shown in cinemas was enshrined in the 1909 Act and the legal decision in the case of *LCC* v. *Bermondsey Bioscope*, but it was this individual right of each authority that caused the inconsistencies about which many complaints were made. The Home Office was trying to gain a measure of consent and uniformity by asking the authorities to sign up to the idea that they would object to no film which had been passed by the government censor, but they could not make the authorities accept the decision to ban a film, hence the coda which allowed the authority to show any film provided it had seen it in advance. Samuel knew that to introduce state censorship of films properly it would be necessary to pass new legislation which not only stripped the local authorities of the rights granted to them in the 1909 Act but also overturned the legal precedent of *LCC* v. *Bermondsey Bioscope*. A small number of local authorities rejected the proposals, unwilling to give up their authority.[37]

Despite these objections, most local authorities were in favour of the idea and, on 31 July 1916, the Home Office held a meeting with their representatives in which a set of conditions, modelled on those of the LCC, was drafted and approved, and subsequently circulated in August.[38] As with the original proposals discussed in April, Samuel was really trying to find a set of conditions around which a consensus would form and thus negate the necessity to pass legislation. The key points of the five model conditions were that no film would be shown which was 'likely to be injurious to morality or to encourage or incite to crime, or to lead to disorder, or to be in any way offensive to public feelings'; no film would be shown that had not been passed by the BBFC unless the licensing authority was given three days' notice and provided with a copy so that it could check the film and make their own decision regarding it; any film passed by the BBFC would be shown exactly in the form in which it was passed, unless consent for any changes was sought in advance; and no lurid or offensive posters or advertising materials were to be displayed. The final condition was that the auditorium would be sufficiently well lit that it was possible to see the whole area in an attempt to stop the indecent behaviour which was widely rumoured to be taking place in the dark. The new censorship body would operate under a President appointed by the Home Office and draw upon an Advisory Committee made up of representatives from various aspects of society and the trade. While the Home Office was actually proposing little more than a remodelled version of the BBFC with an official government stamp, the local authorities almost unanimously agreed to support the new scheme, only a handful holding out and complaining about the loss of power that adopting these new conditions would entail. Despite vociferous opposition from the trade, which in part revolved around concerns over the make-up of the proposed Advisory Committee, in October 1916, the Cabinet was informed that official censorship of films would be in place the following year.[39]

In less than three months, however, the entire process collapsed. The main reason for this was the split in Herbert Henry Asquith's Liberal government which took place in December 1916 and resulted in its being replaced by a coalition under David Lloyd George, himself a Liberal and a former member of Asquith's Cabinet. Herbert Samuel, who sided with Asquith in the split, was replaced as Home Secretary by George Cave, who immediately dropped the proposed new censorship scheme. He did not, however, abandon the idea of state censorship completely. In a letter dated 24 January 1917 to the Cinematograph Trade Council, which represented the

manufacturers', renters' and exhibitors' trade bodies, the Home Office declared that 'Sir George Cave will not proceed with the scheme, but will postpone the question of a central censorship until there is an opportunity for dealing with the matter by legislation'.[40] The threat to the BBFC was therefore not entirely removed. Cave apparently saw the inherent pointlessness of Samuel's scheme, which served merely to try and create an official version of what was already in place, and instead reserved the right to introduce legislation. The letter ended by recommending that the licensing authorities 'exercise to the full extent the powers of control which they possess under the Cinematograph Act'. This emphasis on the exercising of their powers suggests the thinly veiled threat behind Cave's decision, which was that the local authorities had to stop complaining and accept the current situation or risk losing their authority altogether. For the BBFC, the threat was equally clear. Either it had to win the support of the local authorities, or the spectre of the imposition of government censorship would be resurrected.

Acceptance and Consolidation: The O'Connor Years, 1916–29

The BBFC itself was curiously quiet during this period, although according to one letter to the Home Office, Brooke Wilkinson was heavily involved in the trade's resistance to the proposals in the latter half of the year.[41] The main reason for the silence was most likely the ill health of Redford, who died in November 1916. For all his experience in the Lord Chamberlain's Office, Redford had failed to win over the local authorities and establish the BBFC as a viable institution. It was clear that the role of President required political skill and the trade acted swiftly to replace him with someone whom they felt had considerably more influence. For this they turned to Thomas Power O'Connor. O'Connor was an extraordinary figure. He was born in Athlone, Ireland in 1848 and became a journalist in Dublin before moving to London as sub-editor of the *Daily Telegraph* in 1870. In addition to a highly distinguished career as a journalist, he was also by the time of his death in 1929 'Father of the House' of Commons, a title reserved for the longest-serving Member of Parliament at any given time. Astoundingly, given his long service, Tay Pay, as he was known, was actually an Irish Nationalist and advocate of Irish Home Rule. He was first elected to Parliament in Galway in 1880 and then in 1885 he was returned by two constituencies, Galway and Liverpool Scotland, an area of Liverpool around Scotland Road which, ironically, had a large Irish population. Tay Pay chose to sit for Liverpool Scotland and did so until his death, the only Irish Nationalist representing a constituency outside of Ireland itself.[42] From 1917 until his death, therefore, Tay Pay juggled three careers – as an MP, as a journalist/author and as President of the BBFC. As such he was neatly situated at the nexus of several key pressures on the BBFC, notably government, public opinion and the trade itself.

The appointment of O'Connor was a calculated move on the part of the trade to add legitimacy to the BBFC in the eyes of the Home Office and to strengthen its political and public influence. This was further augmented from an unlikely source when the Cinematograph Trade Council invited the National Council of Public Morals (NCPM) to undertake an inquiry into the moral influences of the cinema. The NCPM was an unofficial body, founded in 1904, that concerned itself with the preservation of British culture and society through the investigation of its perceived moral decline, and through the promotion of 'purity' via a mixture of sexual responsibility, both medically and morally, and eugenics. In 1911, the NCPM, which included among its members the Dukes of Fife and Argyll, Lord Strathcona (the High Commissioner of Canada) and James Ramsay MacDonald, leader of the Labour Party, published a Public Morals Manifesto that urged education in the ways of parenthood to tackle the moral decline in society and encourage morally upstanding behaviour in the young. While the links with eugenics and references to the detrimental effects on society of excessive breeding among the so-called 'feeble-minded' were and are deeply problematic, as a body the NCPM was relatively forward-looking, concerned with exploring ideas and concepts rather than making ill-informed, reactionary moralistic pronouncements. As the Council says in the report on the influences of cinema,

> [w]e have sought, not to come out into the streets and with clamouring to strike the evil on the head […] we have rather set ourselves to undermine the evil, to get at the deeper causes […]. And in doing so we have expressly desired to win the sympathy of the men and women who are […] catering for public amusement […] and have under their control the vast machinery for instantly and effectively reaching millions of people. We have seen the folly of making enemies of those who control these great and potent agencies by indiscriminate denunciation.[43]

While the somewhat patronising tone is not dissimilar to that of many groups that set themselves up as *de facto* moral guardians, or indeed of the BBFC itself as presented in its early Annual Reports, there is an element of sophistication to its approach that suggests it was not entirely reactionary. In August 1916, the NCPM had offered to establish the BBFC Advisory Committee proposed by Samuel on behalf of the Home Office, having become involved in the film business the previous year by sponsoring the launch of a film produced by Universal Studios called *Where Are My Children?* (1916). The film was a moral tale that was firmly pro-birth control and anti-abortion, a stance that echoed findings of the NCPM's report on the National Birth Rate which was published in 1916.[44] The decision to allow this highly respected and well-connected organisation to investigate the moral condition and influences of cinema and the film industry in general served to allay some of the fears that had prompted the call for government censorship in the first place.

In early 1917, therefore, O'Connor took over an organisation that had just survived being replaced. One of his first actions as President was to visit George Cave and ask that the BBFC be given the formal support of the Home Office – a request which Cave denied.[45] Instead Cave maintained the distance of the Home Office from the situation by circulating to the local authorities another set of suggested conditions for the granting of a cinema licence which simply adapted those which Samuel had circulated the previous year. What was most notable about the conditions, however, was the extremely pointed omission of the BBFC. Clause three stated that '[f]ilms which have been examined by any persons on behalf of the licensing authority shall be exhibited exactly in the form in which they were passed for exhibition'.[46] The message from the Home Office to O'Connor was very clear, that the BBFC was on probation and had to prove itself before the Home Office would support it – otherwise it could easily be replaced.

The first step in that approval came later in the year with the publishing of the NCPM report. While it expressly suggested that official censorship was desirable, and that stricter censorship was necessary, the report concluded that the BBFC was exercising stricter censorship than it had in the past.[47] In part this was most likely due to O'Connor's public pronouncement to the NCPM of forty-three rules, which in his own words were 'laid down' by the BBFC and which subsequently became known as 'O'Connor's Forty-Three'. In fact the rules were not rules at all, and were not developed by O'Connor. What he gave the hearing was merely the list of scenes against which exception had been taken by the Board as listed in the 1915 Annual Report. Reading the NCPM report now, the so-called 'rules' make no sense because they are merely a list of things such as 'Indecorous dancing'.[48] At no point does O'Connor give some sort of qualifying statement such as 'A film must not contain'. However, the formalising of these criteria into a set of rules indicated that O'Connor was adopting a more proactive stance. The NCPM report concluded that in general the cinema was not a threat to public morality.[49] While this was not a ringing endorsement of the BBFC, it was an endorsement of cinema in general and at the heart of that was the need for stricter censorship. O'Connor's rules were already a step in the right direction.

In December 1917, shortly after the publication of the NCPM report in October, the Home Office agreed to contact once again the local authorities to get a general picture of what procedures they had in place regarding the censorship of films in relation to the provision of licences.[50] It did so in response to the recommendation by the NCPM that government censorship should be considered; but the promised letter was not sent until two years later. The formal reason given for the delay was simply 'pressure of work' and while the final year and immediate aftermath of World War I was no doubt a busy time, the decision to delay is a measure of both the lack of general interest in the issue of censorship in the Home Office at the time and

(top) T. P. O'Connor, President of the Board from 1916–29; (bottom) *Where Are My Children?* (1916): 'firmly pro-birth control and anti-abortion'

Auction of Souls (1919): the Home Office bypassed the BBFC and demanded cuts to the film

the success of the trade's decision to appoint the wily and highly respected O'Connor as President.[51] This marked the point where the BBFC gradually moved towards a position of acceptance both from the local authorities and from the Home Office.

The tipping point came in 1920. Through the end of 1919 and the beginning of 1920, the Home Office gathered the results of its request to the local authorities for information on if and how they integrated the BBFC into their licensing conditions. Replies were received from eighty County Borough Authorities and of these less than twenty stipulated that only films which had been granted a certificate by the BBFC could be shown unless permission was given in advance to do otherwise. However, while the local authorities were still not willing to support the BBFC, representatives of the government were beginning to support the work of the Board in Parliament. On 22 June 1920, Home Secretary Edward Shortt stated in response to another request for government censorship that it would require the passing of legislation, which would be, in his words, impossible to do.[52] The following year, on 17 February, Sir John Baird, Under-Secretary of State for the Home Department, said that 'On the whole these voluntary censors have done their work as we think admirably.'[53]

This reiteration of the lack of support from the Home Office for a centralised censorship body, plus Baird's unprecedented public statement of support, helped to keep the pressure off the BBFC so that it could go about its business, which under O'Connor was becoming more defined. As the 1920s began, the statistics suggest that the BBFC was far more inclined towards cutting than to banning films. In 1921, only six films out of 1,960 submitted to the Board were rejected outright while 433 were subjected to cuts. Although the names of the examiners (one of whom by the early 1920s was a woman) were a closely guarded secret, O'Connor was more open towards publicity than Redford had been. In 1923, he circulated an open letter entitled 'The Principles of Film Censorship', which explained how the BBFC worked and outlined its focus on supporting film producers and working with them in order to get their film to market.[54] O'Connor and Brooke Wilkinson were the only ones who dealt with the trade, and their aim was to offer guidance and support to ensure that the film was suitable for either the 'U' category or the 'A' category.

A far more significant boost to the Board's position came in August 1920 when Middlesex County Council (MCC), which, along with London, was one of the most influential of the licensing authorities, elected to make a condition of its licence that only films with a BBFC certificate could be shown. A year later, in 1921, the concept received legal backing. The Middlesex condition was challenged in the courts in the case of *Ellis* v. *Dubowski*. In 1920, a Twickenham cinema showed the film *Auction of Souls* (1919). The film dealt with an event in which Armenians were massacred by Turkish soldiers in 1915, and while the film was supported by the League of Nations, a forerunner of the United Nations formed in the wake of World War I, it caused sufficient controversy and concern that the Home Office, under Edward Shortt, became involved and effectively bypassed the BBFC by demanding cuts itself. The film was therefore never submitted to the BBFC for certification. The Twickenham cinema was subsequently sued by MCC on the grounds that by showing the film, it was in breach of its licence.[55] In 1921 Mr Justice Sankey of the Divisional Court declared that the stipulation that no film be shown that had not received a certificate by the BBFC was in fact *ultra vires*, that is, beyond the authority of the 1909 Act, because it implicitly granted power to the BBFC that the Board did not have, and which the licensing authority had no legal right to pass on. Furthermore, because the BBFC had no legal authority there was no right to appeal. The condition effectively delegated the power of the licensing authority to the BBFC, and this was not permissible. The Divisional Court did, however, suggest that a clause that maintained the legal power of the licensing authority while at the same

time mentioning the BBFC would not be problematic, and suggested that it would be a valid condition if it were to read that 'no film which has not been passed by the British Board of Film Censors shall be exhibited without the express permission of the Licensing Authority'.[56]

This judgment effectively provided legal backing for the local authorities to include a clause about the BBFC and, in October 1921, Colonel Levita, Chair of the Theatres and Music Halls Committee of the London County Council, met with Sir John Baird to discuss the issue once more. Having asked Baird if the Home Office was reconsidering the introduction of state censorship, and having met with a very firm 'no', Levita told Baird that while the LCC had never to this point recognised the judgments of the Board, the decision in *Ellis* v. *Dubowski* ensured that the inclusion of a BBFC clause would be legal. In December, the LCC Theatres and Music Halls Committee voted to include the clause, which came into effect from 1 January 1922.[57]

This show of public support by the most powerful local authority in the country was of vital importance to the BBFC, and other local authorities began to fall into line, but the development was not without controversy. In addition to stipulating that all films had to have been passed by the Board, and that they must display the certificate issued by the Board, the LCC also dictated that no persons under the age of sixteen should be permitted to see films certificated 'A'.[58] This stipulation was far tougher than that of the Board itself, which only recommended that 'A' films were more suitable for adult audiences than 'U' films. The idea behind the LCC condition was that more films which currently received an 'A' certificate would be cut in order to gain a 'U' certificate, meaning that generally films were less likely to be controversial overall. The trade, however, responded angrily and a deputation to the LCC by the CEA resulted in the LCC postponing the introduction of this particular condition until January 1923.[59] Once it was introduced, the level of controversy was such that the LCC approached the Home Office in February 1923 asking for it to support the council by convening a conference of licensing authorities and asking them to adopt the new LCC conditions.[60] The conference took place on 2 May 1923 and was attended by representatives of twenty local authorities who broadly agreed to adopt the LCC conditions.

As a result, in July 1923, the Home Office sent out yet another circular urging all the licensing authorities to follow suit. For the first time in such correspondence, the Home Office was openly supportive of the BBFC, writing that

> the Secretary of State believes that the work of censorship [...] has been conducted by the Board of Film Censors with a sincere wish to prevent the exhibition of any film which is likely to give offense to public taste, and [...] the work of the Board appears to have met with considerable success.[61]

While the Home Office acknowledged that it could not interfere with the legal right of the authorities to impose their own conditions, it did suggest that 'it is very desirable to secure uniformity of practice as far as possible' and that the *Ellis* v. *Dubowski* ruling meant the proposals had statutory power.[62] The argument was persuasive and in late 1923 and 1924 almost all the licensing authorities adopted the new conditions.[63] Thus eleven years after the formation of the BBFC the necessary agreement was struck between the authorities and the Home Office to give the work of the BBFC sufficient support to make its decisions worthwhile and its future more secure.

While 1924 marked the end of the BBFC's struggle for recognition from both the licensing authorities and the government in the form of the Home Office, it did not, however, prevent further controversy or further questions about its decisions; nor did it protect the BBFC from interference from government departments. The mid-1920s were marked by a number of significant debates, one of the most notable of which was around the film *Battleship Potemkin* (1925) (see case study).

The impact of the controversies surrounding films like *Battleship Potemkin* led to further questions about the BBFC being raised in Parliament, this time in the House of Lords, in 1927 and 1928. The first instance was a motion put forward in May 1927 by Lord Danesfort that the Home Office reconsider its stance on government censorship. Danesfort, while happily admitting that 'I am not a great film-goer', nevertheless went on to berate the film industry for the offensive nature of many of the films it produced, while at the same time acknowledging that many of the worst offenders were American films. Drawing upon the BBFC Annual Report for 1925, Danesfort cited numerous examples of scenes that had been cut by the BBFC, including blasphemous scenes and scenes of gross indecency in dress, dancing or gesture. Danesfort then went on to say that after making what he called 'careful inquiries' it was clear that the licensing authorities had ceased

broadly to exercise their powers under the 1909 Act and instead made no effort themselves to examine films that had been passed by the Board.[64] Given that Danesfort was criticising films he clearly had not seen, the careful nature of his inquiries into the conduct of the licensing authorities is somewhat questionable, but his motion strongly indicates that he was criticising the consensus that developed in 1923–4 between the licensing authorities and the BBFC, and, more importantly, that, three years on, the consensus was still holding. The lack of engagement by the authorities with films passed by the BBFC is evidence that in general the Board's decisions were being abided by and supported. Although there was some support for his motion, there was also strong opposition, in particular from Lord Desborough who countered that

> [t]he Board of Censors ought to be looked upon rather from this point of view, that they are a body of men who, at great sacrifice to themselves in the case of many of them, are willing to go through the very ungrateful task of examining these films and of saying what in their opinion is fit for production and what is not. I think it is a tribute to the successful way in which they have discharged their function that they have won the confidence of both the public and of the licensing magistrates.[65]

At the end of the debate Lord Danesfort withdrew his motion, doubtless due in part to Lord Desborough's unqualified support for the Board and in 1928, when Lord Newton attempted to raise the issue of state censorship, Desborough stepped in to defend the BBFC a second time:

> If the trade had no confidence in the Board, and did not think that the Board's certificate would carry weight with the local authorities, they would not submit films to be reviewed by the Board; and, on the other hand, if the local authorities had found that the Board had failed in their duty and had passed improper films, their confidence equally would have been withdrawn from this Board of Film Censors, whose position then would be an absolutely untenable one. I think the opposite is the case […]. In the early days the Home Office was in constant receipt of complaints about the character of films, and they had to make inquiries. At the present time complaints are very few and far between.[66]

While films like *Battleship Potemkin* continued to swirl controversy around the BBFC, it is beyond doubt that the kind of vocal and public support offered by Lord Desborough, seemingly with the consent of the Home Office, was unthinkable only a few years earlier. T. P. O'Connor died in November 1929 at the age of eighty-one, and was succeeded as President by the Rt Hon Edward Shortt who, as Home Secretary from 1919 to 1922, had seen the gradual legitimisation of the BBFC, albeit from a disinterested distance. Curiously, Shortt would oversee the period of transition to sound in Britain, even though he apparently actively disliked talking pictures. His appointment after the death of O'Connor, coupled with the transition to sound, marks the end of both the silent era and the BBFC's initial turbulent years of development.

The 1929 Annual Report, written by Brooke Wilkinson, who would himself die in post in 1948 having supported four Presidents, eulogises the work of O'Connor and neatly sums up the position of the BBFC at the time. Brooke Wilkinson writes that under O'Connor's guidance the Board

> works between a cross-fire, accused at one moment of ridiculous prudery and, on the other side, charged with licentious indulgence [.] Mr. O'Connor endeavoured to steer a middle course between prudery and licence. […] To him the question of treatment was all important.[67]

The end of the silent era therefore marked a transition in every respect: a transition from O'Connor to Shortt, a transition from silent to sound, and perhaps most importantly a decisive transition for the BBFC in terms of the battles which it had to fight. No longer was the BBFC struggling for recognition while caught between the Home Office and the licensing authorities. No longer did it face the threat of government intervention. That battle was over. Now it faced a much more difficult challenge: to follow the path laid down by O'Connor and to steer a course between prudery and licence.

CASE STUDY: BATTLESHIP POTEMKIN (1925) Aidan McDowell

The famous Odessa Steps sequence

Sergei Eisenstein's classic film about the 1905 mutiny on board the cruiser *Potemkin* was made in 1925. It appeared at a time when the young Soviet Union had been facing enormous industrial problems and it was only the limited freedoms granted by the 1921 New Economic Policy that had enabled the film industry to obtain the film stock and equipment it needed to grow. Lenin saw this as a key part of the process of education and positively encouraged the industry, stating '[o]f all the arts, for us the cinema is the most important'.[68]

Eisenstein's background was in engineering and science and this shaped his outlook and approach to film-making. He became the first and most famous proponent of the concept of 'montage'. In English this notion only had an artistic connotation (e.g. photo montage and cinematic montage) but the original meaning was more relevant to Eisenstein's approach: it meant 'assembly' as in the kind of assembly that took place in factories. So, when he set about constructing his theory of film he approached it from the point of view that film was like a machine and that the purpose of 'film as machine' was that it was designed to control the audience. The purpose of the montage, therefore, was to construct a set of theoretical ideas with the aim of producing a certain reaction in the audience. The film-maker V. I. Pudovkin described this kind of editing as 'the guidance of the thoughts and associations of the spectator'[69] and this was very clearly the principal aim of Eisenstein. He was making films for political ends and for the purposes of propaganda and, even in its day, *Battleship Potemkin* was regarded as the finest example of such a work. Indeed, Hitler and Goebbels considered it the very model of propaganda films, one which they sought to emulate.

The film was submitted to the BBFC but was rejected on 30 September 1926. The file, unfortunately, no longer exists, but it is likely that the film was the instance of 'Bolshevist Propaganda' referred to in that year's Annual Report.[70] Although there has never been any suggestion of political pressure, it was probably unsurprising that the BBFC considered the film to be political dynamite and effectively banned it. It is worth bearing in mind that one of T. P. O'Connor's 'grounds for deletion' nine years earlier had been 'references to controversial politics'. Indeed, the Board had refused classification to both pro- *and* anti-Bolshevist films.[71] A contemporary review in the American trade press probably illustrates attitudes best:

> Those that are out-and-out Reds, and those that are inclined to Socialism, will undoubtedly find great things about the picture, but hardly anyone else will […]. As a pictorial historical record for the archives of the Soviet Government,

it may mean something, but to the average American […] it doesn't mean a damn.[72]

The film did have a UK premiere in November 1929 at a meeting of the London Film Society in spite of a number of local councils upholding the BBFC's rejection.

Then, in 1935, an appeal was made by the film's UK distributors direct to the licensing authority for London, the London County Council. The Council inspected the work and consented to a limited exhibition, subject to certain conditions: two cuts were to be made, to remove 'the red colouring of the mutineers' flag' which, it seems, had been superimposed since the previous submission, and to remove the close-up shots of a 'small boy, shot through the head and bleeding profusely'.[73] A further condition was to limit admittance to those aged sixteen and over. In considering the likely impact of the film the LCC concluded that 'its exhibition is not likely to be injurious to morality, to be offensive to public opinion [or] to lead to disorder'.[74] And so, the film described by academic and film historian Brian Winston as 'a martyred revolutionary text'[75] finally found its way to a limited release to London audiences only.

A further nineteen years were to pass before the film came before the BBFC again. In January 1954 the Board viewed the cut version as approved by the LCC in 1935. The Board passed the film at 'X' (in those days restricting admission to those over sixteen).

The advent of domestic video gave the film another lease of life, bringing it to new audiences. A limited theatrical re-release by the British Film Institute (BFI) in 1987 necessitated a resubmission to the BBFC for a modern classification to replace the 'X', and the film was passed 'PG'. The film has remained at this level ever since and the only warning it now carries for the public is that it '[c]ontains moderate violence'. The most recent submission was in February 2011, again for a BFI theatrical release, and this version not only contained some restored images that had been cut from the film but, for the first time since its release in 1925, included the acclaimed orchestral score by Edmund Meisel which had taken ten years to remaster and re-record.

From an unlikely start as a film dismissed as Communist propaganda, *Battleship Potemkin* is now regarded as one of the most influential films of all time. It appears regularly on critics' lists in the Top 10 of the greatest ever films and is an indispensable text for film students. Its passage through the BBFC, from 'banned' to 'X' to 'PG', also shows how public tastes and attitudes have changed and how the BBFC's approach to classification reflects those changes.

2

'THE PEOPLE'S AMUSEMENT': CINEMAGOING AND THE BBFC, 1928–48

Robert James

From the late 1920s through to the early 1950s, going to the cinema was *the* most popular leisure activity in Britain. Described by A. J. P. Taylor in an often-used phrase as 'the essential social habit of the age', cinemas attracted vast numbers of people to their warm and cosy interiors to enjoy low-cost entertainment.[1] Contemporary surveys attest to the cinema's immense popularity during these years. In 1935, the *New Survey of London Life and Labour* reported that the cinema was 'easily the most important agency of popular entertainment', describing it as 'the people's amusement'.[2] The first national survey of cinemagoing, which had taken place the previous year, lends weight to this claim. The survey, conducted by Simon Rowson, found that 40 per cent of the British population regularly visited the cinema.[3] By 1943, the Wartime Social Survey revealed that that figure had risen to 70 per cent.[4] Clearly, the cinema provided the antidote to the strains the war exerted on many British people, allowing them to escape the stresses of their daily lives. By the early twentieth century, then, cinemagoing had become a mass leisure activity that attracted all social groups.

The growth in cinema's popularity in these years inevitably caused consternation among Britain's governing bodies over its influence on society. Unease was expressed over both the economic effects of the American film industry's dominance on Britain's screens and the influence that the film medium could have on Britain's legion of cinemagoers.[5] One of the government's first objectives was to make the British film industry economically stable by protecting it against the dominance of the American market. The result was the 1927 Cinematograph Films Act, which aided the expansion of British film production by demanding that a percentage of all films exhibited in Britain were British-made. While this did much to improve the situation, disquiet remained, principally generated by ideological concerns. It was the type of film America was producing which caused most unease. In 1932, for example, a Home Office report by Oswald H. Davis argued that America 'sets the standard in English-speaking film production' and went on to lament:

> An inferior type of mind rules the American motion-picture industry [...] [and] this mentality of turbid showmanship, operating through the screen by shoddy conceptions of art and a glossed materialism, saps the traditional culture and disposition of this country.[6]

Davis's stance was typical of many in the Establishment. In a House of Lords debate earlier in the year, Lord Danesfort had remarked that 'the rank and file of our population would be far better instructed if [...] instead of seeing some somewhat perverted American films, they could see good films produced in the Dominions'.[7] Metropolitan Police magistrate J. A. R. Cairns spoke in a similar vein at a Religious Tract Society annual meeting in 1931, complaining that many American films 'give an exhibition of sex, making human love nauseating, disgusting and revolting'.[8] If that was not critical enough, Cairns added, with considerable venom: 'The people who are sending this stuff across the world are fouling civilisation. Hollywood will yet earn a distinction only to that of Gomorrah.'[9] These sentiments were not new. They had been expressed in a House of Lords

debate on the Cinematograph Films Bill in 1927, during which Earl Russell had remarked, 'I can conceive nothing more horrible and nothing less valuable, from the point of view of either entertainment or of instruction, than these dreadful American cowboy films'.[10] These films, Russell believed, were loaded with 'mushy sentimentality' and included adventures which were 'entirely foreign to this country and to the spirit of this country'.[11] Despite the implementation of the Films Act, then, anxiety about the ideological effects of the film product remained constant during the 1930s. In fact, it could be argued to have intensified, for the comments made by Cairns, Davis and Lord Danesfort were certainly much stronger in tone than those of Earl Russell.

The cinema audience's continuing preference for American films, many of which were deemed degrading and immoral, led Establishment figures, along with cultural elites, to blame society's cinemagoing habits causing national decline and cultural debasement. Home Office officials corresponded with American producers over these very issues in the 1930s, conveying their unease over the body of American films made available to the British public.[12] In fact, Will Hays, the chief co-ordinator of the Production Code in America, came to Britain in 1936 to try to further relations with the BBFC and foster a 'common approach' on matters of censorship.[13] Nevertheless, discussions on the nature of the American product continued within a number of government departments and in 1938, with the expiry of the 1927 Films Act clearly causing much consternation, one Foreign Office official criticised the American government for continuing to 'look upon films as a purely commercial item [...] while we regard them partly, at least, as a cultural responsibility'.[14] It was assumed that the influence of these films would create the 'Americanisation' of British culture.[15]

The influence of American cinema may have been less expansive than these examples suggest, but the pre-eminent concern of many in the Establishment was whether the images shown on the cinema screen could have a palpable influence on cinema audiences, especially those deemed to be most vulnerable: children and working-class cinemagoers. The aforementioned House of Lords debate on the 1927 Films Bill had, indeed, expressed concern over the matter. 'I think it is quite impossible to exaggerate the educational value and importance of the cinema in conveying ideas, especially to unlearned and simple people', Lord Bishop patronisingly remarked, concluding: 'The cinema is regarded by many as the university of the poor man'.[16] Of course, ideological concerns were not restricted to American films alone. There were a whole host of productions that were considered to be corrupting the cinemagoing public. Many Establishment figures thus held an overwhelming conviction that cinema audiences needed protecting from the images presented before them on the screen. It is, then, predictable that, when censoring the film product, stringent restrictions were routinely enforced by the BBFC.

Although the BBFC was primarily a trade body, its independence from the government was, as Julian Petley has noted, 'more apparent than real'.[17] Home Office files reveal a number of instances where Board members liaised with government institutions regarding the nature of the film product.[18] Successive Home Secretaries were also heavily involved with the Board's affairs.[19] In addition, after the death of the BBFC's first President, G. A. Redford, in 1916, all the Board's subsequent Presidents had held positions in government prior to their appointment and were, as Jeffrey Richards and James C. Robertson have observed, 'always prominent political figures well versed in the moulding of public opinion'.[20] In fact, this close relationship was recognised by a Ministry of Information (MoI) official who, in 1938, sardonically remarked of the BBFC's Secretary, Joseph Brooke Wilkinson, '[He] insisted that the Board was an independent body. The Chairman was in theory nominated by the Home Office; the officers were appointed by him, and remunerated from the fees paid by the trade.'[21] Far from being independent of the government, then, the Board was closely linked with a number of important government departments. Many of the BBFC's criticisms of the film industry thus closely echo those of the Establishment.

There is evidence to suggest that the Board had a somewhat vexed relationship with members of the film industry. It was noted by a Ministry of Information official that Brooke Wilkinson viewed trade members as untrustworthy and, for this reason, advised against consulting them on matters of 'security' in the period leading up to World War II.[22] This is hardly a recipe for a harmonious working relationship between the two interested parties. Moreover, it could mean that the film industry viewed the role of the BBFC with considerable scepticism. Despite these potential difficulties, though, the BBFC was highly respected by important figureheads in the cinema trade. In 1935, for example, Mr S. G. Rayment, the editor of *Kinematograph Weekly*, arguably the most important film-trade paper in the period, observed that the Board had 'undoubtedly created a solid respect for itself; its decisions are acknowledged to be perfectly honest, and above all, the system works ... [It] carries on its rather delicate task with efficiency and success.'[23] In fact, Rayment had

earlier chastised film-trade members for continuing to produce 'sordid' films despite the Rt Hon Edward Shortt's (the BBFC's President from 1929 to 1935) appeal for producers to avoid such subjects.[24] It is clear from Rayment's remarks, then, that the BBFC held considerable sway in key quarters of the film industry.[25]

Along with moral and political considerations regarding the film product, it is also clear that the Board, with much encouragement from both the government and many working in the cinema trade, was trying to influence the tastes of the consumer. Public taste was, indeed, one of *the* central issues troubling the Establishment in the period; it was certainly a subject which gained much coverage. Establishment officials made a concerted attempt to censor films that were deemed unacceptable for exhibition, while simultaneously launching a campaign to improve public taste regarding the film product.[26] In fact, for some, raising public taste was *the* most important issue. The Governor-General of New Zealand, Lord Bledisloe, for example, stated that 'it is to public opinion, rather than censorship, that we must look for the positive influence which may bring about an improvement in the general standard of the film'; Lord Bledisloe anticipated that pressure from the cinemagoing public would force film-makers to improve the standard of their work.[27] A House of Commons deputation similarly pointed out that the 'cultural value of the film in the ordinary cinema' needed to be raised.[28]

Clearly, the tastes of the majority of cinemagoers were routinely held in poor regard. Nowhere is this more evident than in a discussion of a paper submitted to the Renters' Society by Simon Rowson. Society member Charles Tennyson deprecatingly remarked that he was surprised that 'the standard of the film was as high as it was considering the audience at which it aimed'.[29] Other members of the Society were more accommodating towards the mass audience. In fact, the Society's chairman, Professor Greenwood, was irritated by Tennyson's comments, and retorted: '"Uneducated" people received quite as much pleasure from fine books, pictures and music as their supposed superiors, when they were given the opportunity of reading, seeing and hearing masterpieces.'[30] But the message was clear: Greenwood believed that cinemagoers were simply not being offered the right type of film; 'when they were given the opportunity' are the key words here. Whether they blamed the cinemagoers, then, or the type of film being offered to them, public

Bela Lugosi in *Dracula* (1931), one of the horror films that prompted the Board to introduce the 'H' certificate

Frankenstein (1931), with Boris Karloff as the Monster

figures were certain of one thing: public taste needed to be improved, and film censorship was one way of achieving it.

There were two ways in which the BBFC could influence the types of film people saw: film classification and, from the 1930s, film censorship. The classification system introduced in 1913 included two broad categories: the 'U' certificate, which encompassed films deemed suitable for all cinemagoers, and the 'A' certificate, which indicated films that were considered especially appropriate for adult audiences. Local authorities were expected only to grant licences to cinema owners who followed these guidelines.[31] This system had generally worked well. However, the anxiety generated by the increased number of 'horrific' films being produced in America in the early 1930s – epitomised in the 1931 productions *Dracula* and *Frankenstein* – prompted the BBFC to curb the

exhibition of 'frightening films' in Britain's cinemas. As a result, the Board introduced the 'H' (for horrific) as an advisory designation in January 1932.[32] (It later became a category in its own right.) Thirty-one films were given an 'H' certificate between 1933 and 1939, and the genre came under continued criticism.[33] In 1935, for example, the BBFC President Edward Shortt announced in his Annual Report, 'I cannot believe that such films are wholesome, pandering as they do to the love of the morbid and horrible.'[34]

From the 1930s, and in an attempt to address more directly their concerns over the types of film being produced, the BBFC invited film-makers to submit scripts, scenarios and books or plays intended for production, rather than wait to review the completed film.[35] The Board's censors – until 1946, Colonel J. C. Hanna and Miss N. Shortt (later Crouzet); from 1946 Lieutenant-Colonel Fleetwood-Wilson and Madge Kitchener – would then scrutinise the planned productions and assess their suitability.[36] This avoided the previously, at times, heavy-handed approach taken by the Board, such as when, in response to the advent of sound films and the continuity problems caused by cutting, they banned outright any film that needed censoring.[37] In fact, the advent of sound films heightened the BBFC's concerns over the damaging effect of the medium on cinema audiences, prompting the Board to declare in 1929: 'The introduction of sound films has unquestionably raised new problems from the point of view of censorship. Generally speaking, it is found that the dialogue far more emphasises the situation than is the case with titling.'[38] As Sarah Smith has observed, 'when sound effects were added to hot dialogue, screen sex suddenly became more sexy and screen violence more violent'.[39] With sound films becoming the standard by the early 1930s, therefore, the BBFC had to take more rigorous action to ensure 'damaging' topics were not presented on the cinema screen, and a new list of prohibited issues was drawn up in 1931.[40] This increased action is evident when reviewing the BBFC's scenario reports.

The scenario reports for the 1930s demonstrate the deep concern held by the censors regarding the cinema's influence on society, especially working-class society and minors.[41] The set of exceptions laid out by the BBFC's second President T. P. O'Connor on films released in 1917 – known, as we have seen, as 'O'Connor's Forty-Three' – continued to hold sway, with morality issues at the forefront of the censors' minds.[42] Sexual indiscretion was a subject of significant concern. In 1931, for example, Colonel Hanna noted of the intimate relations in *Water Gypsies*, 'It would require very delicate treatment and Jane's desire for Bryan would have to be very carefully handled and not overstressed', while in 1933, he approved the Aldwych farce *A Cuckoo in the Nest*, but warned that 'no impropriety' should take place between the newlywed Peter and his old flame Marguerite, stressing: 'Care must be taken of course that no such impression is conveyed.'[43] Coarseness was also objected to. Requests for the deletion of certain words on moral grounds – such as 'bum', 'strumpet' and 'harlot' – were continual throughout the decade.[44] The depiction of 'sordid situations', coupled with 'strong language', was also frowned upon, particularly so in sound films. In the scenario report for *Hindle Wakes*, in which Lancashire millgirl Jenny and factory owner's son Alan spend a week together in Blackpool, Colonel Hanna noted that '[t]he dialogue of a talkie film very often accentuates the situation and it will be very necessary to play the various points with delicacy and restraint to avoid emphasising the coarser side of this very strong drama'.[45] The 'coarser side' was not just the romantic liaison between Alan and Jenny, but the

(left) *A Cuckoo in the Nest* (1933) was made from a script approved with reservations about its 'coarseness'; (right) '[M]oral *and* political censorship came into force in the 1930s' with regard to films such as the social drama *Hindle Wakes* (1931)

depiction of a society irreparably divided by class, one which insisted that such cross-class relationships could not prosper.

Interestingly, and as the example of *Hindle Wakes* shows, while the Board was supposed to deal principally with questions of morality, censorship restrictions ensured that a moral *and* political censorship came into force in the 1930s; and it was one which focused primarily on issues concerning working-class society. Film-makers were discouraged from focusing on any issue likely to inflame industrial relations, stress class division or expose social unrest.[46] Indeed, in 1933, censorship restrictions were extended to ban depictions of 'industrial unrest and violence'.[47] The escalation of extra-parliamentary activities during the 1930s – the 'politics of the street' – characterised most clearly in the Cable Street riots, when Oswald Mosley's Blackshirts clashed with 100,000 anti-Fascist demonstrators in London, and the Jarrow March, during which 200 men from the Tyneside shipbuilding town marched on the capital, was evidently causing the Board much unease.[48] Therefore, while films such as *The White Captive* and *Tiger Bay* were opposed due to their 'degrading' and 'sordid' subject matter, many other films were prohibited because they hinted too much of 'political propaganda'.[49] Throughout the 1930s, the issue of 'controversial politics' – especially left-wing politics – is one that surfaces repeatedly; any film that touched on the subject was likely to be banned. In 1937, for example, the subject matter of *Dreamer Awake* was clearly the cause of much controversy. Colonel Hanna believed it was of little concern, and wrote: 'It seems to be mild propaganda against existing Social Conditions [...] I do not think it will do any particular harm.'[50] However, for Miss Shortt, it was far too dangerous to be passed. 'In my opinion this scenario is quite unsuitable for production', she noted, adding '[it] is a series of incidents which seem to be pure Communist propaganda.'[51] The film was subsequently prohibited. Clearly, there was considerable concern over the film's use of left-wing political propaganda.

What is of most interest, however, are the various ways with which films that touch on this subject were dealt. Whether the film was passed or not was highly dependent on how it presented the 'revolutionary' element (and, indeed, where the scene was set). In 1931, for example, a film depicting London 'on the eve of Red Revolution' was prohibited, despite the scenario indicating that the film highlighted the futility and chaos of social revolution.[52] Clearly, the location was the film's undoing. Similarly, *Red Square*, while being set in Russia at the time of revolution, was prohibited because it contained 'sordid settings' and dwelt on issues of prostitution and drunkenness.[53] In contrast, two other films that dealt with the revolutionary topic, *Soviet* and *Knight without Armour*, were allowed to be produced; the former because it emphasised 'the forced labour and hard striving of the working class under the five year plan', the latter because it made 'no attempt at political propaganda'.[54] In fact, *Knight without Armour* also foregrounds the chaos of a country in revolution, presents the working classes as sordid and acquisitive, and is extremely anti-Communist; this is not remarked upon but probably influenced Colonel Hanna's decision. What becomes apparent, then, is that it was not a film's content alone that influenced the Board's decision, but the manner in which it was going to be presented.

Films that explored troubled employer/employee relations or the suffering of the working classes were dealt with in a similar manner. Once again, it was how a film approached its subject

Marlene Dietrich in
Knight without Armour
(1937): the film's political
content did not trouble
the Board

matter that determined the censors' final decision, despite the fact that for the Board, 'from whatever angle it is approached the relations between capitol [sic] and labour will always lead to some controversy'.[55] The scenario report for Gainsborough's *Tidal Waters* can be used as an example of the Board's high moral approach to this issue. While Colonel Hanna points out that '[t]he author does not propose to stress the differences between Capital and Labour', the film is deemed inappropriate because '[s]trikes, or labour unrest, where the scene is set in England, have never been shown in any detail [...] [and] would at once range the film as political propaganda of a type that we have always held to be unsuitable'.[56] Interestingly, these comments contrast pointedly with the Board's approach to *Sitting on Top of the World*, a film intended for Gracie Fields (but actually starring her sister Betty) that was passed in 1935 despite its contentious subject matter: a mill-town strike. It is how the strike is both presented and resolved (and indeed by whom) that is the key to the film's approval. The scenario indicates that the cause of the strike will not be dwelt upon, and instead discusses how the film demonstrates that mutual understanding will resolve the issue. Indeed, it states that Fields's character's actions – avoiding violence, calming the strikers, negotiating with the boss – are directly responsible for the film's satisfactory resolution: the ending of the strike. Not surprisingly, Colonel Hanna had 'no objection to the story'.[57] Likewise, *Strike Down*, which addressed similar issues, was passed because its central character Staples, 'the man whose conduct is the cause of the strike', is presented as a 'nasty type of work'.[58] This is, indeed, indicative of what the crucial determinants were when a film's scenario was reviewed by the Board. If portrayed in a positive light, even the most controversial subjects could be passed. Therefore, even a film that dealt with the exigencies of

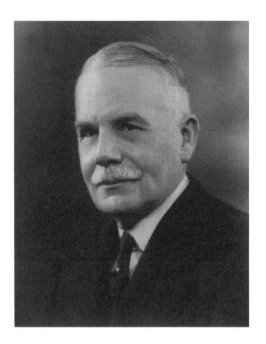

Lord Tyrrell, BBFC
President from 1935–48

unemployment, *The Navvy*, was passed in 1934 because the central character displayed a resolute attitude to his situation. Colonel Hanna noted that while '[he] feels going to the dole very much, he doesn't whine and whimper, but tries to keep his chin up bravely'.[59] The fact that the issue of unemployment was still a reality for many people meant that this film could have inflamed social unease, but any threat was negated through the portrayal of its central character's dogged attitude.

Social problems thus continued to cause extreme concern for those in control of film censorship, and films that dwelt on 'dangerous' issues were always *likely* to be banned unless they presented their material in such a way as to nullify any form of propaganda against the system. What these examples illustrate, then, is that the BBFC's role was to ensure that the film medium was not used to raise challenges to the existing social structure. Indeed, in 1937, the Board's President, Lord Tyrrell, observed: 'We may take pride in observing that there is not a single film showing in London today which deals with any of the burning questions of the day.'[60] Of course, London is not Britain, but it was generally believed that all the 'dangerous' elements had been removed from films being produced and exhibited across the country. Whether Lord Tyrrell's remarks are an accurate description of *all* the films being produced and exhibited during the period is debatable, for film-makers had ways of evading censorship restrictions, and, as James C. Robertson has noted, the 1931 BBFC list of prohibited material had been gradually eroded as the decade progressed.[61] Nonetheless, it is clear that the Board's influence had a profound effect on the film industry and the way in which it operated in the 1930s.

Censorship restrictions on certain 'unsuitable' issues were relaxed somewhat during World War II. In fact, as Robertson has also noted, the war actually further eroded the 1931 list of exceptions.[62] For example, in 1934, the 'anti-Hitler propaganda' evident in *The Mad Dog of Europe* was deemed 'unsuitable for production', but by 1939, the subject matter was less controversial – indeed, even fitting. 'This is purely anti-Hitler propaganda, and personally I think it a pity to dwell on the persecutions', Colonel Hanna noted, before adding, 'but in view of the present situation and alterations in general censorship, I find it impossible to take serious exception to this story.'[63] The film was subsequently passed.

In any case, film censorship was not just a matter for the BBFC during the war years. While the Board continued to be responsible for 'moral censorship', the primary censorship role was now undertaken by the MoI, which had been set up to oversee matters of national interest. In a report drawn up by the Home Office, it was recommended that the control of film censorship during wartime be 'total', allowing the government a veto over film exhibition.[64] To that end, extra officials, appointed by the MoI's Censorship Division, and consisting of representatives from the three armed services, were drafted in to work with the censors at the BBFC, primarily to deal with matters of 'security'.[65] As the war progressed, then, the BBFC's censorship role was increasingly taken over by the MoI. Not surprisingly, this resulted in an often difficult working relationship between the two organisations. In fact, in an attempt to reassert some influence, the BBFC occasionally resorted to cutting or suppressing films that were made or supported by the MoI.[66]

Nevertheless, despite these periodic disputes over film censorship between BBFC and MoI officials, the system that had been put in place in the pre-war years continued to work well, and any issues deemed 'unsuitable' for film production were regularly removed.

Indeed, in many respects, the scenario reports for the war period reveal a distinct consonance between pre-war and wartime attitudes among the BBFC's censors. In common with the pre-war period, the use of vulgar or offensive language was regularly objected to. In July 1941, for example, *The Sign of Colonel Britton* – another film with a strong anti-Nazi stance – was passed, but it was recommended that the words 'bloody' and 'bitch' and the use of the 'v' sign be deleted.[67] Similarly, in 1943, Gert and Daisy's *It's in the Bag* was approved, but Colonel Hanna recommended that the line 'You dirty little fly-blown Casanova' be deleted, while Miss Shortt also suggested that the word 'lousy' be removed, along with 'the sound of fresh raspberries' and 'the depiction of the "Gents" as obviously a Gents'.[68] The Butcher's production *See How They Run*, meanwhile, was passed in

(left) *It's in the Bag* (1944), one of several films from this period that the Board found 'vulgar or offensive' at the scenario stage; (right) World War II changed the Board's attitude to films such as *Love on the Dole* (1941)

1945, but with the following suggestions to the film's producers: 'Delete reference to Miss Philling's bottom'; 'Delete sex appeal'.[69] Significantly, it was Miss Shortt's intervention that often saw the recommendation of such modifications. In 1944, for example, while Colonel Hanna had shown no objection to the Butcher's production *Kiss the Bride Goodbye*, Miss Shortt rather amusingly recommended that the 'rude noises from the hippopotamus' be removed.[70] The strong moralistic stance taken by the censors regarding impropriety and sexual licence also continued in the post-war period. Gainsborough's *Easy Money*, for example, was passed, but it was recommended that any '[u]ndue nudity should be avoided'.[71]

While there was some continuity between pre-war and wartime attitudes towards film censorship, the impact of the war clearly had a profound effect on the BBFC. Of course, the most well-known example of this shift is the initial banning, and subsequent passing, of *Love on the Dole* (1941). In 1936, when the script of Walter Greenwood's novel was originally sent to the Board, its subject matter – unemployment and poverty – was too sensitive for the censors to pass; but by 1940, the film could be used as an example of 'what we were fighting for' – a new post-war social order, where the ordeals of the 1930s would be no more.[72] It is, in fact, apparent from the scenario reports that it was the negative effect the war could have on British society that was of most concern to the censors, and any film that was likely to weaken morale or cause alarm was always frowned upon. In contrast, any films that offered to boost civilian morale were always welcomed. In 1942, for example, Gainsborough's contemporary war film *Raid of Heligoland* was praised for its heroic action sequences.[73] The scenario report for the historical film *Royal William*, meanwhile, records the censors' delight at the way in which the reign of William IV was to be depicted. 'William is held up to admiration as the first democratic King of England', Colonel Hanna gushed, adding that the film would 'put forward his good qualities and loveable nature'.[74] Whether this was an accurate portrayal of William IV's reign appears to have been something of a moot point for the censors. Indeed, Miss Shortt took the view that an accurate representation of the 'somewhat coarse and crude atmosphere of the period' could be damaging, and thus suggested that care be 'taken to avoid [it]'.[75] An adherence to the BBFC's strict views on vulgarity thus came at the expense of historical accuracy.

Intriguingly, this signals something of a shift in the BBFC's attitudes towards historical verisimilitude. As Sue Harper has noted, during the 1930s, the Board 'expressed an increasing intolerance towards historical inaccuracy', and while there was some relaxation of this as the decade progressed, it is clear that, in order to gain BBFC approval, any film depicting an historical event had to get its facts right.[76] The relaxation of this in wartime thus suggests that the BBFC now wanted films to depict Britain's past in a rose-tinted, and highly nostalgic light. It was the image of Britain that, according to the MoI's guidelines for propaganda, 'we were fighting for'.[77] This point is underlined if we consider *Boys in Uniform* which, while being noted as historically inaccurate, was declared 'quite free from objection'.[78] In the post-war period, however, historical verisimilitude was, once again, high on the agenda. Of *The Private Life of the Virgin Queen*, for example, Lieutenant-Colonel Fleetwood-Wilson noted: 'I doubt very much if a film could be made from this book which would come within our standards. There are many statements not accepted

BBFC staff with Ministry of Information counterparts, c. 1940

by historians.'[79] Miss Kitchener concurred, adding: 'It misrepresents and falsifies the character of one of England's greatest sovereigns. It is a book to be shunned more especially as we are within sight of the reign of Queen Elizabeth II.'[80]

It is apparent, then, that the BBFC was actively aiming to bolster public morale by approving films which were likely to do just that. Moreover, as stated above, any film that was likely to have a harmful effect on morale or trigger anxiety was always met with the utmost disdain. Indeed, in 1941, when the full effects of the Blitz were being felt, many scenario reports contain notes advising producers to delete, or at least limit, the use of air-raid sirens. The report for *I'll Marry the Girl*, for example, advised producers to '[d]elete all sounds of air-raid siren'.[81]

Somewhere in the Camp's producers were similarly informed that '[a]ir-raid sirens must not be heard'.[82] While it could be assumed that the censors were simply concerned that cinema audiences would not be sure if the sirens they heard were from the film or actually happening outside the auditorium, the scenario report for *The Lone Wolf Goes High Hat* suggests that it was the *effect* of the sound of the siren on the audience's psyche that was of most concern to them. 'Speaking generally', Colonel Hanna noted of the scenario, 'the bomb crashes, gunfire and other noises of an air-raid siren appear somewhat long, and it might be well not to overdo these effects.'[83] An appended note reveals that a conversation took place between the censors and the film's producer, Mr Baker, in connection with the air-raid sirens, and, following that, it was decided to allow the sirens to remain, but only because Mr Baker had 'promised they would not be too blatant or too prolonged'.[84] Similar negotiations took place regarding *Flying Fortress*, which, while being described as a 'fine war picture', was nonetheless criticised for its use of air-raid sirens.[85] Following negotiations with the film's producers, the censors permitted their use, but, once again, only if they were not 'too prolonged or too blatant'.[86]

While the censors' concern over the use of air-raid sirens in film peaked in 1941, their anxiety over the depiction of horrific images extended across the war's duration. For example, all 'H'-certificated films were banned in 1942, as were a further twenty-three films between 1943 and 1945.[87] Undoubtedly, the BBFC believed that public morale, already low in many areas, could be brought lower by the exhibition of this type of film. Surely echoing the BBFC's concerns, *Today's Cinema* declared in May 1940 that there was 'enough horrifying action in the world today without having to pay to see it at the cinema'.[88] The BBFC's hostility towards horror films continued in the post-war period. In 1947, for example, a scenario report for *Murder in Whitechapel* noted: 'I consider that this story is brutal, sordid and unpleasant. The public could not benefit in any way by seeing it as a film.'[89] Later in the same year, *The Tober and the Tulpa* was likewise described as 'highly distasteful' and 'obviously of the Horrific class'.[90] Neither film was made.

It was not just films placed in the 'Horrific' category that were banned during these years. Any film portraying scenes of death and destruction was always at risk of censure too. In 1941, for example, the producers of the British Secret Service drama *One of Us* were warned not to show any scenes of gas poisoning, and one scene, which depicted a 'skull revolving with gas escaping through the teeth', was recommended for deletion because it was 'likely to be too macabre and gruesome' for wartime cinema audiences.[91] In 1942, meanwhile, MGM's dramatic portrait of wartime France, *Fire in the Night*, was passed, but only so long as its 'disturbing scenes' were 'reduced to the minimum'.[92] Similarly, in 1943, Columbia's *Blitzkrieg* was also approved, but it was recommended that 'the close-ups of twisted dead bodies should not be too gruesome'.[93] It would seem, then, that the BBFC's censors believed that the use of gruesome images in film would have a harmful effect on cinema audiences, and by extension, British society.

Impact of the Blitz:
Addle Street, London,
after bombing by the
Luftwaffe on 29
December 1940

It was not just the short-term effects of these images on civilian morale which prompted these beliefs. The long-term impact of such images on British society were of greater concern for the censors. In 1945, for example, Colonel Hanna noted in the scenario report for *Green for Danger*:

> Attempts at murder in a military hospital by a nurse, followed by her suicide, is in my opinion one which would be most unsuitable to show at any time, but most especially when the military hospitals in England and abroad will be full for many a long day yet.[94]

The medical profession had long been protected from negative representations on screen. As Jeffrey Richards has noted, any film which threatened to reflect badly on it was likely to be banned.[95] However, during the war, and in the years immediately following the conflict, it was less the profession that was being protected, more the patients themselves. The rendering in film of patients suffering from mental illness was particularly susceptible to the censors' ire. Ealing's *The Interloper*, for example, was deemed 'not suitable' in 1944 because of its 'incidents and dialogue concerning the inmates of the Mental Home'.[96]

Significantly, the BBFC's concern over film's representations of mental illness escalated in the post-war years, undoubtedly due to the return of injured servicemen, many of whom would have been both physically and psychologically scarred by the war.[97] In April 1946, for example, London Films' *The Snake Pit*, which was set in a New York mental hospital, was deemed 'quite unsuitable' (see case study).[98] The following month, Columbia's *The Eminent Dr. Deeves*, again set in an American mental hospital, was also prohibited. As Fleetwood-Wilson indignantly noted, '[t]o pass a film depicting the mentally deranged might set up a dangerous precedent, for such a subject is

likely to be as repellent to the public as it is tempting to Hollywood'.[99] In April 1947, meanwhile, the producers of *The House of Doctor Belhome* were reminded that '[c]are should be exercised in the treatment of the hospital scenes and the agonized patients so that the horrors are not unduly stressed'.[100] Later in the year, *Dead on Time*'s depiction of a 'mental home and inmates' led Fleetwood-Wilson to storm, 'I can see no reason to recommend this story. The ingredients are obnoxious [...]. A revolting total.'[101]

It is interesting to note, though, that the decision to ban the majority of films which depicted mental illness was taken regardless of whether they were produced in Britain or America. This was somewhat at odds with the BBFC's usual stance on censoring the American product. More often than not, films that were produced in America (and where the action was set in that country) were passed by the censors, partly because the British cinema industry was highly dependent on the American film market, and partly because they were viewed as less of a threat.[102] For example, while the gangster film cycle of the 1930s caused extreme consternation at the BBFC, and led to a large number of British-produced films being banned, many American-produced crime films were permitted. As Colonel Hanna noted in his report for the Edgar Wallace adaptation *When the Gangs Came to London*, which the Board banned, '[t]he British Board of Film Censors have had a good deal of trouble with "gangster films" in recent years and it was only because they were obviously American that they finally passed'.[103] As with the 'revolutionary' films of the period, then, it was where the action was set that caused most anxiety among the censors.

This pattern of censorship regarding crime films continued into the war period, and also into the immediate post-war years. Ealing's *The Anatomist*, for example, was prohibited in May 1944 because, according to Colonel Hanna, '[t]here is not a single good character of any importance [...] and no moral lesson to be learnt. Its whole atmosphere is sordid and criminal.'[104] In July of the same year, Theatrecraft's *No Orchids for Miss Blandish* was likewise described as '[a] story of unrelieved crime and brutality from start to finish'.[105] According to Colonel Hanna, it contained '[n]ot a redeeming feature of any sort'.[106] An amended version of the script was submitted later in the year, but Colonel Hanna again refused to pass it because 'There does not appear to me to be any very extensive alteration. It seems to me a story of pretty sordid crime and violence.'[107] After the script was amended to include a moral lesson – the gangster 'goes straight' – the film was approved.[108] The censors' desire for a film to contain a moral lesson was thus a key determinant in their decision. If a crime film included one, it was more likely to be approved. If it did not, it would be prohibited. Theatrecraft's *The Business of Death* was therefore banned because it had '[n]o redeeming feature and no moral lesson'.[109] *Uncle Harry* was likewise prohibited because '[t]he plot is morbid and unpleasant. It might easily have a bad influence on certain individuals in a cinema audience, particularly as the murderer gets off.'[110] In stark contrast, Frank Chibnall's crime drama *Jim the Penman* was offered warm praise because it contained '[t]he moral "Crime Never Paid"'.[111] The censors' decision: 'NO OBJECTION' (capitals in original).[112] Clearly, the film carried no threat to public morality.

The BBFC consolidated its role between 1928 and 1948. In the face of immense pressure from a range of government departments and cultural critics, who issued a stream of varying demands throughout the period, the Board cultivated a system that, to a large extent, worked extremely well. Despite initial teething troubles upon the advent of sound film, the Board established a censorship code which ensured that the most harmful elements were removed from the films being produced in the period. Of course, this led to some criticism over the Board's methods, especially in the 1930s, when its hand in political censorship came under increased scrutiny. However, throughout the period, the censors' chief concern was the issue of public morality, and all their efforts were expended towards improving it. In 1948, and after holding the position of Secretary for thirty-five years, Joseph Brooke Wilkinson's time in office came to an end with his death. Despite his untimely passing, he could have taken comfort in the knowledge that, through the work of this organisation, British cinemagoers were largely protected from the screen's worst excesses.

CASE STUDY: ISLAND OF LOST SOULS (1932) Karen Myers

As the nineteenth century ended, scientific communities wrestled with the implications of Charles Darwin's controversial evolutionary theory with many celebrating humanity's progressive path towards civilisation while others wondered if mankind might degenerate into primitive, animalistic beings. Animals themselves were also the subject of scientific debate with increasing sociopolitical pressure for strong anti-vivisectionist legislation.[113] In 1896, into this swirl of ideas, was born H. G. Wells's science-fiction novel, *The Island of Doctor Moreau*.[114]

The book tells of a shipwrecked English gentleman, rescued and taken to a remote island occupied by Doctor Moreau. Moreau, an eminent research scientist banished to the island after the exposure of his vivisection practices, still has a thirst for experimentation. In his laboratory, the 'House of Pain', Moreau endeavours to create fully functioning humans from the animal population but produces only the 'Beast Folk', animal-human hybrids.

Wells's horror fantasy proved rich fodder for the infant film industry with a silent French two-reel adaptation, *Île d'Épouvante*, reputedly appearing as early as 1911.[115] Twenty-one years later, after sound had transformed cinema and before Will Hays's Motion Picture Production Code clamped rigid restrictions on film content, Paramount Pictures produced *Island of Lost Souls*. Directed by Erle C. Kenton, the film featured Charles Laughton as Doctor Moreau and Bela Lugosi as a 'Beast Man'. The script added a controversial love angle, to which Wells himself is reputed to have objected,[116] in which Lota, one of Moreau's animal-human hybrids, attempts to seduce the shipwrecked arrival.

The film arrived at the BBFC in March 1933, a few months after its American release. With no extant BBFC records from that period, exactly why it was immediately rejected is impossible to determine. The 1933 Annual Report states that twenty-three films were rejected but as the list of the reasons is not connected to specific films one can only speculate as to whether '[p]hysiological arguments treated too frankly for public exhibition' or '[i]ntense brutality and sordidness, coupled with promiscuous immorality'[117] led to the rejection. Elsewhere, commentators have conjectured that the film's depictions of vivisection,[118] its challenges to 'natural law'[119] or its irreligious tone[120] might have been the cause.

Letters exchanged between Paramount and the BBFC in the 1950s, when the film was finally resubmitted, throw no new light on the 1933 rejection. In July 1951, the then Secretary, Arthur Watkins, writes only that his predecessors 'did not consider the film suitable for public exhibition in this country'.[121] It was the introduction of the 'X' certificate in 1951 that had prompted Paramount's resubmission but its hopes for classification were soon dashed. A BBFC examiner's report is adamant:

The film is old & bad; whatever might be the case for permitting the theme of this film in a modern production there is no ground whatever for permitting this dated monstrosity to be revived under cover of our 'X' certificate. I suggest merely informing Paramount that there are no apparent reasons for reversing the earlier decision. To do otherwise would do our 'X' a lot of harm.[122]

Island of Lost Souls remained in Paramount's archives for another six years. In 1957, it hoped 'to re-issue this picture worldwide and, as Great Britain was the only place in which it was totally rejected' they wished it to be considered for classification again.[123]

The BBFC's response was, if anything, even more direct:

[I]t was agreed that the basic idea of this film was no less repulsive than when it was viewed before; that the results in the development of the human beings out of animals and the climax on the operating table rendered the film totally unsuitable for public exhibition in this country.[124]

They also warned Paramount that 'if the film were heavily cut (as it would have to be to meet our requirements) there would, in fact, be no story left in it'.[125]

This time, however, Paramount did not accept the BBFC's ruling and, determined to secure a classification, submitted a suggested, and extensive, list of cuts. Among them was a proposal to remove all shots inside Moreau's 'House of Pain'. In the same letter, it argued the film had a valid place alongside similar, and classified, horror features. Their words also hint at 1950s Cold War anxieties:

[T]he horror impact of this picture is no greater than many others dealing with mad scientists who create monsters which get beyond control and ultimately destroy them; in fact the creation of world destroying forces, however fantastic the form in which they are presented, can be a far more frightening thing in this age of advanced and fearful scientific experiment than this story of experiments confined to a small island; a tale which is based on a book which anyone can read.[126]

An internal memo to BBFC Secretary John Nicholls indicates both a reluctance to view Paramount's edited version, with the proposed cuts considered 'totally inadequate', and an active monitoring of public attitudes towards films and their classifications: 'There has been a considerable hardening of responsible public opinion against horror films, and we certainly cannot relax our standards – indeed, a little tightening up is desirable.'[127]

Island of Lost Souls:
rejected in 1933,
classified 'PG' in 2011

The BBFC did concede, however, that the President, Sir Sidney Harris, hadn't viewed the film when it was rejected in 1951 and that it wouldn't be 'right to maintain a contested rejection' until he had.[128] This proved to be the turning point. A version with Paramount's suggested edits was viewed and a record of a meeting between Harris, Nicholls and Paramount's representative states that 'on completion of certain cuts which had already been forwarded to the Company, the film could be given an "X" certificate'.[129] These further cuts, to remove a couple of lines of dialogue and some images of the 'Beast Folk' and Lota on the attack,[130] were made and finally in July 1958, thirty-six years after it was originally produced, this cut version of the film was granted its long sought-after 'X' certificate.

It remained classified at 'X' until 1996, when the original uncut film was classified for a video release. The Board at the time found it 'difficult to see why this [film] was a problem' for their 1950s predecessors, but issued a '12' certificate because it was 'surprising to see how well the horror holds up'.[131] Fifteen years later, the uncut DVD version was reclassified 'PG'. In the modern world where computer-generated film monsters dominate *Doctor Who* and *Harry Potter*, the dated presentation of the vivisection theme and the outmoded make-up effects of this 1930s horror classic have mostly lost their power to frighten children or worry censors.

3

FROM *THE SNAKE PIT* TO THE *GARDEN OF EDEN*: A TIME OF TEMPTATION FOR THE BOARD

Steve Chibnall

Under New Management

As the lights went on again in London after the dark war years the British Board of Film Censors might have been anticipating the resumption of business as usual, even though the Luftwaffe had forced it from its tranquil Carlisle House bastion into a redoubt on busy Oxford Street. Peacetime, however, was not to be a time of peace for the Board. Its executives and Senior Examiner were well beyond retirement age, in poor health, and looked ill-equipped to adapt their policies to a cinema that, during the war, had successfully represented social and political realities and addressed contemporary issues. Colonel Hanna, terror of the scenarists, was invalided out in October 1946 and died four months later in the depths of Britain's Great Freeze. The Colonel's last act at work was entirely in character: the condemnation of the American stage play of youthful promiscuity *Pick-Up Girl* as 'unfit for exhibition in this country'.[1] His final judgment was dutifully supported by the new scenario examiner, Madge Kitchener (niece of the renowned Lord Kitchener), who, over the previous year, had largely taken over the duties of Nora Crouzet (née Shortt). Hanna was succeeded by another old soldier, Lieutenant-Colonel Arthur Fleetwood-Wilson. It seemed as though a continuity of view was to be maintained, but there were to be definite signs of change with the deaths of the Board's two senior executives.

Arthur Watkins, who became BBFC Secretary in 1948

The octogenarian President, Lord Tyrrell, died in June 1947, to be replaced, on the advice of the seventy-six-year-old Secretary, by the relatively youthful seventy-one-year-old Sir Sidney Harris from the Home Office's Children's Department. Described by one of his staff as 'an English gentleman of the old school', his early manhood had been spent under the reign of Queen Victoria.[2] When the almost-blind Secretary, Brooke Wilkinson, died in July 1948 after thirty-five years in post, a new era was finally born – although it was to be a far from easy birth. Determined to bring the Board closer to changing public attitudes, Harris chose forty-one-year-old Oxford-educated Welshman Arthur Watkins from his old department at the Home Office as his Secretary. Watkins had useful experience as a PR officer and, as a part-time playwright, he brought an interest in film as drama and a sympathy with greater realism.[3] His new management style would involve a more intimate familiarity with the production process – involving studio visits and direct conversations with film-makers – and with audience response, as he encouraged examiners to view films in the company of actual filmgoers.

Although Attlee's Labour government would lighten pressure on the Board to suppress sequences challenging imperial assumptions and established hierarchies or potentially offending senior office holders, Harris and Watkins were obliged to respond positively to the government's dominant domestic anxieties, notably its concerns about child welfare, juvenile crime and the unhealthy influence of American popular culture. These and the general approval of wider participation were reflected in new BBFC appointments. Colonial service was still well represented in the examining team by, for example, the future Chief Examiner, Frank Crofts, who joined the Board when Independence and Partition brought an end to his twenty-year career in the Indian judiciary;[4] but this type of appointment was balanced by examiners with a different range of experience. Aware that the government had set up the Wheare Committee to consider the issue of children and the cinema, the Board offered reassurance that its expertise in developmental psychology could be relied upon by recruiting Audrey Field (thirty-eight), an Oxford-educated child-welfare worker, to replace Nora Crouzet. Educational administrator John Trevelyan (forty-six), the Board's future Secretary, became a part-time examiner in 1951 after writing an article criticising the BBFC for its indifference to the effects of films on young people.

However, it is easy to exaggerate the immediate impact of the new regime. Under Brooke Wilkinson, the BBFC had seen its job as the avoidance of offence and the upholding of a dominant morality. Scenarios based on recent notorious criminal cases such as *Eyes That Kill*, which fictionalised the sadistic murders of George Heath, were still being rejected in the early post-war years.[5] Madge Kitchener seemed to specialise in spotting potential embarrassment for local authorities when their place names appeared in crime stories, and in policing historical adaptations for derogatory representations of the aristocracy and monarchy. She worried over the offence that British National's *Mrs. Fitzherbert* scenario (submitted as *Princess Fitz*) might give to a descendant of another of the Prince Regent's mistresses, the Countess of Jersey; and delivered a withering attack on the inaccuracies of Columbia's proposed Elizabethan biopic *The Private Life of the Virgin Queen*, castigating the book on which it would be based for its poor scholarship and Roman Catholic bias and demonstrating a command of Tudor historiography that would rival David Starkey's (see Chapter 2).[6] She detected further unfortunate historical associations for the monarchy in Ealing's script for *Saraband for Dead Lovers*, set in seventeenth-century Germany: 'Our reigning King is a direct descendant of George Louis. It is unfortunate that his profligacy and repellent German attributes are stressed and underlined.'[7]

The protection afforded to the monarchy and nobility by the Board, however, was slight in comparison to that offered to two other 'at risk' categories: domestic animals and women. Not only were storylines involving organised dog fights prohibited, but given that animals used in film-making were protected by the Cinematograph Films (Animals) Act 1937, care was to be taken when performing dogs were seen.[8] The BBFC feared complaints from animal welfare organisations about cruelty in training. Even an apparently innocuous comedy script about some theatrical agents who try to deliver 300 cats to a film studio, only to discover that hats were required, could panic the Board: 'It is unfortunate that "cats" are the main topic of this film. We have had trouble about the same subject in previous films.'[9]

Women, too, enjoyed the Board's protection from physical cruelty such as slaps and punches, but paternalism was further extended to the reputation of their entire gender. A few examples from the scenario reports are sufficient to indicate the scope of this policy. When Renown submitted *Grand National Night*, it was warned that 'a drunken woman is not to be encouraged and should be treated with great discretion'.[10] There was discouragement all along the way for various versions of *Daughter of Darkness*, Max Catto's tale of a 'sex-crazed girl' who apparently turns murderous. Examiners insisted that it should be 'well established that the men do the chasing' and that her motive for the killings is self-protection.[11] The Board was similarly unimpressed by *Irene*, John Argyle's 'sordid' story of 'an immoral girl of the masses', which might suggest that class was a significant consideration in the policing of depictions of the female libido.[12] Argyle had also discovered that any suggestion of miscegenation was strictly off limits when he submitted *The Street of Painted Lips*, a 'singularly sordid succession of degrading and unlikely episodes' set at the other end of the class spectrum, in which the wife of a British Governor-General in India is humiliated: 'On no account must white women be seen with the coloured men, as one finds in this type of cafe in New York.'[13] The Board's policy on the representation of 'the oldest profession' was unequivocal, as John Corfield was advised when submitting a synopsis of *For Them That Trespass*: 'We do not allow a story of the life of a prostitute, or any scenes of her plying her profession.'[14] Madge Kitchener, however, was prepared to hint at ways the script for *Idol of Paris* (a film which would become notorious for its duel with whips between women) could circumvent this

prohibition: 'If references to Cora and other coquettes' promiscuity must be eliminated and they are depicted merely as overdressed vulgarians, the audience can draw its own conclusions, according to its knowledge of such things.'[15] The view that the audiences of 'U' and 'A' certificate films, both likely to include children, should be protected from exposure to the immorality of women was one that certainly outlived the regime of Brooke Wilkinson.

The protectionist mindset of the Board chimed with the views of most of the trade. Eighteen months after the arrival of Watkins, for example, an editorial in *Kinematograph Weekly* could still confidently declare: 'The function of the kinema is simple enough. It is merely to entertain. No exhibitor having regard to his patronage or the success of his business undertaking should permit controversy in any shape or form on the screen.'[16] Setting out his stall in the 1949 *Penguin Film Review*, the new Secretary commented:

> [W]hile an intelligent adult audience might be relied on to reject bad taste and to remain undisturbed by immoral influences, he would be an optimist who would expect such qualities of resistance in the average patrons of the local Odeon or Granada. Bearing in mind the mixed audience who attend the ordinary cinema, imagine what would be the result if no obstacle were placed in the way of films which misrepresent moral values, condone cruelty, debase marriage and the home or mock at religion.[17]

The Board, he assured the *Review*'s readership of predominantly left-leaning intellectuals,

> tries to keep out of films the things which it believes the normal audience would not welcome as entertainment: harrowing death or torture scenes, gruesome hospital and accident sequences, unnecessary physical brutality, cruelty to animals and children; indecency, vulgarity; flippant references to religion or any sincerely held belief; ridicule of respected public figures or institutions [...].[18]

However, Watkins also believed that film censorship (rather like incidental music, one might say) should not be noticed by audiences, who should remain 'happily ignorant' of what may have gone on behind the scenes.[19]

Thus, the widespread assumption that, with the departure of the Old Guard, 'the Board's role as public guardian' passed with it requires some modification.[20] Such an easy view of social progress elides the persistence of paternalism and the struggle that took place in a post-war society in which the forces of reaction and transformation locked horns for years, twisting first one way and then another. Nor does it acknowledge the resurgence of puritanical zeal, widely experienced in social and cultural life, that accompanied the Conservative Party's return to power in 1951. One has only to look at the crisis that accompanied the beginning of Watkins's tenure to appreciate that, rather than ushering in a newly liberal censorship regime, it marked a certain retrenchment.

No Orchids for the Board

Ever since the Ministry of Information had handed back to the BBFC its peacetime powers, the Board had been dealing with a steady stream of scenarios and films that sought to exploit the vogue for hard-boiled fiction and noir thematics by putting a more realistic account of organised crime on screen. Subsequently dubbed the 'spiv cycle', these portraits of predominantly British gangsterism stoked fears of disintegrating social order and irreversible moral decline.[21] The first, British National's *Appointment with Crime* (1946), was green-lit by Colonel Hanna ('three corpses but there is nothing gruesome about any of them') with only minor grumbles from Madge Kitchener, in spite of a torture scene, smash-and-grab raid and violent bag-snatching.[22] Coronet Films' *Dancing with Crime* (1947) was also deemed an acceptable treatment of the gangland theme at 'A'-certificate level,[23] but warning bells were sounded by *They Made Me a Fugitive* (scenario submitted as *A Convict Has Escaped* by Alliance Film Studios), the story of an ex-RAF officer who finds post-war excitement by joining a gang of black marketeers. Arthur Fleetwood-Wilson searched vainly for grounds on which to turn it down but had to settle for modifications to its brutality and references to the drug traffic, while Kitchener took particular exception to the bitter remark from the demobbed protagonist 'I went on doing what the country put me into uniform to do', which she regarded as 'a disparagement of H.M.'s forces' and 'not likely to help recruiting'.[24]

The bells grew louder with the arrival of Graham Greene's scenario for *Brighton Rock*, with its explosive mixture of razor-slashing, acid-throwing and sacrilegious quotation from the Catholic mass – not to mention Ms Kitchener's worry that 'Brighton Town Council may not appreciate having this unpleasant and sinister tale located in their holiday resort'.[25] Nevertheless, the filming of Greene's novel went ahead, and in its slipstream followed gangster scripts of less literary merit, such as *A Gunman Has Escaped*, which made it to the screen as a supporting feature in spite of Kitchener's judgment that its 'sordid story of unrelieved depravity and brutal cruelty' was 'highly undesirable'.[26] It was this apparent loosening of censorial control that was all the encouragement needed by Renown Films to put into production *No Orchids for Miss Blandish* (1948), a valuable property it had been sitting on after three submissions of scripts to the Board during the war. A notorious but highly popular book and play, it was considered highly unsavoury stuff by the Board with 'not a redeeming feature of any sort'.[27] The Board did, however, find the third submitted script to be acceptable (see Chapter 2); Renown made this highly bowdlerised version of the story. It was passed 'A' with minor cuts on 12 March 1948, but it was released into a gathering backlash against the liberal reform of penal policy in the House of Commons, which had voted to suspend capital punishment and had abolished flogging in the Criminal Justice Act. The Board was blown sideways by a gale of criticism. *No Orchids* was seen as a provocation, even by relatively progressive critics. The *Monthly Film Bulletin* suggested that the certification of the film 'seems an extraordinary oversight on the part of the British Board of Film Censors';[28] while Dilys Powell wrote an open letter of complaint to the Board in the *Sunday Times*: 'You have apparently no objection to […] vulgar sexual suggestion [and] attempted rape and murder on the scale of a massacre'.[29] Labour MP Tom Driberg called for a Royal Commission to investigate the BBFC. As the crowds lengthened outside the Plaza in Regent Street, where *No Orchids* had premiered, the London County Council, usually a more permissive organisation than the Board, insisted on two minutes of cuts before allowing further London screenings. The BBFC had taken its eye off the ball during what was effectively an interregnum as Brooke Wilkinson handed over to Watkins. It tried in vain to defend its decision by arguing that the film was no more violent than the average US gangster movie, but Sir Sidney Harris quickly bowed to pressure, admitted 'that there was some justification for the press criticism', and apologised to the Home Office for having 'failed to protect the public' in this instance.[30] As a further bow to criticism, Harris sent a stern warning circular to all the major cinema trade associations:

The Board's decision to classify *No Orchids for Miss Blandish* (1948) attracted a great deal of controversy

The Board has noticed during the past year the growing prevalence in films of brutal and sadistic incidents […]. This development no doubt to a certain extent reflects the aftermath of war, when violence became the familiar accompaniment of daily life, and, on the most charitable view, may represent an attempt to portray on the screen some of the more unpleasant features and characters of the post-war period. On the general ground that an art should, within certain limits, be allowed to express the salient mood of a period, stories and incidents have been permitted which might not have been acceptable in another period. The Board feels, however, that the continued choice of stories of a brutal and sadistic nature, with their dependent incidents, can no longer be regarded as acceptable to large sections of the public […]. The Board will not, therefore, in future be able to grant a certificate to any film in which the story depends in any marked degree on the violent or sadistic behaviour of the characters […].[31]

Not that most producers needed much persuasion. Sydney Box, for example, immediately declared that, though the spiv and the deserter had once been 'legitimate subjects for drama', they were now over-exposed:

When [...] a producer attempts to cash in on sadism and to exploit the lower emotions of his
audience, his action is, to my mind, inexcusable and only encourages hooliganism and crime. Films
based on sadism [...] can only bring their makers into disrepute and, more than that, prejudice the
good name of the whole industry.[32]

It was a somewhat sanctimonious comment from a film-maker who had acquired the rights to *No
Orchids* before apparently seeing the error of his ways.

The *No Orchids* affair was a watershed moment in the history of the Board, not least because
it revived calls from some local authorities for the BBFC's appointments to be taken out of the
hands of the cinema trade and made the sole responsibility of the Home Office.[33] It also ensured
that there would be no immediate liberalisation of policy. In fact, Watkins's first trade interview as
Secretary did not announce a more liberal regime, but supported his President's apology over the
No Orchids decision: 'That type of film in the long run does the industry a very bad turn', he told
Kinematograph Weekly, 'it alienates the most important type of audience – the family audience'.
His views were heartily endorsed by the journal, which wanted no fundamental policy change and
was happy to leave censorship in the hands of the BBFC and the local licensing authorities.[34]

Although 1948 was an *annus horribilis* for the Board, there were still problems to come.
Another warning about sadism and brutality was deemed necessary in 1949, the year the scenario
department received a script that seemed directly to challenge its policy on violence and spivery.
It contained the beating of a woman with a leather belt, a coshing and the brutal murder of a
guardian of the law. Arthur Fleetwood-Wilson responded angrily:

A sordid, vicious, unpleasant story! I deplore this type of film being produced in this country. I feel certain in my own mind that it does a great deal of harm to those of the younger generation who are criminally minded.[35]

It might easily have been returned with the sternest of advice to abandon the project, but the company involved was Ealing, the film was *The Blue Lamp* (1950), and it had the full backing of the Metropolitan Police.[36] Examiner Frank Crofts bemoaned the fact that 'a film illustrating London police work should be just another "American" gangster story', but tried to remain optimistic:

As the company is to have police co-operation, one can reasonably hope for a factual treatment, without sensationalism. It would be disastrous to treat this dangerous subject of adolescent criminals with any glamour. On the other hand, whilst it is necessary to show the criminals as mean, cowardly sneak-thieves, there should not be much emphasis on cruelty towards women, and though the background is sordid, there should not be any prostitution or eroticism.[37]

Although Crofts might have considered it 'just another "American" gangster story', *The Blue Lamp* went on to be the most successful British film at the box office in 1950. The violence in real American films, however, continued to give headaches to the Board. Harris's warnings might have been sufficient to deter most British producers from chancing their arms with hard-boiled hokum, but Hollywood was less easily intimidated and American film culture was more tolerant of the rough stuff. In the autumn of 1948, Watkins agreed to swap notes on issues of mutual interest with Joseph Breen, Head of the American Production Code Administration, and a year later the Secretary of the BBFC felt the time had come to use this open channel of communication to appeal to his opposite number in Hollywood: 'We are still having to make a large number of cuts in the films submitted to us, with the object of removing sadistic and brutal shots or sequences', he wrote. Public sentiment, expressed in press comments and letters from social organisations and members of the public, remained strongly opposed to explicit violence. 'The Board cannot disregard these expressions of public opinion and feels that so far from relaxing its policy expressed in the letter of May, 1948, the Board must enforce it even more strictly.'[38] Watkins emphasised that it was in everyone's interest that he receive co-operation from American producers, recommended the practice of shooting 'alternative takes' for scenes likely to be controversial, and supplied more detailed guidelines on the Board's position for producers.[39]

Protracted arguments with Hollywood companies amazed that British censorship was now more severe than their own Production Code would become a regular feature of the Board's business over the next decade. These disputes would by no means be restricted to gangster films, but would stretch over a variety of genres from Westerns to science fiction and horror. The biggest battles, in fact, would be fought over problematic representations of women and juveniles. The first centred on Fox's *The Snake Pit* (1948), set in a mental hospital, traditionally a 'no-go' location from the Board's point of view (see case study). In October 1950, Watkins became the first BBFC Secretary to visit the Motion Picture Association of America (MPAA). He again warned the US trade about gratuitous violence, but he also briefed it on a major change in the British system of classification that would loom large in negotiations during the new decade.[40]

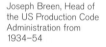

Joseph Breen, Head of the US Production Code Administration from 1934–54

For Adults Only

Revising his classic work *Film* in 1946, Roger Manvell complained:

It is intolerable that all films for public exhibition should be measured by the standards of the culturally under-privileged, for by such standards, if applied to great literature, a large measure of the world's masterpieces would have to be bowdlerised or abandoned.

His solution was a new certificate for a film with appeal exclusively to adults, yet 'which is not a piece of mere pornography'.[41] Local authorities would be invited to allow the exhibition of these films for discerning audiences. Manvell's recommendation was taken up by the Board's new management and endorsed by the Wheare

A poster advertising *Detective Story* (1951), and with it the new 'X' category

Committee, set up to review censorship practices in advance of a fresh Cinematograph Act and to consider the effects of film on children. Its 1950 report recommended the introduction of a new category of films, which should replace the 'H' category (little used since its suspension during the war), from which children should be excluded. The 'X' certificate was duly introduced in January 1951.

'It is not our desire that "X" should be merely sordid films dealing with unpleasant subjects', Watkins assured the film trade, 'but films which, while not being suitable for children, are good adult entertainment and films which appeal to an intelligent public.'[42] He maintained that film-makers would be given the choice of an 'X' certificate or cuts that would allow an 'A'. The certificate was conceived primarily as a means of allowing the metropolitan exhibition of a relatively small number of what we would now term 'arthouse' films for specialist educated audiences, and eleven of the first dozen 'X' certificates awarded were to continental films. The first was actually Robert Siodmak's 1937 French drama *Cargaison blanche* (*Traffic in Souls*), but the main test case was *Occupe-toi d'Amélie!* (*Keep an Eye on Amelia*, 1949), a French sex farce directed by Claude Autant-Lara, which was presented to the Board in April 1950 and was rejected after two viewings as too suggestive and too celebratory of promiscuity. Undeterred, the distributors hawked their product around the local authorities. Most of the London authorities (except Middlesex) allowed the film to be screened with one small cut as an 'A'. Watkins and two of his examiners kept an eye on *Amelia* by attending screenings of a slightly cut print at London's Cameo-Polytechnic. They were surprised to discover that the gender composition of the audience was fairly even, and pleased that the film amused rather than aroused its viewers: 'On this reception we need not worry about an "X" for this type of film', wrote one of the examiners, and the certificate was quickly awarded.[43] The new certificate also facilitated the release of other previously rejected films such as Rossellini's *Il miracolo* (*The Miracle*, 1948) and Clouzot's *Manon* (1949).

The 'X' was not an innovation requested by either local licensing authorities or the film trade. The powerful exhibition circuits were suspicious of a certificate which would exclude much of their regular audience and thus reduce their ticket sales.[44] There was general shock and confusion when films from Hollywood studios, passed for general exhibition by the MPAA, such as Warner Bros.' *Murder Inc.* (a.k.a. *The Enforcer*, 1951), began to be awarded the 'uncommercial' certificate. The Rank circuits in particular were not prepared to risk the goodwill of family audiences and would release only fourteen 'X' films during the 1950s. Although its main competitor ABC released fifty, most were in the last years of the decade.[45] Actually, Paramount's *Detective Story* (1951) was the first 'X' to be booked by a major circuit in November 1951, enjoying considerable success on its London release with the slogan 'X Marks the Spot Where Most Business Is Being Done'.[46] However, the new certificate provided the biggest commercial opportunity to the hard-pressed independent cinemas many of which, by the end of the decade, were advertising double bills of 'X' films and leaving the family audience to the big circuits. As early as October 1951, one grateful manager wrote to *Kinematograph Weekly* to thank 'Mr. Censor' for thinking up the 'X': 'We are a family hall and yet [...] every time we show an "X" film we can be sure of at least 25 per cent extra business. If the circuits had a little more "guts" they would find the same thing.'[47]

The response of the local authorities was very uneven. Some were no longer prepared to trust the judgment of the BBFC and banned 'X' films unless the express permission of the licensing committee had first been obtained. As the new certificate's ship sailed out of harbour, it soon met steadily worsening conditions: choppy waters and a gathering chill were part of a reactionary climate encouraged by the post-war Conservative government in its attempts to purify British culture as the Coronation approached. In the Potteries district, for example, the Stoke-on-Trent Watch Committee regularly turned down 'X' films on the basis of synopses that they insisted were submitted in advance of planned screenings, while Newcastle-under-Lyme's Committee insisted on seeing nearly all the 'X' films and rejected at least 70 per cent of them.[48]

It took some time for the Board to realise just how frosty things were becoming in the provinces. It had gaily waved Max Ophüls's cynical French satire on love, *La Ronde* (1950), on its

La Ronde (1950),
starring Simone Signoret,
was classified 'X',
although the Public
Morality Council
considered it to be a
'dangerous' film

way with an 'X' certificate in 1951, despite the disapproval of the Public Morality Council, which regarded it as a 'dangerous' film.[49] Indeed, hardened examiners had been utterly charmed by the picture, as had the more sophisticated film critics. It ran for almost eighteen months at London's Curzon cinema, with over half a million admissions but only one complaint. Commenting on the record-breaking crowds at the Curzon, London's *Evening Standard* dubbed the 'X' certificate 'the cinema's new secret weapon' (although it warned British producers not to try to make this sort of film themselves).[50] Attitudes were not so relaxed elsewhere. In Nottingham, for instance, the local Watch Committee sought a justification of the film's certification in response to an inflammatory article in the *People* Sunday newspaper, which had described *La Ronde* as 'a model of pictorial corruption',[51] and to a condemnation in the *Sunday School Chronicle*, which called it 'unwholesome, irresponsible and deplorable'.[52] The reply from Watkins is revealing of the type of considerations in play when the Board was deciding its certification. It cited the film's style and wit, its unreal setting, the quality of its acting, 'and the aesthetic taste and discretion with which the subject is consistently handled'. These elements combined 'to produce acceptable adult entertainment, free from offence to the discerning cinema-goer'. If the Board had withheld a certificate, adult audiences in Britain would have been prevented 'from seeing a film which has been seen and enjoyed by adult audiences in almost every European country' and acclaimed by critics at the Venice Film Festival.[53] At last, it seemed the Board was seriously considering the quality of the film as a significant factor in its decision-making. That was music to the ears of people like BFI Film Appreciation Officer Stanley Reed, who thanked Watkins for adopting this line of argument.[54] Nevertheless, Ophüls's celebrated film was banned in Blackburn, Darlington, and Stoke-on-Trent; and the increasingly puritanical climate of Coronation year was evident in the refusal of a certificate to Films de France's *Trois Femmes* (1952), based on risqué short stories by Guy de Maupassant, on the grounds that two of the stories were 'sordid and amoral'.[55]

During 1953, the shrill calls for moral rearmament created a hostile climate for any form of cultural production that was less than thoroughly wholesome and enthusiastic about the new Elizabethan age. There was particular hostility towards what many considered 'degenerate'

transatlantic influences in the form of horror comics and pseudo-American gangster novels.[56] Hollywood distributors discovered that British waters were full of icebergs on which their films could founder. Although it was already causing controversy in the US, it seemed momentarily as if Columbia's *Miss Sadie Thompson* (1953) – Curtis Bernhardt's 3D adaptation of Somerset Maugham's *Rain* – might sail through relatively unscathed. The first examiner's report recommended an 'A' certificate with cuts,[57] but then the *Daily Mirror* ran an exposé of Rita Hayworth's erotic dance number 'The Heat Is On', and things quickly became icy.[58] After a further screening for the BBFC President and Secretary, only an 'X' certificate was on offer, and then only if Rita's dance was entirely removed along with other offensive sequences in her bedroom.[59] The picture was important in Columbia's strategy to counter Twentieth Century-Fox's launch of CinemaScope in Britain, and disgruntled studio head Harry Cohn authorised expensive re-editing. In all there were eleven separate deletions and eight changes of dialogue accomplished through re-dubbing and retakes. Columbia executive Raymond Bell was dispatched to London on mission impossible with Cohn's directive:

> I urge you to use every means at your command to convince Mr. Watkins of the importance to us of an 'A' certificate, and to demonstrate to him the lengths to which we have gone to qualify for it. I feel confident that he will recognise the sincerity of our efforts.[60]

At lunch on 5 February, Watkins gave Bell the bad news that, while the new version now qualified for 'X', he might as well restore the cuts beyond those specified, because the film was not going to be an 'A' as long as the last four minutes, in which Davidson (Jose Ferrer), a pious man, falls for the wicked woman played by Hayworth, continued to turn moral values 'upside down'.[61] After a weekend of soul-searching and feverish attempts at re-editing to modify the meaning of the ending, Bell returned to the US without the approval of the Board for his revised version. He wrote disconsolately to his colleague, Max Thorpe, MD of Columbia in the UK, who had just returned to work after illness:

> Arthur Watkins is an intelligent, warm and conscientious person. He is extremely honest. His maintenance of high standards is admirable and to be applauded. But his decision in this instance is one that can be debated. Youngsters, I feel confident, will not rush home and tear up their Sunday school texts and become infidels as a consequence of this one debatable incident.[62]

Thorpe appealed unsuccessfully to Watkins, but it turned out that Columbia had one final card, and very reluctantly, Bell was authorised to play it: 'When our film was originally being shot an entirely different ending was filmed'. In this ending, Bell explained, Sadie promises her fiancé that she will return with him to America and 'submit to whatever fate or punishment awaits her'. She recognises that 'she must atone for whatever sins she is said to have committed', before she can live her life 'based on the Ten Commandments'. He explained that the conclusion 'was not used in the film now being distributed because in several cities in which the picture was sneak previewed, the American audiences asserted their traditional disfavour for what they thought was an unhappy ending'. Now, however, they were 'prepared to substitute this ending for the one you have already seen'.[63]

The alternative ending was viewed by the full Board on 24 February 1954 and as it was considered that it 'considerably strengthened' the 'moral impact of the film', it was agreed to give Columbia 'the benefit of the doubt' and grant an 'A' certificate. Like Davidson in the film, however, Columbia's joy turned quickly into conscious-stricken guilt. On April Fools' Day Thorpe approached Watkins to see if, as many people now seemed to find the last reel 'meaningless' and 'inconclusive', Columbia might put two versions of the film into circulation: the uncut original ending as an 'X' for 'the critics and large city audiences' and the agreed 'A' for others. Watkins refused point blank to allow this (although he did agree to most of Columbia's voluntary cuts being restored).[64] Columbia, however, had to shoulder the burden of critical ire that the new ending provoked.[65]

There would be more trouble in the third dimension in July, this time for Warners, a company that had already fought tooth and claw to obtain an 'A' certificate for *Caged* (1950), its harrowing depiction of life in an American women's penitentiary (see case study). Now the Board insisted on butchering the key scene in Hitchcock's 3D *Dial M for Murder* (1954), calling for the reduction of the struggle between the killer and his victim, the deletion of the shot of the attacker falling on the ground with scissors in his back, and the 'shot of Margot's clutching hand stretched towards the

(left) The Board made cuts to the attempted murder of Margot (Grace Kelly) in *Dial M for Murder* (1954); (right) *Tea and Sympathy* (1956): MGM removed the story's homosexuality theme

audience'.[66] That would be the film's signature image on the cutting-room floor, then. Before this, however, and only a few days after the *Sadie* dispute had finally been resolved, Watkins received a copy of a controversial American play, Robert Anderson's *Tea and Sympathy*. It was accompanied by an invitation (which he declined) from MGM via the respected British producer John Woolf to fly to the US to see Deborah Kerr in the Broadway production directed by Elia Kazan.[67] The consequent reader's report from BBFC examiner Audrey Field is one of the most extraordinary documents in the Board's archives, and is worth quoting at length for the light it casts on prevailing attitudes towards homosexuality during the witch-hunt of 1953–4, and towards the cinema audience in general. Writing a few months after the much-publicised trials and convictions of Sir John Gielgud and Lord Montagu of Beaulieu for homosexual offences, Ms Field described the story of Tom, an American college student confused about his sexuality, who tries unsuccessfully to test it with the local call-girl, is suspected of an affair with his House Master, and is finally seduced by Laura, the teacher's wife, as 'sincere, moving and entirely credible' (at least in the American context):

> Nevertheless, I hope that our present standards in regard to the discussion of homosexuality in the cinemas in this country will not be relaxed. It is a subject which ought now to be debated and further ventilated, but <u>not</u> in the cinema. The atmosphere is all wrong: who can doubt that a theatre provides the safer and cooler climate for the analysis of this sort of inflammable stuff? The audience, also, is largely wrong, except in a few 'specialised' houses in the West End of London. Millions of boys and girls of the 'working' classes, educated side by side, working side by side, married in their late teens and early twenties, do not need to consider this problem at all, and if they need not it is a pity to thrust it upon them in the guise of entertainment. In fact, even if they see the film, they will not consider it at all seriously: imagine the guffaws of the local yokels when Laura 'saves' Tom! Go one further, and imagine the reactions when Mr. Dent [Adelphi Films] demands – as he will – the right to be equally forthright. And when several score of sincere, honest, respectable film producers follow suit. They will mean well. They won't be sensational. It will therefore be difficult to refuse them. But the cumulative effect of their efforts will be deplorable at home and still worse abroad: there is no need to make out to the rest of the world, and particularly to what is left of the Empire, that 'le vice anglais' is our sole preoccupation.[68]

With the honourable exception of John Trevelyan, she received the full support of the Board, with Watkins agreeing that 'the adult theatre audience is one thing and that with which we have to deal another',[69] and the President lamenting, 'I only hope it is not a true picture of […] an American boarding-school'.[70] The play was also banned by the Lord Chamberlain. Surprisingly, MGM was not deterred and went ahead with a film that removed the homosexual theme entirely, thus simultaneously removing the Board's objection. The subsequent award of an 'X' rather than an 'A' certificate to Vincente Minnelli's movie, though, was criticised by *Films and Filming* and the *Observer* on the grounds that 'Hollywood has already purified the thing to drivel.'[71]

Rebels without a Pause

Sadly, though, Hollywood studios were prepared to accept purification to drivel rather than miss out on the lucrative British market, typically a principal source of profits after production costs were recouped in the home market. Columbia just about managed to pilot *Sadie* into port, but a film submitted at the same time, and starring one of the studio's hottest properties, foundered on the implacability of the BBFC. *Sadie* had been obliged only to navigate the chill waters of sexual repression and religious sensitivity, but Stanley Kramer's *The Wild One* (1953), featuring Marlon Brando in an existentialist story of biker hooliganism in a small Californian town, encountered the gale-force reaction to the emergence of the Teddy Boy, a violent Edwardian-styled interloper in the new Elizabethan realm. On this occasion, the Board was taking no chances with a film deemed 'potentially dangerous on social grounds'. Watkins advised the studio:

> Having regard to the present widespread concern about the increase in juvenile crime, the Board is not prepared to pass any film dealing with this subject unless the compensating moral values are so firmly presented as to justify its exhibition to audiences likely to contain (even with an 'X' certificate) a large percentage of young and immature persons.[72]

Columbia was reluctant to take no for an answer, but prioritised the cause of *Sadie* before returning to *The Wild One* in the summer of 1954, when it might have assumed that the memories of the notorious Teddy Boy gang killing on Clapham Common a year before might no longer be fresh. The Board remained unmovable, again citing 'recent outbreaks of violence and hooliganism on the part of teenage boys – culminating in one instance in murder'.[73] The BBFC's reservations about the lack of punishment for the wild ones in the film prompted Columbia again to offer an alternative ending, the deal-breaker for *Sadie*'s certification, and for good measure, it enlisted the aid of the Kinematograph Renters' Society to put pressure on the Board. Two further viewings opened some cracks in the BBFC's united front with new examiners Newton Branch and Mary Glasgow favouring cutting for an 'X' certificate and Watkins himself wavering. The President, however, remained adamant that young people should not be exposed to the film's 'false values'.[74] Frustrated by the BBFC's continued intransigence after almost a year of negotiation, Columbia took its film to the local authorities, but discovered that they had, unusually, closed ranks with the Board. To make matters worse, Columbia had another film dealing with youthful criminality, *Cell 2455 Death Row* (1955), rejected by the Board for exactly the same reason, 'only with even greater force': its likely effect on young audiences.[75]

> Whatever admissions of responsibility may be made by the young criminal at the beginning or end of the story [...] the film is for almost its entire length a record of juvenile crime of the most shameless and despicable character, underlined at each stage by the cynical immoral outlook and contempt for all authority of the delinquents.[76]

Two appeals were lodged and a cut version of *Cell 2455 Death Row* submitted without success. Eventually, on the suggestion of the Board a new commentary ridiculing the young gangsters was added and further cuts made, resulting in the issue of an 'X' certificate in July 1956.

Throughout the second half of the 1950s, American producers' courting of the drive-in audience with films about juvenile delinquency would be the BBFC's greatest headache. No sooner had the battle over *Blackboard Jungle* (1955) been fought with MGM[77] than Warner unleashed *Rebel without a Cause* (1955), which was viewed by the President, Secretary and Senior Examiners on 14 October 1955. They were not impressed, as this unsigned note testifies:

> Although we did not like the film on censorship grounds and thought it would be no great loss from the artistic point of view, it was not thought practicable to reject it, in view of the action we had finally taken on *Blackboard Jungle* – a better, but also a more violent film.[78]

The cuts called for were not only extensive, but mutilated the scenes that are now considered the highlights of a Hollywood classic:

> Delete all shots of Jim punching and kicking the desk, and trying to throttle his father, the slashing of the car tyre, most of the fight that follows, if not all. The less we have of this whole unpleasant idea of young people met together to witness a contest which could end in the death of one of the

participants, the better. In any event, the part played by Judy should be shortened as much as possible, in particular her unrestrained excitement over starting the race. The dialogue between Jim and Buzz 'Why do we do this?' and 'You gotta do something' should be deleted. The shot of the car actually crashing on the rocks should come out and the close-up of Buzz, and his scream before his death, should be reduced.[79]

Warners reported with some relish that it had 'really gone to town' and ruthlessly trimmed the offending scenes: Jim's frustration with his father, the knife fight and the 'chicken run'. This, it believed, should be sufficient to avoid an 'X', which would oblige the studio 'to cater to the morbid element of the population'.[80] The Board, however, was not prepared to allow children to see what Watkins called 'the spectacle of ridiculous and ineffectual parents', although he remained worried that 'our "X" may appear too heavy handed a category for the rubbish that this picture undoubtedly is'.[81] His President had fewer doubts: 'I agree that it is rubbish for adults but poisonous stuff for the teddy inclined adolescent'.[82] Ultimately, Warners was not prepared to make the extensive list of cuts that the Board required for the 'A' certificate it so ardently desired, because it felt the revisions 'would reduce the film to nonsense'. 'If we don't show the weakness of the parents', they reasoned, 'we have no motivation for the unhappiness and loneliness of the adolescents.'[83] The 'X' was reluctantly accepted. One might have expected director Nicholas Ray to be bitter about the way the British censors had treated his sensitive investigation of the relationship between parenting styles and teenage alienation, but writing to Watkins after a meeting in London he expressed nothing but contentment, ending: 'I wish to express my gratitude to you for granting the time you did, and to wish you a Very Happy Holiday'.[84] Replying to Ray, Watkins thanked him for the 'co-operative attitude' he had shown in enabling the parties 'to straighten out the censorship problem' and hoped that the picture he had privately dismissed as 'rubbish' would 'enjoy a success'.[85] In fact, the film was rapturously received by the critics and was a box-office hit, even in its expurgated form. The BBFC received no letters of complaint and, when the certificate was reviewed in 1976, the original version was passed 'AA' without cuts with the examiners' comment 'We felt that the story tells a moral tale.'[86]

Attitudes remained very different in the 1950s, when each new teenage delinquent film – especially those made by independent American producers – appeared more pernicious than the last. *Crime in the Streets*, with its 'many highly dangerous sequences', only escaped rejection when its distributors, Associated British Pathé, agreed to delete whole scenes (including the title sequence) for an 'X' certificate.[87] The Board demanded fourteen cuts to grant an 'A' certificate to *Rumble on the Docks* (1956)[88] and fourteen for *Betrayed Women* (1955) – including the display of male pin-ups in the girls' reform-school dormitory and references to masochism.[89] As the

Rebel without a Cause (1955) was one of a number of high-profile films of the era that dealt with teenage rebellion

disquieting effects of rock and roll on teenage behaviour became more evident, the BBFC insisted that the vigorous jiving and the wild song-and-dance number performed by Mamie Van Doren in *Untamed Youth* (1957) must be edited 'to remove erotic movements and gestures'.[90] *Runaway Daughters* (1956), submitted by distributors Anglo-Amalgamated, proved even more problematic. Initially rejected by the Board on the grounds that 'sex, alcohol, violence and crime are featured throughout, and there is not a single character, adult or adolescent, who behaves normally and decently throughout', it was acquired by Nat Miller, the most shameless of a new breed of British showmen.[91] Miller made a few cuts and managed to con the Church of England Moral Welfare Council into giving its backing to the film, unaware that it had already been condemned by the BBFC, but the Board maintained its opposition and Miller was obliged to go directly to the local licensing authorities. He had immediate success with the LCC, East Ham, Middlesex and Berkshire, in spite of BBFC warnings about the sharp practices of Miller's company, Orb.[92] After a meeting with Miller and a further viewing, the Board finally granted an 'X' certificate, but made sure that the further cuts were so severe that exhibitors complained that the certificate was misleading.[93] Miller's subsequent pleas for an 'A' fell on deaf ears.[94]

The *Garden* and Its Serpent

From the Board's point of view, Nat Miller had 'previous', having seriously embarrassed the BBFC and disrupted its relationships with the local licensing authorities over a naturist film, *Garden of Eden* (1954). Made in Florida by producer Walter Bibo with the approval of the American Sunbathing Association, the film was directed by Max Nosseck and photographed by Boris (*On the Waterfront*) Kaufman. When it was summarily rejected by the BBFC in January 1955 because it breached the Board's rules on bodily display, Miller worked tirelessly to submit it to as many licensing committees as possible, with considerable success.[95] The Board did its best to counter this flagrant challenge to its authority with a circular to local councils in September 1956 warning:

> While the film itself may well have been made with the legitimate motive of conducting propaganda on behalf of nudism and indeed makes no attempt to exploit nudity from the sexual angle, the Council will no doubt bear in mind the possibility of exploitation at the hands of a commercial distribution company and the number of members of the public who would be attracted to showings of the film for reasons unconnected with any bona fide interest in the cult of nudism.[96]

However, no fewer than 283 councils rejected the advice and certificated *Garden of Eden*, the majority in the 'U' or 'A' categories. There were only thirty-four 'X' certificates and just twenty-five rejections (many of these in chilly Scotland). The traditionally censorious authorities of Birmingham and Warwickshire awarded 'U' certificates. Some Watch Committees, such as Newcastle's, tried to support the Board by initially banning the film without viewing, but reversed their decisions and awarded a 'U' certificate on being persuaded to look at the film.[97] Faced with a devastating defeat in what was effectively a referendum on its policy towards nudity, as well as generally permissive attitudes towards the picture in the film and provincial press, and even among the clergy, the Board might sensibly have accepted that times were changing. After a second viewing, however, it unanimously confirmed its rejection of the film, 'having regard to the undesirable precedent which the issue of a certificate would involve'. It also resolved to send a further letter of advice to local authorities, emphasising what it now identified as evidence of the 'exploitation of nudity for sexual appeal'.[98] The decision was reached after a report on a covert viewing of *Garden* at London's Paris Pullman cinema by one of the examiners and a female friend:

> Almost 40 per cent of a very well behaved audience was women, mostly with male escorts [...] I detected no signs of embarrassment, giggling or anything else untoward. There was laughing only when it was intended. My companion, a homely young mother, [...] found nothing in it to offend her. But she was emphatic that she would neither like her son to have seen this picture by himself nor in her company. She would have been embarrassed.[99]

His main concern, though, was with how audiences in 'tough' cinemas in the poorer urban districts would react to seeing 'nude white women, some of them attractive' on screen.[100] The implicit class and racial dimensions to the fear of male sexual arousal and pleasure through film viewing were rarely nearer the surface than they were in this informal examiner's report. The maintenance of the Board's nudity policy despite its evident unpopularity was Watkins's unwelcome legacy to his

successor, John Nicholls, who was recruited from the Cultural Section of the Foreign Office and was in post by March 1957, just as the Board's reactionary advice was circulating among the Watch Committees. Like Watkins before him, the new Secretary walked into a firestorm that he had not ignited. By September, when he gave a press interview declaring 'Public opinion in matters of taste and behaviour changes with the times', and 'The Board cannot therefore remain rigid; it must adapt its policy to such change', he was burned to a crisp.[101] He had lost the support of the film trade and the licensing authorities, and was quietly eased out of his job. His successor, John Trevelyan, granted an 'A' certificate to *Garden of Eden* in July 1958 with the rider 'This decision does not mean that the Board has changed its general policy, which is to allow nudity in a film only in exceptional circumstances where it is essential to the story and is presented with discretion'.[102]

Cosh Boys and Twilight Women

The story of classification and censorship in the 1950s is dominated by the 'X' certificate, and the vast majority of these certificates were awarded to foreign films. However, although British producers generally tried to avoid the dreaded 'X' like a gamekeeper's mantrap, a few inevitably felt its jaws snap shut. Surprisingly, the first was a 'women's film' from respected London impresarios. *Women of Twilight* (1952), a story set in a 'home' for unmarried mothers, was submitted to the BBFC, first as a West End play script, and six months later as a screenplay, by Daniel Angel in partnership with John and Jimmy Woolf. They were keen to reassure the Board of their respectable track record and that their intended film adaptation would not be sensational,[103] but were told from the outset that any film based on their play would necessarily be placed in the 'X' category 'because of the sordidness of the basic situation'.[104] There were some problematic lines of dialogue and a particularly harrowing scene in which a pregnant woman is pushed downstairs and left to deliver her child unaided, but the project appears to have had the support of the Board's President, who shared Watkins's view that the story was 'well-handled and moving'.[105] Angel and the Woolfs accepted their certificate like gentlemen, realising no doubt that being the first British 'X' would ensure publicity for their picture. Actually the press reaction was interesting in the way it questioned the appropriateness of such 'sordid', 'disturbing' and 'dreary stuff' for a female audience seeking an evening's entertainment. 'Do women like films that have an "X" certificate?', asked the *Daily Mirror*'s Reg Whitley: 'I think the average woman hates them.'[106]

 Women of Twilight's press reception proved to be merely a skirmish before the pitched battle fought over the most controversial of the first three British 'X' films: Lewis Gilbert's *Cosh Boy* (1953).[107] Bruce Walker's stage play *Master Crook*, which would be the source material for *Cosh Boy*, was originally submitted to the BBFC in May 1952, again by Daniel Angel. Its message – violence can be beaten out of teenagers if parents take responsibility by giving them a good thrashing – chimed harmoniously with the disciplinary inclinations of an increasingly vocal section of post-war opinion that believed social order was under threat and more draconian measures were needed to ensure its preservation. The play's examiners noted the 'strong moral thread running through it',[108] but were concerned that the graphic depiction of violence (including prohibited weapons) and sexual desire suggested by the script 'might easily do more harm than good [...] to the young gangsters whom it may be supposed to frighten'[109] and that 'an X certificate would only stir their curiosity'.[110] There was further concern

The exhibition of *Cosh Boy* (1953) was considered in some quarters to be 'a monumental error in taste and judgment'

Derek Bentley (second left), accused of the murder of a Croydon policeman, is driven away from court, 10 November 1952

that the representations of the agencies of juvenile justice and welfare, the Magistrates' Association, the Probation Officers and Youth Clubs would be offended by this 'nasty and altogether unhelpful script'.[111] Watkins's response revealed social attitudes that were rather less liberal than his reputation suggests. He had enjoyed seeing the play on stage, and judged that, with appropriate cuts, it would be suitable for adaptation as an 'X' film: 'This is not a pretty subject and will not be a pretty film, but it deals with the type that is all too common and finishes on a strong moral note'.[112] Backed by the Board's President, he assured Angel:

> If the producer's concern is to present this important theme in an effective manner without sensational exploitation, there should be no difficulty from our point of view and we shall be prepared to co-operate in any way we can.[113]

When rough cuts of Gilbert's adaptation were viewed in September 1952, it became clear that co-operation could extend only as far as an 'X' certificate. With social fears about an epidemic of street attacks growing daily, the producers were also counselled against a change of title to *Cosh Boy*, but the Board did not 'maintain a flat objection'.[114]

However, between the issuing of an 'X' certificate on 12 November 1952 and the premiere of *Cosh Boy* twelve weeks later, a dramatic event occurred on a rooftop in Croydon that would profoundly affect the film's reception and bring down a deluge of criticism on the BBFC for allowing its release. The death of a policeman during a gun battle with sixteen-year-old Christopher Craig, and the subsequent execution of Craig's older partner in crime, Derek Bentley (despite being in custody at the time of the killing), ignited smouldering fears of feral youth and the role that cinema might play in the creation of delinquents. *Cosh Boy* was branded 'a dangerous film' that 'should never have been made' even before its first public screening a week after Bentley's execution.[115] Its exhibition was condemned as 'a monumental error in taste and judgment', and an 'offensive' and 'obnoxious' exploitation of the Craig and Bentley case.[116] Protest letters from indignant groups and individuals – including a bitter missive from 'one of the coshed' – immediately began arriving at the BBFC.[117] They were quickly followed by incredulous enquiries from local licensing authorities such as Warwickshire and Cumberland questioning the leniency shown by the Board. Watkins tried to dampen down the flames as best he could:

> I cannot help thinking that the reception of the film by many of the film critics was influenced to a large extent by events which happened after the film had been made [...]. Unfortunately the public demand for crime films seems to be very strong both here and in America.

He reassured those who feared these films might have a 'seriously injurious effect on young people' that 'expert opinion, generally including that of experienced magistrates and social workers, does not support this view'.[118] Sidney Harris supported his Secretary, but confessed that 'the reduction, if not the elimination, of the sordid type of crime film' would be a 'happy result' of the *Cosh Boy* controversy.[119]

The panic surrounding *Cosh Boy* reanimated a fierce debate across Britain about the necessity of local censorship. Some Watch Committees, such as Beckenham's, allowed the film to be screened as a matter of principle, while others faced public criticism for exercising a veto. A letter to the *Birmingham Mail*, for example, complained of 'a little Kremlin in the city who think the citizens of Birmingham are of such low intelligence that they cannot judge for themselves what to see and what not to see'.[120] In Luton, the licensing authority was so concerned about making the right decision that it test-screened *Cosh Boy* in local youth clubs.[121] As the list of Watch Committees banning the film began to lengthen, Daniel Angel tried to make his film more acceptable by volunteering to make cuts and adding BBFC-approved roller titles explaining its moral purpose at the beginning and end of the picture. The changes seem to have placated most Committees but a few cities continued to impose bans throughout the Coronation summer.[122] The confrontation between the apparently permissive BBFC and the local authorities over *Cosh Boy* would have its mirror image in that between permissive local authorities and the Board over *Garden of Eden* four years later – indicating, perhaps, how much social attitudes changed during the mid-1950s. First, though, there would be other controversial British films which would require the BBFC to make difficult decisions – decisions that the *Cosh Boy* experience ensured would err on the side of caution.[123]

Mothers and Murderesses

Even before the BBFC first saw the script of the play that became *Cosh Boy*, it had received the script of another West End production, this translated from Jean Cocteau's shocking satire of familial relationships, *Les Parents terribles*. The French film adaptation had taken over a year to win an 'A' certificate in August 1949, and Charles Frank's British theatrical version, *Intimate Relations*, had already run into trouble with the Lord Chamberlain. The Board's impression was that the play 'was actively disliked for its sordidness by most press critics',[124] featuring, as it did, a relationship between a mother and son that bordered on the incestuous, the son in love with his father's mistress, and the mother's sister secretly in love with the father. Intended by its author as a comedy, the story made *La Ronde* look like a kids' carousel. The script was submitted by Arthur Dent's company, Adelphi Films, which was about to make itself even more unpopular with the Board by trying to gain a certificate for Tod Browning's circus sideshow drama *Freaks* (1932), which had been rejected by the BBFC twenty years earlier. The *Intimate Relations* script was handed to Audrey Field, whose report suggested that Adelphi was demonstrating a taste for 'tainted meat' in sponsoring Frank's script:

> It seems the sort of story that could not be expected to translate well, or transplant in spirit from France to England at all. For this reason, I think we should be justified in calling the English version 'X', notwithstanding the 'A' certificate for the French film [...] and the more exacting we can be on details, the better, in the hope that the sponsors will give up. One does not want to discriminate unfairly against Arthur Dent's team (as they maintain we do), but they make it very hard for us to credit them with either the wish or the ability to tackle a controversial theme in a decent manner.[125]

The exacting requirements for cuts were communicated to Adelphi. The company's annoyance and frustration were evident in the meeting and exchange of letters that followed. Charles Frank complained that the Board's attitude 'leaves us with the choice of abandoning a project [...] or accepting a mutilated shallow wreck which we should have to send out into the world under our own names and that of Jean Cocteau'. Surely, he argued, 'the treatment of extra-marital relations in any of the arts is no longer a subject of censorship in a work reserved for an adult public!', adding that the 'X' certificate, properly used, could be the financial saviour of the ailing film industry: '[T]he old formulas are finished. We must attack more adult problems or we shall all be finished, too [...]. Please do not deny us your help now in presenting adult stories to an adult public.'[126] Frank's impassioned plea failed to prevent his revised shooting script eliciting forty objections to lines of dialogue and the following warning:

We are still considerably disturbed about the whole project of making a film based on this story. I must make it clear that there is no prospect of such a film being passed unless each one of the above objections receives attention.[127]

The escalating row persuaded Watkins to involve the Board's President, who reduced the number of cuts required ('although none of us liked the script') and ruled that an 'X' certificate was appropriate as the play had been performed on the London stage and the French film had been given an 'A' classification.[128] But Adelphi's joy was brief when it became clear in August that both the Rank and ABC circuits were trying to avoid booking 'X' films. Producer David Dent immediately sent the script to Joseph Breen at the MPAA, in the hope that it might be acceptable in America, but received a substantial list of necessary revisions in reply.[129] Dent felt he had no choice but to comply with Breen's requirements and try to persuade the BBFC that a film cleared for universal exhibition in the US should be acceptable for an 'A' certificate in the UK. By this time, however, most of the major Hollywood studios could have told him from bitter experience that this was certainly not the case.

The Board's response to a script revised according to Breen's recommendations confirmed this. One reader condemned it as 'more revolting than most in the "X" category' and Watkins informed Dent that there was no hope for anything other than an 'X' classification.[130] There was little that the Dents could do except wring their hands and bemoan the 'perfect nightmare' in which the independent British producer was obliged to live.[131] They might have given up and abandoned the film as the Board hoped they would, but the Dents were more stubborn than that. *Intimate Relations* went into production at Walton Studios with an accompanying publicity offensive in which director Charles Frank explained that Cocteau regarded his play as 'devoid of any kind of unhealthy exhibition of complexes' and as 'a drama unfolding itself along a comedy theme'.[132] The London *Evening News* noted that this was how the film was being treated: 'They are trying to cut out any possible misunderstanding which might arise through a too literal translation of French mannerism and speech.'[133] When BBFC examiners Field and Trevelyan saw the results in February 1953, they discovered that Cocteau's sexy beast had been transformed into something far more domesticated: 'Bad directing and acting have made the greater part of this film so insipid and ridiculous that we do not think an "X" certificate is called for'. However, this was at the very point that the *Cosh Boy* controversy was escalating and, therefore, no time for the Board to be seen as soft on smut. The President advised a straight 'X' without cuts.[134] Adelphi's exploitation of the film's notoriety and classification by advertising it as 'The MOST DRAMATIC and PROVOCATIVE STORY EVER SCREENED!' and an 'Xciting Xperience' did not help when it tried unsuccessfully for a regrading to 'A' for *Intimate Relations*.[135]

Associated British, however, had succeeded in obtaining a reclassification for *The Yellow Balloon* (1953), one of the original British 'X's and directed by the up-and-coming J. Lee Thompson. Could this have been in any way related to ABPC's decision to ask Lee Thompson to direct *For Better, for Worse* (1954), the adaptation of a play written by none other than the Board's Secretary, Arthur Watkins? A year later, in November 1954, Lee Thompson and his producer, Kenneth Harper, sent the BBFC a book written by Joan Henry (Lee Thompson's lover), *Yield to the Night*. It was the affecting story of a young woman in the condemned cell thinking back over the circumstances that had led her to murder the woman who had caused the death of the man she loved. The redoubtable Audrey Field was shaken by the poignancy of the tale:

A really heartrending book and, speaking as a private individual, I would gladly pay not to see a film based on it. […] The prospect of a woman about to be hanged is of course much more harrowing than that of a man in the same circumstances – and even more open to exploitation for the sensation-seekers. But it does seem a legitimate subject to be explored for adult cinema audiences.

Her President and fellow examiners counselled extreme caution.[136] They were aware that the previous Lee Thompson adaptation of a Henry prison novel, *The Weak and the Wicked* (1954), had had the temerity to suggest the presence of lesbianism among prison officers. The film-makers were told that a shooting script would be given 'sympathetic consideration' for an eventual 'X' category picture.[137]

The resulting script, submitted to the BBFC towards the end of January 1955, was intended by Henry and Lee Thompson to be a powerful invective against capital punishment,[138] but (perhaps fortunately) this was not the interpretation of the Board. One male examiner commented:

Yield to the Night (1956)
received an 'X' certificate
rather than the
distributor's preferred 'A'

Though it is very much a 'woman's' story, I found it impossible to put the script down [...]. Certainly this film will cause controversy [...] but not, I think, rage against the law [...]. The next time I have murderous thoughts, I shall think twice about *Yield to the Night* – and stop feeling murderous.[139]

In his letter to Kenneth Harper confirming the Board's view that this was the sort of British film that the 'X' certificate had been designed to facilitate (although there was to be no suggestion of lesbian desire and great care over the bath towel that would wrap the film's star, Diana Dors), Watkins conveyed '[o]ur very best wishes for the success of the film'.[140] *Yield to the Night* might have gone into production straight away, but for ABPC's decision to loan Lee Thompson to Rank to make a couple of crowd-pleasing comedies. In the end, it had to wait until October 1955, by which time an event had taken place in Hampstead that altered the whole context of the film's reception, as well as subtly modifying its shooting script. That Easter, a depressed young woman called Ruth Ellis shot her lover and, shortly after – amid considerable controversy – became the last woman to be hanged in Britain. Just as it had done with *Cosh Boy*, the press inevitably made connections between a real criminal event and a film drama that had actually been written well before it occurred, and thus scuppered what little chance *Yield to the Night* (1956) had of the 'A' certificate desired by its makers and distributors. Try as they might, there was to be no reprieve for Harper and Lee Thompson from the final imposition of the 'X'.[141]

Lee Thompson would continue to resent the lack of mercy shown by the Board to what was a brilliant realisation of his most personal project, and would be a constant irritant to Watkins's successors, publicly voicing his dissatisfaction over the subsequent treatment of his *Ice Cold in Alex* (1958) and *Cape Fear* (1962) (see case study). However, he was merely the tip of an iceberg of dissatisfaction within the British Film Producers Association, which had all but discontinued diplomatic relations with the Board by 1956, because the Association believed that over-zealous censorship of British films was making it impossible to compete with Hollywood and television.

The Sanguineous Mr Sangster

If the BBFC could have been rid of any one bunch of film-makers, however, it would surely have been the boys from Hammer – the company that taste forgot, in the Board's view. The exchanges between James Carreras's enterprising little studio and the Censor have been extensively documented by Wayne Kinsey in his painstaking study of the films made at Bray, so we make do with a summary here; but they constitute some of the most revealing files in the BBFC's archive.[142] It is particularly entertaining to observe the Board of the 1950s trying to extract the horrific from the horror film, a genre which appears to have been seen as a blight on the national cinema. While Hammer's desired approach emphasised the exposure of horrible sights that would cause the audience to wince, the BBFC continually counselled 'discretion' and 'restraint' in visual display, i.e. the opposite of what the audience was paying to see. Audrey Field put it thus after reading the script of *The Curse of Frankenstein*: 'excessive cruelty and brutality is no more welcome in horror films than anywhere else'. For her, the horror film should rather be an extension of the thriller – suspense without explicit spectacle.[143] The Board's exemplar for the genre was Henri-Georges Clouzot's *Les Diaboliques* (*The Fiends*, 1955), and it felt justified in preserving the film's shocks because of its appeal to sophisticated audiences.

The tone of the BBFC response to home-grown horror for the masses was set with its advice on Hammer's first venture into the territory with the script for *The Quatermass Xperiment* (1955) in late summer 1954:

I must warn you at this stage that, while we accept this story in principle for the 'X' category, we would not certificate, even in that category, a film treatment in which the horrific element was so exaggerated as to be nauseating and revolting to adult audiences. Nor can we pass uncut, even in the 'X' category, sequences in which physical agony and screams of pain or terror are unnecessarily exaggerated or prolonged.[144]

What followed over the next two decades was a long series of struggles in which Hammer continually tested the boundaries of what was permissible, while exploiting the censorable nature of its product. *The Quatermass Xperiment* (the 'e' from the final word dropped to suggest the forbidden character the entertainment offered) was followed by *X the Unknown* (1956), as if to goad the Board, which was known to deplore the exploitation of its certificates in advertising. Hammer appears to have been the first company actually to request an 'X' certificate for its films,

but it was also quite capable of changing its mind and later unrepentantly requesting reclassification as 'A' when bookers decided that the content was insufficiently horrible. Audrey Field, an examiner of a somewhat nervous disposition, dismissed Hammer's *Quatermass* films – now commonly regarded as the first serious contributions to post-war British science-fiction cinema – as silly 'nonsense'.[145] She was obliged to marshal the Board's defences rather more often than she might have preferred against 'These people' and their 'disgusting' imaginations and 'outrageous' scripts.[146] Her constant tormentor was scriptwriter Jimmy Sangster, whose style she branded 'uncouth, uneducated, disgusting and vulgar'.[147] Sangster's description of 'the Unknown' – 'a dark, seething, putrid mass, writhing with corruption and hideous rottenness' – probably captured Field's impression of his company. In holding the line against these barbarians, she had the full backing of her President, whose verdict on Sangster's script was: 'This is a mixture of scientific hokum and Sadism in equal parts without benefit of wit or humour and incidentally a wicked exploitation of the "X" certificate'.[148]

In reply, producer Anthony Hinds tried to ease the Board's affronted sensibilities with innocent pragmatism:

> [T]he shots of 'the Unknown' will be cut down to the minimum. (I only wish I thought it could look half as exciting as the writer has described it!) […] The shot of the Security Guard engulfed in slime will simply be a shot of a man sprayed with chocolate blancmange and I do not think it will be upsetting.[149]

When submitting the company's first Frankenstein script (Milton Subotsky's *Frankenstein – The Monster!*), he assured Watkins that the forthcoming colour film would be made 'with our tongue in both cheeks', and the two correspondents did their best to maintain a note of jocularity (verging on sarcasm) in spite of continuing disagreements.[150] However, Jimmy Sangster's rewrite provoked revulsion from Field. What she found 'really evil' was the way in which a 'lip-smacking relish for mutilated corpses, repulsive dismembered hands and eyeballs removed from the head, alternates with gratuitous examples of sadism and lust'. Again backed by her President – who described it as 'a loathsome story' which he regretted 'should come from a British team' – she informed Tony Hinds that the scriptwriter 'seems to think the "X" category is a depository for sewage'.[151] She warned him about unpleasant images and dialogue and, particularly, about the inappropriateness of including sexual scenes in a horror film. In response, Hinds assured the Board that he would make the required cuts and 'not include anything too horrid or offensive', but in the knowledge that overseas censorship bodies would be more sympathetic, he gambled by shooting Sangster's script pretty much as written.[152] After Hammer, aware that the BBFC regarded horrific scenes in colour as potentially more problematic than those in monochrome, submitted the rough cut of *The Curse of Frankenstein* (1957) in black and white, a three-month wrangle ensued before eventual 'X' certification.[153] The battle over *Dracula* (1958), fought with John Nicholls leading the BBFC's troops, would turn out to be even worse: as bloody as the film's opening titles. To the considerable annoyance of the Board, Hammer again largely ignored the script readers' comments in shooting the film and then tried to pull the black-and-white trick for a second time. When it became evident that the modification of a few shots would not be sufficient, James Carreras tried to appeal to the Secretary's better nature: 'With the very poor state our industry is in it would be a terrible thing if the horror addicts go to see horror pictures and there is no horror in them, in other words, we will lose this audience.'[154] But even a face-to-face meeting with Nicholls only modified the Board's objections to the lustfulness of Dracula's seduction of Mina and the vampire's final disintegration. As it proved time and again in the censoring of contemporary American schlock horror, the Board believed that even monsters deserved its protection from beastliness, and that care should be taken when showing or hearing them in pain.[155] In the end, it was only an appeal on the ground of the excessive cost of making changes to the final cut that swayed the BBFC into compromise; but it is clear from the notes made by members of the Board that Hammer had further compromised goodwill with their ungentlemanly tactics.[156]

Yielding to Temptation

What British film-makers learnt from all this was the value of shooting alternative versions of scenes likely to prove problematic for the BBFC. Thus the 'overseas' version was born in order to address the issue of divergent national censorship regimes. If one film, however, can be regarded as prising open the door to a British exploitation cinema, it is Raymond Stross's production *The*

Flesh Is Weak (1957), a drama of pimps and prostitutes inspired by the recent demise of the Messina vice ring. The Board had been scrupulously scourging scenarios for any suggestion of the existence of prostitution, let alone its explicit depiction, but its position was undermined in 1957, when the BBC broadcast two programmes on the subject. Previously, a scenario with organised vice as its theme would have been given the shortest of shrift, but Stross's script, written by Leigh Vance, appears to have been tolerated by Watkins when first submitted as *Not for Love*, although reports and correspondence are missing from the BBFC file. It was left to John Nicholls to deal with the completed film on his arrival at the Board. Erotic scenes were cut or reshot in an attempt to minimise possibilities of arousal, but the story was permitted, and an 'X' certificate was finally granted on 19 June 1957, albeit with stern warnings about sensationalist advertising.[157] Although many critics were disparaging, *The Flesh Is Weak* – with the tagline, 'They threatened us "Do not make this film"' – was a major money-spinner for Eros Films Ltd, gaining a full ABC circuit release in 1958,[158] a year before the Street Offences Act 1959 drove the hookers indoors. Worthing was the only council to impose a ban on the film.[159]

Before *The Flesh Is Weak*, the number of British 'X' films could be counted on the fingers of two hands. After its success, and that of Hammer's shockers, the certificate became an accepted part of British film culture and no longer a box-office handicap. As the traditional family audience was increasingly lost to television, the proportion of films in the 'A' and 'X' categories steadily increased, from 40 to 46 per cent between 1950 and 1955, reflecting the turn towards more adult subjects and treatment.

Features Trade shown 1950–5[160]

Year	All features	British	British 'X'	US 'X'	Other 'X'	'A'
1950	589	121	0	1	3	233
1951	579	118	0	7	6	245
1952	583	135	2	10	14	180
1953	535	128	2	12	10	164
1954	522	140	1	13	12	145
1955	484	130	2	7	22	193

By 1957, films such as *The Flesh Is Weak*, with its prostitution theme, could be classified 'X'

As John Nicholls left office, the BBFC was tentatively moving towards the sort of quality test adopted by the Obscene Publications Act 1959, but the Board remained more likely to be influenced by the perceived quality of the audience as much as that of the film-maker. On balance, the BBFC probably hindered rather than helped the film industry's painful accommodation to its residual core audience in deteriorating trade conditions, but the Board had more than commercial interests to consider. Its beleaguered Secretaries and President were obliged to negotiate the shifting moods and dispositions of press, pressure groups, national government and local authorities, and find a way to acknowledge that something was changing in the realm of social attitudes and behaviour – even if that something was next to impossible to decipher in any precise way. And this was pretty much how it would be from now on as the age of deference passed away.

CASE STUDY: THE SNAKE PIT (1948) David Hyman

In 1948, the BBFC rejected *Behind Locked Doors* (1948), a crime film set mostly in a mental institution and featuring scenes showing patients being brutally treated 'in a manner in no way resembling actual conditions in such institutions'. The Board's Secretary, Arthur Watkins, maintained that the Board would only allow scenes set in mental institutions in films that presented 'an authenticated aspect of an important social problem' and without sensationalism.[161]

On 18 February 1949, *The Snake Pit* was submitted to the BBFC. The subject matter was familiar as the novel had been repeatedly submitted in 1946 for guidance, following which the distributor was told that, given its setting, any film adaptation would be 'quite unsuitable for public exhibition' and that this decision was also in line with 'the wishes of local authorities'.[162]

Virginia Cunningham (Olivia de Havilland) is institutionalised in a psychiatric hospital following a nervous breakdown and fails to respond to her treatment until the chief psychiatrist begins a programme of psychotherapy. This reveals aspects of her family life apparently connected to the causes of her condition, and there are several setbacks on the path to her recovery.

After the viewing, Watkins wrote to the film's distributor, Twentieth Century-Fox. He explained that the Board 'always exercised the greatest reserve' about allowing scenes in mental institutions, explaining that such scenes were publicly unacceptable and were also 'liable to cause acute discomfort to anyone unfortunate enough to have a relative in one of these institutions'. He said the film could do widespread harm by suggesting 'that conditions in mental institutions in this country are in any way similar to those represented in the film'

and concluded that the Board could only classify the film if virtually all scenes featuring the inmates were removed.[163]

Watkins also wrote to the Belgian and Swedish classification boards asking about their decisions and how they had been received,[164] and also discussed the film with 'leading psychoanalysts and superintendents of medical institutions' who had attended a preview screening arranged by the distributor.[165]

Watkins then viewed the film with its director, Anatole Litvak, telling him that scenes featuring hospital inmates and details of Virginia's electro-shock treatment would need to be cut, and that a foreword 'disassociating the mental institution scenes in the film from conditions in English mental institutions' was required. He also said that the film would receive an 'H' certificate, which indicated that it contained horrific content;[166] Litvak subsequently claimed this would stigmatise the film.[167]

A cut version was subsequently viewed with representatives from the Board of Control (who were responsible for the welfare of those detained under the various mental-health acts in England and Wales). They believed that 'no amount of cutting would render the film suitable' and that any release would have undesirable and harmful effects on public attitudes towards such institutions. However, the BBFC thought it was 'a sincere film of outstanding quality' and Watkins believed further cuts similar to those previously requested would make the film acceptable. Nevertheless, he wanted the Minister of Health or his representative to view the film.[168]

The Minister, his officials, Watkins and BBFC President Sir Sidney Harris viewed the film. Watkins noted that the

The Snake Pit, starring Olivia de Havilland, was a key cinematic depiction of mental illness

A UK quad poster for *The Snake Pit*, with its special 'adults only' notice

Minister and his Permanent Under-Secretary supported the Board of Control's view that 'exhibition of the film would do harm' and that it should be rejected. Litvak and the distributor were disappointed at the apparent influence by 'a small body of professional experts', but Watkins explained that rejection would be the Board's decision and that the Board sought expert opinion where needed. Watkins also noted that even if the Board considered further cuts, scenes of electro-shock treatment, inmates exhibiting manic behaviour and a 'Snake Pit' sequence showing hysterical inmates would need to be removed.[169]

Watkins warned the Ministry of Health to expect a press campaign attacking the experts' opinion if the film were rejected, and was told that the Ministry would 'accept responsibility for the advice' (emphasis in original), if necessary taking 'unofficial steps to mobilise responsible opinion in support of the Board's decision'. Harris asked whether the Ministry would continue its opposition if extensive additional cuts were made and was told that this 'would undoubtedly lessen the harmful effects of the film, but its exhibition still could not be regarded as desirable'.[170]

Watkins and Harris were then invited to a meeting of the film industry's Trade Representative Committee where they were unhappy to see Litvak and a distributor's representative and felt they were being unreasonably pressurised. Nevertheless, Watkins claimed that the Board had not succumbed to government pressure in reversing its original position. He was also given copies of supportive medical opinion received by the distributor following a screening of the cut version.[171]

Watkins and Harris thought that the supportive letters from doctors and psychiatrists 'materially affected' the Board's position, and the distributor and the Ministry of Health were informed that the Board could classify the film with an 'A' certificate, subject to further cuts to the sight and sound of institutional therapy (e.g. electro-shock treatment or strait-jacketing), the reduction wherever possible of '[a]ll background screams and uncanny laughs', an assurance that children under sixteen would not be admitted and the inclusion of a written foreword stating that the film was not intended to represent conditions in Great Britain and that all of the characters were 'played by actors and actresses'.[172]

The film was resubmitted and finally classified 'A', subject to a statement limiting exhibition to adult audiences only appearing on all posters and publicity material, and the Board issued a press release explaining that the film had been classified following 'the removal of certain scenes and incidents which seemed likely to cause apprehension or distress'.[173]

In 2004, the uncut version of the film was submitted for video classification and the Board noted that this once 'ground-breaking' film was 'still quite a sensitive journey through mental illness'. However, as 'some of the psychodrama' and repeated scenes of electro-shock treatment remained disturbing, the film was only permissible at '12'.[174]

CASE STUDY: CAGED (1950) Jason Green

Films highlighting the conditions of prisons and their dehumanising effect on prisoners were not new when *Caged* was released in 1950. The startling difference was that this film showed the issue from a female perspective. In *Caged*, Eleanor Parker plays Marie Allen, a naïve young first-time offender who discovers that the only way to survive while inside is to 'get tough or get killed'. Her subsequent experiences – enduring squalid conditions, a self-serving administration, sadistic prison matrons and a riot – so brutalise her that she leaves prison a hardened and embittered individual with no realistic choice but to return to a life of crime. Prison has not reformed her, but simply perpetuated a desperate and ultimately tragic cycle. The intention of *Caged* was to shock and appal audiences. The film-makers wanted to raise awareness of the treatment of female prisoners. Lizzie Francke notes in her book about women screenwriters, *Script Girls*, that the film's co-writer Virginia Kellogg spent several months visiting women's prisons in the US, even going so far as staying in one for two weeks, to make the story as realistic as possible.[175]

Very few BBFC records survive from the post-war period, and the file for *Caged* gives a unique insight into the classification process at that time. That the film's subject and its presentation were potent and problematic for the BBFC is made clear. The film required a second viewing on 3 May 1950 and was seen by four examiners this time instead of the usual two. Both the BBFC's Secretary, Arthur Watkins, and its President, Sir Sidney Harris, also sat in on the screening. To underline further the Board's concern about *Caged*, a representative from the Home Office's Prison Commission, identified in the file only as Miss Mellanby,[176] also attended. Perhaps to give an informed female view on the film's depiction of women's prisons?

The BBFC's view was that *Caged* presented an 'extremely sordid picture of [prison] conditions'. The concern was voiced that the film presented 'a disquieting impression of

Hope Emerson (centre, left) in *Caged*, classified 'A' after numerous cuts were made and a foreword added to the film

prison conditions, unrelieved by any ray of hope' and that it contained 'a number of most unpleasant scenes and incidents'. The portrayal of the corruption and ineffectiveness of the prison system and its officers, which result in Marie Allen leaving prison 'utterly corrupted and committed to a life of crime' rather than reformed, contributed to this concern. The BBFC feared that *Caged* could 'lead uninformed members of the audience to draw entirely unwarrantable conclusions' about the British penal system.[177]

Miss Mellanby regarded *Caged* as being 'so far removed from conditions in this country as to avoid the risk of being taken seriously by any British audiences'. Nevertheless, she felt that British prison officers would resent the film and the Prison Commission would prefer that it not be granted a certificate. Like the BBFC, Miss Mellanby was keen that *Caged* should not be regarded by British cinemagoers as a reflection of British prisons.[178]

The Board was unanimous that the film was only suitable for the soon-to-be-introduced 'X' category. This would restrict cinema audiences to those aged sixteen years and over. Even at this category, the BBFC would require 'fairly substantial' cuts to the film before issuing the certificate.[179] If the Prison Commission wanted the BBFC to reject *Caged*, Sir Sidney requested that it provide a 'definite opinion' that the film would have serious effects on UK prison administration and public opinion about it before this option was considered.[180] The official Home Office view was that while it would prefer the film not to be exhibited in the UK, there was no case for pressing for rejection provided an 'adequate foreword' preceded the film. This 'foreword' should make very clear that the prison conditions represented in *Caged* did not, in any way, correspond to those in this country.[181]

These concerns, and the Home Office's suggestion, were fed back to Warner Bros., the film's distributor. The BBFC also presented them with a list of cuts. These included edits to moments of violence and emotional distress throughout the film as well as individual scenes. For example, a sequence in which a prisoner demonstrates how to shoplift without being detected was to be removed in its entirety, as were all references to prostitution. Cuts were also required to a scene in which the main character has her head forcibly shaved.[182] Warner Bros. agreed to these conditions, but requested that *Caged* be awarded an 'A' certificate rather than the 'X' with the proviso that children under sixteen would not be admitted. This had been the same kind of certificate the BBFC had awarded to a similar social-issue film, *The Snake Pit* (see case study) in 1948.[183] The BBFC declined this request, noting that such a certificate had been an unsuccessful experiment and would not be repeated.[184]

Two forewords proposed by Warner Bros. were rejected by the BBFC as being 'not quite what we require'.[185] An epilogue indicating that Marie Allen did not return to prison was also rejected. In the end, the Board's own foreword was accepted: 'This film represents conditions in an imaginary prison. It is no way intended to suggest that such conditions obtain generally in American prisons or that they are to be found in any British prison.'[186] A 'very considerably cleaned up' version of *Caged*, edited along the lines suggested by the BBFC, was resubmitted with a request for an 'A' certificate.[187]

The distributor was informed that, in order to secure the 'A', further cuts were required as the initial edits had been to secure an 'X'. The new cuts included additional edits to the head-shaving sequence and to the scene in which a prison matron is attacked. Further reductions in dialogue were required, such as to the line 'This place smells like a zoo'.[188] Once these reductions had been made, and the foreword attached, *Caged* was considered sufficiently 'safe' for UK audiences and classified 'A' on 1 August 1950. Nevertheless, the film was accused of sensationalism, and *The Times*' film critic urged the Home Office to introduce the 'X' category.[189]

4 THE TREVELYAN YEARS: BRITISH CENSORSHIP AND 1960S CINEMA

Tracy Hargreaves

This chapter looks at some of the documents that exist in the hinterland of British films in the 1960s: the reports and correspondences of the examiners and the Secretary of the British Board of Film Censors. While these documents are indubitably part of the BBFC's particular history, and evidently part of a wider story of censorship in literature, theatre and film, I would like to look at the ways in which they also contribute to the sometimes troubled but nonetheless persistent 'coming out' of intimate life in Britain in the 1960s. I want to do this by looking at some of the specific issues that emerged when the Board considered certain films across the decade, and by considering how representation and censorship were negotiated between arguments for increasing liberality and caution about moral disintegration.

The emergence of intimate life as both ordinary and a matter for public scrutiny was implicated in and facilitated by a number of factors. This interest had begun in the early 1950s, in the literature and poetry of 'the movement' and then in the fiction and theatre of the so-called 'angry young men' whose work was beginning to attract directors like Jack Clayton, John Schlesinger and Karel Reisz. In turn, their particular adaptations helped to foster one of the most significant trends in British cinema of the early 1960s, sometimes bluntly labelled as 'kitchen sink' but offering what one review in *John o'London's* described as a 'whole unnoticed world [...] opened up'.[1] From the *Sunday Pictorial*'s serialisation of Mass Observation's 'Little Kinsey' in 1949 to the receding and eventual abolition of the Lord Chamberlain's power to censor theatre in 1968, a long list of very different events and laws suggests that such recognition also entailed the regulation, deregulation and mediation of intimate life in the political, social and cultural narratives of everyday life. The *Lady Chatterley* trial of 1960, the introduction of the contraceptive pill in 1961, the opening of the first birth-control clinic in 1964, the National Health Service (Family Planning) Act, the Abortion Act, the passing of the Sexual Offences Act (all 1967), the Theatres Act of 1968 and the Divorce Act of 1969 – these legal

John Trevelyan,
Secretary of the BBFC
from 1958–71

and institutional landmarks recognised the existence of intimacy in the interstices of social life and private behaviour, readable, as Matt Houlbrook has suggested, of either increasing liberalism or a 'dangerous sign of a nation in terminal and moral decline'.[2]

The progression of those Acts masks critical pauses across the decade which, as John Sutherland has shown, saw emergent moments of moral sensitivity that revealed censorship as a responsive process rather than as operating from a set of absolutely fixed judgments.[3] Though the Board had policies, as John Trevelyan pointed out in an article he wrote for *Screen* in 1970, it had no set rules: 'If there were rules', he argued, 'they would have to be applied equally to films of quality and to films of commercial exploitation, and both the film-maker and the public would suffer.'[4] In trying to adjudicate between taste and vulgarity, though, Trevelyan and the Board were also capable of making some quite patrician and normative assumptions about the cinema audience, about who could tolerate what, and of what could be tolerated at all.

Trevelyan, the Board's Secretary between 1958 and 1971, was widely (though not entirely) regarded as a liberalising force in film censorship. Alexander Walker described him as a 'courageous censor' in his Preface to Trevelyan's 1973 memoir *What the Censor Saw*.[5] But he cast him, too, as a slightly mythical figure from a bygone era:

> Lean, leathery and tirelessly articulate about his work, Trevelyan might have been created by C. P. Snow for one of his 'Corridors of Power' novels about the dying art of secret negotiations and the cagey confrontations of the devious and the devout.[6]

Trevelyan might have privately enjoyed the description, but it is also one that he might equally have challenged: he repeatedly defended the independence of the Board's decision-making processes during his tenure to anyone who questioned it, from the national and regional press to the viewing public.

Women and the New Wave

There are a number of milestones that stand out during Trevelyan's tenure at the BBFC. *Room at the Top* (1959), director Jack Clayton and screenwriter Neil Paterson's adaptation of John Braine's 1957 novel, gave Trevelyan, Anthony Aldgate has suggested, one of his earliest challenges in his new role as Secretary.[7] The film disperses the novel's first-person narration as it focalises different points of view, so that its adaptation of the story of the socially aspiring, self-fashioning Joe Lampton (Laurence Harvey) takes an interesting sexual political turn in its concern with the unhappily married Alice Aisgill (Simone Signoret), the woman Joe loves and loses. *Room at the Top* was essentially a story that connected sex with social mobility, as Joe has an affair with the married Alice and cynically courts another richer, younger woman, Susan Brown (Heather Sears). The producers envisaged few censorship problems with this adaptation of a popular novel that spoke to the late 1950s *Zeitgeist* of the 'angry young man'. John Woolf, co-producer of the film, was, then, dismayed by the 'bombshell' news that the film had been granted the seedy 'X' certificate, which at that time meant limited circuit distribution. According to Woolf, Trevelyan remained 'adamant' that *Room at the Top* should be an 'X'-certificated film, arguing that it had the potential to re-establish the 'X' 'as a serious rating for adult British films'.[8] It did, though it was never unproblematic. Both John Osborne and Tony Richardson argued that the 'X' awarded to *Look Back in Anger* (1959) (for its language) and *The Entertainer* (1960) (for Archie and Tina's post-coital scene in a caravan) gave the films 'a brand they don't live up to', excluding some viewers while disappointing others.[9] The cuts that Trevelyan and Jack Clayton negotiated for *Room at the Top* were few in number but they offer a revealing insight into the kinds of sensitivities at play at this turning point in the BBFC's history. Alice dies, slowly and painfully, following a horrific car crash; its lurid details are never explicitly described or seen, but are relayed to Joe by a third party in both novel and film. Clayton agreed to find an alternative or to cut the sensational 'scalped'. Following a meeting

Laurence Harvey and Simone Signoret, the luminous stars of *Room at the Top* (1959)

with Clayton, Trevelyan noted that Joe's friend Charles (Donald Houston) was allowed to keep 'You lust after her'. His fiancée June (Mary Peach) wasn't allowed to keep 'Don't waste your lust on her'. 'Bitch' was to be changed to 'witch'.[10] For all the progressive momentum surrounding *Room at the Top*, including the sympathies the camera solicits for Alice, or the focalisation of Joe as the object of her own sexual desire, its producers argued that ultimately the film upheld a proper moral rectitude. Concerned that Alice's gruesome death should not be too understated, John Woolf suggested to Trevelyan that '[d]ramatically, it is of course terribly important and I should have thought too that the fact she met a violent end is morally right from the censorship point of view'.[11] Trevelyan would go on to disagree with such a view, at least in his published response to film critic Derek Hill's attack on the BBFC in a 1960 edition of the arts periodical *Encounter*, as I discuss below. But in 1959, Woolf's appeal was one that chimed as much with the Hollywood Production Code as it did with the Church of England, pitching expectations for British censorship between the conventions of American censorship's *quid pro quo* of 'moral compensation' for sinful behaviour and the English Christian moral view at the time.[12] According to the social historian Claire Langhamer, the Archbishop of Canterbury had referred to a 'tide of adultery' in a *Times* article in 1959, and had asked whether it had 'become such a public menace that the time has come when it ought to be made a criminal offence?'[13] Dramatically, *Room at the Top* sees adultery punished by the woman's death. But if the punishment of women's sexual autonomy seemed to mark the limits of a new liberalism in British film, being as it was attuned to the morality of 'the Establishment', its 'new sexual candour' also needed to be recognised as 'extraordinary', Alexander Walker argued.[14] Where Braine's novel attended to the flattening of affect in relation to the influences of mass-produced culture (his characters reiterate the cheap sentiments of adverts, magazines and mass-market paperbacks in lieu of sincere feeling), the re-articulation of his novel's deliberately clichéd dialogue on screen seemed 'daring' to Walker's critical eye as Susan Brown openly declares the experience of her defloration to have been 'super.'

Daring, too, though for different reasons, was a scene in *Look Back in Anger*, a film that offered the second 'test' of Trevelyan's 'intentions', as Anthony Aldgate describes it. In a scene added to the screenplay, and not in the original stage play, Jimmy Porter's (Richard Burton) wife Alison (Mary Ure) visits her doctor who confirms that she is pregnant.[15] When Alison asks whether it's too late to 'do anything', he looks at her sternly and tells her 'I didn't hear that question'. She apologises, and he tells her that he hopes she won't ask it again 'of anyone – or try to do anything foolish'. The scene then dissolves from her silence to Jimmy Porter at his market stall, but momentarily and significantly, the limit of her agency and the exercise of choice about her own body and its reproductive capacity is raised before it is as quickly quelled. Reading Nigel Kneale's draft script of the screenplay of *Look Back in Anger*, the Board had reservations about this tentatively made allusion to abortion, asking for 'careful consideration' so that references would be unintelligible to children but intelligible to adults (though with its 'X' certificate, sixteen was then the minimum age at which the film could be seen).[16] The Board's caution and the careful treatment of the scene, the unspeakability of the request and the scene's dissolve on Alison's silence was, in its way, though, effective rather than repressive, precisely because it revealed prohibition at work.

Adrian Bingham has suggested that few newspapers were prepared to offer support for abortion-law reform in the 1950s with the exception of the left-leaning *Reynolds News* who demanded that the 'conspiracy of silence surrounding this problem of abortion must be ended'.[17] This was beginning to change by the 1960s, both in light of the consequences of the Thalidomide drug (a 1962 National Opinion Poll in the *Daily Mail* showed that 72.9 per cent of the public supported legal reform 'where there is good reason to believe that the baby would be badly deformed'), but also in response to the increasing visibility given to women's rights, with prominent journalists such as Marjorie Proops at the *Daily Mirror* arguing that there was 'clearly powerful support for the reform of the abortion laws'.[18] The BBFC was, in 1960, unsurprisingly circumspect about representations of abortion, then still illegal. But its responses to a number of films that raised abortion as a question of choice for women reflect something of the tentative transitions of the time in terms of how the Board managed such representations.

When the Board received Alan Sillitoe's screenplay for *Saturday Night and Sunday Morning* (1960) in November 1959, the supercilious tone of the examiners' reports focused on what was for them its provocatively demotic language. Sillitoe, who adapted the screenplay from his own novel, had different issues and found the process of adaptation both ghoulish and banal: 'Disinterring the book after it had seemed dead and out of the way […] was a tedious process', he reflected.[19] The end product, he felt, was a 'much watered down version of the book', in part because of the Board's reaction to the representation of abortion. In his autobiography, Sillitoe recalled that the BBFC

stipulated that though the issue of abortion may be mentioned in the film, the attempt to procure one on the part of Brenda after she gets pregnant by Arthur must not be shown. Not even by so much as a stray word could it be indicated that the abortion had been 'brought off'.[20]

The Board didn't quite put it like that and was not always as high-handed as Sillitoe later represented it, even if a particular moral line informed its decisions. Trevelyan wrote to Harry Saltzman, the film's producer, on 24 November 1959:

> Pages 49–54 and 76–77. This shows a rather casual attitude to abortion and suggests to the young that if they get into difficulties all they need is to find a kind-hearted older woman who has had a lot of children. Provided that it is not too obtrusive it would probably be acceptable, but I must ask you to bear in mind that this film is likely to be seen by a considerable number of young people of 16 to 20 years of age and to recognise that social responsibility is called for.[21]

In Sillitoe's novel, the termination is successful and the attempt to 'bring it off' is the explicit subject of an entire chapter involving quantities of gin and a hot bath, a scene more carnivalesque than wretched, culminating in Arthur's cynical seduction of Brenda's sister. The film is comparatively restrained both in its presentation of Arthur's infidelities and in its representation of abortion, but it was challenging for all that, too. Albert Finney's charismatic performance as Arthur Seaton dominates *Saturday Night and Sunday Morning*, but Rachel Roberts's Brenda temporarily jolts expectations and assumptions about working-class women, sex and motherhood as she articulates her discontent about pregnancy and the consequent waning of her sexual desirability; if there's pleasure to be had at the turn of this decade, women like Brenda want some of it too. Arthur's Aunt Ada (played by Hylda Baker, and more worldly than kindly, as the Board had imagined her from the basis of the script) reminds him that abortion is illegal, the details of the discussion that she has with Brenda are never revealed, either to Arthur or to the audience, and in the end, after an unsuccessful attempt at an illegal abortion, Brenda tells Arthur that she has decided not to go ahead with it. When her husband, Jack (Bryan Pringle), tells Arthur that Brenda is 'sorted', the film offers an intriguing hesitancy: 'sorted' might mean that she did procure an abortion, or that she miscarried, or that Jack will raise Arthur's child; it also implies the reassertion of masculine authority as the recalcitrant Brenda is reined back in by the once emasculated Jack, her sin punished and righted according to the logic of moral compensation.

The Board went on to pass references to abortion in *The L-Shaped Room* in 1962: in one scene, the elderly Mavis (Cicely Courtneidge) gives Jane (Leslie Caron) a bottle of pills, 'something special' as she calls them; but the scene was allowed to pass: 'In this case it should be alright since the nature of the pill is not specified and since they are not that effective'.[22] And although it thought that 'the very explicit sex dialogue and talk about abortions and sterilisation' in *The Pumpkin Eater* (1964) warranted the film's 'X' certificate, the actual dialogue in which abortion was discussed was not deemed censorable.[23] Jo (Anne Bancroft) is a well-heeled woman, married to a successful scriptwriter, Jake (Peter Finch). They have an affluent lifestyle, eight children (she is rather dreamily addicted to having them), Jake has numerous affairs, Jo has a breakdown and consults a psychiatrist on her doctor's recommendation. When she announces that she is pregnant yet again, Jake suggests that she has an abortion. Both *The L-Shaped Room* and *The Pumpkin Eater* contain scenes that develop the brevity of the scene between Alison and her doctor in *Look Back in Anger* and in their detail both

Cicely Courtneidge and Leslie Caron in *The L-Shaped Room* (1962), a groundbreaking study of abortion

are more suggestively critical of, and interested in, the question of who controls women's right to choose. In *The L-Shaped Room*, Jane's doctor is so patronising that it seems to catalyse her decision to have her child in spite of the evident prejudices that this will entail. In the clinical discussion of abortion in *The Pumpkin Eater*, a specialist doctor has already discussed the matter of termination with Jo's family doctor and with her psychiatrist. Given her mental health issues, he explains, the abortion would not be illegal, and a defeated Jo, represented across these brief scenes as a literally out-of-focus and marginal object of medical authority, agrees to a termination and to sterilisation. Only a year later, sadomasochism and voyeurism were the sticking points for the Board in John Schlesinger's *Darling* (1965); Diana's (Julie Christie) abortion passed without mention and, responding to a letter of complaint questioning what the Board was up to for permitting such 'degrading filth',[24] Trevelyan defended both Board and film for the observation of moral limits.[25] The abortion scene in Bill Naughton and Lewis Gilbert's *Alfie* (1966) was seen as part of the film's moral frame, bringing 'home to the young that abortion is not a casual business and that it involves the taking of a tiny human life'.[26] Alfie, considerably less delicate, compared it to 'murder'.

Trevelyan argued that the Board looked at films in relation to their individual merits. When the director Guy Hamilton accused Trevelyan of 'expediency' in relation to decision-making,[27] Trevelyan defended himself: 'We could, of course, have rules which were applied strictly and indiscriminately to all films, but I firmly believe that this would lead to unintelligent censorship'.[28] When the script for *Saturday Night and Sunday Morning* first came to the Board in 1959, at least one examiner responded to it with a newly formed prejudice against 'the new school of Young Writers Speaking for the People', imagining not just the script's transition to screen but also its audience's demographic constitution, as though the film offered behavioural tips for unwanted pregnancies and that every young (working-class) woman in trouble had access to a kindly old one who could sort it out.[29] But when the Board did intervene and ask for caution, the effect was not as neutralising or interventionist as it might have been: *Saturday Night and Sunday Morning* and *Look Back in Anger* potentially open up a niggling disquiet about the muted but nonetheless audible expression of what women in economically tight circumstances or unhappy marriages might and might not want in terms of control over their own sexuality and biological reproduction. In the more upmarket *Darling*, Diana seems temporarily though sincerely abashed by what she has done, declaring herself 'empty' after her termination. It is one of the few moments of feeling she experiences, given that she is usually more hyperreal than realistic, a woman who tells the story of her life through the progressive inflation of its media-constructed image until it overwhelms her, and the vacuity of a life lived through celebrity is laid bare. There was no caution from the Board that anyone would be likely to want to imitate that.

The Board and Homosexuality

In her report for the screenplay of *Darling*, Audrey Field declared herself to be 'not quite sure what cooks in this household' as she meditated on Diana's liaison with a gay photographer, his boyfriend Gino and Gino's apparently intimate 'night-long expedition' with Diana. This, though, scarcely troubled the Board, which was more concerned with the film's potential nude and sex shots and the 'vicious stuff' of a voyeuristic sex scene.[30] The Board's response to representations of homosexuality had already been overtly tested at the turn of the decade with *Victim* (1961). The passing of the Obscene Publications Act (OPA) in 1959 and the ensuing trial of *Lady Chatterley's Lover* had put censorship and a tentatively more 'permissive' (or lax) licence on the cultural, social and legal agenda of this new decade. Lord Wolfenden had recently opened part of that agenda with his Report on the Committee of Homosexual Offences and Prostitution, recommending, in 1957, the decriminalisation of homosexuality; the following year, the Lord Chamberlain lifted the prohibition on representing homosexuality on stage. In November 1957, shortly after the Wolfenden Committee's recommendations to decriminalise homosexuality had been made, the BBC had screened a documentary rather baldly titled *The Problem of the Homosexual*. Its audience was a largely appreciative one (the programme's Reaction Index, the measure of popular reception, had been a respectably high 73) and individual comments on the documentary had ranged from admissions of bafflement to praise for 'giving the man-in-the-street an opportunity of hearing reliable information about the subject'.[31]

Trevelyan, who noted 'the good deal of free discussion in the press and on radio and television' post-Wolfenden, was aware that 'public reaction on this subject tends to be strong'.[32] He divided the cinemagoing audience into two types, 'intelligent people' and 'the great majority of

cinema-goers', an evaluation that often informed the Board's decisions about whether to recommend cuts or not: one type, he thought, would 'approach [homosexuality] with sympathy and compassion', the other might struggle to empathise since 'homosexuality is outside their direct experience and is something which is shocking, distasteful and disgusting'.[33] But, in taking this view, he partly echoed the MP Kenneth Robinson, who acknowledged in his opening comments on the debate in June 1960 that 'this subject is one which is distasteful and even repulsive to many people'.[34]

In May 1960, and shortly before the House of Commons debated Wolfenden's recommendations, Michael Relph wrote to John Trevelyan to remind him about a conversation that they had had about the script for a film 'on the subject of the blackmail of homosexuals'.[35] *Victim* was a critical exploration of the criminal status attached to then illicit homosexual acts and the consequent vulnerability of gay men to blackmail. The character of Melville Farr, a distinguished upper-middle-class barrister played by the British box-office star Dirk Bogarde, transcends the stereotypes of other 'queer' and criminal figures depicted in the film. He might well be seen (Bogarde's star status notwithstanding) in the context of some of the 'testimonials' that Wolfenden had received from a number of high-profile gay men whose social and professional status underlined attempts to 'establish an image of the respectable "homosexual" for whom tolerance and legal recognition should be granted', one that was distinct from the more dissident queer, as Matt Houlbrook has argued.[36] Indeed, Trevelyan's response (guided by his examiners) to the first synopsis of the film seems to suggest such a position:

> [W]e feel that the more we can see of the characters going about their daily lives in association with other people who are not 'queers', the less we have of groups of 'queers' in bars, and clubs and elsewhere the better.[37]

Farr, distanced both from dissident queers and (deliberately) from 'respectable' homosexuals in the film, was shown to be struggling with three sets of conflicting desires, the first being homosexuality and the second being social acceptability in marriage. The third desire is a moral one and is, ostensibly, at the film's political rather than emotional heart as Farr sacrifices the promise of an illustrious career at the bar in order to retaliate against the systematic use of blackmail against gay men following the suicide of 'Boy Barrett' (Peter McEnery), a young working-class man with whom he has had a chaste but sexually tempting encounter. Barrett, protecting Farr, steals from his employer to pay a blackmailer who has mildly incriminating photos of the two of them together;

Dirk Bogarde as Melville Farr in *Victim* (1961)

once in custody, he hangs himself in his cell, an act that sets Farr on the path of moral and legal retribution. The film itself was regarded as a turning point, an opening of the doors to 'homos', as one examiner put it after acknowledging Geoffrey's (Murray Melvin) 'betwixt and between character' in *A Taste of Honey* (1961) and 'the young man' (Christopher Isherwood, played by Laurence Harvey) in *I Am a Camera* (1955).[38]

The screenplay of *Victim* went through a number of rigorous changes at the request and intervention of the Board, revealing its examiners' usual meticulous attention to potentially censorable detail, but also their anxiety about it, with one examiner noting 'I really am rather nervous of this script'.[39] Given the cautious (and for them, recent) censoring of the word 'sodomite' in a close-up shot of a dictionary in Gregory Ratoff's *Oscar Wilde* (1960), nervousness about interventions in contemporary rather than historical representation seemed understandable, arising from concerns about antagonising the public and from the sheer novelty of the script's subject.[40] '[A] film-maker dealing with this subject', Trevelyan told Janet Green, 'is treading on dangerous ground and will have to proceed with caution.'[41]

Michael Relph, the film's producer, asked for Trevelyan's view of the film's probable certificate; as one examiner noted, '[t]he film can only be "X"' and recommended '[g]reat tact and discretion […] if this project is to come off […] [T]he "queerness"', she added, 'must not be laid on with a trowel.' Whilst this was 'a problem' that could be discussed freely on paper ('the world of the arts is full of inverts', she

Victim was, and remains, a significant film in the cinema's treatment of homosexuality

breezily noted), the film's visual identity presented different challenges.[42] Trevelyan modified his examiners' occasionally brusque approaches, but followed their recommendations, asking Relph for a better integration and 'normalisation' of the 'queer'. Trevelyan's examiners initially reacted to the screenplay of *Victim* with a sense of distaste not uncommon for the 'febrile atmosphere', as John Coldstream has put it,[43] of the time: 'There are still a great many homosexual characters in this film: in fact, the makers are obviously aiming at showing a representative selection of the breed'.[44] As Trevelyan's correspondence with Janet Green got going, so too did a debate in Parliament as the House of Commons was called 'to take early action upon the recommendations contained in Part Two' of Lord Wolfenden's report, relating to 'Homosexual Offences', in particular to its 'main recommendation', as Robinson described it, 'that homosexual acts committed in private by consenting adults shall no longer constitute a criminal offence', a motion emphatically defeated by 213 to 99.[45] With the debate and its defeat in mind, Trevelyan wanted Janet Green to proceed cautiously and he not only urged her to write a script that was deadly serious in intent and that reflected the division of public opinion, he also appeared to want to intervene in terms of the moral centre of the script. Noting that the married Melville Farr's 'essential tragedy' lay in restraining the homosexual impulses that were always there within him, Trevelyan seemed to function at times almost as co-writer when he told Janet Green 'I would like this film to be essentially the story of this tragedy'; it was the kind of intervention that a subsequent BBFC examiner referred to as 'the art of creative censorship, co-directed by John Trevelyan'.[46] Even on a pre-release viewing, the examiners were still cautious about the film's sympathetic support for law reform: 'we feel that the case for homosexual practices between consenting adults is too plausibly put and not sufficiently countered'.[47] Nor did they like the fact that one of the film's most unsympathetic figures, the sour Miss Benham (Margaret Diamond), was the most homophobic figure in the film and the agent of the blackmail plot. 'We hope', Trevelyan noted, 'that this can be altered', less for its stereotyping of women, more for its imbricating of homophobia with bitter prejudice.[48] In the end, the 'X' certificate was granted on the proviso that a line about an adolescent boy – 'there's a moment of choice for almost every adolescent boy' – should be cut.[49] Green, on occasion frustrated with *Victim*'s producer and director, wrote to Trevelyan following the film's release and its highly successful reception to thank him for his 'receptiveness and encouragement right from the very beginning of the project'.[50] For his part, Trevelyan was sure that this meticulously detailed process had enabled them to 'get the real work of censorship done before the picture reached the floor [...] I am sure', he told her, 'this is the best way of doing it'.[51] There was agreement, with *Films and Filming* declaring *Victim* to be a 'landmark in British Cinema' and, implicitly, for British film censorship too. The film was banned in the US ('thematically objectionable')[52] but as *Films and Filming* optimistically suggested, 'The British have stopped being hypocrites and the censor has indicated that no subject, responsibly treated, is taboo.'[53] Writing about the Board's sanctioned representations of homosexuality in the 1950s, Derek Hill had suggested that 'clearly homosexual characters are permitted to mince through many English U-certificate comedies, provided they do it for laughs'.[54] *Victim*, a process and a measure of both courage and caution, suggested that the Board's interventions in the 1960s were taking a different turn.

The Profumo Effect

Though Trevelyan declared himself to be against political censorship in his memoir, Derek Hill vigorously contested the Board's impartiality in his withering attack on the BBFC in 1960, an article that was later cited in a House of Commons debate about the need to re-examine the irregularities of censorship in film, television and theatre.[55] The playwright John Osborne was delighted with Hill's critique and, never one to hold back, described the BBFC itself as a body of 'squalid stupidity' and 'an overbearingly partisan operation'.[56] Three years later, the director Guy Hamilton vehemently challenged Trevelyan for overstepping what he regarded as the bounds of the censor's role and for inhibiting freedom of speech when the Board initially refused to grant a certificate for *The Party's Over* in 1963, a film featuring the ennui of a group of Chelsea beatniks, the controversial stripping of a girl presumed to have passed out (though actually dead), and a brief moment of necrophilia when a character who has been unrequitedly in love with her, dazedly, but relatively chastely, kisses her. Hamilton accused Trevelyan of being in the pockets of the Establishment post-Profumo, a link originally fostered by an article in the *News of the World* that associated the film with one about Christine Keeler. Trevelyan rebutted the Profumo charge while appearing to entertain it as a perfectly acceptable possibility: 'I did not suggest that this would, or should, be an influencing factor in our decision, though such a suggestion would not, I think, have been unreasonable in the circumstances'.[57] He put forward a similarly contradictory possibility in his published response to Derek Hill's attack on the Board in a 1960 edition of *Encounter*:

> The British Board of Film Censors cannot assume responsibility for the guardianship of public morality. It cannot refuse for exhibition to adults films that show behaviour which contravenes the accepted moral code, and it does not demand that 'the wicked' should always be punished. It cannot legitimately refuse to pass films which criticize 'the Establishment' and films which express minority opinions. At the same time it believes that there are some films, or scenes in films, which are not suitable for public exhibition even to adults.[58]

The Board cannot assume responsibility for public morality – and yet, 'at the same time', it can, and the BBFC had a responsibility, Trevelyan reflected in his memoir, 'to try to analyse these changing attitudes and to decide what our responsibilities were'.[59] The Profumo scandal was a case in point. Its fallout coincided with a prosecution, made under the 1959 OPA, of John Cleland's eighteenth-century novel *Fanny Hill*. The coincidence of these events, one resting on a political sex scandal that had the potential to imperil national security, the other the seizure of unexpurgated copies of Cleland's novel and the successful prosecution of the retailer, had repercussions for the Board. In his study of offensive literature, John Sutherland has suggested that the overlaps between Profumo and the *Fanny Hill* prosecution led to one of those

Christine Keeler, who was at the centre of the Profumo affair

> periodic fits of punitive moralism about 'vice'. It was not, as seasons go, a good time for liberal causes. Anything which might be alleged, however far-fetchedly, to rot British moral fibre was suspect. Fanny Hill would be scourged for the fornications of Christine Keeler and Mandy Rice-Davies.[60]

The Board remained sensitive to this, as well as to the law on obscenity, when they received three different treatments of *Fanny Hill* the following year. Trevelyan wrote to the producer Albert Zugsmith in response to a draft screenplay of *Fanny Hill* telling him that while the material would have to be 'entirely reconstructed' to be acceptable to the Board, 'I would like to make it clear that in considering this screen-play I have not in any way been prejudiced by recent legal proceedings in this country in relation to this book.'[61] Refused a certificate by the Board on its completion, the film (1964, directed by Russ Meyer) received a bewildering range of certifications. Writing to one Town Clerk, Trevelyan expressed concern that in passing *Fanny Hill* with an 'A' certificate, the council was simply following the lead of other local authorities, and he

pointed out that by August 1965, 'three Local Authorities, including the London County Council, refused a certificate to the film, and [...] three passed it in the "X" category. I feel bound to add', he concluded, 'that one Local Authority, Coventry, passed the film in the "U" category.'[62] Such decisions threw 'the whole question of censorship and the system of appeals to Local Authorities' into question, as Trevelyan (with some justification) complained.[63] When one examiner, Frank Crofts, read Philip Ridgeway's detailed treatment of *Fanny Hill*, he signalled a note of extreme caution, comparing it to 'a piece of pornography'; it would 'not be wise', he advised Trevelyan, 'for the Board to pass a film that follows the book closely'.[64] Trevelyan duly replied to Ridgeway, now taking a different approach to the one he had adopted with Zugsmith:

> Any production of *Fanny Hill* will start with a handicap of the notoriety attached to the book as a result of the police and court action. This, while possibly a commercial asset, produces a censorship headache. You must appreciate that this Board will almost certainly be criticised for accepting a film of *Fanny Hill*, regardless of the nature of the film.[65]

The Profumo scandal was then raised directly by Trevelyan in response to a screenplay of *Fanny Hill* written by David Pelham. Advising Pelham on this screenplay, Trevelyan wrote that '[t]he name "Lord Pfenning" and the obvious parallel with the Profumo enquiry seem to me to lay you open to a great deal of trouble, and possibly expense, and I think it is undesirable'.[66] So, too, was the script in general, from rummaging around and plunging into bodices, implications of full-frontal female nudity, and the casual treatment of infidelity to an overtly homosexual character: 'Could he not be an elderly actor who would genuinely like to help the girl as a patron?', Trevelyan asked, clutching at recuperative straws.[67] Following a long talk with an apparently masterful and persuasive Trevelyan, Pelham performed an astonishing volte-face and reportedly 'talked excitedly about getting the script re-written by Terence Rattigan, getting Anthony Asquith to direct, and Benjamin Britten to do the music', a potentially glittering collaboration that never came to fruition.[68] But there was another issue at stake in discussions about the chance collision between the prosecution of *Fanny Hill* and the Profumo scandal both within and without the Board: 'the guardianship of public morality', the very thing Trevelyan had said that the Board could not assume. In the debates over the prosecution of *Fanny Hill*, John Sutherland has drawn attention to a concern to do less with the subject matter of Cleland's novel and more with social class, to *who* had access to it. Sentiments expressed at the time of the *Lady Chatterley* trial (Lord Hailsham would have preferred the book in 'boards at 12s.6d. than in paperback at 3s.6d.')[69] resurfaced in Peregrine Worsthorne's anxiety about sex and class: 'it would surely be odd for a society pledged to monogamous marriage to allow any citizen with a few shillings in his pocket to buy *Fanny Hill*'. 'It was presumably safe', John Sutherland concluded, 'to allow the citizens with a couple of guineas to buy it.'[70]

The Board often had reservations about 'unseemly' rather than explicitly censorable dialogue, its cautions issued in relation to the tastes, comprehension and susceptibilities of the 'circuit' audience. Writing towards the end of his tenure, Trevelyan acknowledged that understanding public attitudes might be hit and miss, or at least that there was 'no certainty that assessments of public attitudes are accurate'.[71] But the groups that he met with to gauge opinion were fairly self-selecting: 'film societies, university groups and others'.[72] The groups that he *didn't* meet with were the ones the Board made the greatest assumptions about. One of Trevelyan's concerns about Stanley Kubrick's adaptation of *Lolita* (1962) was that its humour would be too cerebral, and he told Kubrick that he 'had great doubts whether the dialogue would be understood at all by the ordinary cinema audience'.[73] Peter Sellers, who played Quilty in the film, had been scheduled to play Leopold Bloom when an adaptation of *Ulysses* was first broached in 1962. In the event, he was unavailable, but the Board worried that his provisional presence in *Ulysses* 'does seem to indicate a certain amount of interest in appealing to the circuit audience'.[74] The Board's examiners were similarly concerned about the implications arising from the number of cuts they required from the first draft screenplay of *Ulysses*: 'we would still be left with a great deal of dialogue which seems to me out of the question for ordinary cinema audiences (with whom, after all, we are concerned, not with the "art theatre" crowd)'.[75] Reflections about breasts and 'what a man looks like with his two bags full' in the original draft were also suspect: 'A few lines like that and it would be worth the Elephant's while to frequent the film however obscure and classy much of it was'.[76] 'Elephant' operated as a euphemism – 'the oaf at the Elephant & Castle' as one examiner spelt it out, again in relation to *Ulysses*.[77] But if the sexual titillation of the working class was one cause for concern, so too were the sexual musings of a particular woman: Molly Bloom.

Ulysses and the Undermining of the BBFC

The adaptation of *Ulysses*, conceived in 1962, was put on hold until 1965 when Joseph Strick, the film's new director, wrote to Trevelyan with his first draft screenplay, pointing out that the new script, co-written with Fred Haines, had impeccable credentials, 'made up entirely of words from the book together with images we have felt would well represent the spirit of this classic work'.[78] Audrey Field, who had reviewed Jack Cardiff's original and revised script submissions in June and August 1962, remained deeply sceptical, seeing in the revised script a preoccupation with perversion that had the potential to affect young people: 'I think it has a profound influence on the "university-type" young, many of whom are gripped by a terrible despair at the best of times.'[79] Field's list of objections to the script presented in 1965 was impressively detailed: she found the many blasphemous references objectionable, as well as single words ('balls', 'bugger') and phrases ('How's your middle leg? Come here till I stiffen it for you'). 'We did not want the first sentence in the previous script', she noted (stiffly). 'We don't want either now.' Inevitably, the 'Circe' or 'Nighttown' section, which featured a dream sequence in which Bloom changes sex and endures humiliation at the hands of a dominatrix, caused anxieties for the Board. Most problematic, though, was the sexually explicit language of Molly Bloom's monologue, boldly occupying the final twenty-five minutes of the film.

Trevelyan sent Strick a six-page letter in July 1965 outlining most of his examiners' comments, indicating what would not be acceptable and what 'we would not want', and a revised script was sent on 14 December 1965; 'this', Trevelyan noted in a private memo to the Board, 'had taken account of almost all the points made on the first draft script'.[80] When they came to view the film, the Board found the first half 'admirable' and reasonably discreet until Bloom's 'Nighttown' sequences and Molly's lengthy interior monologue 'which contained verbal material which would be totally unacceptable'.[81] Only one visual was deemed to be unacceptable, of Molly and Bloom 'making love on the headland in a way which clearly indicated that copulation was in progress'.[82] More cuts were demanded before the 'X' could be given, including some seventeen lines from Molly's soliloquy. Strick, it turned out, had been entirely pragmatic throughout his dealings with the Board. In her review of the film and of the ensuing situation, Penelope Gilliatt revealed that Strick 'told me that he had had to submit a script in advance to Mr. Trevelyan in order to raise any money, and that to protect the endeavour he submitted a doctored version'. When the Board asked for cuts on seeing the film, Strick took Trevelyan literally at his word by mutilating it. Where cuts had been requested, the screen was either blank, or sound was cut as actors appeared to mime, or a buzzer would ring. In a private memo, Trevelyan wrote: 'We feel that this is not proper cutting and is intended to make the Board look foolish.'[83] He was right: it did. Writing in the *Daily Mail*, Anne Scott-James (who had appeared as a witness for the defence in the *Lady Chatterley* trial) noted that

Maurice Roëves and Milo O'Shea in *Ulysses* (1967), the censorship of which, in the words of the *Daily Mail*, reached 'an exquisite degree of nuttiness'

Quite often reforms are achieved not by righteous indignation but by the laughter of the multitude. This could happen with censorship. The censorship of James Joyce's *Ulysses* has reached such an exquisite degree of nuttiness that the whole system could well collapse under the weight of its own nonsense.[84]

Trevelyan duly wrote to her, inviting her to lunch, so that he could – figuratively, at any rate – 'put her in the picture'.[85]

Strick's literal implementation of the required cuts seems, on the surface, an odd decision but in reality was canny, as he generated both controversy and publicity. British Lion, the film's distributors, wrote to Trevelyan to point out that the mutilation of the film was done without its consent or approval but Trevelyan assumed that Strick had done it 'to invite attention to the areas of censorship with a view to producing criticism of this Board' as well as to bring pressure upon British Lion to take the complete film to local authorities with a view to getting an 'X' certificate, uncut.[86] Strick, meanwhile, was planning to make the cuts available to cinema audiences by distributing leaflets with the censored dialogue restored so that they could read for themselves what the censor felt

they should be protected from. Strick circumvented the Board, exercising his right of appeal; after it was shown to the Greater London Council (GLC), the film was given an 'X' certificate, uncut. The resulting situation was that some local authorities showed the film uncut while some refused to pass the film in its completed form. When the *Brighton and Hove Herald* praised Barbara Jefford's impeccable handling of Molly Bloom's frank soliloquy (a view widely shared in press reviews), it suggested that '[i]t probably does all those things that censorship wishes to prevent, such as giving an audience a jolt of sexual stimulation and provoking it to have erotic thoughts'.[87] Trevelyan justified his disingenuous objection that the issue of sexual stimulation was never an issue for the Board by invoking the (temporarily) successful prosecution of *Last Exit to Brooklyn* and suggesting that 'the Board's caution on *Ulysses* was not wholly unjustified' in relation to sensitivity about obscenity.[88] But in a series of frustrated exchanges about the film with O. J. Silverthorne, in charge of Canadian film censorship, Trevelyan confided '[o]ur problems have intensified, and I expect yours have too'.[89] In the case of *Ulysses*, the contemporary issue that prevailed was less to do with what the film dared to represent in terms of language, fantasy and sexuality, and more about retaliation to British film censorship itself.

The director and co-screenwriter of *Ulysses*, Joseph Strick

Censorship and *The Killing of Sister George*

The Board encountered a similarly absurd situation over Robert Aldrich's *The Killing of Sister George* (1968), coincidentally another film that pushed at the representational limits of women's sexual pleasure, adapted from Frank Marcus's popular stage play. 'Sister George' (played by Beryl Reid in both stage and film versions) is a cheery and virtuous character in a popular TV soap opera, played by an actress who is her mirror opposite, June Buckridge, a tweedy, hard-drinking lesbian who shares her flat (overlooked by the BBC in Marcus's play) with her lover, a much younger woman called 'Childie' (Susannah York). The one scene that the Board strenuously objected to takes place towards the end of the film in which Mercy Croft (Coral Browne), a BBC executive, seduces Childie and stimulates her to orgasm. The intensity of the scene is heightened both by its silence (Childie's orgasmic cries aside) and continual cutting between close-ups of the faces of the two women, whose expressions might be construed in a number of ways. As one examiner put it, though it seemed doubtful that the scene would corrupt anyone, it might well prove 'adverse to the liberalism of film censorship' through its shock value, an assumption without foundation, as it turned out.[90] Crucially, the Board felt that the scene was superfluous, that the film had not credibly allowed the women's relationship to build to this level of intimacy, and that the film-makers seemed to have anticipated its possible censorship given that it was shot in silence and easily removable without disturbing continuity or the dramatic weight given to Sister George's discovery of Childie's betrayal. The Board had consistently censored sexual activity between women right across the 1960s; some eighteen or so films required cuts in the BBFC's lists of final exceptions: at its most cautious, it asked for the removal of a line in the 1961 film *The Greengage Summer* – 'A lady loves a lady?'[91] Again, cautiously, it queried a scene in *The L-Shaped Room* in which Mavis, talking to Jane, looks back fondly on the traditions of Christmas pantomime. When Jane asks her about family and marriage, Mavis tells her about her one 'real love match'. Only when Jane looks at the photograph of Mavis's 'friend' (the photo's image is not disclosed to camera) is it implied that she was a woman as Mavis tells her, 'It takes all sorts, dear', a fact that the unmarried pregnant Jane must – and does – allow for. 'This may well pass', Trevelyan wrote to Bryan Forbes, the film's director,

> especially since Mavis is talking about love and not about sex [...] but I suggest that you shoot the scene in such a way as to make the omission of the photograph, if considered desirable, something which could be done without spoiling the scene.[92]

Forbes followed Trevelyan's suggestion, although the camera *had* focused on the photograph earlier, in an unrelated scene, panning slowly enough across it to reveal a woman dressed as a

Coral Browne and
Susannah York in
*The Killing of Sister
George* (1968)

Principal Boy – the photograph Jane later looks at. But arguably such mild intervention was effective, and the scene's understated direction produced a more eloquent telling of Mavis's private loneliness as the effect of what can scarcely be named or acknowledged is movingly registered through her just-controlled facial expressions.

But whereas Mavis's story was about love, which the Board found acceptable, *The Killing of Sister George*, at the decade's end, was about sex, and it presented to the Board 'by far the most explicit scene of Lesbian physical love that has ever been submitted to us'.[93] Trevelyan pointed to a record of what the BBFC regarded as ever-increasing liberalism with regard to women's on-screen nudity, but 'it is', he said, 'a totally different matter when the context is one of Lesbian physical love'.[94] He did not disclose why. *The Killing of Sister George* was passed by the BBFC in the 'X' category on 18 February 1969 with its sex scene cut but the makers took it to the GLC who granted an 'X' with a less severe cut (of forty seconds), and the BBFC then withdrew its certificate. This produced another anomalous situation which threatened to undermine the authority of the BBFC's judgment, since some councils screened the GLC version, some wished to screen the BBFC's version, some screened it entirely uncut and some wished to ban it altogether; all in all, though, considerably more councils screened it than banned it. As Tom Dewe Mathews has suggested, there were points in the BBFC's history when 'Britain's censorship system [...] began to resemble not so much a moral shield as a large colander'.[95] In the Board's defence, Trevelyan told the Clerk of one County Council that while it was appropriate to increase liberality, the Board 'should nevertheless keep a reasonable control, otherwise the position could quickly get out of hand, and the cinema would be showing pornographic films'.[96] Trevelyan was presumably referring to the (then) provocatively sensational nature of the scene, shot in a way that anticipated censorship and exploited in its marketing: 'the film is one of startling frankness, possibly unparalleled in the entire history of motion pictures' ran the distributor's draft press statement for *The Killing of Sister George*.[97] When the Board came to reconsider its view of the scene in July 1970, after the 'X' certificate age limit had been raised from sixteen to eighteen, it was still not ready to pass it in full or in the reduced form permitted by the GLC: this time round, it was 'prepared to pass the scene up to the point at which the young girl starts to writhe and gasp orgasmically. We would not accept the two women kissing passionately, but we would accept a few shots which would lead satisfactorily up to the entry of Sister George.'[98]

Alan Bates and Oliver Reed in *Women in Love* (1969): their nude wrestling scene caused a stir with its homoeroticism

Writing about the censorship of the voyeurism scene in *Darling*, Alexander Walker thought that 'it is instructive to ask what exactly the censor was censoring' when he made the decision to cut a scene in which we watch Diana hardly able to watch a couple copulate.[99] In *The Killing of Sister George* there is no deflection as there was in *Darling* when we watch Diana, rather than what Diana herself is meant to see. Trevelyan regarded the Board as increasingly liberal by the mid-1960s, at least where it was responsive to the *integrity* of films that had more explicit sexual content; *Blowup* (1966) was one (see case study), Luis Buñuel's *Belle de Jour* (1967) another: 'This film had explicit sexual perversions', Trevelyan noted, 'but its quality was undeniable'.[100] *Therese and Isabelle* (1968) was another; adapted from Violette le Duc's *roman à clef* about an adolescent lesbian affair, and directed by Radley Metzger, the film was, to the Board's surprise, 'a film of some quality and sincerity'.[101] Even so, the Board asked for substantial reductions in some of the film's most explicitly erotic moments, including the removal of English subtitles in a scene in which Therese and Isabelle have sex in the school's chapel. Therese's spoken recollection of the scene, taken from le Duc's text, is really about listening rather than looking, a languid evocation in which lyricism burnishes desire ('she was melting my ankles and knees into delicious decay, I burst with warmth like a fruit'). The silencing of the scene's poetically evoked eroticism leaves us with a camera tracking away from the obscured couple and the moment looking more like a documentary about church architecture than a reflection on the consolations of language against lost physical pleasure. *The Killing of Sister George* was suspect for the Board because of the way its sex scene was shot and then used to sell the film. If there seems, too, a lingering unease with what was being shot ('We would not accept the two women kissing passionately') it is difficult to resolve or extricate other feelings that might have informed censorship decisions from the question of artistic integrity that, the Board felt, this film was flouting. Sian Barber has pointed to apparent discrepancies in the treatment of *The Killing of Sister George* and *Women in Love* (1969), in which male nudity and homoeroticism were examined: 'Homosexual overtones were one thing, but lesbian love scenes quite another', she argues.[102] Trevelyan had warned the latter's producer, Larry Kramer, about the potential censorship troubles the nude wrestling scene might provoke:

If they were just indulging in horseplay as two friends there would not be problems, but we have already had clear indications that there are homosexual feelings between them, and this kind of scene could be troublesome if not handled discreetly. I can only advise you to be very cautious about it. I think I am right in saying that in the book all they did was to have a Judo bout together.[103]

With careful negotiation (and, in the end, careful lighting), compromises were reached, and Kramer expressed both his and Ken Russell's gratitude to Trevelyan for his sympathetic understanding:

> That we were all so aware of the others' positions and that we have come so satisfactorily to a resolution acceptable to all of us is in no small way due to your aid and help and for this, as I say, we are both extremely grateful.[104]

It might be argued that the Board did indeed adjudicate on a film-by-film basis, though on occasion, inconsistencies in attitude could be revealed. Responding to a medical student who had written to Trevelyan to complain about his embarrassment at seeing the nude wrestling scene in *Women in Love*, Trevelyan defended what he called 'a brilliant scene' and was to the point: 'A great deal of harm has been done by an inhibited attitude to the human body, and I would have expected that, as a medical student you would have appreciated this'.[105]

The Relaxation of Censorship

And yet, as Tom Dewe Mathews has suggested, 'Trevelyan was one of those rare public figures who instead of becoming more conservative became more liberal with age'.[106] Trevelyan's correspondence with Lindsay Anderson over *If....* (1968) suggests an altogether more relaxed relationship between director and censor. Anderson's past experience with the BBFC had been a reasonably positive one. Julian Wintle, the co-executive producer of *This Sporting Life* (1963), had written to the Board in 1963 thanking Trevelyan for his 'great help [...] and, incidentally, for your personal enthusiasm for the picture'.[107] Trevelyan told Anderson that *If....* had made a considerable impression on him and that the film had something important to say.[108] Anderson wrote a candid letter to Trevelyan outlining some of his feelings about *If....* and his desire that 'the story is ultimately to be taken on a symbolic or poetic level – rather than as straight realism'.[109] He made one last point to Trevelyan, not really an appeal for leniency, but a statement about his own integrity and his aspiration both for his film and for film in general:

> I appreciate greatly that the overall impression of integrity and seriousness which the film makes should count in its assessment, and I think you know that I have done my best to achieve a consistent poetic (even if anti-commercial) style. But for this style to work, it is important for all the elements, of humour and violence, of satire and naturalism and expressionism and sensuality, to work at full strength. I think this is the only way to achieve an artistically integrated work, and one which can stake a claim for the cinema to be considered with the same subtlety and maturity as painting, poetry or drama – and to be capable of resonances as profound, complex, as disturbing, and as relevant to our times.[110]

Anderson agreed to minor cuts and 'trims': '"You shit" (twice) should be removed. The shot of a boy spread-eagled in a lavatory should also go' and a shower bath scene was to be trimmed to avoid shots of boys' genitals.[111] One of the fascinating elements about the Board's response to this film is the extant documentation that reveals examiners' critical verdicts engaging with the film in its entirety rather than singling out particular shots or dialogue for excision since they usually had to imagine the potential censorship issues arising from the screenplay. Trevelyan had warned Anderson that frontal shots of the housemaster's wife wandering through the boys' dormitory naked would most likely be cut. Anderson replied, 'I am hoping [it] be so obviously aesthetic as to avoid any suggestion of offence. It reveals no more, after all, than any member of the public can see at the National Gallery free of charge.'[112] (Trevelyan later borrowed Anderson's argument when defending *Women in Love* to an offended member of the public: 'It is true that it contains some scenes which some people, especially older people, will find objectionable, but the same thing would apply to some of the great paintings of classical art on show in public galleries'.)[113] Anderson's hope was met: Trevelyan wrote to Lord Harlech, BBFC President from 1965, that the film 'in a subtle way was showing that each person living in these institutional surroundings had his or her own private life and private feelings, and when we came to this scene [one examiner] saw it as expressing this'.[114]

Director Lindsay
Anderson and actor
Malcolm McDowell
during the filming of *If....*
(1968)

The BBFC's documentation forms part of a story not just about censorship but also about the testing of the limits of what could be seen regarding both the modesty and the intensity of intimate life and individual agency at significant points of social and legal transitions in Britain's cultural history. By 1967, and following the furore over *Ulysses*, Trevelyan was concerned about the survival of film censorship, writing to John Davis at Rank about *Blowup*,

> As you will probably know, the films of Antonioni are always of interest to the highbrow critics, and any cut that we ask for in such films is liable to produce criticism of the Board from these sources. At the present time the anti-censorship pressures have increased, and we have to be particularly careful not to lay ourselves open to attack on points of censorship that we cannot fully defend.[115]

At the other end of the spectrum, the Board had lengthy discussions about the Swedish director Vilgot Sjöman's sexually explicit *Jag är nyfiken – en film i gult* (*I Am Curious [Yellow]*, 1967), but although Trevelyan felt that Sjöman was 'a man of honesty and integrity, and a film-maker of quality', he argued that the film, if shown unexpurgated in Britain, ran the risk of prosecution, a fear he had claimed in relation to *Ulysses*. Of Sjöman's film, he commented 'some of the scenes in this picture would be regarded by the Courts as legally obscene' and he went on to list ten substantial problems concerning language and numerous explicit scenes of sex and nudity.[116] Defending the Board's position, Trevelyan again pointed to what he felt was the vulnerability of film censorship within the trust of the BBFC: '[A]s you will appreciate', he told the distributor in correspondence about it,

> we have got to accept attitudes as they are in this country, and, if we passed a film which caused strong critical reaction it is likely that this Board would cease to exist, and would be replaced by some much more restrictive form of censorship.[117]

By the end of the decade, and towards the end of his tenure as Secretary, Trevelyan recognised that the Board also had to move with the times. The office of the Lord Chamberlain stretched back to the reign of Henry VII, but its abolition in the Theatres Act of 1968 repealed a piece of early Victorian legislation, the Theatres Act of 1843.[118] The OPA of 1959 also repealed an Act first passed in 1857; if the appetite for Victoriana flourished in the 1960s, the taste for the legacies of Victorian censorship in theatre and literature did not. Hugh Carleton Greene, the BBC's Director-General from 1960 to 1969, had imagined that he would be 'dragging the BBC kicking and screaming into the Sixties', but found it far less resistant than he imagined in terms of creative input.[119] Television's relaxation over language – Trevelyan cited *Till Death Us Do Part* (1965–75) in his memoir – meant that the BBFC had to relax its stringent guard over language.[120] When the BBC broadcast scenes from *Ulysses* that the BBFC had wanted to cut, the screening seemed, said Anne Scott-James, 'a glorious moment for scrapping the whole fatuous, inconsistent system!'[121] And yet, as the BBC's Audience Reaction Reports reveal, the persistently mixed responses of the viewing public revealed both minority and mainstream views that veered between expressions of distaste for either too much or too little in the way of 'adult' discussion and representation. Lord Harlech, President of the BBFC from 1965, had said in a letter to the MP Michael Jopling in 1969 that '[o]n censorship we have to steer a middle course, and I think I can claim that up to date we have done this fairly successfully'.[122] That middle course, Trevelyan said, lay between 'complaints from both sides – from people who thought that we were too liberal and also from people who thought that we were too restrictive'.[123] Tom Dewe Mathews has suggested that film censorship was transformed during the 1960s '[a]s in no other decade'.[124] *Room at the Top* was one of the first films that Trevelyan adjudicated when he began his work as the BBFC's Secretary; *The Devils* (1971) and *WR – Misterije organizma* (*WR – Mysteries of the Organism*, 1971) (see case study) were among the last to pass across his desk and on to his successor, Stephen Murphy. During Trevelyan's term of office, censorship had come a long way from the modest changes required for *Room at the Top* only a decade earlier, when – radically – it was permissible to say that sex had been 'super'.

CASE STUDY: CAPE FEAR (1962) David Hyman

Sexual violence is one of the BBFC's main classification concerns, and was the key issue when *Cape Fear* was submitted on 19 March 1962.

Robert Mitchum portrayed sadistic ex-convict Max Cady who returns to a Georgia town where he plans revenge against lawyer Sam Bowden (Gregory Peck), whose testimony led him to be jailed eight years earlier for a brutal assault on a woman. Cady threatens Bowden's wife and adolescent daughter but Bowden, lacking evidence that could lead to Cady's arrest, and following an escalation from threats to violence, is ultimately drawn into a showdown with Cady.

The film was seen by BBFC Secretary John Trevelyan and two examiners. Their report states that they 'all agreed that the main question here is whether the film is likely to encourage potential or actual rapists' and also notes that even if expert opinion did not confirm the likelihood of harm, Cady 'generates a sense of mental and physical power which will stimulate morbid fantasy in the minds of those who are "sexually unbalanced"'.[125]

Therefore, cuts were proposed to several scenes. These included those in which Bowden's wife is terrorised by Cady's 'threats and his mauling of her and also in scenes where he terrifies and manhandles the daughter', as well as to remove the 'suggestion of perversion' in what Cady does to a prostitute and to Bowden's wife and 'a reduction in the number of cases in which he sadistically talks about harming the wife and her daughter'.[126]

Expert opinion agreed with the Board that there was a potential harm issue. This related to the pervasive theme of 'threatened rape', the emphasis on Cady's character that could result in some viewers empathising with him and

Robert Mitchum as Max Cady in *Cape Fear*. The Board required 'considerable' cuts to the film's sexual violence

concern that some viewers may believe that the US legal system was similar to that in the UK. The opinion stated that if Cady's intention 'to rape the little girl were not made clear', his initial crime could remain ambiguous and that if dialogue relating to the beating of the prostitute and 'incidental dialogue throughout where his desire to rape is made clear' were removed, the film would be less problematic.[127]

Trevelyan wrote to the film's UK distributor, Rank Film Distributors, informing them of the Board's concerns about this 'study of violence associated with sex'. He explained that these were based on likely public acceptability and potential harm, and stated that 'considerable cuts' would be required before the film could be granted an 'X'. Trevelyan told the distributor that the Board was worried about public criticism relating to screen violence, with the greatest concern being 'violence associated with sex'. This meant that a film with sexual assault as its primary theme could be 'particularly open to criticism' and Trevelyan conveyed the Board's expert opinion to them, explaining that '[c]ertain elements in films of this kind are liable to provide stimulation for certain people suffering from a psychopathic disturbance'.[128] The extent of the BBFC's proposed cuts came 'as something of a shock' to Rank, who replied that they were unable 'technically' to comply with the request and forwarded the cuts list to the US.[129]

J. Lee Thompson, the film's director, then contacted the BBFC. He said that Cady was never an 'active rapist' and he took exception to the Board's 'genital emphasis' in the cuts list, stating that this was a 'good versus evil' story and that the audience would identify with Bowden rather than Cady.[130]

Lee Thompson subsequently visited the BBFC where he met with Trevelyan and discovered that the Board was not prepared to modify its position. Trevelyan, in his autobiography, recalls that he and Lee Thompson 'argued violently for over two hours' and that Lee Thompson said that he would report details of their conversation to the press.[131]

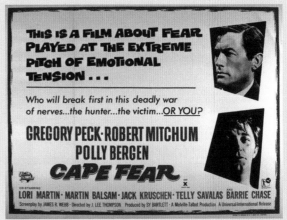

THIS IS A FILM ABOUT FEAR PLAYED AT THE EXTREME PITCH OF EMOTIONAL TENSION...

Who will break first in this deadly war of nerves...the hunter...the victim...OR YOU?

GREGORY PECK · ROBERT MITCHUM POLLY BERGEN
CAPE FEAR
CO-STARRING LORI MARTIN · MARTIN BALSAM · JACK KRUSCHEN · TELLY SAVALAS · BARRIE CHASE
Screenplay by JAMES R. WEBB · Directed by J. LEE THOMPSON · Produced by SY BARTLETT · A Melville-Talbot Production · A Universal-International Release

A letter from Trevelyan to Lee Thompson at the time states that Trevelyan was 'surprised and somewhat annoyed' after Lee Thompson gave a reporter information and 'strongly critical comments' about the Board's reaction to the film;[132] Lee Thompson responded that he did so because the film 'was suffering' at the Board's hands.[133]

However, Trevelyan also claimed in his autobiography that, with regard to Lee Thompson's determination to speak to the press,

> I encouraged him, quite sincerely, to do this, pointing out that since the Board was at this time considered by some local authorities to be too liberal it would be helpful to us if we were attacked in the press for being the reverse.[134]

Nevertheless, Lee Thompson – who still believed that the proposed cuts would 'do harm to the dramatic impact' of the film – carried out the BBFC's instructions.[135]

He maintained that the cuts 'greatly emasculated the film' to the extent that 'we have been forced to turn a problem thriller into what I, personally, can only look upon now as a very ordinary and rather unsatisfactory and straightforward murder melodrama'.[136] However, in a rare instance where a film's star publicly disagrees with its director, Gregory Peck told the Sunday Express that he agreed with Trevelyan's cuts to the film and believed that 'they may have improved the picture'.[137] Trevelyan, for his part, believed that the Board had also been 'rather generous' in its treatment of the film.[138]

The uncut version of the film was submitted for video classification in 1991. One examiner recommended '15' uncut while another expressed concerns over Cady's assaults on Bowden's wife and daughter. Further viewing supported the '15' recommendation, with one examiner noting that the film's content now seemed 'quite oddly discreet given its theme' and that the implied threat was 'a violent one but not clearly a sexual one'. Cape Fear was duly classified '15' uncut.[139]

CASE STUDY: BLOWUP (1966) Edward Lamberti

London, the swinging sixties – and many films were capturing the hedonistic mood of the young and carefree in the capital, among them Darling (1965), Alfie and Georgy Girl (both 1966). And in the midst of all this, Michelangelo Antonioni, already one of the most acclaimed Italian directors thanks to films such as L'avventura (1960), La notte (1961) and L'eclisse (1962), had a significant impact on cinema history when he came to London and filmed his first English-language feature, Blowup.[140] Set over a twenty-four-hour period, it is the story of a celebrated young photographer (played by David Hemmings) whose decadent existence is pierced by a mysterious event: having casually photographed a kissing couple in a park, he finds, on developing the photos, that he may have just witnessed – and captured with his camera – a murder about to be committed. Why he then does what he does with this knowledge is open to a great deal of debate, such as the general conceit of Antonioni's directorial approach, even when applied to a setting as modish as this.

The collection of press cuttings in the BBFC's file says much about the context in which Blowup arrived for consideration. By the time it was submitted in January 1967, the film had already caused quite a stir in the US: it had failed to be granted a Production Code seal of approval, and so MGM had decided, exceptionally, to release the film without one, under a subsidiary called Premier Productions.[141] Meanwhile, the National Catholic Office for Motion Pictures (previously the National Legion of Decency) in the US had denounced the film, meaning that the Catholic Church forbade

its followers to see it.[142] No prizes for guessing, then, what effect this had on the box-office takings: Blowup became not just a critical hit but a commercial smash. The British press understandably began to discuss it, making much in particular of the film's various but brief instances of nudity;[143] one article, considering the threesome scene in which the photographer tussles with two young women, said that '[n]o doubt one or two frames from this exuberant sequence will be primly deleted before the film is shown in London'.[144]

The press also made much of Antonioni's 'Italianness'. At least three reviews refer to the director as 'Signor' Antonioni,[145] and one of them cannot help but invoke that other famous Italian Michelangelo, as it posits that 'the talented Michelangelo hoped to chisel out the definitive "swinging" movie'.[146] Another review refers to the film-maker as 'this man Antonioni' and adds that the name is 'easy to pronounce if you know when to stop'.[147] These comments evoke a sense that critics attached a certain exoticism to Antonioni, as a non-Brit and more specifically, perhaps, as an Italian, and that this could be used to explain, or excuse, any debauchery in the film.

So, when Blowup was submitted to the Board, it was already a known quantity: a crossover arthouse hit from a master director from abroad, with content that was said to push the boundaries of acceptability. It was viewed on a Friday by the Board's then President, Lord Harlech, and a team of two examiners. John Trevelyan, the BBFC's Secretary, had already seen the film once, but was unable to join the examiners for their viewing because he was unwell.[148]

One examiner felt that the film could be passed 'X' uncut; the other felt that cuts should perhaps be made to the threesome scene. The main objection was that it went beyond what was allowed at the time: '[W]e have not previously had a man behaving thus with either one or two naked women'.[149] Although there is no mention in the examiner's report of the fleeting glimpses of pubic hair in the scene, the examiner does cite the President as feeling that perhaps the scene should be cut 'before [the] 2nd girl is de-leotarded';[150] later, Trevelyan was to mention the 'brief "flashes" of pubic hair' in his autobiography,[151] and these images did become the scene's primary talking points.[152] The President's opinion was somewhere in between: the examiner's report states that Lord Harlech was 'a little bit dubious' about it,[153] while a later note from Trevelyan indicates that the President 'did not personally feel too strongly about it'.[154] Trevelyan discussed the matter with him and with each examiner in turn, and by the Monday evening it had been decided that *Blowup* would be classified without cuts.[155] The 'X' certificate was issued on 19 January 1967.

To pass the film uncut only a few months after the US system had refused it its seal of approval, and in the face of disapproval from the Catholic Church, feels like a bold move on the part of the Board. But, while surface indications in the file suggest that staff were unflappable, documents also reveal that behind this quick decision lay some anxiety over how the BBFC would look if it did not pass the film uncut. Trevelyan noted internally at the time that one of the examiners had suggested to him that 'any risk we were taking would probably give us less trouble than we would get from the "hou-ha" that would arise if we cut the film',[156] while in a letter to the prominent critic Bosley Crowther, complimenting him on his review of the film for the *New York Times*, Trevelyan stated that '[a]s you may know, we have no rules and judge each film on its merits. In this way we are able to make allowances for artistic quality and integrity.'[157] And, as we have seen in Chapter 4, the Board also felt anxiety at this time over the strength of anti-censorship feeling more generally.

It is fair to say, then, that while the Board's decision was the product of the acceptability of the film's content (even the examiner who had reservations about the threesome scene was content to let through the film's other nudity and its depiction of hashish-smoking), it was helped over the finishing line by the insistence of the reputation that Antonioni and his film had amassed; if the Board had cut *Blowup*, it *may* have led to a furore. One of the ironies of all this is that, in order to notice the infamous pubic hair in the threesome scene, you have to scrutinise the image to a degree similar to that of Hemmings's photographer as he 'blows up' the photographs in his studio. Sometimes, like the esteemed protagonist in this classic film, we have to look more than once.

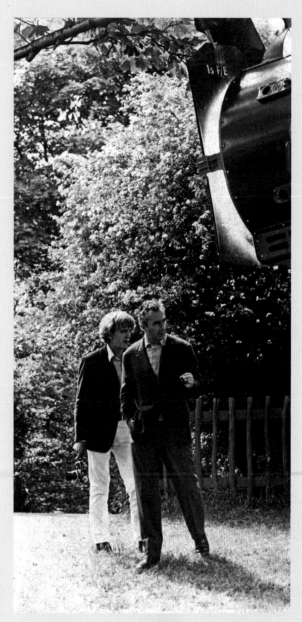

(above) Actor David Hemmings with director Michelangelo Antonioni during the filming of *Blowup*; (left) Even with its 'exuberant' threesome scene, the film was passed uncut

5

WAKE OF THE FLOOD:[1] KEY ISSUES IN UK CENSORSHIP, 1970–5

Stevie Simkin

In 1969, a film purporting to be a serious study of a rising social trend, Derek Ford's *The Wife Swappers*, was submitted to the BBFC. The Board refused it a certificate, but advised the distributor that, with the imminent change in the 'X' certificate from sixteen and over to eighteen and over, some cuts might make the film acceptable in due course. BBFC Secretary John Trevelyan's early remarks prevaricate, fret about 'social responsibility', and display some familiar prejudices ('we believe that this [the practice of wife-swapping] is likely to appeal essentially to people living in urban areas').[2] Nevertheless, the final decision to pass the film at 'X' with the raising of the age to that of adulthood (eighteen years) shows how, in the words of one examiner considering the film nearly twenty years later for home video, 'the notion of adult freedoms had arrived […] and in doing so laid the basis for many of our current attitudes as censors'.[3] The five years following certification of *The Wife Swappers* would be tumultuous, but would lead to a major shift in the kinds of films available to the viewing public in Britain. At the same time, the dice were also cast for particular kinds of material – especially martial-arts violence and sexual violence – that would remain troublesome for many years to come.

This study of one of the most turbulent periods in the history of the Board will begin with a consideration of the social and cultural climate and of the various 'arenas' in which the work of the BBFC was under scrutiny: first, the general public, both as individuals and in the form of pressure groups which attempted to operate a kind of 'grass-roots' censorship; second, the media, which sensed a potential feeding frenzy at the turn of the decade and would make the most of what was to come; and finally, local authorities, which were beginning to challenge BBFC judgments. This half of the chapter will focus chiefly on the most high-profile controversial films of the early 1970s. The second part will offer an in-depth analysis of the evolution of BBFC policy between 1970 and 1975. By viewing the BBFC's decisions over a five-year period through a wide-angle lens, looking at every film requiring cuts over that time, a picture emerges of the day-to-day work of the Board that can be lost when attention focuses too intently on the more familiar films such as *The Devils*, *Straw Dogs* and *A Clockwork Orange* (all 1971). The so-called 'Blue Books',[4] which contain, month by month, a list of every cut to every film, help piece together a more complete picture of the BBFC's operating principles, and the key controversies of sex, violence and sexual violence will be considered in turn.[5] Some of the decisions made by the Board at this point in history would dictate censoring and certificating practices in the UK for many years to come, and some reverberate even today.

The first two years of the 1970s formed something of a watershed for the BBFC, with John Trevelyan resigning his post as Secretary and Stephen Murphy taking over in July 1971. Furthermore, the Board instigated a significant change in its certification practices, not only at 'X', as noted above, but with the introduction of a new 'AA' rating (fourteen and over). Although the change in classifications was intended to allow a greater degree of artistic freedom, Trevelyan admits in his memoir that the hope it might result in a reduction of censorship proved to be 'optimistic', and that 'the Board still found it necessary to ban certain films entirely and to continue

to make cuts in "X" films'.[6] Stephen Murphy, as incumbent Secretary, barely had time to warm his seat before a number of films that were riding high on the rising tide of more graphic depictions of sex and violence came crashing down – not only Ken Russell's *The Devils* (certificated under Trevelyan's regime but released in the month that Murphy took over) but also Sam Peckinpah's *Straw Dogs* and Stanley Kubrick's *A Clockwork Orange* arrived within months of each other in 1971–2, followed by *Last Tango in Paris* (1972), *The Exorcist* in 1973 and *Emmanuelle* in 1974. The profound impact of the first three of these films has been well-chronicled;[7] Tom Dewe Mathews has suggested that, between them, they 'almost provoked the downfall of British censorship'.[8]

The Public

While the changes at the Board were important, the real significance lay in the cultural turn that was taking place at the end of the 1960s, with the first signs of manoeuvres by the political right to represent the counter-culture as an unwelcome tide of permissiveness that had to be resisted. In 1968, Richard Nixon was elected President in the US, signalling a cultural sea change: the election had been fought largely on a 'decency' manifesto and the invocation that a 'silent majority' was appalled by the decadence that had engulfed the American way of life; two years later, in June 1970, the return of the Conservatives to power in the UK under Edward Heath suggested a similar movement. It was far from an auspicious time for the BBFC to be pushing for greater liberalisation, and, sure enough, their efforts were met by the opposing backlash of moralising pressure groups and campaigns such as the Nationwide Festival of Light and the National Viewers' and Listeners' Association (NVALA). The impact of such groups, their members no doubt emboldened by the political tailwind, was considerable in terms of public visibility: in September 1971, for instance, the Festival of Light gathered around 35,000 supporters in Trafalgar Square.[9] Notable figures in the ranks included Malcolm Muggeridge, Mary Whitehouse and Lord Longford, whose Commission on Pornography (1971–2) concluded that pornography led to 'deviant obsessions and actions' and recommended a tightening of appropriate legislation such as the Obscene Publications Act, and closer control of the BBFC by the government.

The Festival of Light and the NVALA took aim at what they perceived to be the 'pernicious' influence of cinema, and repeatedly attacked the Board's decisions on films featuring 'excessive' representations of sex and violence. *The Devils* had been singled out by the Christian-based Festival of Light since it was also considered blasphemous. In February 1972, four members of the group met senior Home Office officials to outline their proposal to replace the 1952 Cinematograph Act and introduce 'Y' and 'Z' ratings for pornographic content, suggesting that people under the age of twenty-five should not be admitted.[10] When official approaches proved fruitless, the pressure groups turned to alternative strategies to further their aims, including (vain) attempts to block *Last Tango in Paris* and *La Grande bouffe* (1973) via private prosecutions.

In the teeth of such campaigns, however, there were signs that the Board itself was pressing ahead with a tentative move towards greater liberalisation. With at least 70 per cent of audiences now made up of people between the ages of sixteen and thirty-five,[11] it is only to be expected that many filmgoers were looking for movies that engaged much more explicitly with their own lives, culture and values. The BBFC found itself in something of a cleft stick; as Murphy wrote to one outraged cinemagoer in reply to a complaint about the certification of *Straw Dogs*:

Mary Whitehouse (left) singing with Judy Mackenzie in Trafalgar Square, London during a rally by the Festival of Light, 25 September 1971

There is a growing polarisation of public opinion in this country: of this we are well aware. As in my predecessor's day this Board will continue to exercise one of the stricter film censorships in the free world. We are, nevertheless, caught in this public debate, and there are certain films about which whatever judgement we make will be seen by many people to be wrong. In confidence, may I say that I have four such films on hand at the moment, knowing even before the films are completed, and the judgements made that we will be under attack from either the liberal wing, or from people who share your views. Such, I fear, is the fate of those of us who do not take up one or other of the extreme positions.[12]

For those working at the BBFC, who, according to Murphy, understood their roles not as 'moral guardians of society' but as 'that of reflecting the taste and attitudes of intelligent public opinion in Britain',[13] this was a calibrating act that has remained a central dilemma ever since.

If, according to Lord Harlech, 'the public attitude to films is largely expressed through the local authorities',[14] then the tensions between the Board and local councils (who, after all, were the bodies with statutory power in terms of film exhibition) also suggest that the majority of cinemagoers had more robust mental constitutions than the Board imagined, since during this period the councils began to flex their autonomy, passing films uncut that the BBFC refused to certificate at all. Indeed, a motion to abolish film censorship altogether raised in a debate by the Greater London Council was only narrowly defeated in January 1975.[15] As in the US, the right-wing backlash was by no means unanimous, with many committed to continuing liberal reform; the feminist movement in particular remained in the vanguard, picketing demonstrations by the likes of the Festival of Light. Groups like the National Council for Civil Liberties, the National Co-ordinating Committee against Censorship and the Campaign for the Abolition of Film Censorship, the latter vocally supported by the recently retired John Trevelyan himself, provided a counterweight to the moralising of the likes of Mary Whitehouse's NVALA.[16]

The Press

John Trevelyan had always prided himself on his 'friendly relationships with the film critics' whom he felt 'gave me a very fair deal throughout my period of office'.[17] His memoir does, however, express a degree of irritation at inaccurate reporting of the BBFC's activities, particularly when the implication was that the Board had been overly censorious, and he was quick to try to correct and balance out bias or misconception. Stephen Murphy was not as fortunate as his predecessor. From his earliest days, largely on account of the triple whammy of *The Devils*, *Straw Dogs* and *A Clockwork Orange*, the pressure from newspaper coverage was intense. Reviews, editorials and press reports often seemed intent on provoking (while simultaneously titillating) the newspapers' more conservative readers – a wearyingly familiar tabloid strategy.

Press coverage was central to the controversy surrounding Ken Russell's film *The Devils*. Adapted from Aldous Huxley's book *The Devils of Loudon* (1952), via John Whiting's 1960 play bearing the same title as the film, it told the story of a seventeenth-century French priest burned at the stake for seducing a convent full of nuns in his parish. The film as submitted to the Board far exceeded the limits of what was deemed acceptable at the time, including a scene in which nuns cavort with a life-sized figure of the crucified Christ, and the sight of Vanessa Redgrave's character masturbating with the charred bone of her lover's corpse. Even before its submission, however, significant elements of the press had been aligning themselves with the moral campaigners, and the BBFC, as a prominent gatekeeper for the kind of popular culture deemed objectionable by the UK's 'silent majority', was a high-profile target for some, notably Felix Barker of the *Evening News,* Alexander Walker of

Oliver Reed and Vanessa Redgrave in *The Devils* (1971)

"DUSTIN HOFFMAN'S FINEST PERFORMANCE SINCE 'MIDNIGHT COWBOY'!"

"A BRILLIANT FEAT OF MOVIE-MAKING!"

"IT FLAWLESSLY EXPRESSES THE BELIEF THAT MANHOOD REQUIRES RITES OF VIOLENCE"

ABC PICTURES CORP. presents

DUSTIN HOFFMAN

SAM PECKINPAH'S

"STRAW DOGS"

A DANIEL MELNICK Production

Starring SUSAN GEORGE as Amy Music by JERRY FIELDING Screenplay by DAVID ZELAG GOODMAN
and SAM PECKINPAH Produced by DANIEL MELNICK Directed by SAM PECKINPAH **R**
A SUBSIDIARY OF THE AMERICAN BROADCASTING COMPANIES, INC. [COLOR] DISTRIBUTED BY CINERAMA RELEASING

'For the first time in my life I felt concern for the future of the cinema': Dilys Powell on *Straw Dogs* (1971)

the *Evening Standard* and Fergus Cashin of the *Sun*. *The Devils* acted as a lightning rod: reports from the shoot, for example, included a story that a number of actresses had been sexually assaulted by actors on set.[18] The debate about passing the film was intense and protracted, and there was a degree of shock and outrage among critics, audiences and even the examiners themselves when a (significantly cut) version of the film was finally certificated.

With *The Devils* furore still raw, the UK release of *Straw Dogs* at the end of 1971 and *A Clockwork Orange* six weeks later led to a flood of reviews and opinion pieces brandishing rhetorical questions about the purpose and viability of the BBFC. Sam Peckinpah's film told the story of an American peacenik, David (Dustin Hoffman) and his young British wife, Amy (Susan George) returning to her home village, only to have the community slowly turn on them. Sexual tension and jealousy over Amy leads to a violent rape, and the film climaxes with a siege of Amy and David's home that seemed more appropriate to one of Peckinpah's Westerns than to the film's Cornish location. Kubrick's film was entirely different (although critics often linked the two in their reviews and opinion pieces): urban, icy and clinical where Peckinpah's film was earthy, passionate and instinctual, *A Clockwork Orange*, adapted from Anthony Burgess's 1962 novel, chronicled the adventures of a teenage delinquent, Alex (Malcolm McDowell), and his gang of 'droogs', and Alex's capture and brainwashing under an experimental regime aimed at rendering him incapable of committing further acts of violence. Kubrick's film included two rape scenes, as well as other scenes of sexualised nudity and violence. One sequence, in which the droogs kick a tramp to death, was blamed for two incidents of copycat violence, one in Oxford and one in Manchester,[19] as well as others in the US.[20]

Although press coverage of *The Devils* had been aggressive, it was these two films that provoked the firestorm. Fergus Cashin accused Murphy directly of 'open[ing] the floodgates of pornographic violence as depicted in the gang rapes of Clockwork Orange, and the obscure sadism of Straw Dogs'.[21] Some reviewers of *Straw Dogs* dismissed it as 'sadistic porn'[22] and a 'raw presentation of salacity and mayhem'.[23] Margaret Hinxman, by contrast, would declare Kubrick's film 'a masterpiece',[24] and Walker, branding Murphy's certification of Peckinpah's film 'a dereliction of duty',[25] would shortly after select *A Clockwork Orange* as his number one film of the year.[26] The highly respected critic Dilys Powell declared in her review of *Straw Dogs*, 'For the first time in my life I felt concern for the future of the cinema'.[27] The *Sunday Mirror* wanted to know, 'How much more violence, sadism, and rape is [...] Stephen Murphy going to let movie-makers get away with?'[28] The *Sun* namechecked both *Straw Dogs* and *A Clockwork Orange* when it affirmed, '[F]ilms like this, it seems to us, are far more likely to inflame people to violence than conventional pornography is to inflame them to sex'.[29] (See the case study on *A Clockwork Orange* for further discussion of that film.)

More significantly, a group of fourteen film critics put their signatures to a letter published in *The Times* on 17 December 1971, damning *Straw Dogs* by arguing that the use to which it

employs its scenes of double rape and multiple killings by a variety of hideous methods is dubious in its intention, excessive in its effect and likely to contribute to the concern expressed from time to time by many critics over films which exploit the very violence which they make a show of condemning.[30]

Murphy and the BBFC President Lord Harlech's response to *The Times* letter offers a considered but robust riposte to all of this, describing a screening of the film that had taken place before an invited audience chosen to represent all sectors of the population, and noting that a majority of them 'disagreed with the [*Times* letter's] critics' strictures of the film' and that 'the board's decision to certificate it was not seriously questioned'.[31] With the strong backing of the Board's President, Murphy survived the storms of 1971–2 intact, if a little wiser and more cautious. On occasion, Murphy would use the press to his advantage, citing it as an indicator of public opinion when it supported a position he had taken himself: thus, when controversial sex education film *Love*

Variations (1971) generated innumerable press clippings about the different decisions from various local authorities, Murphy justified a U-turn on its certification (the Board had initially declined it a rating) in part by referring to favourable reviews. Likewise, positive responses from the French critics ahead of the submission of *Last Tango in Paris* were cited to justify minimal cuts to the infamous anal sex scene, even though this did not stop papers such as the *News of the World* and the *Daily Mirror* from publishing huffing and puffing reviews and opinion pieces after its release: the *Evening News,* the *Daily Mail* and the *Daily Express* also railed against the decision to pass the film with only a token ten-second cut.[32]

The Board's sensitivity to press coverage occasionally raised the hackles of figures within the industry: in an argument over the certification of his Western *Chato's Land* (1972), for example, Michael Winner suggested that the Board was being 'over-influenced by the sensational press or the more extreme local councils'. He was prepared to concede certain cuts only 'because I am appreciate [sic] of the present position as regards the Board and the publicity you have been receiving'.[33] Murphy countered by appealing to him to look at their dispute over a final edit 'in the whole context of the problems about screen violence in this country', adding, 'we are asking everyone to keep violence in films down to the minimum possible'.[34] Refusing the crime drama *Bloody Friday* (1972) a certificate, Murphy admitted that the examiners had been 'slightly alarmed that it contained certain immediately imitable ideas that we thought potentially socially dangerous', and added, 'You must also understand that there is a very considerable pre-occupation in Britain today with violence in the media'.[35]

If the Board could be accused of having been overly cautious in its regulation of screen violence at the beginning of the 1970s, it is important to remember the volatile social and political context of the era; the Troubles, for example, were hitting the headlines with greater frequency at the turn of the decade, with the militant Provisional Irish Republican Army forming in 1969 and the loyalist Ulster Defence Association in 1971. On 30 January 1972 (what came to be known as 'Bloody Sunday'), members of the British parachute regiment shot and killed fourteen demonstrators, and by the end of the year nearly 500 men and women would die in the sectarian conflict. While it would be an exaggeration to say that the fears about screen violence were on a scale commensurate with the moral panic surrounding the 'video nasties' in the 1980s, Murphy and his examiners were keenly aware of debates in the media and among politicians, and they would make reference to those concerns in letters to distributors to justify cuts or rejections.

The Devils, *Straw Dogs* and *A Clockwork Orange* would all become key touchstones in the debate over screen violence: Murphy referred directly to the latter two in his justification of a rejection of *Bloody Friday*, arguing that they were both 'very serious films with something to say about the problems of violence in modern society, and employing violence only to make their point'. He told the distributor it was impossible to view *Bloody Friday* in the same light.[36] The decisions about the triumvirate would reverberate in a number of ways, not least with respect to the debate about art and exploitation, and I will return to them in this context at the end of the chapter. For now, it is enough to note the impact of the films on the public consciousness via the occasionally hysterical press coverage they received, and the subsequent increased sensitivity on the part of the examiners as they continued to cut and certificate 'X'-rated films as the decade wore on.

Local Councils

One of the striking aspects of Murphy's time as Secretary of the Board is the way in which the relationship between the BBFC and local councils, previously relatively stable, began to crack and shift during his four-year tenure. Although it was the councils who had the power to ban a film from exhibition, until the turn of the decade the policy was almost always that if a film was passed by the BBFC, the local authorities would follow suit. The alternative, as one chair of a film-viewing sub-committee put it, would have been 'total chaos'.[37] Murphy, however, chose to build upon Trevelyan's practice in the 1960s of encouraging local authorities to classify films the Board did not feel it could approve nationally, a practice which had allowed Trevelyan to test public and critical reaction to a film before making a decision on BBFC classification. With the arrival of a new generation of films far more likely to provoke and disturb those given the responsibility of viewing them at local-authority level, by acknowledging far more openly the councils' legal powers, the Board was effectively undercutting its own traditional position as final arbiter. As a result, it would not take long for matters to unravel in something not far removed from the chaos Patterson had feared.

The relationship had first come under scrutiny when a number of sex education films began to appear on the Board's radar around 1968. *Love Variations*, a 'documentary' exploring sexual positions, was typical of the genre, and its press book soberly stated that 'The film does not seek to entertain – only inform'.[38] The Board seemed unsure as to how to proceed. One letter written by Trevelyan suggests that while they accepted the argument that the film was educational, they also felt that 'a good many people [...] would feel that this kind of film should not be exhibited in cinemas which are essentially places of public entertainment'.[39] Only after a large number of councils passed the film did Trevelyan agree to certificate it, and the Board's hesitation seemed to provoke a certain amount of consternation: members of Halifax County Council, for instance, wrote that they

The Board hesitated over the 'sex education' film *Love Variations* (1971)

were perturbed by the attitude of the Board of Censors and particularly by their decision to categorise the film after first refusing it a Certificate, and then to advise local authorities so that, in effect, the onus of responsibility has been thrown on to local councillors.[40]

Somewhat snippily, Trevelyan replied,

Your members have perhaps forgotten that in law the responsibilities for film censorship, as far as cinemas licensed by them are concerned, rests with your Council, and in effect this Board acts as an agent for licensing authorities, while such authorities always have the power to alter or modify any decision made by the Board.[41]

The damage to the BBFC in terms of its reputation for unassailable judgment was probably exacerbated by the press attention, which featured numerous headlines about the Board's treatment of what was generally believed to be the most explicit sex film yet seen in the UK. In any case, what was framed in a letter to local authorities as policy ('We have been watching the position [on censorship of the film], and trying to assess public reaction')[42] smacked more of indecision, and impacted on far more culturally significant films than *Love Variations* or *Ur kärlekens språk* (*Language of Love*, 1969). In 1971, fourteen local councils would overturn the BBFC's certification of *The Devils* and ban it from exhibition, although the GLC would at the time reaffirm its commitment to a policy of accepting films passed by the Board,[43] despite a concerted campaign by the Festival of Light.[44]

A number of films would also find their distribution considerably disrupted by local decisions in the years that followed. However, even when local councils disagreed with a BBFC ban, they would sometimes follow the Board's advice on cuts: *The Bloody Fists* (1972), for example, was refused a certificate until 1976 but in 1974 the GLC passed it for exhibition after significant cuts primarily to violence inflicted with weapons such as chainsticks, thus following BBFC guidelines on the matter.[45] In other cases, films rejected by the Board would be passed by numerous local authorities, as happened with *Las poseidas del demonio* (*The Demons*, 1972), which would not be certificated by the BBFC until its home video release in 2008. Other films would split opinion quite radically at local level: Paul Morrissey's *Heat* (1972), for example, was cut by the BBFC for scenes of masturbation and fellatio, allowed through uncut by the GLC and banned in Surrey and Essex, while Berkshire allowed it subject to the cuts proposed by the Board; *Daddy Darling* (1970), rejected by the Board for the 'double theme of incest and lesbianism' according to Murphy in a letter to Brighton Borough Council,[46] was passed with an 'X' by that authority, and allowed after cuts to the lesbian scene as early as September 1971 by the GLC; *Oh! Calcutta!* (1972) was

refused a certificate, and in the intervening years, especially 1974–5, dozens of local authorities passed it, one by one, until the Board finally followed suit in 1978.

* * *

Having considered some of the key arenas for controversy during the handover from John Trevelyan to Stephen Murphy, and Murphy's subsequent tenure, it is time for a closer look at the day-to-day censorship and certification processes. The fact that the Board had no written guidelines or published policy on issues such as the representation of violence or sex in the 1970s makes it at times difficult to determine precisely what decisions were being made, and on what basis. At the time, it seemed a natural part of the Board's methodology and, indeed, philosophy to avoid official, concrete guidelines: John Trevelyan seemed proud of the fact that they had none, and instead operated a kind of 'case law' system, where each film was judged individually, in the light of previous decisions, and Murphy adopted the same practice. Judgments made about particularly notorious films such as *The Devils* or *Straw Dogs* are well documented and relatively easy to track. However, what this fails to give us is a sense of the bigger picture: the Board found itself on the back foot in the early part of the decade, largely reactive in the face of the sudden influx of controversial material, and a survey of the archive reveals key 'triggers' that would most often lead to cuts or bans. From there it is possible to build up a picture of how censorship decisions evolved over the period, in the wake of the flood.

Violence

In the late 1960s, a number of films had broken new ground in their unflinching representations of violence, notably Robert Aldrich's war film *The Dirty Dozen* (1967) and, in the same year, Arthur Penn's *Bonnie and Clyde*, which had pioneered the use of squibs (small explosive charges) to represent bullet impacts and the consequent spurts of blood; Peckinpah took the same technique and heightened the effect with the use of slow motion and montages in his Western *The Wild Bunch* (1969). The following year, *Soldier Blue*, another Western, also featured close-up footage of bullet impacts, as well as a brutal rape scene featuring nudity, and a decapitation (both cut by the Board). As the 1970s dawned, such scenes of violence became increasingly common in mainstream, box-office hits such as *The Godfather* (1972), which included a scene strongly

Faye Dunaway as Bonnie Parker in *Bonnie and Clyde* (1967)

reminiscent of the climactic killing of the eponymous characters in *Bonnie and Clyde:* the depiction of Sonny (James Caan) being mown down in a hail of machine-gun fire was cut by the BBFC to reduce the number of bullet impacts as well as a kick to the head. Other films followed the trend, and the bloodiest shootings were edited out of a number of films around this time, including crime dramas like *The Stone Killer* (1973) and *Anna, quel particolare piacere* (*Secrets of a Call Girl*, 1973) and war pictures like *Murphy's War* (1971); graphic representations of blunt trauma were also singled out (for example, *Ricco* [1973]), although less frequently, until martial arts movies began to have their own particular impact.

Of greater concern to the Board, however, was a sudden rise in films depicting far more extreme acts of violence: although it is a difficult category to define, a survey of the Blue Books for instances of what I call 'extreme violence' (what the BBFC might today call 'strong, bloody violence') reveals that the amount of films cut on these grounds in this period was substantial:[47]

NUMBER OF FILMS CUT FOR SEQUENCES OF 'EXTREME VIOLENCE'

1970	1971	1972	1973	1974	1975
17	8	26	32	42	21

By the early 1970s, independent film-makers from the US and the continent were experimenting with the horror genre, producing prototypical slashers such as *Reazione a catena* (*A Bay of Blood*, 1971), a film refused a certificate 'on the grounds of the extreme violence of the murders scattered throughout',[48] and *Frightmare* (1974), which suffered cuts to scenes of a boy being killed by a pitchfork to the face (reduced to two blows) and blood gushing from a girl's mouth after being stabbed with a poker. Another 'exploitation' piece, *Exposé* (1976), had a number of shots of bloody stabbings cut, although its sexual violence was more of a concern (see below). At the other end of a putative art/exploitation scale, Pasolini's *Il fiore delle mille e una notte* (*Arabian Nights*, 1974) ran into trouble for a scene in which a girl's hands and feet (and finally her head) are cut off, even though a letter from Murphy to the distributor does note that the actual impact is 'out of vision'.[49] In more familiar horror mode, typical examiners' notes include a request to reduce 'general goriness' in *Una vela para el diablo* (*A Candle for the Devil*, 1973).[50] From *Non si deve profanare il sonno dei morti* (*The Living Dead at the Manchester Morgue*, 1974) various shots of mutilation, including a scene depicting 'corpses ripping female telephonists [sic] body to pieces after they have strangled her with the telephone cord', were removed.[51] Footage of a character's eye gouged with pins was cut from *Hands of the Ripper* (1971),[52] while Paul Morrissey's take on the legend made popular by Hammer Studios, *Blood for Dracula* (1974), suffered extensive cuts to the sex scenes, but also had excised a scene of Dracula vomiting blood and another of him 'licking up hymenal blood from [the] floor'.[53]

Censorship of violence took a somewhat unexpected twist when the Bruce Lee vehicle *Enter the Dragon*, submitted in 1973, received several cuts.[54] In its wake, the martial arts genre would

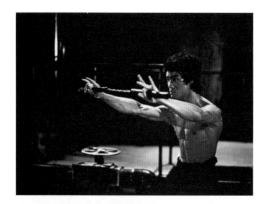

soon make its presence felt both via imported films and through an influence on homegrown US crime and action films, notably the blaxploitation franchise *Cleopatra Jones* (1973), *Black Belt Jones* (1974) and *Cleopatra Jones and the Casino of Gold* (1975). Cuts for martial arts-style violence are almost non-existent before 1973, when thirteen films were cut on this basis: this more than doubled the following year (to twenty-seven) before tailing off to five in 1975. The impact, however, was considerable: the Bruce Lee vehicle *The Big Boss*, made in 1971 and submitted for classification in 1974, had cuts to footage of weapons (knives, ice-picks and chains are mentioned), as well as 'close shots of kicks to heads'.[55] Nevertheless, Lee's films were relatively tame by Hong Kong standards, with some of the other imports considered simply too extreme: of *The Bloody Fists*, Murphy remarked that 'the violence [...] exceeds almost anything we have seen, and I have no alternative but to reject it'.[56] Other martial arts movies cut significantly in 1974 include *King of Kung Fu* (1973), *Kung Fu – The Headcrusher* (1972), *Hellfighters of the East* (1972) (noted in the Blue Book as requiring 'massive reductions'), *Deaf and Mute Heroine* (1971), *Enter the Tiger* (a.k.a. *Screaming Tiger*, 1973) (the distributor 'virtually removed reels 4 and part of 5' after an initial rejection, according to the Blue Book), and *Kung Fu Girl Fighter* (1972), where the company was asked to cut the violence 'by 50%'. A number of films were noted as having suffered cuts 'too numerous for detailed description' in the Blue Book in the same year.[57]

Details of such demanding cuts might give the impression that the Board was being particularly ruthless during this period. However, given the sudden spike in representations of violence at this time, it is probably more accurate to see it as engaging in a delicate operation of calibration, balancing the views of older cinemagoers against the predominantly youthful audiences supplanting them. There is no doubt that the more extreme, gory images (many of which have since been passed for home video at '15')[58] were subject to cuts, and there appears to have been growing concern about imitable violence – presumably related, at least in part, to the censorious attitude towards martial-arts movies.

(top) Bruce Lee in *Enter the Dragon* (1973), one of thirteen martial arts films cut that year; (bottom) The Board rejected *The Texas Chain Saw Massacre* (1974) but a number of local councils permitted its exhibition

NUMBER OF FILMS CUT FOR SEQUENCES OF 'IMITABLE VIOLENCE'

1970	1971	1972	1973	1974	1975
4	20	23	10	26	9

Although not singled out as such, so-called 'imitable' techniques were seen as potentially harmful in terms of their impact on audiences: kicks to the crotch and to the head and double earclaps are familiar examples.

One of the most significant cases during this period was Tobe Hooper's *The Texas Chain Saw Massacre* (1974), which was rejected outright by the Board. The level of 'terrorisation' was deemed to be unacceptable; furthermore, in a crucial development (in terms of film-making, of censorship, or both), it was decided that cutting the film would not resolve the problems, since it was the atmosphere of threat and impending violence that was the issue, rather than any specific representations of violent acts. Previously, films had been rejected when it was felt that the required cuts would damage the narrative or continuity too severely, but this was an unusual case in that it was the 'atmosphere' of the film that had been the deciding factor. At the time of the film's release, a number of local councils ignored the BBFC's decision and allowed the film to be shown.[59] However, it would not be passed by the Board until 1999.

Sexual Activity

At the turn of the decade, the taboo of nudity in film had already been breached. The Board was less well prepared for the proliferation of sex education films and, hard on their heels, a sudden rise in the number of pornographic films being submitted for classification, following a trend that had

They shared
the pleasures
of the flesh
and the
horrors
of the
grave!

RANK FILM DISTRIBUTORS LIMITED
PRESENTS

VAMPYRES

STARRING
MARIANNE MORRIS · ANULKA
MURRAY BROWN · BRIAN DEACON · SALLY FAULKNER
MICHAEL BYRNE · KARL LANCHBURY
Directed by JOSEPH LARRAZ · Produced by BRIAN SMEDLEY-ASTON
Screenplay by D. DAUBENEY. COLOUR

Vampyres (1974) received 'routine cuts' for its mixture of eroticism and horror

taken hold in the US. Over the next few years, the BBFC would be bombarded with sexploitation movies, many of which were refused certification. By December 1970, Trevelyan had announced his retirement from his post, confessing in an interview with the *Evening Standard* that he was 'sickened by having to put in days filled from dawn to dusk with the sight and sound of human copulation'.[60]

More significantly, nudity and ever more graphic representations of sexual activity were becoming increasingly common in mainstream movies, both in US and continental European film, and the impact was being felt by the American equivalent of the BBFC, the MPAA, which raised the age limit on 'R' and 'X' ratings from sixteen to seventeen. The studios responded by becoming increasingly cautious and by the end of 1969, according to Stephen Farber, 47 per cent of exhibitors were refusing to show 'X'-rated films, as the category was now firmly established as an indicator of pornography; furthermore, the majority of the press would not advertise them.[61] In April 1971, as Peckinpah worked on *Straw Dogs*, ABC production supervisor Lew Rachmil had sent a memo to the film director and his producer Dan Melnick with copies of an article from the *New York Times*, sent in order 'to re-inforce [ABC President Martin Baum's] caution that he realizes the picture will get an "R" rating […] but that it be an easy "R" and not one that could turn into an "X"'. The *Times* article claimed that a number of film companies had put 'an outright ban on X-category films', and had 'also decided to make very few, if any, R-category films'.[62]

The amount of sexually explicit material the examiners were having to deal with had clearly become a problem, as the table below shows:[63]

NUMBER OF FILMS CUT FEATURING SEQUENCES OF EXPLICIT SEX

1970	1971	1972	1973	1974	1975
36	25	30	40	39	30

Guy Phelps points out that the BBFC's working practices at this time determined that some sexual positions were allowed and others were not. 'Such rules no doubt encourage consistency of decision', he remarked, 'but any logical explanation for their retention is not forthcoming.'[64] A form of explanation, however, can be found in an examiner's note on the Swedish pseudo-documentary *Kär-lek, så gör vi: Brev till Inge och Sten* (*Love Play*, 1972) which refers to a scene depicting lovers lying in a position that the examiner describes as 'joint fellatio'.[65] The report goes on to describe, a little awkwardly, a scene depicting 'making love from behind' and notes, 'Both are "positions" not allowed under the present policy of "status quo"!'[66] In other words, the 'missionary position' is permissible in principle, while all other sexual positions are seen as outside the 'status quo' and are therefore subject to cuts.[67]

A number of terms were in use at this point to denote either anal sex or rear entry: as well as 'making love from behind', examiners deployed the terms 'rear sex' and 'back scuttling'; films cut for such scenes show one of the most well-defined changes over the period and evidently the trend here was not for more cutting by the Board but for more submissions of films featuring the act:

NUMBER OF FILMS CUT FOR SEQUENCES DEPICTING 'REAR SEX'

1970	1971	1972	1973	1974	1975
0	1	1	6	15	16

The Board appears to have held a fairly consistent line throughout the period, perhaps not entirely unexpectedly in the context of attitudes towards sex, and indeed what was permissible under the law at this time. Perhaps more surprising for a cinemagoer in the twenty-first century was the standard response to what the Board's examiners referred to either as 'riding' or 'straddling' (i.e. sexual positions with the woman on top). The figures for these scenes depict a definite rising trend, and such scenes were invariably cut or considerably reduced:

NUMBER OF FILMS CUT FOR SEQUENCES DEPICTING 'RIDING'/'STRADDLING'

1970	1971	1972	1973	1974	1975
4	9	8	11	17	21

Footage of masturbation (male or female) was usually removed or substantially cut, and the same went for oral sex, again regardless of gender specifics:

NUMBER OF FILMS CUT FOR SEQUENCES DEPICTING MASTURBATION

1970	1971	1972	1973	1974	1975
8	6	3	12	12	14

NUMBER OF FILMS CUT FOR SEQUENCES DEPICTING ORAL SEX

1970	1971	1972	1973	1974	1975
2	13	9	18	28	24

Paul Kersey (Charles Bronson) takes the law into his own hands in *Death Wish* (1974)

Such cuts seem to have been made routinely, regardless of context or the 'quality' of the film: Pasolini's *I racconti di Canterbury* (*The Canterbury Tales*, 1972) had a scene of anal sex and a brothel scene featuring fellatio cut and, at the other end of the spectrum, *The Case of the Smiling Stiffs* (1973) was refused a certificate: the final murders, dubbed 'fellatio killings' by the examiners, were felt to be tantamount to hardcore pornography.[68] Other sex comedies like *Sex Clinic* (a.k.a. *With These Hands*, 1971), *Das sündige Bett* (*The Sinful Bed*, 1973) and *The Ups and Downs of a Handyman* (1975) were cut for representations of oral sex and/or masturbation. The trend for softcore lesbianism in horror led to routine cuts, too: for example, *Lust for a Vampire*, *Twins of Evil*, *Les Lèvres rouges* (*Daughters of Darkness*, also cut for *implication* of fellatio and mutual oral sex) (all 1971), *The Demons* and *Vampyres* (1974). Lesbianism became a feature of exploitation films such as *Exposé* (cut for lesbianism, masturbation with a vibrator and consensual rear-entry sex). Even implied oral sex could be targeted: softcore comedy *The Naughty Stewardesses* (1975) was cut for a scene in which a woman licked cream from a clothed man's crotch area.[69] Nevertheless, such cuts were not always enough for some members of the public: one outraged viewer, buying a ticket for *Naughty* (1971) in the expectation of a 'sex comedy', was outraged by 'the scenes depicting fellatio and reference to them'; the enraged correspondent, with a sidelong reference to the OPA, told Murphy, 'You must be an evil man to pass such filth and this could well corrupt and deprave anyone'.[70]

Sian Barber has noted the Board's tendency to cut more readily scenes depicting female sexual pleasure, particularly when depicting women 'taking this pleasure with other women and not with men'.[71] However, it is possible to chart some modulations over the five-year period:

NUMBER OF FILMS CUT FOR SEQUENCES DEPICTING LESBIANISM

1970	1971	1972	1973	1974	1975
17	7	9	11	26	16

What the raw statistics do not reveal is that the cuts were most frequently couched in terms of 'remove' in 1970–1; by 1972, 'shorten' or 'greatly reduce'; and by 1973–4 'reduce' (with the occasional 'considerably reduce' or 'remove the detailed lesbianism' – clearly the exact nature of the footage would have been a factor in determining the extent of the cuts required). In other words, a gradual modulation of the Board's attitude towards this kind of sexual activity is in evidence. Representations of male homosexual activity, however, were far less common; Barber describes Trevelyan's concerns over the 1971 film *Villain*, expressed in a letter to the producer, namely that the homosexual relationship depicted between two male characters be removed 'entirely': 'As you know, homosexuality is not a popular theme with the main cinema audiences in this country', he declared. He continued with a rather surprising assertion that the film might encourage 'stimulation': 'I have in mind these horrible cases that we get occasionally where naked young men are found dead, tied up and mutilated.'[72] A few other films featuring male homosexuality were also treated ruthlessly: *Goodbye Gemini* (1970), for example, had cuts to a sex scene involving 'Myra and another homosexual transvestite'.[73] Rather oddly, *Eskimo Nell* (1975) had a cut described thus: 'Remove word "Vaseline" on Scrabble Board & shot of homosexual's face as he looks at it'.[74]

Sexual Violence

Sexual violence would become perhaps the most enduring and vexed issue in UK censorship over the next forty years, and *Straw Dogs* would establish itself as a landmark in the Board's regulation of its representation on cinema screens and, in due course, on home video, with the introduction of the Video Recordings Act 1984 (VRA).[75] The film features a double rape in which the character Amy is first assaulted by a former lover, Charlie (Del Henney); what begins as a brutal attack seems to turn into consensual love-making. A short time later, Charlie's friend Scutt (Ken Hutchison) arrives at the house and, after an initial refusal, Charlie turns Amy onto her front and holds her down while Scutt rapes her from behind. After seeing the first cut of the movie, and having discussed it in detail with Dan Melnick, Murphy made a number of requests for cuts, including some significant editing of the second rape. Unfortunately, the inadvertent outcome of the edits was that it was no longer clear whether Scutt's attack was rear entry or anal rape. An undated note in the BBFC archive admits that '[t]his impression [anal rape] is a result of the Company's cuts to reduce the sequence to help us'.[76] Having demanded the cuts in the first place because he felt the scene was 'far too long – giving, it seemed to me, the feeling that the film was wallowing in it', the 'drastic shortening' of the sequence

had led to this unfortunate impression. Whatever might have been intended, the attempt to censor such sensitive sexual material had done nothing but create a more complex controversy.

Michael Winner's *Death Wish* (1974) is another film that would later be caught under the wheels of the VRA.[77] The initial debate centred on the combination of the explicit visual nature of the rape and the repeated use of the word 'cunt' in an aggressive context. In a long exchange of letters between Winner and Murphy, the Secretary outlines in some detail the reasons for the BBFC's sensitivity about the issue, arguing that 'not even murder' carries 'quite the emotional revulsion of rape' in the British mindset.[78] Winner protested that the scene in question was justified in the context of the revenge narrative and was 'considerably less severe' than similar scenes passed by the Board[79] – a point Murphy disagreed with.[80] *Death Wish* was eventually passed uncut, although it would later be edited for home video release.[81]

The accepted wisdom is that James Ferman had a very specific influence on BBFC certification practices with regard to sexual violence, and both *Straw Dogs* and *Death Wish*, with their long-term bans, would prove that point in the 1980s and 1990s. However, this can obscure the fact that there was already a fairly fully formulated policy on sexual violence at the beginning of the 1970s, with routine cuts or bans: in 1972, rejecting the biker movie *Wild Riders* (1971), Murphy's letter acknowledged, 'Sex coupled with violence is our greatest problem', and went on to note how *Straw Dogs* and *A Clockwork Orange* were 'bringing down the roof on our heads'; '"WILD RIDERS"', he continues, is 'one great long screaming sexual assault, sometimes implicit, sometimes explicit, from beginning to end'.[82] Similarly, a letter to the distributor of the rejected *The Candy Snatchers* (1973) refers to the film's scenes of 'sexual violence which, as you know, is one of the Board's main concerns'[83] and *The Last House on the Left* (1972) is described as dealing with 'the very area of sexual violence which the Board finds most difficult'.[84] The chart below shows how frequently sexual violence featured in 'X'-rated films in this period.

NUMBER OF FILMS CUT FOR SEQUENCES FEATURING RAPE OR OTHER SEXUAL VIOLENCE

1970	1971	1972	1973	1974	1975
17	26	24	18	24	21

To give a sense of the kind of material cut, some brief examples: *Bamboo House Dolls* (a.k.a. *Bamboo House of Dolls*, 1973) was rejected for 'brutal' rape scenes and a scene in which 'a lecherous soldier amuses himself by throwing broken glass at a woman, torturing her with the point of his sword before raping her on a floor covered with broken glass'.[85] *Exponerad* (*Exposed*, 1971) suffered considerable cuts to its rape scene, as well as to a bondage sequence; and *The Hunting Party* (1971) went back and forth between the Board and the distributor at least three times before an acceptable edit of its rape scenes was agreed. Instances of forced fellatio were often also singled out for cuts, as in *Blood for Dracula*,[86] although equivalent footage in *Death Wish* would not be cut until 1987.

Other scenes would be cut for merely associating sex and violence in ways deemed inappropriate: for instance, the Board refused to allow the shot of a gun being rubbed along a woman's breasts in the opening scene of Russ Meyer's *Beyond the Valley of the Dolls* (1970). *The Hot Box* (1972) was cut substantially, for scenes including sexual humiliation and forcible stripping; in the *giallo* genre piece *I corpi presentano tracce di violenza carnale* (*Torso*, a.k.a. *Carnal Violence*, 1973), footage of 'sight of gash made between breasts of dead girl' and 'sight of killer caressing muddy breasts of girl he has killed' was removed;[87] a shot of Fiona Richmond's character's legs streaming with blood was cut from *Exposé*; and footage of naked bloody bodies was cut from the pre-credit sequence of *Vampyres*. It is also worth noting that it was not only footage featuring women as victims of sexual assault that was deemed objectionable: a scene from *La figlia di Frankenstein* (*Lady Frankenstein*, 1971) was cut substantially, with the exception form noting: 'The suggestion that Tanya is astride Thomas and experiencing sexual satisfaction while Charles suffocates him must be removed'.[88]

The Legacy of the Murphy Era

When Ken Russell submitted *The Devils* to the scrutiny of the BBFC, one examiner described it as 'a nauseating piece of film-making', and another, 'thoroughly sick and kinky'.[89] The latter made explicit his intent to 'demolish any argument by Ken Russell that his film is a serious work of art'; this was a deliberate attempt to counter the justification offered by Trevelyan and Harlech, who

The BBFC's Secretary, Stephen Murphy, and its President, Lord Harlech, in 1975

The Last House on the Left (1972): '[I]f we are to go in to this area of sexual violence, it will have to be for a film in which we detect greater merit than this'

Sylvia Kristel as
Emmanuelle (1974)

were convinced that it was exactly that. In the end, Harlech's passionate belief in *The Devils* as a sincere artistic statement prevailed and, despite cuts, the film was finally granted an 'X' certificate. It has been a familiar allegation aimed at the Board's practices over the years that 'arthouse' films tend to be treated with a greater degree of leniency for representations of violence and particularly sex than their mainstream counterparts.[90] The unspoken assumption is that the more artful films will attract more intelligent viewers, who are in turn (perhaps) less likely to be negatively 'influenced' by what they view.

While there is no overt practice of this kind any longer at the offices of the BBFC, the agenda in the 1970s was clear and unapologetic: if a film crossed any of the unwritten but, as I have shown, well-understood boundaries of taste that the Board had established, the artistic quality of a film was a key criterion in determining its fate. *The Demons*, for example, was described as having 'no object other than pandering to the lowest tastes of the audience' and the conclusion was, 'we consider it should be rejected'.[91] Similarly, *Ilsa, She Wolf of the SS* (1975) was rejected by Murphy in 1975 and again by Ferman the following year, who remarked, 'The intercutting of sex with atrocities is not, we feel, a legitimate basis for entertainment, and the film has no higher or remotely serious purpose at all.'[92] Neither Trevelyan nor Murphy was afraid to be caustic: the former told the distributor of *Bloody Mama* (1970), 'If you will make these films of nasty and sickening violence you must expect rough treatment from us';[93] the latter told the Director-General of the GLC that '"BLOODY FISTS" in our view is cheap, nasty, vicious and undeserving of certification'.[94] *The Last House on the Left* was rejected with the admission, 'May be [sic] we are wrong. But if we are to go in to this area of sexual violence, it will have to be for a film in which we detect greater merit than this.'[95] Certain distributors attempted to dispute cuts and bans with an appeal to precedent-setting cases. Murphy's responses were consistent, and based solely on the same criterion of artistic merit; so, a film about bank robbers, *Bloody Friday*, was rejected thus:

> I am afraid that I can not [sic] see any relevance in the comparison with 'STRAW DOGS' and 'A CLOCKWORK ORANGE', both of which were, in our view, very serious films with something to say about the problems of violence in modern society, and employing violence only to make their point.[96]

Nevertheless, once again the BBFC was eager at least to try and calibrate its responses along this axis of art and exploitation. Asked by one council about the certification of *Emmanuelle,* Murphy wrote that

> as a result of the editing process, [the film was brought] to a level that we thought acceptable to British taste […]. We are reinforced in the view that this was the right course by the fact that the national press seem to see it as a film of some merit, though not a great work of art.

He goes on to mention that the only written complaint received so far had come from the Festival of Light.[97] The push of liberalisation was often to be resisted by the pull of a more old-fashioned sense of 'taste and decency': Trevelyan wrote to the distributor of *Bloody Mama* that

> [t]he fact that other countries do not worry about [the scenes regarded by the Board as unacceptable] is not really relevant, and merely makes me think that we have more sense than they have; indeed, owing to our activities here, perhaps there may yet be some hope for this small country.[98]

For Murphy, it would seem, his was a very *British* Board of Film Censors.

The period from 1970 to 1975 saw some of the most significant changes in certification practices in the Board's history. A confluence of a rise in films significantly more graphic in terms of sex and violence, changes in audience expectations, increases in pressure from newspapers, moral pressure groups and the general public led to a reappraisal of the Board's role as cultural gatekeeper. The changes can be tracked through the histories of the most notoriously controversial films of the period, but, as we have seen, many other films long since forgotten, or at least largely neglected, have their own stories to tell.

CASE STUDY: THE PANIC IN NEEDLE PARK (1971) Murray Perkins

John Trevelyan felt that *The Panic in Needle Park* presented 'a picture of sordid and degraded human life'

In *The Panic in Needle Park*, Al Pacino plays Bobby, a heroin addict in New York City. It is a critically well-regarded look at the life and lifestyle of a drug addict; the film won Pacino's co-star Kitty Winn the Best Actress award at the 1971 Cannes Film Festival. In its representation of drug addiction, it is far removed from cinema's earlier portrayals in notable exploitation films like *Reefer Madness* (1936) and *Marihuana* (1936), with their now comically blatant anti-drugs messages. *The Panic in Needle Park* is born of a different time and followed *The Trip* (1967), *Easy Rider* (1969) and *Trash* (1970), all aiming to present more realistic portrayals of drug use. Paul Morrissey's *Trash*, in particular, was to play a prominent role in the classification of *Needle Park*.

The Panic in Needle Park was first submitted to the BBFC on 16 June 1971. In the original examiner's report, it was noted,

> On several occasions we see, in close-up, preparation of 'fixes', people injecting themselves or each other and the making up of sachets of heroin in great detail by the main pusher. Since drug addiction is becoming an increasingly serious problem in this country, we think that a film of this particular type would be against public interest.[99]

The BBFC's Secretary, John Trevelyan, wrote to the distributor Twentieth Century-Fox to inform them he had seen the film and was not prepared to issue it a certificate, stating,

> You will know that for many years this Board has taken a strong line about films concerned with drug-taking, basing its policy on the many personal tragedies that drug-taking has produced. While it is true that this film shows that the taking of heroin leads to personal degradation, at the same time it draws attention to drugs.[100]

Trevelyan ended his letter with his own observation: 'I might add that in my personal opinion this film is unlikely to be attractive to many cinemagoers since from start to finish it presents a picture of sordid and degraded human life.'[101]

When Stephen Murphy replaced Trevelyan, *The Panic in Needle Park* was seen again. A note added in February 1972 to the bottom of the original examiner's report follows the viewing by Murphy: 'It was agreed that this is a powerful film but its showing for the time being (cf Trash) could not be more inopportune'.[102] The note stated further that Murphy would 'tell the company that it would be best to hold the film back. But his feeling is that it should eventually be passed with cuts in some of the scenes in which the injections are prolonged and in close-up'.[103]

Murphy then wrote to Twentieth Century-Fox, expressing a different view to that of Trevelyan:

> I saw 'PANIC IN NEEDLE PARK' again yesterday, and I think it is a tremendous film. The problem is largely a political one. First, I know that some Local Authorities will object to any film which shows as much detail of drug-taking as this one does, and I fear that we will have to ask you for some cuts in it. But, secondly, I am sure that this is the wrong time to release it because it would make our position on 'TRASH' untenable. As you will know 'TRASH' is a fiction film about drug-taking. It presents two problems. One is its whole attitude towards drugs, and the loving care with which it dwells on drug-taking. The second is the problem of taste which it presents. 'PANIC IN NEEDLE PARK' doesn't present the second of these problems, but it certainly does the first, and in any case the critics would not discriminate between the two since, oddly enough, it was

our rejection of 'TRASH' which started up the whole row about 'STRAW DOGS'. You will I know forgive me if I say that I am reluctant to see it all start up again.[104]

Murphy suggested to the distributor that a release in September or October would be preferable, and asked that he be reminded of the film at that time.[105]

But the 1972 release never happened, with the distributor itself choosing not to pursue the classification. Instead the BBFC would next see the film when it was resubmitted, and passed uncut, on 21 November 1974. A brief handwritten note on the back of an earlier letter from the distributor determines,

[t]hough we found the film very squalid and in parts disgusting – especially CU's of injections – we decided to pass it X, uncut. It undoubtedly has power, a classic example of cinema verite tendencies, and we are convinced it would be a deterrent to this form of addiction.[106]

It would fare less well when it was submitted for a video certificate in 1987 and viewed on 15 April. An examiner said,

On film, I'd still be quite happy to pass it '18' uncut; but on video it presents problems for 'viewing in the home', mainly because of the replay/instructive factor […]. [S]ome heroin addicts still do inject, partly because it gives them a faster 'buzz', and partly because the needle itself is attractive to them in a quasi-sexual way. For this reason, lingering close-ups of injections, or close-ups which show the technique of mainlining in a copiable way have to be treated with extreme caution on video.[107]

This concern about imitable techniques and drug addicts being attracted to the sight of needles piercing skin led to fifty-seven seconds of cuts being made to two scenes for the video release, significantly reducing sight of drugs preparation and the injecting of heroin. With these cuts made, *The Panic in Needle Park* was passed '18' for video on 31 December 1987. The same concern about the almost fetishistic appeal to drug addicts of needles piercing skin would lead to similar cuts for the video releases – following uncut classifications on film – of both *Pulp Fiction* (1994) and *Trainspotting* (1996).

In 2002, *The Panic in Needle Park* was submitted afresh. With new, publicly informed Guidelines and with similar cuts to the detail of drug-taking having been reinstated for video release in the German feature *Christiane F.* (1981) in 2000 (see case study), the BBFC examiners did not believe the existing cuts needed to be maintained. Rather, the concern was whether the scenes presented novel and easily copied detail of drug preparation and use; and whether drug use was promoted or encouraged. Neither of these concerns was realised. Nevertheless, the Board believed, 'graphic drug taking […] and the overall theme of drug addiction with frequent drug references, still justifies restricting this to the adult category'.[108] *The Panic in Needle Park* was given an '18' uncut certificate for video release on 4 April 2002.

In the wake of this decision, and that same year, *Trainspotting* was also submitted again and passed '18' uncut for video release. *Pulp Fiction*, with regard to which cuts were achieved by reframing the images, was not submitted again for several more years. But it too eventually came back into the Board, and was classified uncut on 31 August 2011.

CASE STUDY: WR – MISTERIJE ORGANIZMA (WR – MYSTERIES OF THE ORGANISM, 1971) Craig Lapper

Dušan Makavejev's *WR – Mysteries of the Organism* marks a little-known milestone in the history of film censorship in the UK. Although it is commonly assumed that Nagisa Oshima's *L'Empire des sens* (*Empire of the Senses*, a.k.a. *In the Realm of the Senses*, 1976, but first classified by the BBFC in 1991) marked the first time the BBFC permitted scenes of unsimulated sex in a film for adults, that distinction in fact goes to Makavejev's film, which was classified 'X' without cuts some twenty years earlier.

After a screening at Cannes in 1971, *WR – Mysteries of the Organism* was acquired for distribution in the UK by the Academy Cinema. Anticipating that the film might cause censorship difficulties, the distributor wrote to John Trevelyan,

the outgoing BBFC Secretary, stating that he had discussed the matter with the film's director and that they would be prepared to make reductions in two scenes, if necessary, in order to ease its passage through the BBFC.[109] Nevertheless, it was the full version of the film that was viewed by the BBFC's President, Secretary and examiners on 21 June 1971.

It was agreed that the film went beyond the normal standards permitted at 'X', even though it possessed significant merit and the sexual scenes were not there to provoke titillation. The examiners expressed the view that it might be better if the film was submitted to the Greater London Council instead, as it might see its way to classifying the film uncut. If the distributor insisted on a BBFC classification for national

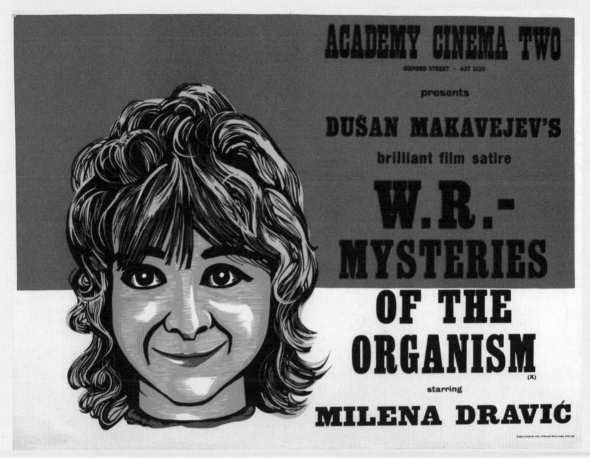

exhibition, cuts would need to be made to remove or reduce (1) a scene of unsimulated fellatio, (2) a protracted sex scene and (3) the famous scene in which a plaster cast is made of a man's erect penis.[110] John Trevelyan wrote to the Academy Cinema on 22 June stating that 'This film does present us with problems even though we regard it as a film of considerable quality and considerable interest. I wish that we were in a position to pass it complete, but we cannot do this.'[111] He went on to list the cuts suggested by examiners, while also suggesting that it might be better to approach the GLC for a London-only certificate, which would allow the BBFC to judge how audiences reacted to the film.

The distributor responded that the unsimulated fellatio could be removed quite easily and that the 'plaster cast' scene could perhaps be reduced, although not removed altogether. However, he expressed particular concern that the highlighted sex scene would be very difficult to cut because of the important dialogue that occurred during it. He reminded

Trevelyan that the Board's intention in raising the age of admission for 'X' films from sixteen to eighteen in 1970 had been to reduce the need for adult censorship. He also reassured Trevelyan that the confidence English critics had expressed that the BBFC would pass this 'artistically brilliant and politically courageous film' should make things easier for him.[112] In the meantime, the film was submitted to the GLC for its consideration.

At this point, Stephen Murphy took over as BBFC Secretary and he viewed WR with two examiners on 6 July 1971. The examiners remained of the view that cuts should be required for 'X' and Murphy appeared content with the position already established by Trevelyan.[113] Shortly after this screening, however, the GLC announced that it was prepared to classify the film 'X' uncut for screenings in London. This appears to have seriously concerned Murphy, particularly given this was his first major decision as Secretary. He clearly felt the appearance of a critically acclaimed film in London,

without a BBFC certificate, ran the risk of making the Board look ridiculous. He therefore arranged an urgent meeting with the Board's President, Lord Harlech, sending a note in advance suggesting that most of the requested cuts, with the exception of the real fellatio, should perhaps be waived.[114] After all, nobody at the BBFC felt the film was exploitative or erotic and some of the cuts would be very difficult to implement in an effective manner. Although there is no record of the meeting between Lord Harlech and Murphy, following their meeting it was agreed that *WR* should be passed at 'X' completely uncut. This was on the strict understanding that the film would be exhibited only at the Academy Cinema in London and that any subsequent commercial distribution would be discussed with the BBFC in advance. This would allow the BBFC the opportunity to write to any local authorities in whose area the film was to be shown, explaining the Board's decision. It was also agreed that the film would not be released to sex cinemas, as had been the fate of Makavejev's earlier film, *Ljubavni slucaj ili tragedija sluzbenice P.T.T.* (*The Switchboard Operator*, a.k.a. *The Tragedy of a Switchboard Operator*, 1967).[115]

As it turned out, the BBFC's concern that the film might be exploited by sex distributors proved to be justified in the 1980s when it was submitted for video release by a well-known sex video distributor.[116] In the event, the version submitted was a dubbed German VHS of the film, without subtitles, allowing the Board to request that subtitles should be added before any further consideration could be given.[117] Given the fact the distributor had obviously picked the film up on the basis of its explicit content, and did not have the time or inclination to add new subtitles, the submission was simply withdrawn. Nonetheless, examiners were generally of the view that, were the distributor to supply a suitably subtitled (or English-language) version, the artistic and historical importance of the film pointed towards an '18' uncut.[118] Subsequent to this, the film was shown on Channel 4 television, although broadcasting rules at the time made it impossible for an uncut version to be transmitted.[119] Therefore, the most explicit sequences were covered with a variety of digital effects, apparently approved by the film's director. When the film was finally submitted to the BBFC for video release in 1995, it was this censored TV version that was presented to the BBFC and passed '18' without further cuts.[120] At the time of writing, the original uncut version has yet to be submitted for video release.

CASE STUDY: A CLOCKWORK ORANGE (1971) Karen Myers

The classification histories of some films have acquired a certain mythological status with rumours and conjecture solidifying into publicly accepted 'fact'. Perhaps there's no film of which this is more true than Stanley Kubrick's *A Clockwork Orange*.

Five years after the publication of Anthony Burgess's novel, a first attempt to translate it from page to screen was submitted to the BBFC in script form. The Board's immediate response, while recognising that '[t]he theme has point and purpose', was to make it 'pretty clear that we would not be able to pass the film'.[121] The biggest concern was that the script's 'unrelieved diet of hooliganism by teenagers is not only thoroughly undesirable but also dangerous'.[122] Kubrick wasn't connected to the project at this point and the book went through another aborted adaptation (by Burgess himself, with Nicolas Roeg on board to direct) before, in 1970, Kubrick began penning his own screenplay.[123]

By this time there had been some changes in terms of international film regulation. A flood of increasingly violent and sexual films were coming out of the US, exploiting the MPAA's new self-regulatory rating system, introduced in 1968. In response, and as we have seen in Chapter 5, the BBFC increased the legal age limit for audience members of 'X'-rated films from sixteen to eighteen. When, in December 1971, Kubrick's *A Clockwork Orange* was viewed by the BBFC it was swiftly classified 'X' uncut, with the Board firmly of the opinion that it was a serious treatise on the subject of society's response to violence. Still being asked to defend the classification decision as late as 1974, the then BBFC Secretary, Stephen Murphy, wrote:

> I remain strong in my advocacy of this film: funny, savage and moving, it is an important examination of the problem of violence in urban society. This Board is quite ruthless with films which seek to exploit violence, and we are known as one of the most severe censorship boards in the free world where exploitative violence is concerned. But we would find it difficult to accept that, in a free society, a censorship board should refuse certification to a serious examination of social violence: 'A CLOCKWORK ORANGE' is precisely this.[124]

Felt to be significantly less explicit than Burgess's original novel, in which the 'droogs' raped girls as young as ten, Kubrick's film was released in the UK in January 1972,

although from its opening date to September of the same year, it played in just one London cinema. Kubrick and the distributors, Warner Bros., hoped that this would allow the controversy over the sexually violent content that had followed the film across the Atlantic Ocean to die down before a nationwide release.[125]

That hope proved futile. A *Clockwork Orange* was entering the public consciousness at a time when there was a growing backlash against the perceived permissiveness of the 'swinging sixties'. Vocal pressure groups, such as the Nationwide Festival of Light, spearheaded by Mary Whitehouse and Malcolm Muggeridge, aimed to show that the 'moral liberalization of the 60s had been pushed by an unrepresentative minority at the expense of a "silent majority" of Christians'.[126] The Festival of Light, along with other similar organisations, mounted 'a quite deliberate campaign […] to discredit the work of the Board with the Local Authorities' and pressed for the film to be banned'.[127] By the time the film was ready for a nationwide release, in January 1973, some of this pressure had been brought to bear and it was the local authorities of Hastings, Worcestershire, Leeds, Blackpool, Brighton and Ruthin, not the BBFC, who deemed it unfit for presentation in their region's cinemas.[128]

Along with anti-permissive lobby-group pressure, *A Clockwork Orange* soon found itself facing accusations of encouraging copycat crimes among impressionable British youngsters. This began as early as April 1973 when a London newspaper reported that the police believed the murder of an elderly man had been 'inspired by the film'.[129] Similar cases sprung up all over the country and, despite lacking evidence of any definitive causal link connecting the film and the crimes, not only the national press but also the police and the criminals themselves began to use *A Clockwork Orange* as a scapegoat.[130] The BBFC felt such theories had little validity. In a letter to the Irish Film Censor's Office, Murphy wrote:

> [S]ince 'A CLOCKWORK ORANGE' has coincided with a decline, nationally, in crimes of violence, it is difficult for anyone but a journalist to argue that it has led to a new crime wave. Such, however, was the atmosphere created by the press that even learned QC's and judges have berated the film as having a direct relationship with certain crimes of violence. Frankly, I think this is nonsense […].[131]

While this debate rumbled on in the press, the initial run of *A Clockwork Orange* came to its natural end in 1974. Neither the BBFC, Warner Bros. or Kubrick himself ordered that the film be removed from cinemas – it simply stopped being screened when the planned run had finished. In 1976, however, as Warner Bros. were planning to re-release this now critically acclaimed and award-laden film internationally, Kubrick intervened, asking the distributor to withhold the film from any further UK release.[132] It was therefore Kubrick's personal decision and not the BBFC's, that prevented *A Clockwork Orange* from being legally shown anywhere within the UK until after his death.

There was, of course, the occasional illegal breach of Kubrick's wishes – for example, in 1992 the Scala Cinema in London screened the film, leading to its prosecution for infringing copyright.[133] However, the following year, Channel 4 successfully overturned a court injunction that had initially prevented them airing *Forbidden Fruit*, a documentary about the self-imposed ban that included nearly ten minutes' worth of clips from the film.[134] With this precedent set, later documentaries succeeded in airing extracts without facing any legal challenge, including the BBC's *Empire of the Censors* in 1995.

When Stanley Kubrick died in March 1999, there was immediate speculation over whether his 'ban' on a British release for *A Clockwork Orange* would be overturned. Unsurprisingly, Warner Bros. felt 'it was too close to Kubrick's death for the matter to be re-examined, but conceded that the ban could be lifted at a less "sensitive" time'.[135] That time came in December 1999 when Warner Bros. requested a modern certificate for a cinema release. *A Clockwork Orange* was classified at '18', with subsequent video releases receiving the same category, accompanied by the consumer advice that the film '[c]ontains strong sexual violence'. Kubrick's complex morality tale hit British cinema screens in 2000, and after thirty-six years, bowler-hatted, Beethoven-loving Alex and his droogs could resume their cinematic rampage unassailed.

6

THE 'POACHER TURNED GAME-KEEPER': JAMES FERMAN AND THE INCREASING INTERVENTION OF THE LAW

Guy Osborn and Alex Sinclair

The period 1975–82 was a highly charged and important one for the BBFC. Whereas the law had always cast a significant shadow over the work of the Board,[1] this period saw the legal penumbra becoming more pronounced. From films coming under the gaze of the Obscene Publications Act 1959, to the impact of the Home Office Report of the Committee on Obscenity and Film Censorship (the Williams Committee), and on to the passing of the Protection of Children Act in 1978, this period sees significant legal developments that need to be unpacked in tandem with the key decisions and cases during the period. As such this chapter uses these significant legal events as signposts, while locating them within the context of the BBFC decisions of the time. In addition, the roles of local authorities and, in particular, their interventions and responses to these developments are important markers of the period and are analysed below.

Perhaps most importantly during this period however, even more so than the legal developments and *cause célèbre* films classified, the workings of the Board were particularly marked by the presence of one man – James Ferman. While this chapter is framed around these important legal developments and films, the character of Ferman runs through it and is imprinted throughout, and it is with Ferman that this part of the story begins.

In 1978, James Ferman himself noted that:

> [d]uring the past three years, several events have helped to clarify the legal framework of film censorship in Britain, and the setting up of a Home Office Committee on Obscenity and Film Censorship, under Professor Bernard Williams, points to a further clarification in the near future. Although I am not a lawyer by training, my appointment as Secretary of the British Board of Film Censors in June 1975 has brought me into close proximity with many of these developments and made it necessary for me to comment on some of them from time to time.[2]

While not a lawyer or legally trained, Ferman understood and engaged with the legal dimensions of film policy and was a most capable and able barrack-room lawyer, and something of a polymath who could turn his talents to most things.

The Ferman Agenda

Writing in 1973, John Trevelyan posited, in a postscript to his book *What the Censor Saw*, how he envisaged the future of film censorship developing. He noted that he thought censorship should be modified, not abolished, and continued:

> I think that there will be a continuing need for the protection of children and young people, and that this will satisfy the public social conscience, but I also think the time has come when we should treat adults as adults, and let them choose whether they will see a film or not.[3]

James Ferman, who joined the Board in 1975 and would remain there until 1999

When Ferman's tenure at the BBFC began he too had his own particular, and personalised, agenda – some of which drew on Trevelyan's vision.

Ferman was appointed Secretary of the BBFC in June 1975, and held the post (subsequently renamed Director) until 1999 – a quarter of a century which embraced not only change in the way in which films were viewed and classified but significant technological, legal and societal shifts that affected the BBFC on both a micro and a macro level. The earlier years of the decade were, as Stevie Simkin has shown in the preceding chapter, not easy for the Board, which was under an almost constant assault from the popular press, politicians and pressure groups. Into this maelstrom stepped James Ferman, appointed by Lord Harlech 'to reform the Board and to restore its credibility'.[4]

Contrary to his outward appearance as a somewhat Nivenesque English gentleman, Ferman was in fact an American, domiciled in London, having arrived in the UK to do national service in Suffolk with the US Air Force. He stayed after his national service, collecting an MA from Cambridge and studying under the influential F. R. Leavis. His eclectic career continued with him obtaining some acting experience and training as a TV director with ABC Television and then ATV, where, as a director, his series of dramas and documentaries included *Emergency Ward 10* (1960) and *The Plane Makers* (1963–5). Other important work included a series of five films entitled *Drugs and Schoolchildren* (1973), highlighting his concerns with what appeared to be an increasing problem, and this led to him being invited by the Polytechnic of Central London, now the University of Westminster, to teach a course on the subject. While at the Polytechnic, he lectured part-time in Community Studies from 1973 until 1976, ran a thirteen-week course related to drugs, and later wrote about his experiences at the BBFC for the *Polytechnic Law Review*.[5]

Initially Ferman's BBFC agenda focused upon what he perceived as the 'problem' of the OPA 1959:

> The question is why were films on licensed premises specifically excluded from the Act? There is evidence to suggest that they were seen in much the same light as television and sound broadcasting, which were also excluded. Both were subject to censorship through prior restraint, and this censorship was in the nature of a close and detailed editorial control, in many respects more rigorous than the criminal law could possibly apply.[6]

Ferman lobbied the government to bring film within the ambit of the OPA as this allowed for the defence of artistic or cultural merit not possible under the common-law offence of gross indecency, which had no equivalent argument. With the support of the Cinema Consultative Committee, a body that represented local authorities and film industry trade associations, Ferman petitioned the Home Secretary demanding legal parity with the theatre. The Theatres Act 1968 safeguarded the theatre from proceedings at common law (where the essence of the offence was that the offence was obscene, indecent, offensive, disgusting or injurious to morality) by bringing it within the OPA and removing the historic role of the Lord Chamberlain in terms of vetting.[7] A key result was that the permission of the Attorney General was now needed in order to bring a prosecution. The OPA 1959 was a statute that consolidated the common-law position.[8] A number of significant changes were made by this transition to a statutory framework, including, importantly, the requirement that a work was to be looked at as a whole, that the likely audience needed to be considered and that the idea of aversion was to be introduced (something that we see below with regard to Pasolini's *Salò o le 120 giornate di Sodoma* [*Salò, or the 120 Days of Sodom*, 1975]).[9] In addition, a defence of public good was created, which allowed a work that was technically obscene to be permitted on the grounds that its artistic merit outweighed this. OPA 1959 section 4(1) provided that

> [a] person shall not be convicted of an offence against section 2 of this Act [...] if it is proved that publication of the article in question is justified as being for the public good on the ground that it is in the interests of science, literature, art or learning, or of other objects of general concern.

As section 2 made it an offence to publish an obscene article, the effect of the defence was to render legal something that was technically obscene. This created a number of problems in terms of application, Zellick, for example, noting that a jury might have difficulty working out when something that depraves and corrupts can be for the public good, and that even the judiciary have had difficulty evaluating how it operates.[10] However, while this defence worked for a number of areas of art and literature, film was notable by its absence.

That being the case, one might have presumed that it would be all the more reason to provide a safeguard for film through the Act in tandem with the other areas of art and literature. This absence may have been the result of a distinction being made between high and low culture, the idea that more elitist forms of artistic expression were deemed worthy of protection while these more 'trashy' areas were not.[11]

In the event, resolution came via the unlikely source of the law of conspiracy. While concerned with far broader issues, the Law Commission, in its Report on Conspiracy and Criminal Law Reform,[12] dealt with how conspiracy had been applied to cinematographic films. The Commission gave four examples of cases, three of which were in Soho and the other in Gloucester, where parties such as projectionists, receptionists and money collectors were charged with offences such as conspiracy to corrupt and conspiracy to outrage public decency.[13] As the Commission noted,

> The conspiracy charges in the cases described above were brought because of the existence of certain defects in the Obscene Publications Act 1959, which made it impossible to bring charges under the Act even though it seems probable that the Act had been intended to cover most of the situations that arose in these cases.[14]

The Law Commission was at pains to make clear that it was not going to recommend a change to the test of obscenity itself or to the meaning of 'article' under the OPA 1959. Indeed, the point was made that the Williams Committee was investigating this very issue and that, in fact, findings on film in terms of conspiracy were to be seen as an interim measure pending the government consideration of the Williams Report. However, given that the Commission was looking at issues around conspiracy, it was therefore able to try to rectify the problems created by the utilisation of conspiracy offences within film. Some of the options had been discussed in a previous working paper,[15] and these had included extension of the OPA 1959 to the exhibition of all films except those given on licensed premises. The Commission noted, however, that it had not realised, when the Working Paper was published, that many local authorities did not want to exercise control over films and that this, in tandem with the removal of the common-law offences, would have led to no legal control over the showing of films on licensed premises.[16] The Commission was of the view that the extension of the OPA 1959

> to penalise the exhibition of films which are obscene within the meaning of the Act would appear to be the simplest means of dealing with the exhibition of films when our recommendations in regard to conspiracy and related common law offences are implemented.[17]

This was then brought into force via s53 of the Criminal Law Act 1977, with films finally coming under the purview of the OPA, s1(2) being amended so as to define 'article' as including 'any film or other record of a picture or pictures' and s1(3) being amended so as to read:

> For the purposes of the Act
> ... a person publishes an article who –
> a) distributes, circulates, sells, lets on hire, gives, or lends it, or who offers it for sale or for letting on hire or;
> b) in the case of an article containing or embodying matter to be looked at or a record shows, plays or projects it.
> Provided that paragraph (b) of this subsection shall not apply to anything done in the course of television or sound broadcasting.[18]

Ferman later stated that the interesting thing about having film (and videos) covered by the Obscene Publications Act is that the 'deprave and corrupt test' in the Act is not of manners but of morals, so that, unlike in many other countries, the legal is the moral in Britain.[19] Under this test the Board recalled the film *Emmanuelle* and cut the whole of a violent rape that took place in an opium den in the last reel of the film.[20]

One key aspect of the amendment to the OPA that Ferman had campaigned for was that the consent of the Director of Public Prosecutions (DPP) had to be sought before a prosecution could be brought. The first test of this occurred with *Salò*. On 27 February 1976, Ferman contacted United Artists, the distributors of the film, informing them that the overwhelming opinion of the examiners and Lord Harlech was that it far exceeded the standards that would be set by most of the local authorities in the UK and that the film was vulnerable at law. He expressed his personal admiration for the film but refused it a certificate.[21] In a personal letter to Ferman, Lord Harlech made clear his opinion on *Salò*:

> I am afraid I have a very different assessment of this film to yours. However good a film maker Pasolini had been, I think that in his latter days, and this is to some extent borne out by the evidence of his last year of life, he had become a vicious psychopathic hater of the human race, and of women in particular. I think this is reflected in this film and I find very little to do with politics or fascism in it.[22]

Lord Harlech was in no doubt that the film would be held obscene and/or indecent in any court in the land, and there was no chance of it being granted a certificate in the foreseeable future. The BBFC Monthly Report of February 1976 reiterated the position, adding, however, that the film would be *unlikely* to be held obscene under the OPA test of deprave and corrupt and that 'until there [was] some clarification or amendment of the law on gross indecency it would be difficult to certificate [the] film'.[23] Given all the circumstances, they felt that the final decision to screen the film should be left to individual local authorities.

Due to these difficulties, United Artists passed the rights to a smaller distributor, Cinecenta Ltd, whose intention was to show it in cinema clubs. The film was subsequently seized by the Obscene Publications Squad in early June 1977 after being screened at the Compton Cinema Club in Soho, London. The Greater London Council had refused the film a certificate the previous January, but the Compton Cinema Club was a members' club and these were not covered by the provisions for public screenings; in order to become a member at the Compton Cinema Club you

This still from *Salò* (1975) indicates both the film's explicit content and its formal elegance

This members' only venue showed *Salò*, resulting in a police raid

were charged fifty pence and after a reasonable period of time you gained entry by paying the admission fee. The waiting period for *Salò* appears to have been ten minutes.[24]

The film had been shown uncut on the advice of Ferman as he felt 'it would be wrong to cut a film widely regarded as the last major work by one of the great directors of the post-war Italian cinema'.[25] A summons alleging the common-law offence of keeping a disorderly house was served on the Compton Cinema Club and Cinecenta, and on 2 September they were committed for trial.[26] The prosecution was ultimately dropped due to the introduction of the Criminal Law Act 1977, noted above, which brought film under the OPA and the change in the legal test of obscenity.

Sometime in 1978, Cinecenta sought Ferman's advice again on the best way to achieve a release of the film so as to ensure it would not be caught under the deprave and corrupt test. Ferman spent a great deal of time and effort in some judicious cutting and, at the suggestion of Lord Hutchinson QC, a long introduction was prepared setting out the historical and cultural background to the film, and an epilogue was also added.[27] The film was scheduled for a release in arthouses and cinema clubs. The DPP was invited to view the film before release. As a consequence, in May 1979, the film was again seized, this time under section 3 of the OPA after the film had been seen by the Principal Assistant Director of Public Prosecutions and a Senior Treasury Counsel.[28] Ferman felt compelled to write directly to the Head of the DPP, Sir Thomas Hetherington, outlining his concerns. In his letter, he notes the irony of the fact that, having campaigned for the amendment to the law, and for the DPP role within it, he now finds himself writing to the DPP disagreeing with the possible prosecution: 'I believe, however, that this prosecution would not only be wrong in law but would constitute a serious – and potentially damaging – error in policy'.[29] Noting that the film had been shown widely throughout Europe and the world with only minor problems ensuing – only Italy had initially deleted four short scenes of simulated buggery, but even these had been restored on appeal[30] – Ferman made clear his views that the portrayal of evil is not the same as its endorsement and that, indeed, the film was not about encouraging such behaviour but was the opposite, his argument therefore more closely aligning the film with the possible aversion defence to obscenity. Of course, *Salò* had first been submitted to the BBFC in 1976, before the amendment to the OPA and therefore the film had not been covered by the Act or any potential defences. In the BBFC Monthly Report for February 1976, the BBFC had noted that it was unable to grant a certificate, on the basis that on taste grounds, the film exceeded the limits set by the various local authorities.[31]

The role of local authorities was a significant factor during this period. As long as a council reserved the right to review the decision of the BBFC, that council could make the granting of a licence contingent on the screening of films that had been certified by the Board. This was confirmed in the 1976 case of *ex parte* Blackburn when Lord Denning for the Court of Appeal noted that 'I do not think the county councils can delegate the whole of their responsibilities to the board ...; but they can treat the board as an advisory body whose views they accept or reject, provided that the final decision – aye or nay – rests with the county council'.[32] So the upshot was that local authorities needed to maintain some supervisory function; this being so, they were able to prohibit films within their districts. This function, duplicating as it did the role of the BBFC and the criminal law, although seen as superfluous by the Williams Committee, persisted throughout this period and beyond.

A classic example of this is a film now celebrated as one of the greatest British comedies, *Monty Python's Life of Brian* (1979). Notionally a 'Monty Python biblical epic', the film nevertheless drew upon archetypal Python themes such as class and politics. It was extremely contentious upon its release in the US, whipping the press and pressure groups into a frenzy and soliciting a number of complaints, Rabbi Abraham Hecht stating that the film 'is blasphemous, sacriligious [sic] and an incitement to possible violence'[33] and Father Sullivan of the US Roman Catholic Office for Film and Broadcasting considering it 'morally objectionable in toto'.[34]

This hysteria continued when the film was slated for release in the UK, due in no small part to the critic of the *Telegraph*, among others, labelling the film blasphemous,[35] and the BBFC was

The Monty Python team on the set of *Life of Brian*. (left to right) Michael Palin, John Cleese, Graham Chapman, Eric Idle, Terry Gilliam and Terry Jones

inundated by an unprecedented number of requests from local councils for a synopsis of the film, with many more demanding that they should view the film beforehand. Ferman was put under heavy pressure from the Nationwide Festival of Light and Mary Whitehouse, who at the time was fresh, and flush, from her high-profile victory in the *Gay News* case.[36] Here a rare successful prosecution had been brought under blasphemous libel, over the publication of James Kirkup's poem 'The Love That Dares to Speak Its Name' in the magazine *Gay News*. The Nationwide Festival of Light's view on *Life of Brian* was plain – they concluded a letter about it with the exhortation 'I need not remind you of the wider implications of scurrilous abuse of God, Christ or the Bible'.[37]

Given this atmosphere, Ferman had commissioned legal opinions from eminent barristers John Mortimer and Michael Grieve of the film's legal status. The opinion stated that *Life of Brian* was not blasphemous; nor was it a representation of the life of Jesus: 'No scene, in our opinion, contains any attack on the Christian religion, or on Christ, or on religious observations nor are these matters derided. In our opinion Christianity remains untouched in the hilarious misadventures of Brian.'[38] The opinion went on to distinguish *Life of Brian* from the decision in the *Gay News* case on a number of grounds, including the fact that the Python film lacked the element of vilification that proved key in *R* v *Lemon*. The BBFC subsequently gave the film an 'AA' certificate, and braced themselves for the fallout.

The film gave rise to much correspondence between the BBFC and local authorities. By July 1980, 101 councils had insisted on viewing the film, of which sixty-two had confirmed the BBFC rating, twenty-eight had enforced a local 'X' certificate and eleven had banned it from their jurisdiction.[39] Following this, the BBFC sent out a short questionnaire to the local authorities to investigate their positions and opinions as to their role in the film censorship process.[40] In terms of *Life of Brian*, even in the twenty-first century, the film was still making headlines, the *Telegraph* noting that it took until 2008 for Torbay Council to remove its local 'X' certificate, allowing the film to be shown in the area.[41] The role of local councils perhaps reached its nadir with *Life of Brian*, but their influence started to recede. In 1982, Ferman acknowledged: 'Since the Williams Report was published, most of the local authorities have stopped involving themselves in censorship decisions, but the situation was different when I joined the Board in 1975'.[42] Certainly the Monthly Reports were part of the catalyst for this receding local authority intervention, as they both reassured the local authorities and helped them realise that the area was an intricate one they were best to leave to someone else. It is to a consideration of the aims and effect of the Williams Report that the chapter now turns.

The Impact of the Williams Report

As noted above, a key event during this period was the appointment of the Williams Committee in July 1977. As Geoffrey Robertson, acknowledged expert on media law and barrister, put it, in admittedly somewhat florid terms, '[i]nto this turbulent sea of sex, violence and blasphemy the Home Office has launched a brand-new lifeboat: the Report of the Committee on Obscenity and Film Censorship (the Williams Committee)'.[43] Whether it in fact turned out to be a lifeboat is a moot point, but the remit of the Committee was

> to review the laws concerning obscenity, indecency and violence in publications, displays and entertainments in England and Wales, except in the field of broadcasting, and to review the arrangements for film censorship in England and Wales; and to make recommendations.[44]

The Committee was chaired by the moral philosopher Bernard Williams and comprised thirteen members.[45] They met thirty-five times and solicited views from a wide variety of sources and respondents, taking written submissions from around 150 organisations and nearly 1,400 individuals. The Report was wide-ranging, embracing issues such as psychological impact, the role of the criminal law and other possible methods of control, and the very nature of morality within contemporary society, drawing in particular on the work of John Stuart Mill.[46]

It also, of course, focused upon film censorship, and here Ferman was of particular help to them, spending four afternoons with them, explaining policy and approach and showing excerpts, often 'before' and 'after' clips, from around ninety films. In addition to these four formal meetings, Ferman met with the Committee on a number of other occasions, and also received them at the Soho Square offices so that they could see the Board at work on its home territory. The Committee also saw a number of films in their entirety, including *Salò*, *Straw Dogs*, *In the Realm of the Senses*, *A Clockwork Orange*, *Language of Love*, *Histoire d'O* (Story of O, 1975), *Pretty Baby* (1978), *Manson* (1973) and *Growing Up: A New Approach to Sex Education, No. 1* (1971). These were a mix of films that had been subject to criticism after being granted a certificate (*Straw Dogs*, *A Clockwork Orange* and *Language of Love*), films for which a certificate had at some point been withheld (*Story of O*, *Salò*, *In the Realm of the Senses* and *Pretty Baby*) and two curios outside of these categories – *Manson*, which had been refused a certificate on the basis that it might incite violence, and the sex education film *Growing Up*.

The Report itself was highly critical of what it called the unworkable test of 'tendency to deprave and corrupt' as the litmus for obscenity and argued that this should be abolished – primarily on the grounds that obscene material cannot be said to do any actual harm.[47] The Committee did recognise that film was a powerful medium worthy of specific treatment:

> Film, in our view, is a uniquely powerful instrument: the close up, fast cutting, the sophistication of modern makeup and special effects techniques, the heightening effect of sound effects and music, all combine on the large screen to produce an impact which no other medium can create.[48]

In this light, the Committee made some specific recommendations as regards film censorship. These included the far-reaching proposal that all existing restrictions on cinema be swept away and that the BBFC be replaced by a new statutory body, a Film Examining Board, whose membership of around a dozen would be drawn from the film industry, local government and others with relevant expertise. The censorial role of local authorities would be removed as they were not deemed able to deal with the delicate task with which they had been somewhat curiously entrusted. The fact that conflicting and disparate views might pertain in bordering districts was one particular anomaly that the Committee was particularly concerned with, and the following complaints seem even quainter, although no less relevant, in a more globalised and technologically enhanced age:

> [T]he most frequent arguments were that in an age of mass media and easy mobility, disparities of taste between geographical areas were plainly diminishing and were likely to be over-emphasised: that in a country as small as ours, when the nearest cinema subject to a different authority's control was often no more than a few minutes' drive away, the idea of a local authority censorship was futile and nonsensical; and that local councillors were far from being the best people to perform a censorship role since, granted the realities of local politics and the very minor role enjoyed by film censorship, they were not in any real sense answerable to local electors for the

way in which films were censored and, being often middle aged and not cinema-goers, they were liable to be out of touch with the contemporary cinema and the tastes of predominantly young audiences.[49]

Perhaps surprisingly, the role of local authorities as regards films was critiqued not only by the obvious suspects such as distributors and exhibitors but also by such diverse groups as the Free Church Federal Council, the Catholic Social Welfare Commission, the Police Federation, the National Council of Women, the Law Society and the infamous Nationwide Festival of Light.[50] That said, there was support for some sort of local input in the process, with the Association of Metropolitan Authorities arguing that, while the current responsibilities for assessing films should cease, their role should not be removed completely and there should be some local representation on the new statutory body that they proposed be set up. The BBFC also strongly supported the local option as, even though it sometimes created difficulties for the Board, 'the advantages of local discretion outweighed the disadvantages'.[51] The Committee was unconvinced by these arguments, finding that the so-called benefits of the 'local option' were peculiar to the current system and that, rather than remaining in hock to these, the issues would be more easily remedied by a modified system.

Perhaps the most striking recommendation was that 'Parliament should institute a new statutory body which will have the necessary powers to replace those now wielded by local authorities'.[52] This body would have responsibility for setting policy and guidelines and employ a number of professional examiners to implement these. There was a sense that this proposal was not in line with the broader tenor of the Report as a whole, and that the Committee had been unduly influenced by the evidence of the BBFC:

> Acting (overacting?) on the BBFC's evidence that film censorship was indeed necessary, the Committee reversed its overall administrative strategy (to decentralise and privatise control of pornographic materials) and instead recommended that the BBFC be replaced with a central state censorship body, to be called the Film Examining Board.[53]

Brown's point about the 'overreaction' makes a consideration of the submission made by the BBFC apposite. While notionally a BBFC submission, the document presented to the Williams Committee was, effectively, the work of James Ferman. The submission itself was a weighty document. It began portentously with a quote from W. B. Yeats's 'Meditations in Time of Civil War' ('We had fed the heart on fantasies, The heart's grown brutal from the fare'), and included fourteen appendices. The text itself ran to seventy-five pages, covering the role of the Board, comparative systems of film classification elsewhere, both statutory and voluntary, and a consideration of a number of legal concepts, including obscenity and indecency. One very interesting suggestion was for a reformulation of the test of obscenity to reflect the interpretation of obscenity normally applied by the BBFC. The submission's rewording of s1 went thus:

> For the purpose of this Act, an article shall be deemed to be obscene if it depicts or describes physical behaviour of a grossly immoral or illegal kind in such a manner as, taken as a whole, to have the effect of endorsing or encouraging the imitation or toleration of such behaviour by a significant proportion of those who are likely, having regard to all relevant circumstances, to read, see, or hear the matter contained or embodied in it.[54]

This is extremely interesting as certain elements of the legislation remain – the holistic approach and the significant proportion requirement – but with a reconfiguring of the test of obscenity. Perhaps most importantly for our purposes is that, having been an actor and film director, and acting in the capacity of Secretary of the BBFC, James Ferman was now appearing to embark on a side career as a Parliamentary draftsman!

Responses to the Report were varied. Robertson summed it up well when he stated that 'despite reservations from all sides of the moral spectrum, the Report provides the most authoritative and reasoned guide to reform of an archaic and inefficient system of cinema censorship'.[55] In terms of film censorship itself, the Williams recommendations were not enacted in their entirety. Interviewed some years later, and questioned on the recommendation that the deprave and corrupt test would be removed and the BBFC would become the arbiter on the offensiveness of films, Ferman replied:

We want to *apply* the law, we don't want to *be* the law. Williams wanted to turn us into a statutory authority and give us absolute dictatorial powers, with no second guessing from the local authorities. We said to them that the flexibility and inefficiency of the local authority option was healthy in democracy. We are only fallible human beings: critics make mistakes, high court judges like Lord Denning can make mistakes, everybody can make mistakes, and you must have a system which allows for second-guessing by other people.[56]

Children and Film: Folk Devils and Moral Panics

Another concern of Williams had been the issue of children and film, and during the 1970s, issues around the protection of children became increasingly pertinent. These can broadly be characterised into two approaches: *participatory* and *consumptive*. In terms of participation, the idea that children as participants, as performers, were in need of protection became more marked. This included economic protection that looked at safeguarding income against exploitation by unscrupulous agents and managers, as well as protecting children from abuse within the visual media. There were some high-profile and contentious examples of the use of children within visual art during this period: perhaps Robert Mapplethorpe's 1976 photograph *Rosie* and a series of photographs of a ten-year-old Brooke Shields, commissioned by *Playboy* and taken by Garry Gross, also in 1976, are the most well-known of these, and both have caused problems since.[57] In terms of *consuming* film, children have in fact long been protected; for example, the Cinematograph Act 1952 imposed a duty on councils to censor films for children.[58]

Often attitudes and responses to the protection of children can be seen in terms of a broader moral panic. The term of course is Stanley Cohen's,[59] and while he wrote about youth subcultures and the moral panics around the so-called deviant behaviour of mods and rockers, he noted in his conclusion that

[m]ore moral panics will be generated and other, as yet nameless, folk devils will be created. This is not because such developments have an inexorable inner logic, but because our society as presently structured will continue to generate problems for some of its members – like working-class adolescents – and then condemn whatever solution these groups find.[60]

There have, as predicted, been many moral panics since, and indeed the legal dimension or response to this is often what Redhead termed 'panic law'.[61] Concerns for the safety of children can be seen as an example of this, as well as a response to inappropriate images of children.[62] Later, of course, the moral panic rhetoric was applied to 'video nasties', and Julian Petley has authoritatively charted this trajectory.[63]

As noted in the Williams Report, the Protection of Children Act (PCA) was emerging while the Committee was sitting, introduced as a Private Member's Bill by Cyril Townsend MP, partly as a response to the moral panic around children and paedophilia in the light of pressure groups such as the Paedophile Information Exchange. Whether such legislation was necessary was contested; the Williams Committee, for example, was in some doubt:

Certainly no evidence was put to us that child pornography was a growing problem – indeed, the Director of Public Prosecutions told us that he had no evidence that there was any new problem, or one of any significance, and he considered that the existing law was adequate to deal with it.[64]

In any event, the Bill became law in July 1978, with Brown noting that

[t]he PCA is ostensibly a form of child labour law, prohibiting the showing of any indecent photograph which includes a child performer; unlike comparable legislation protecting animals, which allows out-takes and other evidence of ill-treatment, the PCA regards only the finished film.[65]

Louis Malle's *Pretty Baby* not only provides a beautiful example of the potential application of this new legislation, but, bizarrely and handily for our purposes, was submitted to the Board for classification as Townsend's Bill was passing through Parliament. The film itself concerns prostitution, but seen through the gaze of a child.

The film was received by the Board on 28 March 1978,[66] and on 28 April Ferman wrote to the distributor Cinema International Corporation to point out that *Pretty Baby* was likely to run into

some difficulties in Britain, noting that the Protection of Children Bill had been passed through the Commons the previous week and was anticipated to have an easy passage through the Lords. Acknowledging that the Act would apply to films purporting to show children under the age of consent, he added:

> From this point of view Louis Malle's film would clearly be vulnerable at law. We showed the film to Lord Harlech and to a representative of the Home Office, as well as to three representatives of the Director of Public Prosecutions, without whose consent no proceedings may be instituted for an offence under this Bill (Clause 5). All those present admired the film, and the senior representative of the DPP gave it as his opinion that should the film be reported to their office, he personally would not recommend prosecution. On the other hand, one of his colleagues stated that, were it given to him as a barrister to handle the prosecution of the film, he would be able to make a strong case against it.[67]

Ferman stated that how the law would be interpreted was still uncertain and that there would be a period following its Royal Assent when its reach would be tested. He continued, 'As this is a film of some considerable merit, I would not like to see it involved in a controversy of this kind'.[68] Ferman asked the distributor to withdraw the film and not resubmit it to the BBFC without consultation. As we have seen, *Pretty Baby* was one of the films viewed by the Committee, and by the DPP and Customs and Excise. News of these viewings, and of the film's contents, was leaked to the *Daily Mail*, provoking responses from local-authority licensing sub-committees and others showing concern at the possible certification, 'in view of the reported child sex nature of the film'.[69] Given this, and the broader moral panic around children and paedophilia, the BBFC felt obliged to rush out a press release noting that no hasty decision would be taken by the Board on the acceptability of the film, particularly as changes in the law were ongoing.[70] Ferman, in addition, wrote to several of the concerned parties following this *Daily Mail* 'scoop'. For example, in reply to a woman from Stoke-on-Trent, Ferman not only outlined the unhelpful nature of the *Daily Mail* article and its misrepresentation of the nature of the film but also supplied admirable detail of approaches to the

Brooke Shields as the child prostitute Violet in *Pretty Baby* (1978)

film in other jurisdictions and an explanation of recent findings of the Home Office Research Unit on sexual violence.[71] In that very month, July 1978, the Protection of Children Act was passed, and on 16 August the distributor was informed that two minor cuts would need to be made for an 'X' certificate to be granted: one to the moment in reel four when Madame pulls away the towel that had been preserving the child Violet's modesty, and one in reel five to delete the full-length nude shot of Violet posing on the sofa.[72] Malle agreed, somewhat reluctantly, to make the first alteration, but was very uneasy with the second, feeling that the scene was crucial. Ferman agreed with Malle as to the importance of the shot but felt that his hands were tied:

> We all appreciate the visual beauty of this shot, and the significance it has for you in its evocation of Bellocq's photographic style. Yet we can see no way round the objection that the model in this case is only 12 years old and that she has been posed in a manner which many adults would feel to be indecent for a child of that age.[73]

Ferman explained this further, and Malle's eventual resolution of the matter, to Beverley Brown:

> Now, the PCA does not equate indecency with nudity as such, but we felt that, particularly with the way the scene was lit, given the girl's youth and absence of pubic hair, that this was – however beautiful – an immodest shot. Louis Malle did try to find some outtakes with less detail but none were suitable, so the compromise that was worked out was to darken the shot, and thus obscure the lower half of her body.[74]

Following this, the film was eventually classified 'X' on 27 July 1979. Even this, however, was not the end of the matter. First, there was an initial problem with an uncut print of *Pretty Baby* being inadvertently shown at the Ritz in Leicester Square, something that was put down to human error and possibly due, in part, to the long gestation period of the certification.[75] Second, while the DPP advised the Attorney General not to bring criminal proceedings against the film,[76] the following year Cardiff City Council overruled its own licensing committee decision that *Pretty Baby* could be shown and effectively banned it. Ferman was enraged by this, unsurprisingly given that he had spent so much time working with the authorities and with Malle to get this important film by an extremely well-regarded director certificated and released, and that it had been shown in many parts of the country without complaint. Indeed, Ferman felt that the council's behaviour here brought the whole role of local authorities in the process into disrepute:

> [I]f, as reported, they banned it sight unseen and largely on hearsay evidence, this can only bring discredit on the system of local censorship which the British Board of Film Censors would like to be preserved. [...] Local censorship, if it is to continue, must always balance the views of the community as a whole against the rights of the individual and freedom under the law is a principle too valuable in Britain to be disregarded.[77]

Returning to the issue of moral panic, R. T. H. Stone noted in a later review that, by 1982, only around thirty prosecutions had been brought under the PCA 1978, that there had been no prosecutions under the earlier Children and Young Persons (Harmful Publications) Act 1955 and that '[t]he infrequent use perhaps suggests that the need for these pieces of legislation was not in fact so great as it seemed at the time at which they were passed'.[78]

Whether or not the statute was necessary or an overreaction, its effects can be easily illustrated. Even though released some years before, *The Exorcist* was viewed again through the fresh eyes of the child-protection legislation and was found not to be legally vulnerable. *Taxi Driver* (1976), originally passed uncut, was also reconsidered as it included a scene in which a child prostitute, played by Jodie Foster, attempts to seduce the eponymous taxi driver, played by Robert De Niro:

> During the course of this scene she kneels in front of him to undo his belt, while at the end of the shot her hand drops below the frame to unzip his trousers and her head leans into his crotch. In the following shot he pushes her away. We felt that, although the unzipping was unseen (and, indeed, the sound of the zip may have been added afterwards), the implied offer of oral sex from a girl of 12 might easily be considered indecent in the meaning of this new Act.[79]

A cut of just over two seconds to the moment of unzipping was agreed with the production company, the distributor cutting all British prints to that effect.[80] Similarly, cuts were required in

Christiane F. – Wir Kinder vom Bahnhof Zoo (*Christiane F. – We Children from Zoo Station*, 1981) (see case study); in particular, the removal of a scene in reel seven, in which Christiane F. is seen in the same shot as a naked client being whipped.[81]

Increasing Legalisation and Future Issues

> The simple fact is that at every societal level we have been inculcated with the idea that censorship is necessary – to preserve the social order, to protect 'us' from 'them' and to keep in check what the censorious regard as our baser instincts. [...] And censorship is most evident in cinema because, unlike books, plays, exhibitions and TV and radio programmes, every film we see, every DVD we buy is prefaced on the screen or on the disc box by a certificate stating that the work has been examined and judged fit for us to see.[82]

As we move to the next period of the BBFC's history, a number of other significant legal and film-related developments were taking place. Technological advances in the preceding years had seen the advent of the video cassette recorder, which had great implications for the film industry, including how to control piracy and how bodies such as the BBFC could police this new form of output. However, before the law turned to these new technologies, three other important pieces of legislation were passed, the first of these being the Indecent Displays (Control) Act 1981. Its target was the public nuisance aspect of indecent displays so it focused not on the films but on posters and advertisements for cinema clubs. As Stone noted in his commentary on the Act, this could be seen as part of a response to long-standing issues around pornography, not least with the Williams Committee and the Home Office Working Party on Vagrancy and Street Offences,[83] but it could not be seen as a first step to adopting the Williams proposals as there are a number of major differences, including the definition and scope of the word 'indecent', the lack of a restriction on private prosecutions and the inclusion in the legislation of written as well as pictorial material.[84]

Following this, two more cinema-related measures were enacted towards the end of this period, both of which extended licensing controls into the moral sphere and could be seen as a continuation of the approach outlined in the Indecent Displays (Control) Act 1981.[85] These pieces of legislation, the Local Government (Miscellaneous Provisions) Act 1982 and the Cinematograph (Amendment) Act 1982, were both felt by Robilliard to be an 'implied rejection' of Williams, and that '[w]ere we to have prohibited or restricted material as the base for our criminal law a licensing system would be placed on firmer ground'.[86]

As is noted later in the book and elsewhere, Ferman's methods, particularly towards the end of his tenure, were sometimes idiosyncratic and his 'high-handedness' and tendency to procrastinate caused the Board certain problems.[87] That said, Ferman did make a real attempt to balance the equally valid claims of freedom and responsibility, and in so doing, showed both his love of film as an art form and his wider understanding of the responsibilities inherent in trying to marry issues of control and creativity. As Brian Appleyard wrote in the *Independent* some years later,

> [y]ou don't just get Mapplethorpe for the connoisseur, you also get vicious drivel for the masses. More painfully, you also get unarguably fine films such as *Taxi Driver* and *Goodfellas*, which if you are honest, you would rather were not watched by certain types of people.[88]

Ferman acknowledged these difficulties and tried to balance them: much of his approach was distilled from his pre-BBFC career and life-long love of film, and as he himself noted in his well-titled private paper entitled 'Poacher turned Gamekeeper', 'I never stopped thinking as a filmmaker, I've tried to see the Board's role less as a policeman of the industry than as its conscience'.[89]

CASE STUDY: SHIVERS (1975) David Hyman

Canadian director David Cronenberg's first feature film *Shivers* was originally submitted for film classification to the BBFC on 9 September 1975 as *The Parasite Murders*.

Residents in a luxury high-rise apartment tower on an island are infected by a sexually transmitted parasitic virus, which transforms its victims into sex maniacs who are also compelled to commit violent acts. As the virus spreads, a doctor at the island's private clinic tries to uncover the cause of the outbreak and find a solution.

The BBFC examiner's report described the film as a 'well-made and gripping horror film' and noted that '[a]lthough some audiences may be disturbed by the bloody visuals, it is just acceptable for a horror film within the "X" category'.[90] This view was subsequently communicated to UK local authorities in the BBFC's December 1975 Monthly Report, which also noted that the film had received critical acclaim when screened at the Edinburgh Festival.[91]

Following its release, the BBFC received only two public complaints. In one reply, it noted that '[i]t is certainly about an unpleasant subject but [...] is in many ways an adult version of the familiar monster theme which children watch regularly in *Dr Who*. Far more is suggested than is actually shown.'[92] In the other, the Board defended its decision to allow this 'Grand Guignol' film with a central premise that was 'pure fantasy', believing that it would not 'have a corrupting effect on the normal audience'.[93]

However, Doncaster Metropolitan Borough Council and Leeds City Council both called the film in for review, and asked the BBFC to provide them with any information that could assist them in reaching their decisions.

The BBFC reiterated its position that the film's 'sexual horrors' warranted an 'X' certificate, noting in one reply that although 'the theme may be found offensive by some [...] those who would find it so would probably not choose to attend'.[94]

Shivers, one of director David Cronenberg's 'body-conscious' horror films

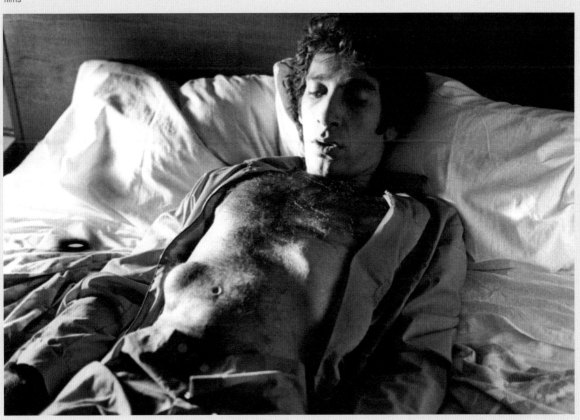

Nevertheless, following viewing by the relevant committees, both authorities refused permission for the film to be publicly exhibited. Leeds City Council's Director of Administration noted that it was the only film to be viewed and refused permission for exhibition in Leeds in 1976.[95]

Shivers was examined for video classification in January 1992. The first team of two examiners was divided on its recommendation. One examiner recommended '18' uncut, while the second expressed concern over the acceptability of two scenes for viewing in the home. In the first scene, which occurs at the beginning of the film, a young woman dressed in school uniform is attacked by a male doctor who strangles her, places her on an operating table, removes her blouse to expose her breasts and cuts the woman's stomach open before pouring a corrosive liquid into the cavity and cutting his own throat (although the cutting scenes are not shown in detail). It is unclear until later in the film that the man is attempting to destroy the sexual parasite that he has created, and the examiner's concern revolved around the ambiguity of the scene and whether it invoked the BBFC's sexual violence policy by eroticising the violence. The second scene features a young girl, who has been infected by the parasite, putting her mouth on a man's mouth, with the concerned examiner 'not convinced that young anonymous girls should be drawn into the adult sex fever'.[96]

Further examiners' views were sought, and these resulted in an '18' uncut recommendation. The BBFC concluded that it is 'always clear that there is no sexual intent' shown by the man in the first scene, with the second scene deemed less concerning, given that the characters are in the grip of uncontrolled sexual mania, and the film was classified '18' uncut.[97]

Shivers was the first in a cycle of distinctive 'biological horror' films directed by David Cronenberg, who has stated that these 'films are very body-conscious' rather than being 'technologically oriented, or concerned with the supernatural' like other science-fiction or horror films of the time.[98] His early films often dealt with the fear of viruses infecting the body and mutation, tapping into prevalent fears about the potentially unchecked spread of diseases like rabies; Cronenberg's second film *Rabid* (1977), for example, dealt with a woman who develops a phallic spike in her armpit that can infect those attracted to her with a murderous rage.

The 'body-conscious' theme combined with sexual elements reappeared in a more visually explicit form in Cronenberg's 1983 film *Videodrome*, in which a man running a cable TV station discovers an obscure channel broadcasting programmes featuring strong torture and violence and becomes part of a bizarre conspiracy involving mind control.

The BBFC classified the film '18' uncut in March 1983. However, prior to the video release, the UK distributor sought legal advice as it was concerned that *Videodrome* was vulnerable to prosecution under the Obscene Publications Act 1959.[99] Consequently, they pre-cut the film prior to submission and it was this version that was classified '18' uncut in 1987. In 1990, the uncut version with the pre-cut material restored was submitted for classification and classified '18' uncut, and a longer 'Director's Cut' version was classified '18' uncut in 1999.

To date, the BBFC has never cut a David Cronenberg film as none has transgressed Guidelines, policy or the relevant legal tests. (See Chapter 8 for a discussion of the controversy surrounding Cronenberg's 1996 film *Crash*.)

CASE STUDY: DIE BLECHTROMMEL (THE TIN DRUM, 1979) Craig Lapper

The Protection of Children Act 1978 introduced a range of new criminal offences relating to the manufacture and distribution of indecent images of children. At the time, the Act defined children as persons under the age of sixteen (subsequently amended to eighteen by the Sexual Offences Act 2003). As we have seen in Chapter 6, the new law had potential implications for a number of films the BBFC had already classified or was in the process of classifying.

A key difficulty for the BBFC was the lack of any statutory definition of 'indecent'. This meant that, when the Act was first introduced, the Board found it necessary to adopt an extremely conservative position in the absence of any relevant case law. This uncertainty regarding what was likely to be found 'indecent' by the courts led to a small cut being demanded to Volker Schlöndorff's *The Tin Drum* when it was submitted for

cinema release in March 1980.[100] The Board had been anticipating problems with the film after press reports from the 1979 Cannes Film Festival (where the film had shared the Palme d'Or with *Apocalypse Now* [1979]) had indicated that the young actor would be engaged in 'sex scenes'.[101] However, this turned out to be something of an exaggeration. The majority of the scenes had been filmed with discretion and restraint and there was no clear evidence that the child actor had been exposed to anything sexual. The examiners were, however, concerned by one particular sequence, in which the child character watches a woman undress, after which he appears to bury his head in her crotch. Although there is no clear sight of contact between the child's face and the woman's pubic region (indeed, Schlöndorff confirmed that a barrier had been placed between the two), some of the shots

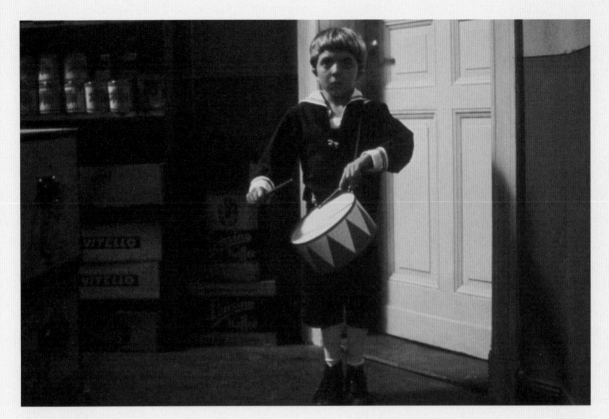

The Tin Drum, one of the
first films assessed under
the new Protection of
Children Act

in this sequence were felt to be in potential breach of the new Act.[102] Significantly, the legislation allowed for individual frames of film to be judged indecent and there was no requirement for any image to be considered in context. Nor was there any defence of artistic merit, unlike with the Obscene Publications Act 1959. Accordingly, following discussions with Schlöndorff, twenty-four seconds of material were deleted from this scene and the film was classified 'X' on 25 March 1980.

Subsequent to the announcement of the BBFC's decision, the *Evening Standard*'s film critic, Alexander Walker, questioned whether the Board's actions had in fact fulfilled the wishes of Parliament.[103] The stated intention of the Protection of Children Act was to prevent the exploitation of children. Walker's point was that if the child had already been 'exploited', then simply removing evidence of what had happened did not serve to 'protect' the child concerned. James Ferman replied to Walker, stating:

> The Court of Appeal ruled in 1976 that no licensing authority may give its consent to that which is illegal, and this new Act

makes it illegal not merely to take such photographs but to distribute or exhibit them in this country, wherever in the world they were produced. Children abroad are beyond the protection of the British Parliament except through the deterrent effect of such a ban. As the Williams Committee commented, 'We should not be parochial about the prevention of harm to children: if English law is to protect children against offences in this country, it is hypocritical to permit the trade in photographs and films of the same activities taken overseas.[104]

Walker's argument about removing the 'evidence' of what had happened was already familiar to the Board in relation to another legal test, the Cinematograph Films (Animals) Act 1937. This Act makes it illegal to exhibit films in the UK if any animals have been cruelly mistreated by the film-makers. In practice, the Board's approach to such scenes was to remove any sight of cruelty (for example, dangerous horsefalls) rather than to impose a ban on any film that had involved cruelty in its production. Had the Board adopted the

latter approach, a large number of Westerns would never have been seen in the UK. In fact, the 1937 Act had also come into play during the classification of *The Tin Drum*, chiefly because of a scene in which some children appear to boil live frogs in a pot. After querying this scene with the distributor, an assurance was received that the water in the pot was not boiling and the impression of smoke was created by the use of dry ice.[105] There was nothing on screen to contradict this assurance and no clear evidence that the frogs had been made to suffer. So, in spite of the cautious cut for potential indecency, no cut was required to *The Tin Drum* on the grounds of animal cruelty.

In 2003, the BBFC was asked to look at *The Tin Drum* again, this time for DVD release. By this stage, considerably more case law had developed surrounding the Protection of Children Act and it was clear that, in order to fall foul of the Act, there had to be some degree of lewdness involved in the shot in question, rather than mere nudity. Given that the shot removed on film in 1980 did not involve anything more than a boy's head apparently next to a woman's crotch, it seemed unlikely that it would fall foul of the Protection of Children Act in 2003. Nothing specifically sexual occurs in the shot, no clear nudity is seen, and there is no clear contact; any impression of sexual activity is created merely through careful editing rather than through the child actor being forced to do anything indecent. Nonetheless, before waiving the cut, the Board sought the views of a consultant psychiatrist, who confirmed that the scene was not likely to be useful as a 'grooming tool' for paedophiles (in other words, something that could be used to encourage a child to engage in sexual activity).[106] Given more recent interpretation of the Protection of Children Act, and the lack of any realistic harm concerns, *The Tin Drum* was passed '15' uncut for DVD release on 23 October 2003.

CASE STUDY: CHRISTIANE F. – WIR KINDER VOM BAHNHOF ZOO (CHRISTIANE F. – WE CHILDREN FROM ZOO STATION, 1981) Craig Lapper

Uli Edel's adaptation of the 1979 autobiographical book about a teenager's experiences of drug addiction and prostitution in Berlin was first seen by the BBFC on 8 September 1981. Although it was recognised that the film's powerful anti-drugs message might have a positive effect on some viewers in their mid-teens, it was also felt that the film was far too harrowing and explicit in terms of its sexual dialogue to be passed at any category other than 'X'. Concerns were also expressed about the manner in which the film focuses almost wholly on the young people, emphasising their sense of camaraderie, with little in the way of any adult counterbalance. It was felt this could make the film and the lifestyle it depicts romantic and attractive, rather than repellent, to more vulnerable teenagers. There had already been reports from France that two teenagers claimed to have become heroin addicts after watching the film.[107] The idea of an 'AA' certificate, with or without cuts, was therefore discounted.

Having established that the film could only be classified at 'X', concern shifted to the age of the actor playing Christiane, Natja Brunckhorst. Although the majority of scenes were discreetly shot, the climactic scene of degradation in which Christiane whips a masochistic client was felt to be potentially vulnerable under the terms of the recently introduced Protection of Children Act 1978. Enquiries were made as to the actor's age and it was discovered that she was indeed under sixteen at the time of filming. Therefore two small cuts were made in the whipping sequence in order to ensure that the young actress never appeared to be in the same shot as her naked male client.[108]

In 1983, the film was submitted for video release. Although there was no formal requirement at that stage for video works to be classified by the BBFC, the Video Recordings Bill seemed likely to be passed into law in 1984. The distributor was therefore aware the film would probably require a formal video classification in the near future. The Video Recordings Bill (ultimately passed as the Video Recordings Act 1984) proposed additional conditions on video releases, over and above those applied to cinema releases. In particular, it required that the BBFC consider the suitability of a work for 'viewing in the home'. With that in mind, the Board was particularly conscious that videos could be viewed repeatedly, that favourite scenes could be viewed out of context, and that there was a higher chance that underage viewers would see a film. This was perhaps especially true of *Christiane F.*, because it focused on the experiences of a young lead character, within what at the time was a reasonably contemporary-looking setting.

Some examiners who viewed the video version felt that it might not be 'suitable for viewing in the home', particularly given the likelihood that it would appeal to underage viewers. Again, concerns centred on the idea that some younger teenagers might find the lifestyle presented attractive rather than off-putting, particularly if they felt they had little to lose, and might identify with the central teenage character in a potentially harmful manner. Examiners suggested it might be helpful to seek expert opinions from professionals working with drug users. Further screenings were arranged in 1984,

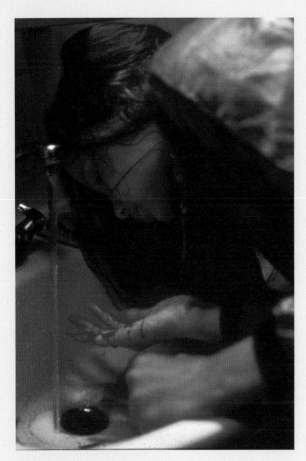

Expert advice on
Christiane F. suggested
the 'cold turkey' scene
might be harmful on
video

resulting in differing recommendations, including '15', '18' and 'Reject'.[109] Expert opinion from the Drug Dependence Clinic tended to confirm the views of some examiners that the film might be attractive to certain teenagers, partly because of the group solidarity shown and partly because of the lack of any significant emphasis on the difficulties of recovery from addiction, including the subsequent struggle against cravings and relapses; some younger viewers might feel that drug use was a feasible 'way out' of their problems and that addiction

could be relatively easily overcome.[110] It was agreed to attempt trial cuts to see whether the video could be toned down in an acceptable manner. Cuts focused on the more ritualised aspects of drug preparation, as well as the more excessive elements of the 'cold turkey' scene. Expert advice suggested that this scene might be misleading and counter-productive because it emphasised the purely physical aspects of withdrawal and ignored the psychological impact. Cuts were also made to some of the cruder sexual dialogue, in view of the danger of underage viewing.[111]

Concerned that the Board might ultimately decide to reject the video, the distributor commissioned a legal opinion from counsel as to the film's suitability for video classification. This legal advice suggested that the film was unlikely to be considered obscene. However, in the light of current concerns about 'video nasties', counsel agreed it might be prudent to make cuts to the work in order to avoid the possibility of police action and to make it more 'suitable for viewing in the home'. Having watched both the full version and the Board's trial cut version, he went on to suggest a number of additional cuts that could be made, with which the distributor was apparently content.[112] Accordingly, a final version of the film was agreed by the Board and the distributor, after five minutes and two seconds of cuts.[113] This allowed the film to be released on video in 1984, with an informal BBFC certificate. Because the Video Recordings Act did not come into operation until 1985, and a staggered system was introduced for classifying works that had already been approved by the Board for film or video release, this video classification was not formally confirmed until 1986.

In 2000, the uncut version was submitted for release on the outgoing VHS format and the new DVD format. A careful examination of the whipping scene revealed that the cuts made in 1981 were an overly cautious reaction to the introduction of the Protection of Children Act and did not clearly show Christiane in the same shot as her naked client. With regard to the other scenes cut on video in 1984, it was concluded that the film did not have quite the same appeal to modern teenagers and was more likely to be seen as a dated but interesting historical piece. Furthermore, BBFC policy on depictions of drug use had moved on since the mid-1980s, when scenes of heroin injection were routinely cut for their fetishised and ritualistic aspects, with the emphasis turning to whether the drug use was glamorised. This was felt not to be the case in *Christiane F.*, because it was dated and therefore less appealing to modern teenage audiences, who would probably be attracted to more contemporary works. Accordingly, the film was passed '18' with all previous film and video cuts waived.

7

MORE THAN JUST A 'NASTY' DECADE: CLASSIFYING THE POPULAR IN THE 1980S

Sian Barber

By the start of the 1980s, James Ferman had established his control of the Board, soothed the ruffled feathers of local authorities, defended the BBFC to the Williams Committee and successfully campaigned for film to be brought under the auspices of the OPA. Yet the 1980s were not to be a period of gentle and gradual development. The technology that had emerged at the end of the previous decade had created a brand new product: home video. This product was to prove challenging for the Board but it also led to the BBFC being awarded statutory powers for the first time in its history. The Video Recordings Act was added to the statute book in 1984 and was fundamentally to alter the censorship of film and video in Britain with the BBFC becoming responsible for classifying videos according to their 'suitability to be shown in the home'.[1] To reflect the VRA's designation of the Board's Presidents as the authority responsible for classifying video works, the organisation changed its name to the British Board of Film Classification.[2]

While the 1980s saw big changes for the Board, the decade was also business as usual for the BBFC. As well as dealing with the 'video nasties', the BBFC was also getting to grips with the changing social climate of the decade and its impact on mainstream cinema. British film-making experienced a revival in the 1980s with a slew of high-quality productions which were financially and critically successful. Films such as *Chariots of Fire* (1981), *Gandhi* (1982) and *My Beautiful Laundrette* (1985) all indicated a new confidence in British cinema, yet none of these films came close to the success of certain American films such as *Raiders of the Lost Ark* (1981), *Return of the Jedi* (1983) or *Ghostbusters* (1984). In this chapter, I juxtapose the BBFC's archive material pertaining to popular British and American films with the video nasties to draw attention to approaches to film content throughout this decade. This will allow a tentative map of BBFC policy to be drawn which encompasses the extremes of the decade such as *The Driller Killer* (1979) but also incorporates the popular in order to look beyond the obvious narratives of the decade.

The 1980s

Lester D. Friedman suggests that in Britain in the 1980s, the new Thatcher government offered 'a combination of economic, political, social and ideological principles that completely broke with the post-World War II consensus and totally restructured British daily life'.[3] Thus the influence of Thatcherism went far beyond a discernible impact on the film industry; popular taste and standards of acceptability were swinging heavily back to the right following the liberal incursions of the 1960s and 1970s. This was also the case in the United States where, as Graham Thompson identifies, the election of Republican Ronald Reagan in 1980 heralded the emergence of cultural and political rhetoric which eschewed the 'damaging moral, social and cultural promiscuity' of the 1960s in favour of a conservative agenda.[4] The changes brought about in British society, notably the ideological changes to which Friedman alludes, can be mapped alongside the debates recorded in the BBFC files. As John Hill has pointed out, 'It is impossible to talk about British cinema in the 1980s without taking some account of how it was engaged in an ongoing debate with Thatcherite ideas, meanings and values'.[5]

Nowhere were these ideas, meanings and values more evident than in the government's approach to the family and children. As Pilcher and Wagg have suggested, the 1980s saw the beginning of heightened debates about childhood and children which emerged from this right-wing political agenda. They note, 'Children are morally preset in new right discourses as instruments of wider political concerns about the condition of society'.[6] For institutions such as the BBFC, these broader sociopolitical debates and government agenda were of the utmost importance. The files for films such as *My Beautiful Laundrette*, *Sammy and Rosie Get Laid* (1987), *Rita, Sue and Bob Too* (1987) and *Drugstore Cowboy* (1989) show clear evidence of these politically driven discourses and indicate how the Board was grappling with issues of sexuality, promiscuity and drug use in the changing cultural and social landscape.

Anxieties about children and childhood are also clearly present in the video-nasty debate with the findings from various commissioned studies into media violence being used to generate bold newspaper headlines. In 1983, the *Manchester Guardian* claimed that 'More than 40 per cent of children aged from six upwards have seen at least one video nasty showing violence and perverted sex' and 'In some families, the video nasty has replaced the conjuror or games at children's parties, Church of England researchers said last week'.[7] The inaccurate reporting of the media-violence debate has been dealt with elsewhere, notably by Martin Barker and Julian Petley, but it is important to consider the stance adopted by the BBFC as an organisation in relation to these discourses.[8] Back in 1976, James Ferman had written privately:

> There is no cast iron evidence for a one to one cause and effect relationship between violence in the media and violence in society. But there is undeniable evidence for a correlation between the two. Those societies which have a high incidence of media violence have also a high incidence of social violence.[9]

Here the cautious and canny Ferman is acknowledging that, although the BBFC did not accept the notion of violent films causing violent behaviour, it needed to be aware of the connections between what was presented onscreen and what could happen offscreen. In an interview in 1980, Ferman publicly declared that 'We must remember that film is a teaching medium. In fact, the process is cyclical because the media reflect society and, in reflecting it, they offer back, usually as glamorised images, models for behaviour.'[10] Again, while not accepting the simple reflexive model proposed by the media, Ferman is suggesting that the BBFC was well aware of the problems caused by films which glamorised unsuitable behaviour and how dangerous this was when it came to children. Worry about imitable behaviour was not new, yet as debates on the influence of the media grew more vocal, the BBFC took note of the prevailing concerns and the files reflect the facts that these external debates affected its decisions.

Internal Changes

Another major change for the Board in the first half of the decade was the revamp of the classification system. Since the mid-1970s, the BBFC examiners had been calling for a certificate to address the needs of teenagers who could easily accept the material provided to them by 'AA'-certificate films but were not ready for the extremes of the 'X' certificate.[11] In November 1982, the classifications became age-specific; the '15' certificate replaced the old 'AA', 'X' became '18' and the 'A' morphed into a 'PG'. Yet despite this overhaul another new category was formally adopted at the end of the decade. The '12' certificate was created in 1989 to sit alongside the American category of 'PG-13' and the first film to receive it was Tim Burton's *Batman* (1989). One examiner dubbed the film 'bleak' and 'nightmarish' and suggested that this made it too strong for the 'PG'.[12] Other examiners argued that it would look 'over-classified at 15' and that its content featured far less violence and sadism than other '15' films, including 'the illusion-shattering cynicism of *Gremlins*'.[13] The compromise was to allocate the first '12' certificate, a change which actively recognised the development of a new pre-teen market that film-makers were targeting, notably those in the action and adventure genres. This again highlights how adolescent audiences were being carefully considered in the decade.

In order for the Board to meet its new statutory requirement to classify all videos, it had to expand, taking on new staff and training new examiners. For most of the previous decade, the BBFC had operated with a team of seven examiners but, as a letter from 1987 reveals, by the late 1980s, the Board consisted of twenty-one examiners, ten of whom were women, plus the Director James Ferman, Deputy Director Ken Penry and Assistant Director Margaret Ford.[14] The total

number of staff at the BBFC was now forty-eight, twenty-one of whom were working at the Board on a part-time basis.

This rapid expansion had implications for the internal operation of the BBFC, which as an organisation was now structured around the views and opinions of a disparate collection of individuals, rather than a tight core of examiners. Nowhere is this more evident than in the files for specifically problematic films such as *The Driller Killer*, *The Evil Dead* (1981) or *Death Wish II* (1982), for which the full examining team was consulted. Films like these were also used as training material for new examiners – a definite shift from the relatively informal and *ad hoc* approach of the previous decade. One direct result of these changes was the increase in internal discussions about individual films. This is all carefully recorded in the film reports which document who was in favour of cuts and who was pushing for higher or lower categorisation. This increased discursive dimension within the BBFC examining team is in contrast to the drastic reduction of discussion and engagement with production, exhibition and distribution companies. Unlike earlier periods, notably the 1960s and 1970s, where letters and memos burst from the files of almost every film, the 1980s material is much more formal. Personal contact from directors or producers is rare and only appears in the form of letters of complaint, such as those from Michael Winner about *The Wicked Lady* (1983) or those from distributor United International Pictures (UIP) following James Ferman's intervention on *Indiana Jones and the Temple of Doom* (1984) (see case study).[15]

Nasty Content (I)

Although the BBFC was classifying around 400 films a year throughout the course of the 1980s, the cases which received the greatest amount of media attention were a disparate collection of films which Kate Egan has pointed out 'were not predominantly grouped together on the basis of shared formal, thematic and/or structural features, but on the basis of historical and political circumstances'.[16] The video nasties have shaped the entire 1980s censorship debate but, as Julian Petley has observed, to lump them together without thought for genre or content into a pejorative category of 'nasty' does not encourage critical interrogation.[17] It is important to note that the Board actively considered the individual merits of these films and more than one examiner admitted to seeing something noteworthy in them. One of the first to reach the BBFC was Sam Raimi's *The Evil Dead* in 1982. BBFC responses to the film were mixed: one examiner commented that the film made her want to 'giggle and heckle', while another described it as 'grand-guignol horror at its least artistic and most unappetising [...] I find it emotionally taxing, disgusting and way over the top of what the normal cinema-going public expect at X'.[18] Despite their personal responses, the BBFC did seriously discuss how the film could be passed for exhibition – one senior examiner suggested that 'the eye-gouging scene' would have to go – and there was no immediate institutional cry for it to be suppressed.[19]

Yet the real problem the BBFC had with *The Evil Dead* related to its audience. One examiner noted wearily:

> We have to reduce it to a level suitable for more or less anyone over 18, regardless of whether they are familiar with the recent clichés of the horror genre [...]. So in fact what we are being asked to do is to make the film suitable for the very market that the film laughs at. Not on! Tell them to take the 18R and go to hell or destroy their own bloody movie in their own way and not blame us for it.[20]

Finally, after extensive internal discussions, at the end of 1982, it was suggested that the film should be cut along lines recommended by the Board and resubmitted. Unfortunately for Raimi's film, in 1983 the Director of Public Prosecutions published his list of nasties and *The Evil Dead* soon became one of the most high-profile titles to be added to the list. Copies were seized from video shops and the film was held up as an example of unregulated video which could be seen by anyone, including children, in the home.[21]

In the midst of this ongoing furore, *The Driller Killer* arrived at the BBFC. Although the Board was apprehensive about this latest submission, the examiners' reports are again thoughtful and considered. One noted that the film was 'quite an interesting and realistically realised portrayal of people on the periphery of society, caught up in the urban decay and angst' while another observed 'I cannot but admit that I found much more in this video worth watching than say *I Spit on Your Grave* or *House on the Edge of the Park*'.[22]

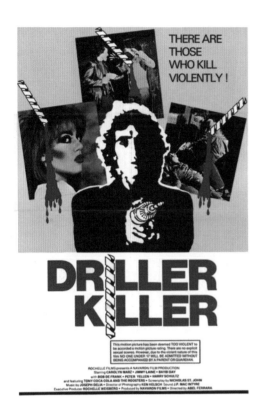

THERE ARE THOSE WHO KILL VIOLENTLY!

DRILLER KILLER

This motion picture has been deemed TOO VIOLENT to be accorded a motion picture rating. There are no explicit sexual scenes. However, due to the violent nature of this film NO ONE UNDER 17 WILL BE ADMITTED WITHOUT BEING ACCOMPANIED BY A PARENT OR GUARDIAN.

ROCHELLE FILMS presents A NAVARON FILM PRODUCTION
Starring CAROLYN MARZ • JIMMY LAINE • BAYBI DAY
with BOB DE FRANK • PETER YELLEN • HARRY SCHULTZ
and featuring TONY COCA COLA AND THE ROOSTERS • Screenplay by NICHOLAS ST. JOHN
Music by JOSEPH DELIA • Director of Photography KEN KELSCH Sound J.P. MAC INTYRE
Executive Producer ROCHELLE WEISBERG • Produced by NAVARON FILMS • Directed by ABEL FERRARA

The BBFC felt that Abel Ferrara's début, *The Driller Killer* (1979), was the work of 'a film maker of talent'

However, the majority of the examining team considered the film to be poorly made, dull to watch and of little importance. One scathing report suggested it had 'as much tension as a piece of knicker elastic' while another judged it 'incoherent in both visual and narrative terms and both tension and motivation are absent'.[23] Despite these reports highlighting the film's perceived inadequacies, none of the examiners called for it to be rejected. Most agreed that it needed to be cut and suggested ways in which this could be accomplished, but some drew attention to the film as a worthwhile piece of film-making which did not deserve to be suppressed. One of the more detailed reports notes:

I do not warm to 'The Driller Killer' but I do think, with cuts, it is a viable commercial proposition and I can imagine a young audience for whom it might have a genuine significance [...] I do not say the film is either likeable or very good but it is the product of a genuine, if disturbing imagination, of a film maker of talent.[24]

While the BBFC's liberal stance towards *The Driller Killer* is illuminating, crucially all of these comments were made secure in the knowledge that the film could not be granted any kind of certificate. As one of the films identified as a nasty and sitting close to the top of the DPP's list, there was no way that the film could be treated like a standard submission.

The Driller Killer and *The Evil Dead* were films with some extreme horror content, but the umbrella term 'video nasty' encompassed a range of films with completely different thematic preoccupations. *I Spit on Your Grave* was a notorious film from 1978 that had never been submitted to the Board for cinema classification but which the BBFC viewed in 1983 and 1984 during a period of voluntary video classification, prior to the introduction of the VRA. In their reports, examiners describe the films as 'rape nasty', 'inhumane rape exploitation', 'rape revenge', 'sex and violence exploitation' and 'unabated women hating sexual humiliation'.[25] These descriptions unequivocally sum up the BBFC's response to the film at this time. Unlike with *The Evil Dead* or *The Driller Killer*, there were no voices calling for the film to be treated as a serious contender for classification. One examiner felt it was 'a truly repulsive film' and another firmly stated 'the simple plot [...] disguises the totally depraved and unacceptable manner in which the director treats the subject'.[26] One BBFC examiner, who had previously worked as a psychologist, noted, 'The theme and treatment here are unacceptable since the whole film is devoted to the inextricable linking of sex and violence in a depraved and potentially depraving way'.[27] It was not simply the content of the film that the BBFC examiners found to be so objectionable; it was also how the director presented the material to the audience. One examiner wrote rather ponderously:

Freedom of artistic expression carries responsibilities and the line ought to be drawn when an artist abdicates these responsibilities by using his skills not to illuminate the human condition but simply to titillate an audience by inviting them to enjoy rape and then indulging their blood lust.[28]

The BBFC had been concerned with on-screen representations of rape since the early 1970s and was firmly committed to a policy that did not allow sexual violence to be represented in a way which could be construed as enjoyable for the victim or titillating for the audience.[29] This was a publicly expressed policy, with James Ferman declaring in 1979 that 'Film-makers in recent years have used rape as a turn on for a male audience and this is something which the Board will no longer allow.'[30] The handling of the sexual violence was seen as *I Spit on Your Grave*'s chief failing and the film's approach to the sensitive topic of rape was deemed unacceptable by the BBFC. Yet other films did manage to tackle this problematic subject matter in a way which the Board could and did approve.

Nasty Content (II)

As a direct contrast to *I Spit on Your Grave*, courtroom drama *The Accused* (1988) tackled the subject of rape in a very different way, calling for the BBFC to make a landmark decision. The film featured Jodie Foster as a rape victim and Kelly McGillis as her lawyer determined to acquire justice; it dealt with rape in a way that was thoughtful and sensitive but which was nevertheless explicit, with the full horror of the victim's ordeal revealed in a lengthy flashback sequence.

The film-makers were well aware that its content could be contentious and had requested the '18' category, but the real problem was the risk of cuts. The Board was quick to note that the film was not sensational, but did concede that the flashback sequence was very long, with some 'visual-reward' nudity, including the sight of bare breasts.[31] Both of the examiners pinpointed the problem as the representation of the rape as a male group activity, which actively communicated 'excitement and sex' and *could* be construed as pleasurable and titillating for an audience. Ultimately, the crucial issue was whether these flashbacks might potentially influence or excite some audience members. However, the BBFC sensibly recognised that the way in which audiences responded to films was beyond its scope to control. One examiner observed that after seeing the film, 'We felt like we had been silent witnesses to a very nasty crime. Let us pray that after general release, audiences in the cinema are similarly silenced.'[32] After agreeing that the film would not be cut at all for the '18' category, one female examiner declared 'I am content to be a member of a team making this decision which would undoubtedly be controversial and I am ready to defend it'.[33]

The Accused became the first film classified at '18' to depict rape so explicitly and the BBFC defended its decision by claiming that the material 'did not exploit or eroticise sexual violence but instead made a serious point'.[34] A similar argument could not be applied to either *Class of 1984* (1982) or Michael Winner's *Death Wish II*, both of which featured scenes of graphic rape and which were subject to cuts before they were certificated.

The classification of *Death Wish II* was a bad-tempered affair, with examiners frustrated by what they saw as the blatant attempts by Winner to use sex and violence to ensure box-office appeal in his sequel to the successful *Death Wish*. One examiner declared 'This determined and calculated attempt to arouse man's basest instinct deserves to be given no consideration at all' while another suggested 'We could make cuts in the obvious excesses; the rapes and the incidents of overkill, but the film constantly reinforces the righteousness of violent personal revenge, with those in authority always admiring the vigilante hero'.[35]

The report continues:

Jodie Foster as Sarah Tobias, a rape victim searching for justice in *The Accused* (1988)

I think it is a very, very dangerous film in that it reinforces a view of society that many of its depressed and fearful underdogs believe to be true. It is a film designed to attract a violence-loving and hence loutish audience. [...] I can't see that this message will change with cutting, and I would prefer to reject the film outright. [...] I think the film is a threat it would be irresponsible not to take seriously.[36]

As well as the film's message and treatment, the specifically problematic sequences were the respective rapes of the hero's daughter and maid. The examiners labelled these episodes 'appalling', 'gratuitous', 'exploitative' and 'disgraceful' – strong reactions which anticipated how they would later respond to *I Spit on Your Grave*. The list of cuts detailed for the film is extensive, and it was only after a total of four minutes was cut from the rape episodes that the film was finally given the 'X' certificate.

The school-set *Class of 1984* was another film containing such extremes of horror and sexual violence that one examiner felt it was 'quite nauseating and yet compulsive viewing. The problem is whether to reject it on the basis that it appeals to the lowest common denominator to an audience seeking violence.'[37] The rape scenes were immediately identified as content which needed to be cut for the highest category and the reports identified other questionable material, including a mutilation with a circular saw and a sequence of someone self-harming. However, it was the tone of the film which the examiners found objectionable; one labelled it 'dishonest and cynical [...]. The treatment is shallow in the extreme using and reinforcing stereotypes', while another felt 'I suppose this could be a X except that I don't particularly want to unleash it on the kind of audience I suspect would lap it up'.[38] General concerns about the impact of this film on society and the 'unhealthy' nature of the violence presented within it also form the basis for a number of the examiners' reports, with a particular focus on how such material could have a dangerous effect on a teenage audience.

Growing Pains

The greater degree of consideration given to teenagers was not simply about what children might find upsetting or offensive, but rather *when* and *if* children should be exposed to certain material. Nowhere was this debate more prevalent than on the issue of drugs.

The German-made *Christiane F.*, as we have seen, had been passed with minimal cuts; however, drug-taking continued to be one of the biggest headaches for the BBFC. Teen film *The Breakfast Club* (1985) was felt to glamorise drug-taking, while the frequency of the drug use in *Drugstore Cowboy* posed a slightly different problem.[39] This film, with Matt Dillon as a drug-

Matt Dillon in *Drugstore Cowboy* (1989)

addled and frequently comical anti-hero, divided the BBFC examiners over whether it set out to deliver an anti-drug message or normalised drug-taking. One examiner suggested 'Personally I felt that the film did not glamorise the taking of drugs though it acted honestly in resisting any attempts to conceal the fun and excitement which might result from it for some'.[40] Another examiner dubbed it 'brilliant' and considered it to be

> [a]n honest and unexploitative movie about the addicted personality [...]. There is not the attractive squalor of *Christiane F.*, nor the glamorous though dated, psychedelic adventures of *The Trip* but a simple matter of fact presentation of people dedicated to drugs.[41]

Of course, crucially the drug-taking does not involve young teenagers and much of the action is played for laughs. One of the examiners noted that 'some of the farce is well done and more suited to [a] film called 'Carry on Shooting Up' [...]. The scene where he escapes from the guards in the hospital seems to have been taken from 'Raiders of the Lost Pharmacy' as he leaps from window to rooftop.'[42] In the lengthy discussions about the film's attitude to drugs, a number of the examiners commented as that as *Drugstore Cowboy* is set in 1971, the casual drug use is taking place before a general awareness of AIDS, justifying to a certain degree the comical treatment. Importantly, and unlike *Christiane F.*, *Drugstore Cowboy* featured adults, which allowed the BBFC to award it the '18' certificate, secure in the knowledge that it was not marketed at a teenage audience. Discussions on drug use resurfaced throughout the decade, becoming more prevalent following the introduction of the '15' certificate in 1982.

Other films also caused problems: Oliver Stone's *Platoon* (1986) reached the BBFC in February 1987 and reignited the debate about whether younger teenagers could safely be exposed to violence on screen and whether there was an 'educational' value in showing them such material. The American war film was an important genre in the 1980s with directors like Stone and Stanley Kubrick producing seminal work on America's involvement in the Vietnam War.[43] The examiners reacted to *Platoon*'s violence with predictable concern, but also identified that the drug use shown could prove problematic for teenage audiences, with one examiner asking 'what arguments would be advanced for justifying scenes of drug-taking which are presented both as lifestyle and as a legitimate relief from tension'.[44] The strong language was also cited as an issue, yet it was the violence which dominated discussions, with one examiner commenting, 'If ever there were a case for an "18" on the grounds of quantity of violence, it is here. [...] [T]here is hardly any let-up in graphic, realistic violence, most of it gory.'[45]

But other BBFC examiners argued that the film carried a powerful anti-war message and should be seen by younger teenagers as it could educate and inform. The producers and distributors were certainly in favour of the lower category, yet one examiner actively queried whether such an approach was in fact ethical, observing thoughtfully, 'To enable a good film reaching a larger audience is not a bad thing; but is this what we as censors are supposed to do?'[46]

Despite its violence and language, *Platoon* was ultimately awarded the '15' classification, but this soon became a hostage to fortune for the BBFC as it struggled to position other films alongside it. When *Full Metal Jacket* (1987) reached the Board later that same year, the debate about *Platoon*'s violence and language resurfaced. Some examiners suggested that Kubrick's

(left) Tom Berenger, Charlie Sheen and Willem Dafoe starred in the hard-hitting, but '15'-rated *Platoon* (1986); (right) *Full Metal Jacket*, with R. Lee Ermey as the drill sergeant, earned an '18' in 1987

effort was far more extreme than Stone's and so deserved a higher classification, while others strenuously rejected such arguments. One of the reports noted heatedly:

> [i]f I were Stanley Kubrick [...] I would feel that there has been a certain amount of discrimination here. Granted, his film is more intelligent, ironic, humane and powerful, but it is certainly no less moral, and, in its avoidance of the pitfalls of myth-making cine-heroism, is certainly no more of a problem for 15-year-olds than the previous Vietnam movies.[47]

The examiners were divided, with some considering that the language and 'Peckinpah-esque' violent spectacle could not be anything other than '18',[48] and others firmly asserting that the film deserved more sympathetic treatment because of its anti-war message. One of the film examiners wrote passionately,

> This is an important, meaningful film which insists that we use our category system with maximum social conscience; that as with other films of import to younger as well as older people we make it available despite its specifics.[49]

The film was ultimately passed '18'.[50] The debates about the teenage audience show no signs of abating within the BBFC files, even after the introduction of the '12' and '15' certificates.

Sex and Society

In addition to the ongoing debates around drugs, violence and adolescents, the portrayal of sex on screen, although not as frequently debated as it had been in the 1970s, was still a contentious issue. In 1987, UIP requested a '15' certificate for *Fatal Attraction* (1987), a request which was promptly rebuffed by the BBFC. One problem with the film was the realistic and graphic nature of the sexual encounters between the adulterous lovers played by Michael Douglas and Glenn Close. One examiner observed pointedly, 'Sex between Close and Douglas has all the wild urgency of the real thing – pants and trousers yanked down in the kitchen, bare asses of both up against the wall in close up'.[51] Yet, although the sex scenes were graphic, it was the potent combination of explicit sex, a bloody attempted suicide and 'terror within a domestic setting' which made the film 'too emotionally harrowing for the 15' and thus consigned it to the '18' category.[52] One examiner mused about sex on the cinema screen and attitudes towards fidelity, commenting:

Alex (Glenn Close) attacks Dan (Michael Douglas) in *Fatal Attraction* (1987), an '18' – and a sensational hit

No easy, trivial seventies-style adulterous liaisons now in the heavy-hearted late 80s; rather an old fashioned reassertion of the primacy of wedlock and we are never in any doubt as to the prime importance to Dan of his marriage and his family life.[53]

However, as another examiner observed, the thematic consideration was one thing but the presentation of sex was often problematic, especially when it was so graphic. He noted:

The relationship between many audiences and screen sex is a delicate one with many in both older and younger age groups feeling comfortable only as long as the idea of intense physical exertion is kept in the background. It certainly isn't here.[54]

Fatal Attraction's content helped to push it right to the top of the '18' category, and although many other films included sexual content, few others ventured this far, instead opting for tamer depictions which would be less likely to unsettle audiences.

Although frequently expressing its distaste for films about sex, in the later 1980s, the BBFC recognised that the inoffensive nature of many of these films would not disturb or upset audiences. In 1988, one examiner labelled *Scandal* (1988), a filmic interpretation of the Profumo affair, 'sleaze' and considered that its theme of 'call-girl life, cynical sexual dealing and pathetic frolics of the ruling classes all get us into 18 as probably do some pretty frank remarks about cruising, bondage, pimping and the nature of prostitution'.[55] Yet the film was passed with only a single tiny cut. Another film with sexual content, *Personal Services* (1987), a fictionalised account of the activities of London madam Cynthia Payne, presented the BBFC with an unusual problem. By the time it reached the Board in November 1986, Payne was awaiting trial for offences under the Sexual Offences Act. A stern legal letter warned the BBFC of contempt of court if the film were to be publicly screened or exhibited, and so the film was classified but the certificate was not issued until the conclusion of Payne's trial in January 1987. Aside from the legal prohibition, there was little in the film's content to trouble the BBFC or audiences. One of the Board's examiners considered

Personal Services (1987), starring Julie Walters (right), was inspired by the life of Cynthia Payne

it to be 'an X rated Carry On film [...] [O]ne expects Kenneth Williams to appear at any minute', while the other believed it to be more like 'an Ealing comedy of sexual manners' although remained adamant that the 'explicitness of the deviant sexual practices both visually and in dialogue class [it] for the adult 18 certificate, but the humorous context in which they appear means their explicitness is not too strong for the 18'.[56]

In the same year, *Rita, Sue and Bob Too* – a film which would be publicised with the tagline, 'Thatcher's Britain with her knickers down' – continued the British take on sex in the 1980s. The BBFC observed that, despite the film's 'gritty realism and comic sentimentality', the amateur fumbling of the eponymous teenage girls in the seats of Bob's car was too much for the '15' category.[57] Although not as adult as *Fatal Attraction* or *Personal Services*, the inclusion of an unlikely cinematic threesome ensured that this film was also placed in the '18' category. The reports for the film highlight its teenage promiscuity, an issue which the Board was keen to avoid presenting in a positive way. In a 1980 interview, Ferman had stated unequivocally, 'I think there's no doubt that the permissive generation became glamorised through the media, which showed free and easy promiscuity as not only the norm but fun'.[58]

This view of promiscuity as fun and frolicky is an idea which many 1970s films had effortlessly captured. But by the late 1980s, with the growing awareness of AIDS, such cinematic depictions of casual sex were seen to be irresponsible and quite out of step with the prevailing social and political climate. Samantha Lay suggests that the Thatcher government was instrumental in spearheading a series of 'moral panics' relating to 'the sexuality of young people from teenage pregnancy and single parenthood to the sustained attack on the gay community and their lifestyles in the era of AIDS'.[59] Certainly, attitudes to sexuality and the public morality of the decade directly influenced both the production and the reception of films like *My Beautiful Laundrette* and *Another Country* (1984).

When *Another Country* was submitted in January 1984, the BBFC examiners were unanimous in judging that the film's homosexual themes and content should not push it into the '18' category. One examiner commented,

> We felt that intelligent teenagers will get a lot out of this film (those who could afford it rushed to see the play) and that it would be totally unreasonable to give it an 18 just because of a homosexuality theme.[60]

Another felt that 'The homosexuality is quite clear throughout – but discreet in the picturing of sexual activity [...]. The treatment of the homosexual theme is serious throughout and should in fact be useful to older teenagers considering their sexual identities.'[61]

The fact that *Another Country* was sincere in its treatment, was adapted from a successful stage play and was neither exploitative nor titillating undoubtedly helped secure it the lower certification. But problems emerged for the film's classification on video in November 1984 when one examiner challenged suggestions that the film could be awarded the 'PG'. He argued that

> [a] mistaken conviction in the need for parity in presentation of sexual behaviour patterns should not lure us into giving this video anything other than a 15 certificate. Understanding of sexual differences still requires careful explanation and a PG video is not the place to introduce it.[62]

In 1985, the age of homosexual consent was twenty-one, following its partial decriminalisation in 1967, and the comments made here by this BBFC examiner must be read as reflective of the socio-political climate and the deep anxiety which accompanied discussions about homosexual behaviour.

My Beautiful Laundrette, financed by Channel 4, was a bold film which won critical accolades for the resolutely honest gay and interracial relationship at the heart of the narrative. This realistic portrayal of sexual identity was lauded by the BBFC, and one examiner noted, 'The homosexual element of the film was finely handled, almost as though it were not gay at all which is rare on the screen and interracial aspects are in fact rather underplayed'.[63] It is interesting that, despite concerns about AIDS, the film makes no reference to the broader social and cultural climate of homosexual behaviour but rather focuses upon race and racism, once again underlining the normality of the relationship at the heart of the film. Unlike *Another Country*, the film had a straightforward passage through the BBFC when it came to being classified for video as it had already been shown on Channel 4 and eased into the '15' category for video with no discussions about the suitability of its content for adolescents.

Omar (Gordon Warnecke) and Johnny (Daniel Day-Lewis) in love in 1980s Britain in *My Beautiful Laundrette* (1985)

The Family Film

Some of the biggest hits of the 1980s were films destined for a family audience, with heroes like the unstoppable James Bond continuing to woo the ladies and defeat the villains throughout the decade. Roger Moore would be replaced as Bond in 1987's *The Living Daylights* by Timothy Dalton, who brought a more rough-and-ready approach to the role or, as one female examiner put it, 'a chauvinist model of behaviour in true keeping with [the] original Bond character'.[64] Throughout the 1980s, Bond continued to generate returns at the box office and the BBFC examined *For Your Eyes Only* (1981), *Octopussy* (1983) and *A View to a Kill* (1985) in quick succession.

Although James Chapman identifies that the generic formula of the 1980s Bond films allowed the series to 'adopt and modify itself according to various industrial, political and cultural determinants', its content posed few problems for the BBFC.[65] One of the examiners noted that *For Your Eyes Only* was '[l]ess tongue in cheek and more geared to adventure than previous Bond movies starring Roger Moore', while another commented '[T]his is very much a back to form Bond with an all-action, multi-location film. Plot is sacrificed to action but who cares.'[66] *Octopussy* was also straightforward for the BBFC, with one of the senior examiners noting that the series as a whole was

> presenting fewer and fewer problems as the genre exudes self-confidence to an extent where it can send itself up. The bed scenes all stopped well within the PG and none of the aggro was serious enough to give us serious pause.[67]

It is telling that another senior examiner dubbed *Octopussy* 'an action and humour epic', suggesting that the comedy in the series had not only became a crucial part of the franchise but also removed many of the BBFC's anxieties about the violent or risqué content.[68]

The *Octopussy* file also sheds light on how classifying the Bond films had become a production in itself. One of the examiner's reports noted that the film was screened by Eon Productions for members of the BBFC including James Ferman, but that also present were representatives from the US censors, the US Department of Defense and the Indian government. Perhaps this select audience was intended to ensure that the film did justice to its Indian locations and characters and that it accurately (but perhaps not *too* accurately) presented US defence policy? Regardless of its intentions, this screening indicates that the presentation of the Bond films to the Board had become a highly organised event; one of the more experienced BBFC examiners alluded to the screening as 'the usual jamboree'.[69]

By the time *A View to a Kill* came to be classified in 1985, the films were seen as unproblematic texts; one of the examiners termed this film 'a lightweight romp'.[70] Despite this, both the male and female examiners noted the shift in the series' presentation of Bond girls. A female examiner considered that 'the women are treated with rather more respect than usual and I would have thought there was nothing to offend anybody', while a male examiner concluded, 'Sex is fairly minimal and even sexual innuendo is at a fairly low level for a Bond film'.[71]

While Bond was still a favourite with 1980s audiences, he was being challenged by a hero of a very different kind who spearheaded a new genre. These films shared characteristics with the recently established blockbusters and with Bond, but also paid homage to swashbucklers, adventure films and imperialist narratives. One BBFC examiner labelled this new series 'the barnstormer' and this partially sums up their appeal as films.[72] With Harrison Ford as the adventurous archaeologist Indiana Jones, *Raiders of the Lost Ark* proved a massive hit with audiences. Less suave and far more physical than Bond, Indiana Jones came to epitomise a new kind of 1980s masculinity.[73] Although its hero was straightforward, the classification of the film was not; despite being passed for audiences in the 'A' category in 1981, the high levels of violence caused headaches for the video-examining team in 1986. One examiner noted:

> I found the violence and splatter rather strong for the PG and judging from the numerous letters on file, many parents and children did too. Though the category decision was well justified by various members of this Board, the fact remains that the violence and horror passed PG in this movie far exceeds what is acceptable at PG by current standards.[74]

The second examiner also commented on the violence in the film and made a broader point about Board policy, noting:

The BBFC's classification of *Octopussy* (1983), starring Roger Moore and Maud Adams, was 'a highly organised event'

> The fact that young boys might like this sort of stuff is besides the point. Surely the point being made at the last Board meeting is that people can too easily become insensitive to the depiction of violence – or even come to enjoy it. This is all the more true given that here [...] the hero is meting out most of the violence. This makes it attractive rather than aversive to a young audience.[75]

In the space of five years, questions about the impact of violence on young video audiences had moved to the forefront of Board discussions and the BBFC was clearly concerned about the effects of the comic-book violence carried out by the film's hero. Such overt violence in what was essentially a family film presented the Board with a real conundrum. The original video classification team advocated a '15' certificate while the second team of examiners called for the 'PG'. In a file note to James Ferman, a senior examiner pithily summarised the problem that 'None of the examiners seem happy with the PG although they are prepared to pass it at this category on pragmatic grounds'.[76] Ultimately, the BBFC recognised the immense popularity of the film and it was this which helped to secure it the 'PG' certificate. Yet allocating this film the 'PG' did not solve the problem; the issue of violence in this family-friendly genre resurfaced with *Indiana Jones and the Temple of Doom* three years later.

Along with the blood-letting, the creepy crawlies and the gruesome torture imagery, *Temple of Doom* was difficult for the BBFC as it was not a standalone film. The archive files indicate that the Board had trouble allocating certificates to films produced as part of a series. One of the biggest of the 1970s and 1980s was George Lucas's epic science-fantasy series, *Star Wars* (1977), *The Empire Strikes Back* (1980) and *Return of the Jedi*. Back in 1977, *Star Wars* had been awarded a 'U' certificate. Despite concerns from a senior examiner that both this film and its sequel were 'more appropriate under the A category', *The Empire Strikes Back* was allocated the 'U' because no complaints had been received about the classification of *Star Wars* as a 'U'.[77] Both examiners objected to the torture of Han Solo (Harrison Ford) and his off-screen screams, clearly audible on the film's soundtrack, but on referral to James Ferman it was agreed that *The Empire Strikes Back* could receive the 'U' certificate without cuts. By the time the final film of the trilogy, *Return of the Jedi,* was submitted to the Board in 1983, the 'PG' had been introduced and the classification of the film as 'U' was called into question. Examiners cited two sequences as potentially difficult: the first sequence with Jabba the Hutt and the scene in which the Emperor (Ian McDiarmid) attempts to kill Luke (Mark Hamill) with what one examiner termed 'electric forces'.[78] However, the film was part of a series and as one examiner observed:

> I think that if this had been an isolated film I would have passed it PG (the category given it in America). As the two previous films in the *Star Wars* series have been passed U without complaint from the public I am prepared to pass this also in that category as it is very little stronger than *The Empire Strikes Back.*[79]

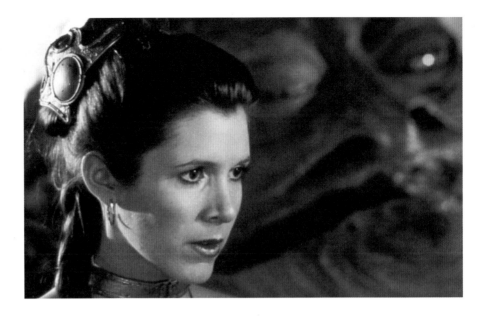

Princess Leia (Carrie Fisher) watched over by the infamous Jabba the Hutt in *Return of the Jedi* (1983)

Another examiner commented sagely that '[t]hose that choose to take their children to see this will already know the saga's conventions and will therefore know what to expect'.[80] Here clear emphasis is placed on parental responsibility in monitoring what children watch but it also acknowledges that the BBFC knew that the public was aware of the type of content in these films and that comic-book violence was now a key part of the cinematic landscape. And indeed, by 1989 even Bond was causing trouble for the Board (see case study on *Licence to Kill*).

The 1980s Reconsidered

This consideration of the BBFC files has revealed a number of important trends as well as focusing on some of the most popular and well-known films of the decade. It is clear that broader social and cultural discourses about childhood, adolescence, media effects and viewing in the home were all impacting heavily on BBFC policy and informing decisions being made about particular age groups. The discussion about the '15'/'18' category distinction is evident in many of these files and revolves around what young teenagers could and should be exposed to. The old debates about imitable violence are present, but other issues had begun to claim the Board's attention, notably drug-related issues, explicit war films and comic-book representations of violence which had begun to establish themselves firmly in the lower categories.

The exploration of the video nasty files indicates that the Board was no more or no less sympathetic towards these films than they were to other submissions with similarities of content or treatment. It is even possible to see that they preferred *The Driller Killer* and *The Evil Dead* to *Class of 1984* and that they considered *I Spit on Your Grave* to be akin to *Death Wish II*. Positioning these films alongside others submitted for classification in the decade locates them as simply part of the cinematic landscape rather than seeking to remove them entirely or focus on them to the exclusion of everything else.

By the end of the 1980s, the BBFC was a very different organisation from the one that had begun the decade, and a large team of examiners worked to apply a wider range of categories. Many of the reports are detailed and extensive and actively consider the broader issues, often drawing upon social and government research. The archive material illustrates the wide range of problematic content with which the BBFC was wrestling, and this focus on popular and successful films rather than simply the stand-out cases helps to reveal its broader policy and increase our understanding of film censorship and classification in this period.

CASE STUDY: INDIANA JONES AND THE TEMPLE OF DOOM (1984) Edward Lamberti

'The hero is back', proclaimed UK posters in the spring of 1984. But *Indiana Jones and the Temple of Doom*, Steven Spielberg and George Lucas's blockbuster adventure – and the *prequel*, lest we forget, to *Raiders of the Lost Ark* (1981) – ran into censorship trouble both with the BBFC and in the US.

From its first screening for the Board's examiners on 30 April 1984, it was clear that the film posed serious problems for the desired 'PG' category.[81] The concern was the strength of the violence and horror in many parts of the film, notably the sequences in the Temple of Doom itself, which included a sacrificial victim's heart being ripped out while he is still alive, the film's hero (played, as before, by Harrison Ford) being forced to drink human blood, and various brutal fights.

After a further viewing, the BBFC issued a letter to United International Pictures (UIP), the film's UK distributor, stating that fourteen examiners, including James Ferman and the Board's then President, Lord Harlech, had seen the film 'and each, reluctantly, ha[d] conceded' that it was too strong for 'PG'.[82] The reluctance was due to the Board's recognition that the film included much that would appeal to children, and that 'boys of 8 or 9 upwards will be breaking down the doors of cinemas all over Britain if we stop them seeing the sequel to RAIDERS'.[83] Nevertheless, the Board was clear on its position, and with the letter was a cuts list for 'PG':

Reel 4: a) In the sacrificial Thuggee ceremony, remove entirely the tearing out of the young victim's heart and all subsequent sight of it bloody and pulsating in the High Priest's hand.

b) Greatly reduce the prolonged terror of the victim as he is slowly lowered into the fiery vortex, removing in particular 1) the low-angle shot of him screaming as the cage descends towards the camera, and 2) all later shots of him being lowered past camera to emphasise his agonised anticipation of death.

[We suggest that after the first reaction shot of Indiana and Shortie, followed by drumming and chanting, there should then be a cut of 35 feet, resuming on the side-angle shot of the victim falling into the flames. The shorter this scene is, the less the audience will be asked to share either the agony of the victim or the sadistic bloodlust of the spectators.]

c) Reduce the forced drinking of blood and the brutal whipping of Indiana, and remove entirely the flogging of Shortie.

d) Reduce the scenes of Willie being lowered into the flames and minimise her realistic screaming throughout, carrying into reel 5.

Reel 5: a) Greatly reduce the brutality of the fight between Indiana and the huge, turbanned overseer, reducing the sounds of all impact blows, and removing at least some of the following details: sledgehammer blow at overseer's body, very heavy punches to his back and chest, heavy blows to Indiana's face and chest throughout the sequence, fighting

with pickaxes, and close-ups of overseer's foot pressing down to crush Indiana's chest.

b) Also reduce the sadistic horror of the overseer being dragged under the stone-crushing roller, and remove the sight of blood on the roller after his death.

Reel 6: Remove High Priest's head bouncing off rock face as he falls into water.[84]

The BBFC's issue with *Temple of Doom* was not the film's only classification difficulty: controversy over the 'PG' rating it had received in the US led Spielberg himself to suggest to the MPAA that they create a new category – which resulted in the 'PG-13', introduced that summer.[85] Back at the BBFC, communication between the Board and UIP led to James Ferman's agreement to fly to Hollywood for a session with the film's co-executive producer Frank Marshall and

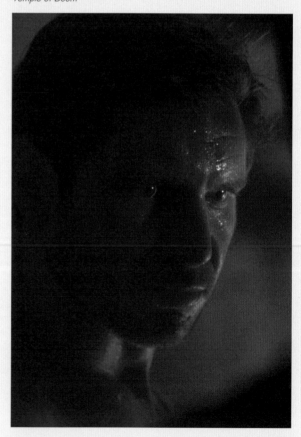

Harrison Ford as the eponymous hero in an intense moment from *Indiana Jones and the Temple of Doom*

others to hammer out a solution.[86] This resulted in further cuts being proposed, in particular to the soundtrack; the cuts were made, and the film was passed 'PG' on 31 May 1984 with one minute, five seconds and sixteen frames removed. Even given this, the Board received some letters of complaint from members of the public who felt that the film was too strong for 'PG'. Its general response included a note that the 'PG' category was designed to warn parents and guardians that the film may not be wholly suitable for children.[87] (Letters also came in complaining because the film had been cut.)[88]

In a way, the *Temple of Doom* decision was representative of an issue that was pretty prevalent in the mid-1980s, when there were a number of films that, while clearly holding appeal for children, did not fit easily into the 'PG' category. *Gremlins* (1984) was another such example – with one examiner noting that '[w]e seem to have been mightily exercised recently by the category challenges thrown to us by directors whose concept of childish tolerance is less bounded than ours';[89] that film ended up being classified '15' uncut. One of the examiners' reports on *Temple of Doom* nails the trickiness of the gap between 'PG' and '15': 'It is the old dilemma of a large age range at "PG" and how to protect the younger end of the range from real fear and disturbance while allowing the older range a wonderfully rich and exciting experience'.[90]

The Board would go on to introduce the '12' category (in August 1989 for theatrical releases and July 1994 for video), but even after that, there remained the question of films marketed to a family or young teen audience but containing material that some people think unsuitable for those demographics. It is an issue that the Board (with its '12' having now been replaced by '12A' in cinemas, so that parents have discretion to take their youngsters if they think it appropriate to do so) still encounters today – but now we have content advice on film posters and extended content advice online and on the BBFC app, rounding out the category decision and serving to flag up content that viewers may appreciate knowing about in advance of buying their cinema ticket. The '12A' and, on video, the '12' category afford the Board more nuance in its decisions than it was able to achieve prior to August 1989. (Indeed, the fourth Indiana Jones instalment, *Indiana Jones and the Kingdom of the Crystal Skull* [2008], earned a '12A' uncut.)

Across the years, however, *Temple of Doom* remained available only in its cut-for-'PG' version. Then, in 2012, Paramount, preparing for the Blu-ray release, submitted the full-length version afresh – and the Board was able to classify it '12' without cuts. At last, the film could be released in its complete form in the UK. The hero was back!

CASE STUDY: LICENCE TO KILL (1989) Edward Lamberti

By the 1980s, the James Bond series of films was getting on for a dozen 'official' entries (that is to say, those made by EON Productions, the company formed by producers Albert R. Broccoli and Harry Saltzman), with 1983's *Never Say Never Again* joining the 1967 version of *Casino Royale* as another 'unofficial' Bond film. Before *Licence to Kill* in 1989, all Bond films had been classified 'A' or, post-1982, 'PG' (some of them after minor cuts or as a result of advice given to the films' producers by the Board); video versions had been 'PG' without exception.[91] Over the years, BBFC examiners had occasionally questioned the categories given to previous Bond films, as some contained moments of violence and/or sexual innuendo that were perhaps at the limit of what was appropriate for a family audience. Overall, however, the Board recognised the films' familiarity within British popular culture and reasoned that audiences knew what to expect and that this allowed for the advisory category to suffice.[92] The prevailing view of the series was probably close to that expressed by an examiner considering *The Spy Who Loved Me* (1977) for its initial theatrical classification: 'Bond films are, by tradition, "A" certificate, and have enormous appeal for a

family audience. They know their summer-holiday market thoroughly, and stay well within the accepted conventions, both in the fights and the bed-scenes.'[93] And as Sian Barber has noted in Chapter 7, the series continued to prove fairly straightforward for the Board through the 1980s.

But when, on 23 February 1989, BBFC staff viewed *Licence to Kill* for the first time (in a rough-cut form so as to advise the distributor on the probable category), they were concerned that it posed serious difficulties for the 'PG'. The first viewing team of three examiners (accompanied by three others) was split between '15' and '18'. They felt that, as against the Bond films' usual emphasis on exotic locations, glamorous characters and Bond's suave heroics, the new film was a harder-edged proposition.[94] In *Licence to Kill*, Bond (played for the second time by Timothy Dalton) is out for revenge after an attack on an old friend, and his mission (a 'personal' one, as he conducts it in defiance of orders) leads him to uncover a major drug ring, with some testing moments of violence ensuing. Reports from the first examining team and from subsequent examiners expressed views that the series had evidently undergone a toughening-up in order to compete

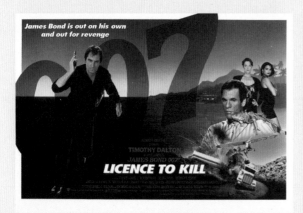

A UK poster for *Licence to Kill*. The '15' was unprecedented for a Bond film

The death of Milton Krest (Anthony Zerbe) was one of several moments in *Licence to Kill* subject to BBFC cuts in 1989

with contemporary action (and crime) movies; examiners cited films such as *Lethal Weapon* (1987) and *Scarface* (1983), both of which the Board had classified '18'.[95] As well as being influential in many ways, Bond films had always reflected the time in which they were made; this time, that reflection took the Board by surprise. And so, a few days after its initial viewing, the Board advised the distributor, UIP, by phone that the film was some way beyond 'PG' standards and that even for the '15' category, cuts would be required to several instances of violence. The moments in question were the whipping of the villain's girlfriend, one character being lowered into a shark tank and attacked, another character meeting a nasty end in a decompression chamber and yet another being crushed by a grinder.[96]

On 23 March, the film was seen in full again by a new team of three examiners, with the cuts having been made. From this, the Board concluded that further cuts would be required for '15' and that, given the film's tone, the soon-to-be-introduced '12' category would not be a viable option, even with extensive cutting.[97] A second cuts list, asking for reductions to be made to two further visuals as well as to a number of points on the soundtrack, was issued.[98]

The reels in question were resubmitted and re-viewed twice more, before the completed film, with its finalised sound mix and credits sequences included, was viewed on 15 May by a new team of four examiners; they were happy to recommend the '15'.[99] On 23 May, the film was classified.[100]

But the '15' was, for obvious reasons, not what the distributor wanted. It is easy in hindsight to see how, with summer 1989 offering a bumper selection of likely blockbusters, including *Indiana Jones and the Last Crusade*, *Lethal Weapon 2* and the film that would prove the biggest hit of the year, *Batman*, a '15' certificate for the usually family-friendly Bond could be damaging to its box-office takings. More than that, however, and this is evident from exchanges on file, there was a clear concern that the Board was

overreacting to the film and that this would deny countless kids the fun they had previously derived from Bond. It was similar to the *Temple of Doom* problem, but this time the 'PG' category was out of the question.

So, how about the '12'? The distributor had appealed the '15' and so, on 30 June, *Licence to Kill* was viewed again by the Board's Presidents and three more examiners. Two days earlier, the film had been seen at the Odeon Leicester Square by James Ferman, six examiners and 'assorted young people from 15 to 20+'. A note from that screening reports '[u]nanimity that 15 is correct category and no support at all for reclassifying 12 even with cuts'.[101] Nevertheless, after the Presidents' screening, a '12' was offered with some further minor cuts suggested. But it was a moot point: the introduction of the '12' category was not going to happen in time for this particular film's release.[102] The producers and distributor, therefore, agreed to accept the '15'.[103] This was evidently with some reluctance: on 18 August, the distributor wrote to Ferman, expressing the view that *Batman* (which had by then been released with the '12') was a darker film than *Licence to Kill* and urging the Board to rethink the '15' given to the Bond film.[104] No response from the Board is on file, but given that *Licence to Kill* had by this time been on release in the UK for several weeks, any decision not to revisit the category may have been purely pragmatic.

Since then, Bond films have been classified largely at the '12' or '12A' categories (*GoldenEye* [1995] and *Tomorrow Never Dies* [1997], both cut for theatrical release, were subsequently passed uncut on video at '15', the latter more recently regraded to '12' uncut). And with Pierce Brosnan and then Daniel Craig both proving popular in the role, the series has continued its astonishing record of success. *Licence to Kill* has been submitted to the BBFC several times since 1989 for video classification, with previously cut footage restored incrementally;[105] the Board has passed it '15' without cuts on each occasion.

8

HEAD-ON COLLISIONS:[1] THE BBFC IN THE 1990S

Julian Petley

'Exposure to violent films'

In 1993 the long-dormant 'video nasty' panic was reignited, and with a vengeance. The immediate cause was the wholly unwarranted remark made by Mr Justice Morland on 23 November at the end of the trial of the two children found guilty of murdering the toddler James Bulger. His comment that '[i]t is not for me to pass judgement on their upbringing [sic] but I suspect that exposure to violent films may be in part an explanation'[2] immediately sparked off a frenzied hunt by most of the press for the film or films which could have brought about such a dreadful act. And almost immediately they found a culprit which seemed to fit the bill, but only, of course, by distorting the film out of all recognition. This was *Child's Play 3* (1991), which the BBFC had passed for cinema exhibition at '15' with two minor cuts for violence, and at '18' on video with the cuts reinstated. From thence it was but a small step to the press and politicians demonising horror videos as a whole, criticising the BBFC for being too lenient, and baying for stricter video censorship. By April 1994, there was a real danger that the VRA would be supplemented by an amendment that would have effectively banned any video not suitable for children from the home, and thus to all intents and purposes from commercial distribution in the UK – which was, of course, exactly what the most extreme proponents of the Act had wanted, but failed to achieve, in the first place. Finally, however, a form of sanity prevailed, and a more workable amendment was put together by Home Secretary Michael Howard and his shadow Tony Blair, with considerable input from the BBFC.

I have discussed this episode at length elsewhere,[3] and the first edition of *Ill Effects: The Media/Violence Debate*[4] is almost entirely taken up with its ramifications, but in this chapter, I want to approach it from a different angle, concentrating on its consequences for the BBFC. It is, however, important to note at the start that in his Introduction to the *Annual Report 1993*, the BBFC President, Lord Harewood, stressed that no evidence of a link between the murder of James Bulger and either videos in general or a particular video

> had ever been presented in the trial or cited by the police, but a national newspaper named a suspect video and the rest of the media followed suit. Similar allegations followed in two more murder cases, equally brutal and inexplicable. The media claimed that all three murders could be attributed to two videos. It took another six months for the truth to come out, when the Home Office Minister in the Lords, Earl Ferrers, stated unambiguously [on 14 June 1994] that 'the police reports did not support the theory that those crimes had been influenced by exposure either to any particular video, or to videos in general, and no evidence about the role of videos was presented in any of the prosecutions'.[5]

Harm

As a result of an amendment to the Criminal Justice and Public Order Bill then going through Parliament, the VRA was amended in 1994 so that it required the BBFC when classifying a video to have

> special regard (among the other relevant factors) to any harm that may be caused to potential viewers or, through their behaviour, to society by the manner in which the work deals with
> (a) criminal behaviour;
> (b) illegal drugs;
> (c) violent behaviour or incidents;
> (d) horrific behaviour or incidents; or
> (e) human sexual activity
> [...] and any behaviour or activity referred to in subsection (1)(a) to (e) above shall be taken to include behaviour or activity likely to stimulate or encourage it.[6]

The amendment also clarifies what is meant by the 'potential viewer' whose proneness to harm is such a key consideration in the legislation, explaining that '"potential viewer" means any person [...] who is likely to view the video work in question if a classification certificate or a classification certificate of a particular description were issued'.[7]

 Although this appeared to satisfy both censorious newspapers and politicians, this was largely because both failed to understand that the amendment simply put on a statutory footing the manner in which the allegedly 'over-liberal' BBFC had been interpreting its duties under the VRA since 1984. As Lord Harewood explained in his Introduction to the *Annual Report 1994–95*,

> The possibility of harm had always been at the heart of BBFC policy, so the new clause did not require a fundamental shift in examining practice. It did, however, clarify the test of suitability for viewing in the home by explaining why video standards should be stricter than film standards. It reinforced the deprave and corrupt test of British obscenity law by adding the simpler test of anti-social influence on behaviour. And it concentrated the mind on the extent to which a video was likely to attract the attention of children, so that the more probable this is, the less the Board may rely on the assumption that an '18' certificate will be adequate protection. Board policy has become more cautious since this test was introduced.[8]

Similarly, in its evidence to the Home Affairs Select Committee in June 1994, the Board explained that the harm criteria 'represent not a break with former policy, but a confirmation of it, since they put on the face of the legislation factors which the Board has been taking into account for many years'.[9] And in his oral evidence to the Committee on 22 June 1994, BBFC Director James Ferman made it clear that '[w]e do all these things already, but we cannot be held to account for them [...]. Now we can be challenged.'[10]

The 'Deprave and Corrupt' Test

The Board's policy on representations of violence up till this point can be gleaned from the internal document 'BBFC Guide: Obscenity Law and Video Violence'.[11] This points out that, in July 1984, the Attorney General made public a statement by the DPP which outlined how his office interpreted the 'deprave and corrupt' test in the OPA when it came to videos featuring violence. The statement revealed that the following questions were taken into account:

> (a) Who is the perpetrator of the violence, and what is his reaction to it?
> (b) Who is the victim, and what is his reaction?
> (c) How is the violence inflicted, and in what circumstances?
> (d) How explicit is the description of the wounds, mutilation or death? How prolonged? How realistic?
> (e) Is the violence justifiable in narrative terms?[12]

The document also revealed that a work was likely to be regarded as obscene by the DPP 'if it portrays violence to such a degree and so explicitly that its appeal can only be to those who are disposed to derive positive enjoyment from seeing such violence'.[13]

Other factors taken into account by the DPP include:

violence perpetrated by children;
self-mutilation;
violent abuse of women and children;
cannibalism;
use of vicious weapons (e.g. broken bottle);
use of everyday implements (e.g. screwdriver, shears, electric drill);
violence in a sexual context.[14]

The DPP adds that '[t]hese factors are not exhaustive. Style can also be important. The more convincing the depictions of violence, the more harmful it is likely to be.'[15]

The Board also quotes its response to the Williams Committee, in which it argued that material unlikely to pass the deprave and corrupt test

depicts or describes violence or sexual activity or crime in such a manner as, when taken as a whole, to encourage the imitation or toleration of seriously harmful or criminal behaviour in a significant proportion of those who are likely, having regard to all the circumstances, to read, see or hear it.[16]

The Board continues:

This is still the interpretation we apply, and it is this element of immoral influence which seemed to us to be lacking from the DPP's guidelines, particularly with regard to the moral position of the film-maker towards his own material. We would therefore add some further questions to those put by the DPP:
(a) Is the sympathy of the film-maker on the side of the victim or the aggressor?
(b) Is the process of the violence indulged in for its own sake, rather than to tell us anything significant about the motives or state of mind of the persons involved?
(c) Does the camerawork or the editing belie the ostensible moral stance of the film by seeking to enlist or encourage our vicarious enjoyment of the atrocities portrayed?[17]

Reassessment

Any doubts that the BBFC, both prior to and following the 1994 amendment to the VRA, did not concern itself with what it took to be the moral 'message' of the films and, more particularly, the videos which it classified should be laid to rest by these quotations. But, on the other hand, this is not to suggest that the murder of James Bulger and its aftermath had no effect on the BBFC's activities. As the *Annual Report 1993* puts it, 'We have learned in the past year just how young potential delinquents can be, and as a result the Board has become even more paternalistic than hitherto',[18] while Lord Harewood made it plain in his Introduction to that report that '1993 and '94 have been a period of intense study, research and reassessment. In the meantime, we asked the video industry to hold back on some violent submissions until these various initiatives had borne fruit',[19] while in his Introduction to the *Annual Report 1994–95*, he notes that 'a number of videos were held up for detailed consideration' as a result of the VRA amendments, and '[m]ore videos [five] will have been rejected in 1994–95 than at any time since 1988'.[20] Similarly, the BBFC was keen to make clear in a report to the Home Secretary on 6 December 1996 exactly how much cutting, and indeed banning, had taken place over the past three years.[21] Thus:

Year	Number of video titles	Number of separate cuts	Total duration
Violence and horror			
1994	28	122	16m 13s
1995	32	73	45m 44s
1996 (11 months)	34	84	34m 42s
Weapons and criminal or harmful techniques			
1994	38	107	15m 23s
1995	36	55	26m 23s
1996 (11 months)	33	79	15m 29s
Violence to women, including sexual violence			
1994	43	94	78m 43s

1995	38	117	77m 59s
1996	47	116	69m 3s
Total	369	938	401m 24s

The report also lists the reasons why fourteen videos were rejected altogether during this period:

Gross violence in a martial arts context – 2 videos
Callous acts of gross violence by a nine-year-old boy killer – 1 video
Excessive violence to women, including sadism, rape and mutilation – 6 videos
Gross violence in illegal bare-fist fighting, extensively displayed and promoted – 1 video
Advertising the services of prostitutes – 1 video
Encouraging the sexual corruption of innocent schoolgirls – 1 video
Sex and rape observed and encouraged by sadistic children – 1 video
Horror film set almost wholly in a torture chamber. Passed '18' on film for adult audiences, but rejected on video where scenes of torture and mutilation could lend themselves to viewing out of context by sensation seekers old and young. – 1 video[22]

'Anti-social influence'

The same Annual Report also contains an extract from the BBFC's *Draft Code of Practice: Violence and the Question of Harm*, which states that

Board policy on violence has always been clear. We want to protect children from fear and potential delinquents from anti-social influence. This does not mean protecting adults from fear, or from unpalatable facts about human nature or the world. Films that tell the truth about violence and about the price of violence have always been given a clearer run than those which glorify it. On the other hand, some people can only stand so much truth. We must strike a balance. We dare not sanitise violence lest we conceal its dangers, nor exaggerate its menace lest we make people frightened and insecure. Professor George Gerbner has warned against both 'happy violence' that has no serious consequences and the 'mean world syndrome' by which viewers come to see the world as a far more violent and threatening place than it really is. Children may enjoy being frightened – temporarily, but they must have the chance to overcome those fears and rise above them. They must learn that being strong is safer than being weak, but that being strong at the expense of others is rarely excusable.[23]

And the main body of the report avers that '[b]oys tend to ape screen heroes, and the tailoring of role models for the young and impressionable is a recurring problem for a responsible industry'.[24]

In the early 1990s, the BBFC became increasingly concerned that its classifications were being so regularly disregarded that they no longer provided an effective barrier to underage viewing, leading it to argue in its *Annual Report for 1992* that

[i]f we are to hold the line on anti-social violence in the interests of a more peaceable society, as many believe we should, then we have to stop pretending that an '18' can ever prevent youngsters from finding role models in video violence.[25]

Similarly its *Annual Report 1993* noted that

we must see it as our task to classify videos for all potential viewers, whether or not they are younger than the classified age. [...] [C]uts in violence were regularly imposed in 1993 to make action adventures suitable for the age range most likely to seek them out. And this happened right through the category scale.[26]

And in his oral evidence to the Home Affairs Committee on 22 June 1994, James Ferman revealed that 'we do not any longer (as we do on film) treat the "18" as strictly speaking, an "18" category. It is an "18" with a great deal of leakage in the home.'[27] He also stated that

I think in the early years under the Act I have to say that there was a kind of unwritten understanding between the industry and ourselves and the Home Office that if we passed something at '18' we were classifying it for the people that watched it for the category for whom it was classified. I think now we are classifying it for those likely to see it irrespective of category.[28]

Meanwhile the *Annual Report 1996–97* is quite open about the fact that '[c]uts were increasingly imposed on "18" videos, abridging the freedom of adults in the interests of protecting children'.[29] It is also significant that after a Policy Studies Institute report on the viewing habits of young offenders, which was commissioned by the BBFC and other media regulators, revealed that 45 per cent of films chosen by the offenders as their favourites, and 44 per cent of those chosen by the control group of non-offenders, were '18'-rated, Lord Harewood in his Introduction to the *Annual Report 1994–95* noted that 'the Board's policy on such films has become appreciably stricter'.[30]

But what becomes abundantly clear from the Annual Reports and other documents produced by the BBFC in the 1990s is that the manner in which the VRA was enforced by the Board was heavily coloured by James Ferman's own particular interpretation of what the legislation actually meant by 'harm', and that this was based on a model of 'media effects' which is not exactly uncontroversial. Admittedly, Ferman's position on 'effects' was considerably better informed about film and far less crude in psychological terms than traditional US-based 'effects' studies, but there is nonetheless a strong argument that the influence of films on attitudes and behaviour that it posits is far stronger and more direct than the available evidence actually warrants. It is also difficult to avoid the conclusion that, on occasion, films containing violence were judged not in their own right but rather as malignant symptoms of a film culture driven by a commercial imperative to deliver increasing amounts of increasingly violent entertainment. Indeed, Ferman virtually admits as much in his swansong, the *Annual Report 1998*, in which he avers:

> My instinct is still to reduce the level of violence in action adventure films, simply in order to have less of it. Too often in my view it functions like a drug, like the pounding beat of rock music which keeps the serotonin levels up. I worry that violence has so little meaning, that younger cinemagoers take the view that 'violence is cool', a view which seems to me to be simply an excuse for not empathising with victims.[31]

It was here, too, that he stated that

> John Trevelyan, my most distinguished predecessor, said that the BBFC 'cannot assume responsibility for the guardianship of public morality'. I once sympathised with that viewpoint until I realised that public morality is actually at the centre of our concerns and must remain there. If we don't want entertainment to influence human behaviour in a harmful or anti-social direction, then we can only intervene on grounds of public morality.[32]

In terms of violence, the Board was also concerned about films showing imitable criminal or dangerous behaviour. As the *Annual Report for 1990* explained,

> Copycat crime is a perennial concern when modelled on the exploits of screen heroes or villains, and the Board sets limits on the extent to which films or videos can teach criminal techniques, lethal blows, or the use of dangerous weapons. The screen is not the only source of such knowledge, but it is a powerful influence, with video one of the great teaching aids of our time.[33]

On one level this is sensible enough – there is, for example, no good reason for demonstrating on screen exactly how to hotwire a car. But for Ferman, the very images of certain weapons seemed to be imbued with almost magical properties which could exert a spell over the viewer, and thus these images had to be removed. So, for example, the Board worried about butterfly knives being 'dextrously and seductively manipulated prior to threat'[34] while crossbows are described as 'irresistibly photogenic. Close-ups of a crossbow being primed are glamorous and also instructional, a blend that self-recommends cuts.'[35] Similarly, the following year's report expressed concerns about knives being 'lovingly photographed'.[36]

The BBFC reports contain numerous illustrations of how Ferman's philosophy of screen violence and its effects worked out in terms of actual censorship/classification practice. Thus, for example, *Lethal Weapon 2*, which had been passed as a film at '15' with cuts in 1989, was cut even at '18' on video the following year because the Board 'refused to reinstate fully the cuts in two scenes in which the hero indulged his vengeful instincts far beyond the needs of the narrative'.[37] Similarly *RoboCop 2* (1990) was cut on both film (1990) and video (1991) at '18' because it 'replaced the wit and ingenuity of its science fiction original with a far cruder level of personalised aggression'.[38] The BBFC refused to countenance uncut '18' video versions of

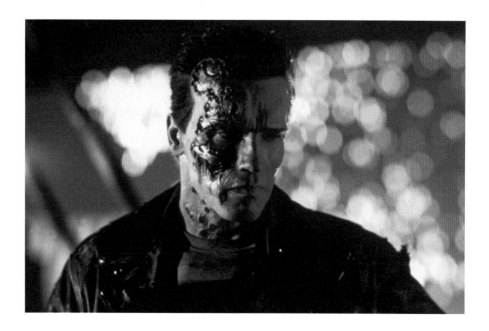

Terminator 2: Judgment Day (1991 – passed with cuts on film at '15') and *Under Siege* (1992 – passed uncut on film at '15'), both of which were passed on video with cuts at '15' (though a laser disc version of *Terminator 2* was passed '18' uncut). Further Steven Seagal vehicles *Under Siege 2* (1995) and *The Glimmer Man* (1996), along with the Jean-Claude Van Damme film *Maximum Risk* (1996), were cut on video at '18', although all had been released uncut on film in this category. *The Rock* (1996), which starred Sean Connery, and the Jackie Chan vehicle *Rumble in the Bronx* (1995) were both passed complete at '15' on film, but cut on video in the same category. And *Ransom* (1996), *Sleepers* (1996), *Con Air* (1997) and *Cop Land* (1997) were all moved from '15' to '18' for their video release, albeit uncut.

However, it was the classification of neither a film, nor a video, but of a video game, which gives the clearest insight into BBFC thinking in the 1990s about media violence and its alleged effects. This was *Carmaggedon* (1997).

'Dubious pleasures': *Carmaggedon*

Relatively few video games were classified by the BBFC during the 1990s as, unless they dealt with subjects containing sex, violence or imitable criminal techniques, they were exempt from classification. Submissions jumped fourfold in 1995, but this was partly because the exemptions were tightened up when the VRA was amended in 1994, and partly because the renewed furore over 'video nasties' in the press and Parliament helped to fuel already nascent fears about the alleged ill effects of video games.

The software designers Sales Curve Interactive Ltd (SCi) submitted a sample of *Carmageddon* on 8 August 1996 to the Video Standards Council (VSC) for age certification under the voluntary age rating system established by the European Leisure Software Publishers Association (ELSPA). The VSC regarded the game as exempt from BBFC classification under the VRA and granted it a '15+' certificate. However, a mother came across a review of the game in her son's PC magazine and complained to her MP about it; he contacted the Home Office, which in turn contacted ELSPA. By this time, inevitably, the press had got hold of the story ('Ban Killer Car Game!: MPs Enraged by Sick Computer Game', *People*, 23 February 1997) and so, on 11 April 1997, SCi decided to submit it to the BBFC for classification, with a request for a '15'.

As one examiner explained in their assessment of the game on 17 April, it is 'focused significantly towards acts of violence and [...] these acts are committed against screen characters who cannot be interpreted as anything but humans and animals'[39] and

gives the user permission to carry out atrocious acts of carnage in the safely contained world of the PC screen – this is not uncommon in many PC games, but we have tended to leniency because the game environments have generally been abstract and unreal, and because there is often a 'penalty' against the player for gratuitously eliminating targets. This is not so with CARMAGEDDON. The game positively urges the user to commit maximum damage and destruction with bonus points awarded for stylish 'hits' with frequent screen textual prompts popping-up to reward the user who can kill and maim most imaginatively.[40]

In this examiner's view, '[t]he game's own behavioural code is utterly irresponsible and repugnant';[41] however, they go on to admit that

I see no straightforward resolution to this game. Whilst I would concede that it is deeply unpleasant, that is all it is (unless someone can tell me otherwise). I do not immediately see what harm there is unless young children were to gain access to it and that, I fear, would not be too difficult. However, rejecting the work outright is likely to cause tremendous ructions throughout the games industry and could have a seriously damaging effect on the company involved. However, it may be that the time has arrived when the boundaries of acceptability have been pushed too far and that the line must finally be drawn with computer games designers.
Overall, however, I am just about in favour of the '18' [.][42]

For another examiner on the same day, the problem was that '[t]he situations depicted are not fantastical – city streets, football games, ski resort etc. – there are no monster villains or the like to destroy and the mundaness [sic] of the settings only adds to the concern'.[43] On 25 April, another examiner notes that

[t]here is one crucial difference between this and other killing games – here the targets are solely victims who cannot aggress against the player. Hence what we are joining in is not a fight but a slaughter. Add to that the game also allows you to see and hear the fear that the targets experience and I think you have nearly the most perfect vicarious sadism experience that we have seen here. That in turn rather points down a rejection route […]. The central reason to reject this is one of harm. As with all rejects we have to ban in the knowledge that the vast majority of [the] likely audience could use the product and be effected [sic] by it not one jot. I imagine that they are the people for whom a catharsis argument could be mounted. However, the 'vulnerable' minority in this case are being given a half way stepping stone between the desire to act on violent impulses and the reality of doing so.[44]

On the same day, a colleague complained that 'there is no externally imposed narrative or resolution which might offer some sense of security or key to our understanding. This game appears entirely without authored morality.'[45] In their view, the game was 'in pretty poor taste and […] offering dubious pleasures which I do not believe that we can legitimate'.[46] At the examiners' meeting on 30 April, opinions were expressed that *Carmaggedon* should be rejected.

In May, SCi suggested using the German version of the game in which the pedestrians were replaced by zombies and therefore became more appropriate targets for destruction. However, the examiners still saw the unrelenting emphasis on the gleeful infliction of pain as a problem, and decided that even the new version would be difficult to pass unless there was a narrative justification for running down the zombies. It was suggested that this might be resolved if they threatened the player in some way, thus making it possible to regard the player's action as self-defence. Accordingly, at a meeting with the company on 15 May, the BBFC suggested that the driver could be trying to destroy the zombies because they are threatening the world. At a further meeting with the company on 22 May, 'Drive to Survive' was suggested as a sales motto, with the stipulation that the new zombies vs the world scenario must be clearly emphasised on the game's packaging and publicity. And in the new version, in order to lessen the game's realism, the blood would now be green.[47] In the examiners' view, the game looked possible at '18', but in June it transpired that SCi's deadlines precluded them from changing the packaging, publicity and press campaign to the extent required by the BBFC. The Board thus refused to grant *Carmageddon* a certificate, and the revised version was released with an ELSPA '15+' rating. (Because the victims in the game had been modified from humans with red blood to zombies with green blood, the game no longer featured gross violence against humans or animals and was therefore technically exempt from classification, in spite of the Board's continuing refusal to grant a formal certificate.)

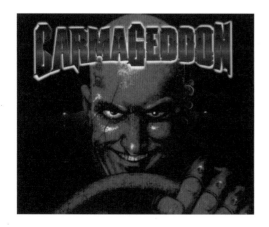

But by this time, of course, the Board was being blamed by the press and politicians for passing the game, forcing the BBFC to go public and make it perfectly clear that it bore no responsibility either for the UK version or for the original version which was then being released on the continent.[48]

SCi then took its case to the Video Appeals Committee (VAC). The BBFC reiterated the points made by the examiners above, adding that the techniques of violence were

> significantly different from [games] where the killing is with weapons, often fantastic weapons, of a kind not readily available in real life; in *CARMAGEDDON*, on the other hand, the lethal weapon is one that many of us wield every day, a motor car, and the death toll caused by cars is a major problem in every advanced nation.[49]

It also noted that

Carmageddon (1997): 'The limits of acceptability on violent video games are still being determined', said the BBFC

> [i]t is always difficult to argue that works of entertainment may have a corrupting influence on behavior, but it is far more likely they can have a slow drip-drip effect on attitudes, perhaps desensitising, perhaps offering exciting alternatives. We know that many teenagers indulge in joyriding, that is, reckless high-speed driving for kicks, which occasionally results in casualties. And we know that many of these joyriders are of the type who frequent arcades featuring violent (and unregulated) video games.[50]

On 29 October, the VAC decided by a majority of three to two that the game should be classified at '18' provided a parental lock was put on it. It also noted that in Australia and New Zealand, the game had been given a '15+' certificate, that over 300,000 copies of the game had already been sold 'without apparent detrimental effect', and that what little research had been done on it indicated that 'adults are not directly affected in that the game is unlikely to adduce copycat effects in them'. It did, however, stress the need for 'serious research, not only into the sociological effects but also into the psychology of games playing'. In its view, 'the purpose of the game is scoring points and winning. If one concentrates on killing it is unlikely that you will win.' It also argued that the game is clearly a fantasy game in that

> [t]here was no real feeling of hitting a pedestrian or an animal because the speed of the game threw up the next obstacle very quickly. [...] The blood on the windscreen is a joke: a bad joke but nevertheless a joke.

In its deliberations, the Committee took into account the fact that the game could be played only on a PC (which, in those days, was a far more expensive item than it is now, and to which children would thus be unlikely to have access without their parents' permission or supervision) and not on a console; had it been available on the latter, the Committee made it clear that it would have reached a different decision. And, while arguing that 'a game is very much less likely to have an imitative effect than a film', the majority also indicated that 'the game is up against the limit of acceptability and the decision should not be regarded as a precedent. We would wish that in future, every game should be considered on its own contents and merits (or otherwise).'[51]

Somewhat reluctantly, the BBFC awarded *Carmageddon* an '18' certificate on 11 November. Its press release two days later noted that

> [t]he limits of acceptability on violent video games are still being determined. Parliament is deeply concerned about video violence, including interactive games. But where games are concerned, the Act lacks teeth and a credible system of enforcement. The Board is convinced that teenagers will have the skill, determination and expertise to access most games brought into the home, whatever the BBFC category. More and better research is needed into the extent to which games can teach violent attitudes and lifestyles to the young. In the meantime, if publishers want an easy, trouble-free commercial life, perhaps they should avoid violent games that focus on deliberate killing.[52]

And in its *Annual Report 1996–97*, the BBFC made it very clear that it felt 'deeply uneasy about the classification of *Carmageddon*. The implications of this decision will continue to reverberate.'[53]

'Genital geography': *The Lovers' Guide*

Almost inevitably, this being the UK, the other topic which caused the Board a great deal of soul-searching during the 1990s was the representation of sex, although the decade started well enough with the remarkably uncontroversial decision to pass at '18' sex-education videos containing scenes of unsimulated sexual activity.

Up until the end of the 1990s, the Board had never passed hardcore pornography either on film or video; even at 'R18' (the licensed sex shop category) all that was allowed was 'vanilla porn' or 'medium-core' (of which more below). However, at the start of the decade the Board felt that the time was right to allow at '18' sex education videos, which portrayed real sexual activity, providing that these were genuinely educational and not merely pornography in disguise. The first of these was *The Lovers' Guide* (1991), and as this was a new departure fraught with potential difficulties, the Board actually advised the film-makers at script stage about what was and was not permissible. The report of one of the examiners makes it abundantly clear why the Board felt able to pass the tape at '18':

> This piece manages to include more explicit sex and nudity visuals than any porn film we would on average pass at '18'. However, this is as it should be because it does not at any stage of its one hour and three minutes even mildly tend towards exploitation. Visuals of masturbation, graphic shots of clitoris and masturbated and erect penises, distended, stimulated labia, cunnilingus and fellatio are all divested of titillating potential by clinical and graphically technical voice-overs read out by unnervingly sexless and cheery voices who might just as well have been describing tonsillitis or the timetable of a sports club [...] As an unknowing teenager in search of information I would have liked more actual brass-tacks information on how to get on with it than the concentration on attitude and approach and even at times 'genital geography'.[54]

The Board believed that *The Lovers' Guide* (1991) 'was a work of serious intent, treated in a responsible way'

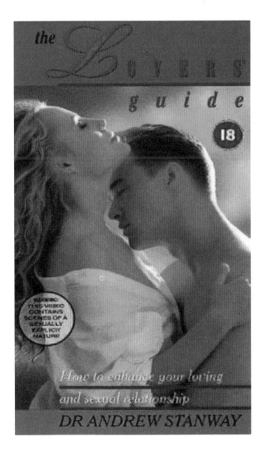

And in a press statement released on 3 October, James Ferman explained that

> [t]he Board took the view that this was a work of serious intent, treated in a responsible way. There can be little doubt that further education in sexual matters can only be beneficial, and, just as there are many books widely available in this area, there seems no reason why the audio-visual media should not also broach this subject. The obscenity laws make a very clear distinction between pornography and works that have artistic, educational or other merit, and we had no doubt that *The Lovers' Guide* fell into this latter category. The '18' restricts its distribution to adults who, by that age, may legally have been married for two years and are unlikely to be unduly surprised or offended by scenes of love-making in this sort of context.[55]

Meanwhile the *Annual Report for 1991* observed that

> [p]erhaps the most important aspect of this development in video standards has been the legal recognition that, in British obscenity law, no image is taboo per se, and that context must always be a key factor in deciding whether any image or sequence of images constitutes an obscenity.[56]

As we shall see below, the classification of videos containing scenes of unsimulated sex was a potential minefield, but in this case the Board emerged unscathed. Admittedly, the title was banned by Woolworths, causing the *Star*, 9 September 1991, to run a story headed 'Woolies Pull Plug on Too-Blue Video', with the strap 'Sex Guide Shocker'; its editorial, 'The Star Says', argued that 'the authorities should follow their lead and BAN this objectionable rubbish' and described the film as 'tat', 'outrageous', 'filth' and 'sleazy'.[57] But as Ferman noted dryly in the press release,

[t]he attention given to this latest release has distinguished it from all the others [sex-education videos] by providing a publicity launch unprecedented in the sex education field. That is the only precedent broken in the case of THE LOVERS' GUIDE.[58]

The video and its successors went on to become bestsellers.

'Peaks of evil and atrocity'

However, even in the case of films and videos featuring simulated sex, there were definite no-go areas, and these involved sexual violence, particularly towards women. As the *Annual Report for 1992* points out,

Board policy on such material maintains that, if scenes of rape or violence are contrived to induce sexual excitation in male viewers through the humiliation, torture or terrorising of naked or semi-naked women, these should be removed to reduce the likelihood that some viewers might find such practices acceptable or arousing, as entertainment or in real life.[59]

The *Annual Report 1998* expands upon the Board's thinking in this area, explaining that

[w]here scenes of sex and violence are staged in such a way as to offer significant sexual thrills to a male audience, or to reinforce dangerous myths about rape, the Board is concerned that real harm might result from viewing, and especially from repeat viewing in the home. Violent scenes which also trigger sexual arousal, like assaults on naked or semi-naked females, could encourage an association between violence towards women and sexual gratification which might lead to the encouragement or reinforcement of anti-social attitudes or behaviour. Scenes and narratives which encourage a belief that women somehow 'deserve' or 'enjoy' being sexually assaulted run the risk of introducing false and dangerous ideas to young minds, or confirming and encouraging pre-existing prejudices in adults.[60]

This policy was backed up by specific reference to US-based 'effects' research into the viewing of pornography, which, it should be pointed out, is as controversial as the above-mentioned research into the viewing of films containing violence.[61] Nevertheless, the *Annual Report 1994–95* states that

[t]he Board has had regard to American research which indicates that men who are predisposed to find rape enticing, or who find it hard to sympathise with victims of sexual assault, can have their prejudices confirmed or reinforced by scenes in which women are forced, perhaps violently, to respond to the sexual needs of others. Such scenes are normally removed by the Board from sex films or videos on the grounds that the sexual pleasure provided by them conditions men to associate sexual gratification with anti-social or criminal behaviour. This policy also extends to the association of eroticised nudity with violent victimisation. Research has shown that a significant proportion of men find aggression against women sexually arousing, whether or not it appears to be sexually motivated. Images of force or violence to female victims must be assessed in the light of this.[62]

What James Ferman found particularly unacceptable in this respect can be easily discerned thanks to the characteristic catalogues of atrocities which are such standard features of the 1990s reports. Here, for example, is the catalogue from the *Annual Report for 1992*:

Cuts included twenty-nine scenes of forcible stripping or breast exposure or of bare-breasted women attacked and raped, fourteen sequences featuring bondage as a preliminary to rape of the bound woman, often in a prison setting, nine scenes involving threats to bare breasts with knives or scissors, seven in which rape threats were couched in prurient dialogue, and six featuring blood on breasts or naked torso. Cuts were required also to remove the whipping of a naked, terrorised woman; the burning of a bound woman's neck with a cigar, the piercing of breasts with a pitchfork, a threat to a vagina with a gun, and three sexual assaults containing potentially mixed messages, e.g. a blindfolded woman forced to fellate men as if enthusiastically, a rape victim responding to her rapist with grateful pleasure, and the intercutting of an attack on a frightened woman with a consenting sex scene evincing female desire.[63]

Ferman took particular exception to women-in-prison movies. In his view,

> [t]he appeal and address of such films has been mainly to men, many of whom are likely to be stimulated by the sight of naked women penned up with no means of escape, to be humiliated, degraded and violated.[64]

That year, he was particularly incensed by two rather elderly continental European examples of the genre: Jess Franco's *Sadomania – Hölle der Lust* (*Sadomania*, a.k.a. *Prisoners of the Flesh*, 1981), which, for Ferman, represented 'peaks of evil [and] atrocity',[65] and Oswaldo de Oliveira's *A Prisão* (*Bare behind Bars*, 1980), which in his view consisted of

> a relentless reduction of all that is human or valuable in these women as individuals. It distorts the way women are thought of by the male viewer in his search for sexual gratification, reinforcing myths about female sexuality which must be damaging to the viewers, to their future sexual partners, and, by extension therefore, to society.[66]

(As an example of changed standards, it is interesting to note that the former was passed in 2005 with seventeen seconds of cuts, and the latter in 2010 cut by one minute thirty-five seconds.)[67] But, as in the case of the movies involving violence mentioned above, it is hard to avoid the conclusion that works featuring scenes which mingle sex and violence were judged not simply on an individual basis and in their own right but as examples of a kind of film-making which was seen as undesirable and unwelcome *per se*:

> [T]he Board must consider not only direct incitement to harmful or criminal acts, but also the tendency of a film or video to shape attitudes or inclinations so as to encourage immoral or anti-social behaviour. In this connection, the cumulative impact of a whole series of films all bearing the same corrupting message is likely to prove as pernicious as the effect of any one of them on its own. That is why the consistency of BBFC policy in the treatment of these genres is important.[68]

The 'R18'

On the other hand, throughout the decade, James Ferman was extremely keen to resolve the absurd situation whereby vast numbers of videos which should by rights have been classified at 'R18' and sold in licensed sex shops were cut, at the request of their distributors, so that they could be rented and sold at '18'. This was because so few local councils were prepared to grant licences to sex shops that the 'R18' was a largely unviable category in commercial terms. In 1992, for example, there were only eighty licensed sex shops in England, one in Wales and none in Scotland and Northern Ireland. In 1990, the BBFC passed fifty-five videos at 'R18'; the figures for subsequent years were 1991: 22; 1992: 14; 1993: 19; 1994: 14; 1995: 23; 1996: 27; 1997: 32. On three separate occasions, the VAC overturned 'R18' classifications as constituting a restraint on trade and awarded an '18' on the understanding that distribution would be primarily by mail order. By the same token, in 1991 the Board removed over three hours of material from seventy-five sex videos in order to be able to classify them at '18'; in 1993 nearly four hours were cut from 103 videos; and in 1996 ten and a half hours were cut from 153 videos in what the *Annual Report 1996–97* describes as 'the most soul-destroying use of professional expertise yet invented'.[69]

Absurd though this situation may have been, however, what also needs to be understood is that even videos passed at 'R18' did not constitute hardcore but 'vanilla' or 'medium-core' pornography, a strange hybrid largely confined to the censorious UK. This was because when the 'R18' category was created in 1983 by the BBFC in conjunction with the Home Office and the DPP, the policy was established that 'straightforward heterosexual or homosexual activity between consenting adults will be permissible so long as the scene does not focus solely or dominantly upon the genital organs. "Long shots" of sexual activity will be more acceptable than close-ups.'[70] But, of course, hardcore pornography operates precisely on the principle of what Linda Williams calls 'maximum visibility',[71] and well-lit close-ups of male and female sexual organs, of penetrations of one kind or another, and of ejaculations, are absolute staples of the genre.

Partly because of the paucity of licensed sex shops, but also because of the relatively tame nature of the material which they sold, an increasing number of unlicensed and illegal sex shops sprang up in Britain. Indeed, London's Soho, where the BBFC is based, was absolutely stuffed with them. No sooner were these closed down by the police than they sprang up again. It was

thus that in 1996, an agreement was reached between the Home Office, the Metropolitan Police and the BBFC to liberalise the 'R18' guidelines, at least up to a point, in an attempt primarily to combat the illegal sex shops. The first video to be passed under the new dispensation was *The Pyramid* (1996), and in February 1997 this was presented to the examiners as a benchmark for the new guidelines; crucially, these now permitted 'shots of a more explicit degree, previously prohibited, such as: long shot to medium/medium close shot images of penetration, oral sex and masturbation'.[72] However, when shortly after 'New Labour' came to power in May 1997 the new Home Secretary Jack Straw discovered that the BBFC was classifying hardcore pornography, albeit of a rather limited kind, at 'R18', he was absolutely outraged, and ordered an immediate halt to the liberalisation process, mild and tentative though it was (see Chapter 9). The old guidelines were reinstated and all further attempts at liberalisation were firmly blocked by the Home Office, although as all of this political intervention took place behind the scenes, the Board was put in the remarkably invidious position of appearing arbitrarily to chop and change its own Guidelines at will. This is an extremely complicated story,[73] and its denouement will be revealed in the following chapter. But it is also an extremely important one, partly because it demonstrates the limits of the BBFC's independence from government and partly because it marks the beginning of the end of James Ferman's tenure as the Board's Director.

Crash

Deborah Kara Unger and James Spader in *Crash* (1996), passed uncut by the BBFC in the face of massive opposition

The beginnings of the 'R18' saga also overlapped with a particularly unpleasant episode for the Board, namely an all-out attack waged upon it, and upon its staff personally, by the London *Evening Standard* and the *Daily Mail* for passing David Cronenberg's film *Crash* (1996). Again, I have discussed this matter at length elsewhere,[74] but what I would like to stress in the present context is the Board's examiners' determination to see the film passed uncut and the resolute

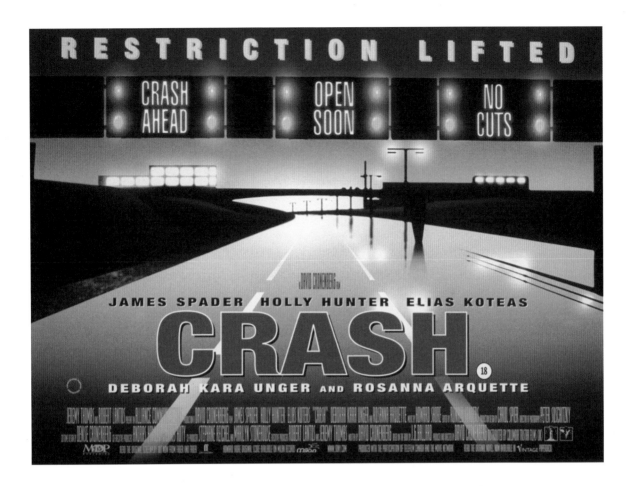

RESTRICTION LIFTED

CRASH AHEAD OPEN SOON NO CUTS

JAMES SPADER HOLLY HUNTER ELIAS KOTEAS

CRASH 18

DEBORAH KARA UNGER AND ROSANNA ARQUETTE

This poster for *Crash* announced its approaching release, classified '18'

manner in which they stood up to the vicious and highly personalised campaign waged against them by Associated Newspapers.

Crash was submitted to the Board on 26 September 1996, four months after Alexander Walker's diatribe against the film, headed 'A Movie beyond the Bounds of Depravity' in the *Standard*, 3 June. Walker had seen the film at Cannes, but its inclusion in November's London Film Festival (for which it did not require classification by the BBFC) gave Associated the opportunity to ignite the fire carefully prepared earlier by Walker, with the *Mail* running a front-page story on 9 November headed 'Ban This Car Crash Sex Film', with the strap 'Campaign to Stop Depraved Movie Being Shown in Britain'. The campaign was of course being run by none other than the paper itself, as part of which it had contacted the Culture Secretary Virginia Bottomley who had helpfully provided a quote, even though she had not actually seen the film, to the effect that 'I would urge local authorities to use the powers they have to refuse the film a screen'.[75] The same edition of the paper also gave its film critic Chris Tookey the opportunity to denounce the film in lurid terms and at some considerable length. And so began the process which led Westminster City Council, on 21 November, to threaten to ban the film from the parts of London which it controlled unless the BBFC 'reviewed' three particular scenes.[76] Thus the BBFC staff were in the distinctly unenviable position of having to examine the film with three separate guns pointing at their heads.

Between 3 October and 13 November, it was seen by no less than four teams of examiners. It was also viewed by the Acting President, Lord Birkett, and Vice President Monica Sims, on 22 October, who pronounced it a '[d]isturbing film but not outside [the] parameters for theatrical release at "18"',[77] and by a forensic psychologist and a leading QC, before it was finally passed without cuts on 18 March 1997. None of the examiners' reports suggests anything other than that the film should be passed uncut, and indeed some engage angrily with those campaigning against

the film. Thus, one complains on 11 December, after a viewing occasioned by Westminster Council's request to 'review' the film,

> I shouldn't have to be writing this report. I understand the BBFC's 'difficult political' situation following the naming of CRASH by Bottomley and the Tookey led attack on the film. However the former of those positions is based on ignorance of [...] the specific film [...], whilst the latter is also ignorant, and also, I suspect, playing to the likely audience of the *Daily Mail*. If I had seen this film on an ordinary viewing day without a predefined set of 'concerns' I have no doubt whatsoever that I would have signed the top box out at '18' uncut.[78]

Another examiner avers on the same occasion that 'I have to say that I find the fuss surrounding this film very difficult to sympathise with, and the request for the specific cuts ludicrous',[79] while a third argues that '[t]o cut *Crash* – particularly the details required by Westminster – would be to interfere with a work that has integrity and intelligence, sparkles with ideas and deserves respect'.[80] Two days later, another examiner worries that '[t]he tight rope we walk on is set particularly high this time and whichever way we fall, we will "crash" so to speak',[81] but the most interesting comment was written the same day by yet another examiner, who complains that

> [t]he current controversy over *Crash* is, in my view, based on the political opportunism of a few journalists and politicians and is unrelated to the film itself which is well within the broad standards of films currently being passed by the Board at '18'. I think that the Board's decision to delay passing the film has only stoked the controversy and we should be prepared both to pass the film and to defend the decision publicly on the basis of freedom, art and learning.[82]

The BBFC and Its Critics

As this last quotation suggests, the *Crash* affair raises the whole question of how the BBFC dealt with its critics in the 1990s – foremost among which was a predominantly illiberal and censorious press – and, more broadly, of how it responded to 'public opinion', which was to a significant extent based on myths and untruths peddled assiduously by agenda-driven newspapers. Indeed, this is a topic which is discussed in a number of the Board's reports. For example, the President's Introduction to the *Annual Report 1995–96* notes that the year began with a flood of complaints about a film which the complainants had not seen (*Natural Born Killers* [1994]) and ended in the same vein (*Kids* [1995]), noting that '[a]ll those letters were based on real anxieties fuelled by rumours which research proved to be largely untrue'.[83] But, it continues,

> however little justified by the facts, the fears and anxieties of the public need to be taken seriously, since they create the climate in which films and videos are viewed and judged. [...] The effect is that the BBFC is faced not just with depictions of violence, which worry us, but with the public's perception of that violence, which we must take just as seriously.[84]

The Report itself takes a similar line over the alleged role of *Child's Play 3* in the Bulger murder, noting that

> [w]hether or not these fears were justified, they were plainly real. Crimes of violence to and by children can be uniquely unsettling, since the destruction or corruption of innocence violates our faith in human nature. When that faith is shaken, as it was in 1993 and too frequently afterwards, it is understandable that people should seize on something like video violence as an explanation. For a while, it seemed a plausible scapegoat, not just for the Bulger killing, but for two other murders as well. When the true facts emerged, however, they were not enough to assuage the public's unease [...]. Even today, those discredited rumours are still plucked from cuttings libraries and computer files where they go on breeding unease. In John Ford's film *The Man Who Shot Liberty Valance*, a newspaperman played by James Stewart says to one of his editors, 'When fact becomes legend, print the legend.' Legends clearly satisfy a need, and if the culpability of video violence has become a legend, it must be because of the need people feel to fight back against the intrusion into our homes of an unsafe world, replete with danger.[85]

Finally, in this respect, it is worth noting that in its report to the Home Secretary in December 1996, the Board stated that

[i]t is difficult to gauge the importance of letters written in response to media coverage, since they tend to reflect the effectiveness of journalistic argument rather than the acceptability of the work itself in the form in which it was classified. What they do measure is the **temperature of public opinion**, and the Board can never ignore such moods, however transitory, since they may well determine the level of public confidence in the Board's decision-making [emphasis in original].[86]

Now, no one would envy the BBFC its erstwhile position as one of Fleet Street's favourite whipping boys, particularly as those who worked for the Board were all too aware that it could at any moment be 'de-designated' by the government as the body responsible for administering the VRA, which is precisely what papers such as the *Mail* intended. On the other hand, however, it could be argued that the Board was unnecessarily over cautious when faced with potentially controversial films, and that its repeated and lengthy delays in classifying these served only to offer hostages to fortune to the censorious press and to encourage the public to believe that the films concerned must indeed be problematic. So, for example, *The Good Son* (1993), which features a murderous child but which Lord Harewood in his Introduction to the *Annual Report 1994–95* described as having 'a strong moral core' and 'no similarities to the Bulger case', was classified only 'after a decent delay to let bruised memories fade'.[87] Similarly, after the press, in the Board's own words, 'whipped up [...] a storm of speculation and rumour'[88] over *Natural Born Killers*, the Board still felt it necessary to embark upon 'serious and protracted' debates about allegations in the US and France that it was responsible for several copycat killings. This

made it necessary for us to delay our decision until we had checked up on all those allegations. We did a thorough search of media reports in America and also in France, where another rumour had started, and we followed up every alleged link by telephoning the FBI or local police [...]. In no instance were they prepared to attribute any of the killings to this film or any other film. In only two of the twelve murder cases we uncovered had the accused actually seen the film in question [...]. [However, s]ince both the offenders [...] were cases of unbalanced or disturbed teenagers, and not indicative of any general tendency of the film to influence behaviour, it would have been inappropriate to draw generalisations from either of them. Thus the Board was satisfied that there had been no instance in which this film could be held to have been responsible, directly or indirectly, for homicidal behaviour.[89]

However, as the *Annual Report 1995–96* points out,

so concerned was the Board about the possibility of a delayed reaction that the distributors were informed that no video classification would be considered until sufficient time had elapsed to gauge whether or not there had been any violent incidents in Britain or elsewhere which could justly be attributed to the film.[90]

By the end of 1995, none had been reported, and the video was classified in February 1996 (although not before the BBFC had informed the Home Office of its actions).

Now, although the Board was certainly in an extraordinarily difficult position in these matters, it could be argued that, in the long run, it might have made life easier for itself and less circumscribed for film fans had it fairly and squarely faced down its critics in the press and Parliament. As Lord Harewood noted,

[o]ften we feel that the public's response is based on a misconception which can only be corrected through the provision of accurate information and advice. One of the things these Annual Reports can do is to provide such information.[91]

Unfortunately, however, these remarkably informative documents were little read, particularly by newspapers with an ideological axe to grind and by the politicians in their thrall, worried as they were about postbags swelling with letters agitating over 'video nasties'. Furthermore, as we have seen, some of James Ferman's pronouncements about media representations of sex and violence could be read as actually giving succour to the 'ill effects' brigade, while delays in classifying problematic films succeeded simply in turning up the heat under the pressure cooker which the Board's well-meaning dithering had caused to be put on the stove in the first place. What was needed, above all, was a campaign of broad public education and information about the Board's standards, judgments and *modus operandi*. Such a process had in fact begun in 1992 with the

Board's first survey of the views of video consumers, which was published under the title *Video in View*, and continued with the Consumer Advice scheme for video which was first introduced in 1994.[92] But it was not until the end of the decade, when Andreas Whittam Smith was appointed President, that the process really got into its stride; thus it is more properly discussed in the following chapter.

'A new approach'

This chapter has examined how the BBFC operated in the 1990s, particularly in the wake of the 1994 amendment of the VRA. It has argued that the Board's operations cannot be fully understood without recourse to the particular ways in which its Director, James Ferman, interpreted the 'harm' provisions of that Act, as well as the 'deprave and corrupt' test embedded in the OPA. It has also suggested that, at times, and entirely contrary to the way in which he was habitually represented by illiberal papers such as the *Mail*, Ferman was stricter and more cautious than these laws actually required the Board to be. Indeed the glaring, and highly gratifying, irony of this period is that in undermining a censor whom they regularly excoriated as overly liberal, newspapers and politicians unwittingly paved the way for a regime at the BBFC which was actually more, not less, liberal than Ferman's.

However, it should also be pointed out that James Ferman was more aware than most that the era of the old-time censor was rapidly drawing to a close, and that new technological developments would mean that, ultimately, viewers would have to become their own regulators. As he put it in his written evidence to the Home Affairs Select Committee in 1994:

> In a world where the media are exploding all around us, with new forms of delivery posing ever tougher obstacles to regulation, a new approach is almost certainly needed. This cannot involve adding ever more legislation to an already extensive list. Increasingly, this regulation is going to have to be self-imposed. Statutory bodies can only go so far. In the end, it is up to adults to police their own viewing and the viewing of their children.[93]

But he was also concerned about how children themselves dealt with the media, pointing out that 'if children are to survive in a media-saturated world, they will need to make informed choices, too'[94] and was thus extremely worried that media education had been removed from the national curriculum. In tandem with this, in the same year, BBFC Vice President Lord Birkett wrote to Sir Ron Dearing, Chairman of the School Curriculum Assessment Authority, arguing that media education 'is essential to the survival of our children', in that new communications technologies meant that the controls currently exercised by bodies such as the BBFC

> may one day be overwhelmed by the sheer flood of material available around the world [...]. Some of this material will be vicious, some pornographic, some will be depraving and corrupting, and much of it very dangerous for children. The best defence children will have against the blandishments of such material will be their own knowledge and understanding. If you understand how things work, you can usually defend yourself against them, and at least you are not in the power of their mystique. [...] Our children will be inundated with messages. Some will be valuable, mind stretching, even life-enhancing. Many will not. The only way to be sure that children are not damaged in the process is to see that they are educated.[95]

These were premonitory words, and are as true now as when they were first written.

CASE STUDY: INTERNATIONAL GUERILLAS (1990) Jason Green

The Satanic Verses, a novel by the noted Indian-British writer Salman Rushdie published in 1988, ignited a far-reaching controversy when its author was accused of blasphemously mocking the Islamic faith. Reaction was swift and, in some cases, extreme. The book was burned in a number of countries, including the UK, and was the cause of demonstrations and riots in several Islamic countries. Translators and publishers of the book were attacked and on some occasions murdered.[96] On Valentine's Day 1989, the Supreme Leader of Iran, the Ayatollah Khomeini, issued a fatwā against Rushdie, offering a bounty for his execution. This declaration resulted in Rushdie's being taken into police protection. Another reaction to the outcry, albeit a lesser-known one, was the release of a Pakistani action film, *International Guerillas*, in April 1990.

In the film, Rushdie is portrayed as a ruthless and decadent 'super villain' protected by a private army on an exotic island hideaway. He is shown committing all manner of

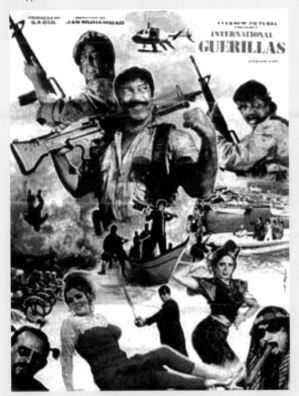

A jolly poster but a problematic film. The BBFC's decision to reject *International Guerillas* was overturned on appeal

heinous acts. In one scene, he slits the throats of innocent Muslims and ghoulishly sniffs their spilt blood. In another, he tortures the mother of one of the film's heroes by forcing her to listen to audio extracts from *The Satanic Verses*. A gang of outraged and devoted Muslim soldiers, calling themselves 'the International Guerillas', seeks to destroy him in vengeance for his crimes against the Islamic faith. However, all their efforts fail and Rushdie is finally destroyed by being struck and incinerated by retributive bolts of lightning sent from Heaven.

International Guerillas – when released in Pakistan – was a considerable success, and exclusive rights to distribute the film in the UK were obtained by the Tooting Video Centre in London, one of the largest importers and distributors of Pakistani and Indian films in Europe.[97]

The film was submitted for video classification in the week the threat against Rushdie was reiterated, and was viewed by the entire examining team during June 1990. The range of recommendations included rejection on legal and moral responsibility grounds, '18' uncut, '18' with cuts and '15' with cuts.[98] One examiner recommended that the start of the film feature a disclaimer denying that the character of Salman Rushdie was intended to bear any resemblance to the real author.[99] Other than the unusual central character, the film was indistinguishable from a number of similar 'revenge action' South Asian films which had been classified without problem in the past by the BBFC. *International Guerillas* contained chase sequences, dance numbers and comedy slapstick asides, as well as some bizarre touches such as the heroes gaining access to Rushdie's hideaway dressed as Batman. However, the portrayal of the Salman Rushdie character as a murderous sadistic maniac troubled the BBFC. It therefore sought legal advice as to whether this depiction could be vulnerable to a charge of criminal libel. Criminal libel is defined as the act of 'writing and publishing defamatory words of any living person, words calculated or intended to provoke him to wrath or expose him to public hatred, contempt or public ridicule or damage his reputation'.[100]

The BBFC's legal counsel advised that *International Guerillas* represented a *prima facie* case of criminal libel on a British citizen,[101] and 'a reasonable and properly directed jury would convict'.[102] The Board is under a duty to seek to ensure that works that infringe the criminal law are not classified. *International Guerillas* was duly refused a certificate.

The distributor appealed against this decision. In its Notice of Appeal, the appellant described the decision as 'perverse in all the circumstances'. The Notice argued that 'any reasonable viewer' would recognise that the film was not libelling the author 'given the grossly exaggerated and melodramatic nature of the work'. In addition, the Notice claimed that this decision was inconsistent with other certificates awarded by the BBFC. The '15' given to *The Naked Gun* (1988) was cited as an example. The film contained – according to the Notice – 'a clear prima facie criminal libel for the late Imam Khomeini when he was alive'.

The Notice also drew attention to the fact that Salman Rushdie himself had indicated publicly that he believed the video should be available for viewing in the UK.[103]

In a twist not out of place in a Hollywood courtroom drama, Rushdie had issued a statement through his solicitors about the film and the BBFC's decision to refuse to classify it. In the statement, produced before the Appeal hearing, he claimed he had seen the film – which he regarded as a 'distorted, incompetent piece of trash' – and stated that he believed that audiences, regardless of their religious affiliation, would understand that the character in the film purported to be him 'is ludicrously unlike the real me'. He stated unambiguously that he wanted *International Guerillas* to be certified for sale. This was, he believed, 'the surest way of revealing its shabbiness and of preventing it from becoming a "cause celebre"'. Rushdie also stated his opposition to what

he described as the 'archaic' law of criminal libel because he felt it was contrary to freedom of expression. However, if any material accompanying the film's distribution incited people to violence, he expected 'such material to be subject to the due process of law'.[104]

In the light of such overwhelming support for the film's classification by its allegedly defamed subject, the independent Video Appeals Committee upheld the distributor's appeal. In its judgment, the Committee also noted that it did not believe 'even the most gullible viewer would believe for one moment' that the portrayal of Rushdie in *International Guerillas* was a true reflection of the real person.[105] The film was duly classified '18' on 29 August 1990. Nevertheless, despite the trouble the distributor went to get the work classified, it would appear that the title was never officially released in the UK.

CASE STUDY: MIKEY (1992) Jason Green

A child and a serial killer: *Mikey*, starring Brian Bonsall, was rejected by the Board

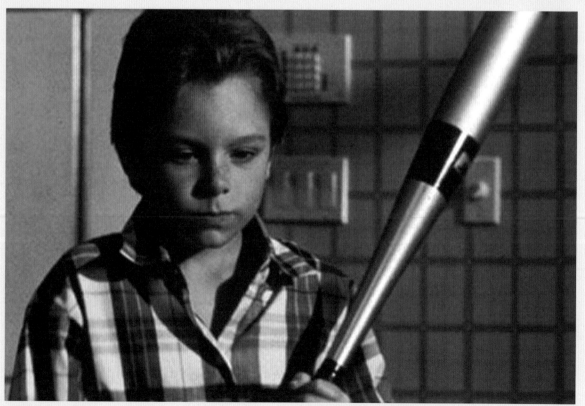

The chilling and unsettling figure of a child killer, ostensibly angelic but later revealed to be manipulative and murderous, has long been a staple of the horror film. The satanic Damien Thorn (Harvey Stephens) in *The Omen* (1976) and the sociopathic Rhoda Penmark (Patty McCormack) in 1956's *The Bad Seed* are perhaps the most notable examples of this genre.

An American horror film entitled *Mikey*, submitted to the BBFC for video classification at the end of 1992, continued this theme. The eponymous character (though it is never made clear in the story if 'Mikey' is his real name) is a seemingly 'perfect' nine-year-old boy who turns out to be a psychotic and remorseless serial killer. During the film, he is adopted by two loving families who welcome him into their homes and lives, and whom he systematically murders. One of his victims is his very young adoptive sister who is drowned in the family pool; a pair of interfering teachers are also dispatched along the way. The film ends with 'Mikey' being adopted by another unsuspecting family.

The examining team recognised that while *Mikey* contained some unpleasant and violent moments, it fell comfortably within the parameters of the '18' category at the time, and was deemed suitable for an adult audience.[106]

The tragic murder of James Bulger on 12 February 1993 by two ten-year-old boys prompted internal concerns about the release date of *Mikey* in the light of its plot and main character. The video work was viewed again by two separate teams in 1993 and by the Board's Presidents. While it was acknowledged that the film did not breach the prevailing classification standards of the time for an '18' horror work, current sensibilities and the media coverage prompted by the Bulger tragedy could not be ignored. Although the film bore no significant resemblance to the real-life case, there was a recognition that classifying the film at the present time would make for a 'sensational story in the Press'.[107] Further delays to confirming a classification were recommended until the passing of the Criminal Justice and Public Order Act.

The Act was passed in 1994 and amended the Video Recordings Act 1984 to take into account the suitability of video works for viewing in the home and the likelihood of underage viewing. James Ferman, the BBFC Director at the time, noted that these new provisions meant that the Board could no longer

> assume that to classify a video '18' is sufficient protection against under-age viewing. Instead, we must classify for the real world, a world in which children, including those from dysfunctional families, may well seek out a video about a wicked child.[108]

In anticipation of the Act, the BBFC attempted various trial cut versions of *Mikey,* reducing the 'most violent sequences in the film, in particular to ensure that the killings happened offscreen'.[109] These cut versions were judged unsatisfactory as a 'fairly clear sense of the methods used and the satisfaction taken by the little boy in his dreadful deeds' could not be concealed.[110]

The BBFC also sought advice from experts in child mental health on the extent to which *Mikey* 'might disturb or adversely influence the behaviour of vulnerable children'.[111] James Ferman, in his letters to the experts, noted that since the Bulger case 'it became impossible to view killings by a child as mere fantasy'.[112] The experts were asked to consider both the cut and uncut versions of *Mikey* and any potential harm likely to be caused to underage viewers. While the experts found that the film overall was 'poorly made' and 'implausible', nevertheless it did contain enough 'psychological touches' to make it 'reasonably credible'.[113] The concern shared was that the portrayal of 'Mikey' was 'appealing' and 'easy for other children to identify with', coupled with the 'ordinariness' and 'realism' of the setting. This led one expert to state his belief that *Mikey* 'is a very disturbing and potentially damaging film'.[114] This would be especially true for children in foster and adoptive families and those who had been victims of abuse or witnesses to violence between parents.[115] This group of children comprised 10 per cent of the child population, according to one of the experts.[116] Another troubling aspect was that 'Mikey' is 'rewarded' for his crimes in that he is never caught and his lies are believed by adults. All the child experts consulted believed *Mikey*, either in cut or uncut form, would have a negative impact on the feelings, and possibly behaviour, of a minority of children.

Meanwhile, the patience of the distributor began to show signs of snapping; 'this subject has dragged on far too long'.[117] The company was understandably keen to push on with the release of *Mikey*; its licence period for the title had already half expired without the work having been classified, let alone released.[118] While reassuring the Board that it would never resort to 'sensationalist publicity of any kind', the distributor wanted to press ahead with the work's release with 'all guns blazing' in order to ensure a return on the title.[119]

Four years after *Mikey* was submitted for classification, the BBFC came to a decision. On 20 December 1996, the distributor was informed that *Mikey* was not considered suitable for a classification certificate for viewing in the home. On the advice of its consulted experts and its new legal obligations under the Criminal Justice and Public Order Act 1994, the BBFC judged that *Mikey* was likely to cause harm 'to and by a small but significant proportion of potential viewers whose behaviour might be dangerously influenced by it'.[120] Interestingly, in the letter of rejection, the BBFC noted that it had not taken a view on the acceptability of *Mikey* being shown in cinemas 'where children might be successfully excluded'.[121]

Even though the possibility of releasing *Mikey* in cinemas was raised, the distributor appears to have decided to cut its losses on this title. The option to consider a theatrical release was not pursued and no appeal against the rejection decision was lodged.

9

'THE LAST DAYS OF THE BOARD'

Robin Duval CBE

Early in March 1998, James Ferman invited me to his office in Soho for a glass of Chardonnay. He wanted to know if I'd be interested in succeeding him.

Jim had been the chief film censor since 1975. I had known him since 1985 when I switched from film production to regulation, and joined the Independent Broadcasting Authority. He used to ring me up whenever television companies proposed to transmit, uncut, films that had been previously trimmed by him. If – as sometimes happened – he failed to get satisfaction, he would go direct to the company concerned. And, as often as not, get his way.

In 1998, Jim was the best-known and most respected film regulator in Europe. In the UK, however, he was under siege. Every Director of the BBFC expects criticism. But Jim was taking flak not just from both the libertarian and pro-censorship wings, but from government, the film industry, filmgoers. Even within the British Board of Film Classification, his own backyard, he had been for some time an embattled figure.

His policy of banning outright films like *The Exorcist*, and for making swingeing cuts in others, had been criticised by the *Guardian* and the left-liberal classes. The *Daily Mail* and its constituency were pillorying him for passing films like *Natural Born Killers* and David Cronenberg's *Crash*. Local authorities were exercising their historic right to overrule the BBFC within their own borders. In the late 1990s, for example, Labour-run Camden had given the BBFC-banned *The Texas Chain Saw Massacre* a local '18' classification, while Tory-run Westminster – the next borough along – had unilaterally banned *Crash*.

Robin Duval joined the Board as Director in 1999

Jim employed a team of film and video examiners to view the 4–5,000 video and cinema titles that passed through the BBFC, and to recommend cuts and classifications. But delegation never came easily to him. He had found himself increasingly in conflict with the opinions of younger colleagues. Any videos or films he thought likely to be problematic – and there were many – he viewed alone, staying in his office until close to midnight. The pace of classification, to the frustration of the industry, had slowed to a crawl.

He might well have survived all this and carried on for – who knows – ten or more years or as long as his health held up. The BBFC was his life and Jim had no desire to hand over the reins to another.

What had scuppered him was the 'R18' *débâcle*.

* * *

When the Video Recordings Act (VRA) was passed in 1984, the BBFC took on responsibility for the classification of all videos, including that special category of pornography rated 'R [for

Father Merrin (Max von Sydow) attempts to exorcise the demon from Regan (Linda Blair) in *The Exorcist* (1973), which was finally passed for video release in 1999

Restricted] 18'. The restriction meant that such videos were only legally available through the (then) sixty or seventy specially licensed sex shops around the country.

There were practical problems with this from the outset. There were never enough licensed sex shops to satisfy the market. The licences were in the gift of the local authorities many of whom, with more than half an eye on the sensibilities of their electorate, simply refused all applications. By the late 1990s, something like half of all licensed sex shops in Britain were concentrated in Soho.

Another problem had to do with the standards the BBFC was applying to 'R18' videos. In line with legal interpretation of the Obscene Publications Acts, the BBFC censored out all explicit portrayals of sexual activity and passed as 'R18' only what, even in those days, most people might call 'soft porn'.

All this left a vacuum that was occupied by a large, unregulated black market. The bulk was 'hard' porn familiar to British businessmen from adult channels in continental hotel bedrooms. Jim was much more disturbed by what washed up on the edge of this unregulated tide: scenarios in which young people, usually women, were violently and even sadistically abused.

He concluded that this transgressive material needed to be isolated – by legitimising the rest. In early 1997, he met up with Tom Sackville, a junior minister in the Home Office (which then had responsibility for the VRA), who had recently spoken at the AGM of the British Video Association about the need to reduce 'the high level of violence in videos and on television'. Jim proposed to him that the BBFC should – quietly and unilaterally – allow greater explicitness in 'R18' videos while continuing to bear down on elements of violence; and Sackville (or so Jim believed) agreed.

Catastrophically, this policy of discretion also meant that other enforcement bodies were kept out of the loop. When the General Election of that year was called, and a New Labour broom swept into the Home Office, no official memory remained of the Sackville/Ferman 'agreement'. Jim had constructed his own time bomb.

The fuse was lit a few months later when a consignment of video porn from France was impounded by Customs. The distributor protested that similar material was now perfectly acceptable to the BBFC. Customs in turn protested to the Home Office that it knew nothing of this about-turn of standards. When the BBFC was asked to elucidate, Jim was on sick leave. The response was handled at a lower level and the letter of explanation was (all too) straightforward, honest and frank: it confirmed that, yes indeed, the Board was now operating more liberal guidelines for pornography.

The affair escalated to the level of the new Home Secretary; and Jim and his Acting President, Michael (Lord) Birkett, were summoned to Jack Straw's presence.

It would have helped if Jim had briefed Lord Birkett more thoroughly. But for years now he had been running the BBFC as his personal fiefdom. By 1997, the role of President had become in effect supernumerary.

It was a great shock to the new Home Secretary. In his view the Acting President had fallen asleep on the job, and the Director was out of control. Most of all, Mr Straw was outraged by his own ignorance. It was unacceptable for the BBFC to develop policy in such a sensitive area of public concern without keeping him fully informed.

Now … the Secretary of State has strictly limited powers in relation to the BBFC. S/he cannot hire and fire Presidents and Directors – only the Board's own Council of Management can do that. Nor does government have any legal authority to direct BBFC classification policy. What it can do is determine – in relation to videos (the major part of the Board's work) – who does that classification. Just as previous Home Secretaries had formally 'designated' BBFC Presidents under the VRA to classify videos, so this Home Secretary could de-designate them and transfer video regulation to some other body.

In short order Mr Straw made it abundantly clear that the Council of Management needed a new President to clear out the Augean stables; and Lord Birkett was replaced by the founding editor of the *Independent* newspaper, Andreas Whittam Smith.

* * *

Andreas was nobody's 'yes' man. And observers who disparaged him for not having a film background (unlike his predecessor) entirely missed the point. He was a sophisticated operator who identified the BBFC's most obvious weaknesses from the outset: its lack of transparency, accountability and political resilience. Major change was inevitable. Meanwhile it was essential to get the 'R18' pornography issue under control; because on that matter if no other rested the future of the BBFC.

Accordingly, he set about his new task with a vigour and commitment probably unmatched by any President in the Board's history. Jim was required to redraw the rules on pornography so that only the most anodyne imagery was acceptable for the 'R18' category. And the post of Director was publicly advertised.

When I took Jim's call that March, I knew enough about the BBFC's history to recognise a poisoned chalice when it was placed before me. Back in 1971, when John Trevelyan retired after many authoritarian years at the helm, he too left a troubled inheritance. Stephen Murphy, his successor, struggled unavailingly until he resigned, leaving the future of the BBFC in jeopardy. Only the combined efforts of a strong President (Lord Harlech) and the third head of the BBFC in four years – James Ferman – staved off disaster and allowed the BBFC to rise like a phoenix from the ashes.

The question for me was whether my role was more likely to be Stephen Murphy's; or the younger Jim's. As it happened, I had known Stephen well. Media regulation is a small club and I'd succeeded him at the IBA in 1985. He was a cultured intellectual, and a kind and gentle man. I wished I were more like him. But since I was not, I might stand a better chance at the BBFC.

I knew quite a lot more by the time the Council's Chairman offered me the job in the autumn of 1998.

The most alarming discovery was the extent of the Board's own internal malaise. The examiners had become under James an elite, the only ones with whom he had regular meetings. He enjoyed the craic of noisy examiner argument even as he autocratically overrode their views. But the rest of the staff resented their status and the arrogance of some of the examiners. It was like a badly parented family in which the older children, reflecting their own Victorian treatment, worked off their frustrations by taking it out on the young ones.

The low level of morale was at the centre of everything. It expressed itself in disaffection with the Board's management (at all levels up to and including the Council), lamentably slow turnaround times for classification, unhelpfulness – even rudeness – to clients, internal bickering and mutual distrust, and a general assumption that things would never get any better. Some even assured me the Board had not long to survive.

The same view was held by journalists and media commentators. Even as my appointment was being made public, a Channel 4 team was in Soho Square filming a documentary about the BBFC. It was transmitted in peak time a few weeks later. The programme talked freely of an organisation 'heading for extinction'. It was called *The Last Days of the Board* (1999).

To a media transfixed by the BBFC, like passing witnesses to a car crash, the new Director's appointment was headline news.

The *Daily Mail*'s coverage led off with 'A television watchdog who has championed the right of broadcasters to screen more violence, sex and bad language is the new chief film censor [...]. The news was greeted with dismay by TV and film clean-up campaigners [...]' The headline was 'Channel 4 Liberal Is New Censor'.[1]

I had never in my life worked for Channel 4 – a fact characteristically irrelevant to the *Mail*. An old adversary in Channel 4's legal department rang up to inform me merrily that her Board was considering action against the paper for defamation.

The *Daily Sport* reported the appointment slightly differently. They had an ancient photograph – looking not much older than when I was at school – and placed it beside a busty nude. Their shrieking headline – which greatly amused my wife – was 'Will This Man Give You the Sexual Freedom You Deserve?'[2]

* * *

The programme for action then was clear.

We needed to wrest the agenda from a hostile media and start winning the arguments, seize the regular news-breaking initiative, assert an authority based on evidence and public approval, establish our own presence on the broadcast channels and in editorial coverage. This entailed a programme of research and consultation (to provide the necessary *vires*), publication of Guidelines transparently based upon those outcomes, and of proactive and if necessary aggressive press and public relations.

The essential interests of the BBFC's clients had also to be addressed. A much greater responsiveness to their concerns. The opening up of lines of full and detailed information. Considerably improved efficiencies, turnaround times and reliability. We needed to bear down also on the costs of classification.

The industry had, in short, to be persuaded that the BBFC was a preferable organisation to any devil they did not know.

Meantime, the 'R18' issue lay unresolved, like a sleeping volcano. It took up a substantial part of my time during those early months and had been the main topic of the face to face I'd had with the Home Secretary in late 1998. A meeting in which Jack Straw had not noticeably simmered down since his session with Lord Birkett and James Ferman. In which he made it abundantly clear that – in his view – the Board had 'no proper management structure' and needed 'a clean break with the old regime'. The BBFC, he emphasised, would not survive 'any more surprises'.

Since 1997, matters had become even more complex. An 'R18' video, *Makin' Whoopee!* (1997), had been granted interim uncut approval before Jack Straw's intervention; but was subsequently refused classification without cuts. Vexed by this change of direction, the distributor had responded by referring the matter to the independent Video Appeals Committee, which had statutory authority to overrule a Board decision.

The VAC had concluded that the video was not obscene and should be classified. When I arrived, the Board and the Home Office's legal advisors were all attempting to hold the line on the basis that *Makin' Whoopee!* was a *sui generis* case, and not to be used as any kind of precedent.

This was clearly nonsense since the VAC was hardly likely to contradict itself should another video with similar content come before it. To no great surprise then, the distributors of seven porn titles declined early in 1999 to make the required cuts for 'R18' and lodged an appeal.

They were led by Frank Sullivan, brother of the more famous David who had holdings in scores of sex shops around the nation, the *Daily Sport* and Birmingham City Football Club. They had money to burn and were ready to take the regulator as far as the law would allow. The BBFC on the other hand had, in its last profit and loss account, posted an operating margin of a little over £30,000 on a turnover of £2.5m.

The VAC had originally been set up as an inexpensive forum for challenging BBFC video decisions before a small panel of the great and the good (e.g. retired lawyers and lady novelists, attending for a nominal fee). The opposing parties had represented themselves or at worst involved a solicitor. But the Sullivans then greatly raised the ante by employing one of the most eminent and expensive advocates in the land, David Pannick QC, to argue their case for *Makin' Whoopee!* We had little choice but to respond in kind.

Andreas Whittam Smith was determined that, since we could not now argue a case for obscenity, we should do so on the basis of the risk of harm to children. This was also the argument put forward by Geoffrey Robertson QC with whom the Board initially consulted. The chief difficulty lay in the lack of evidence that 'R18' material was likely to be seen by children. But I accepted – as other colleagues did – the need to make every effort to sustain our current position. If at the end of the process we lost the battle – as I thought likely – then at least we would not have 'surprised' Mr Straw. Indeed, our position would be the stronger, because for the first time we could construct clear, legally tested Guidelines.

In the event, we assembled the best evidence of harm available and the Board's case was robustly made by Lord Lester QC. But the counter-arguments put forward by Mr Pannick for the distributors prevailed and their appeal was successful. The only remaining option now was to go for a Judicial Review of our own Video Appeals Committee, arguing that in its written judgment it had applied too narrow a definition of 'harm'.

Thus it was that, only when the Judicial Review in due course failed, were we at last in a position to do what – in a more perfect world – we should have done in the first place. That is, to bring together around a single table all the enforcement bodies with an interest – principally the Home Office, Police, CPS, Customs & Excise, the BBFC – and thrash out a rational solution.

At this point we had a stroke of fortune. The lead Home Office lawyer was replaced by a brilliant young woman who whipped the rest of the table into line behind our new, pragmatic, 'liberal' policy. Without her, I suspect the process would have dragged on for months; or more. But she stayed just long enough at the HO to complete the process before moving on to greater deeds elsewhere. Her name was Shami Chakrabarti.

The new 'R18' Guidelines subsequently published in 2000 permitted explicit depictions of consensual sex but forbade illegal and violent material. As well as conforming to the lessons offered by social research, they reflected the results of a recent British Public Attitudes survey that had revealed a correspondingly relaxed view of sexual portrayals.[3]

The Guidelines did not go as far as some onlookers, including sections of the porn industry, would have liked. Nor did they satisfy all sections of opinion within the Board itself. I had become accustomed to some quite high-falutin defences of pornography at examiner meetings. To me, it was basically filmed prostitution, with its own female – and male – victims; the main difference being that the clients were not actually present during filming. The moral distinction between a pimp making money from a brothel and a businessman producing and distributing porn videos escaped me.

I regretted one other outcome. The quantity of 'R18' submissions rocketed over the years and some of it included transgressive content that was wholly incompatible with the new Guidelines. Viewing such material was the most unpleasant task imposed on examiners. Distributors had occasionally to be reminded of our requirements, with the threat that – if they consistently breached them – the Board would refuse to accept their submissions. Even so, cuts and rejections were by 2002 more frequent for 'R18' than for all other video categories put together.

But the new Guidelines were pretty well the outcome looked for by James Ferman way back in 1997. It had been a long, tedious and expensive haul, but we'd got there in the end.

* * *

All this while, and on a parallel track, the Board had been progressing towards a new set of Guidelines for all the other categories from 'U' to '18'.

It may seem incredible now that, until 1998, the BBFC had no published Guidelines at all. In some ways, the Board's position had remained unchanged since at least the 1960s, when John Trevelyan declared in a television interview:

> We have no rules, which I think is important. I think it is the only way to do it. You see, if you have rules, you've either got to stick to them right through or you've got to interpret them and I think either's foolish. So therefore we try to assess what we believe are public attitudes at any one time and to work on those.[4]

Almost the first action of Andreas Whittam Smith when he became President was to require James Ferman to publish a set of Guidelines explaining what was and what was not permitted at each category. But even this document was – in the Trevelyan sense – based more on a subjective notion of public acceptability than on any research-based analysis. The 1998 Guidelines simply reflected current Board practice. They were therefore vulnerable to attack from any newspaper or pressure group that felt it had a better finger on the public's pulse.

This was a weakness that needed urgent attention.

So in 1999, a year-long public consultation process was initiated. It took in Citizens' Juries, extensive and detailed public surveys and questionnaires, and a lengthy series of 'roadshow' debates. The industry and other interested groups were consulted. The process of collation and analysis then took almost as long as the research programme.

One of the most significant findings was the general public conclusion that adults should be free to make their own viewing decisions, provided the film or video contained nothing illegal or harmful. Most people were relaxed about depictions of sexual activity, at the adult level and at the mid-teen level. They were much more concerned about what was inappropriate or harmful for children.

All this fed through to new Guidelines which covered all aspects of the classification process, including violence, language, sexual portrayal, drugs as well as the legal bases for decisions. A draft was sent out for further public consultation, after which refinements were made particularly for lower age groups. The final document was published in September 2000.

Not that the process was ever complete. Research – of public attitudes and of the possible effects of content – continued to be a Board commitment. Classification decisions were exposed to its independent consultative bodies for comment and criticism. The Guidelines remained under constant review; and were to be revised and republished on a regular basis.

* * *

These developments all improved morale. But there were more fundamental problems within the Board to be addressed. The internal hostilities, inefficiencies, organisational difficulties. Even the conditions in which people worked. The contrast between the Director's grand office and the dark Dickensian cubby holes of many of the staff was embarrassingly stark.

So, progressively, the management team was reorganised, some faces disappearing, new ones arriving. Our weekly meetings concentrated on new efficiencies and a progressive reduction of turnover times. The team's enthusiasm and energy took me by surprise. Within a year, the period for classifying a film or DVD had been slashed to days rather than weeks (or sometimes months). We were able to reduce the fees we charged and did so no less than four times between 2001 and 2004. An extranet facility to allow clients to track their submissions confidentially and a dedicated client helpline were just two of many innovations.

All this made the industry a great deal happier. It also enabled us to deal with latent problems before any hostile head of steam could build up. There were political benefits too. When, in 2000, the Government's Communications White Paper proposed that the BBFC's video function be taken over by the new Ofcom, the industry supported the Board's robust counter-arguments and the proposal was abandoned.

Meantime, new structures were put in place. Examiners were divided into teams under 'Senior Examiners'. Though every individual had a generalist duty to understand and apply all the new Guidelines, each also had – within the team – specialist responsibilities, for drugs portrayal, or children's issues or research. With the arrival of new examiners to supplement the considerable talent already in place, an impressive body of internal expertise began to build up.

One other less pleasant inheritance, though, was an irregular flow of malicious leaks about the Board and, worse, colleagues to a couple of hostile websites. The eventual departure from the BBFC of the individuals concerned solved that problem.

Regular meetings were scheduled, not just with the examiners, but to allow all staff an equal say. Individuals were encouraged to approach the Director personally. Sound MBA principles – or the version known as Management by Walking About – were the order of the day.

I had made an early assumption that it would be necessary to bring several new people in at senior levels. I was wrong. One particularly happy discovery was the quantity of real ability lying undeveloped within the BBFC which was soon promoted.

One key outside appointment, nonetheless, was of a public relations head. The arrival of Sue Clark transformed the Board's relationship with the outside world. With great determination and tenacity, she bore down on any newspaper, journalist or programme channel that made unsubstantiated claims or otherwise misrepresented the Board (in the early days, at least, a not uncommon occurrence). Good journalists loved her. For some of the others, she became known as 'the BBFC's Rottweiler'.

With these improvements and – it has to be said – a significant upturn in business as the industry rode a boom in the video/DVD market came economic opportunities. As well as all that expensive research, there was a chance to deal with the Board's working conditions. Every floor was refurbished – from the basement cinema to the IT unit in the attic. More light, more space and (as the workflow increased) more people. A radical rebranding of its corporate image in everything from cinema certificates to the Annual Report brought the Board smartly into the modern world. Alongside a new website, others were developed for young people (www.cbbfc.co.uk – the first of its kind in the world) and later for students.

* * *

James Ferman had had a habit of slipping intractable problems – quite literally – into the capacious bottom drawer of his magnificent, leather-lined desk. Twenty-four years of problems in fact. The arrival of a new Director was the opportunity for which many distributors had been waiting.

Typically the films that had caused most difficulty broke into two groups.

First, there were the titles from the early 1970s that had caused so much difficulty to Stephen Murphy. They included *The Exorcist*, *Straw Dogs* and *The Texas Chain Saw Massacre*. Second, there were the so-called 'video nasties', a disparate collection of titles that caused problems in the early 1980s. The usual response (as Jim locked the tapes away) was that now was 'not the right time'.

So it was that within a short period of my arrival, I was confronted by new submissions of those three '70s titles, plus the original version of *The Last House on the Left*.

The Exorcist was one of the films that Jim and I had wrangled about when he rang me up at the IBA. I had disagreed then that it was unsuitable for broadcast, and I knew of no evidence now (other than anecdotal hearsay) to suggest that the film could not be given a video release. The Board's examiners were unanimously of the view that it should be classified uncut at '18'. The decision to overturn Jim's embargo was not a difficult one.

But we put a lot of work into the public presentation of our decision. In our press release, for example, we noted that *The Exorcist* had been successfully video-released in the US, Europe and other countries without difficulty. Its special effects were now dated and many subsequent films had diluted the novelty − if not the power − of the original.

Similarly, it was a relief for the BBFC to put *The Texas Chain Saw Massacre* finally behind it, a film that looked pretty tame twenty-five years after its original release, with all the developments that had taken place in horror films and horror effects since its original production.

But not all the problematic titles from the past were as easy to deal with. It was one thing to give a certificate to old horror films where the general effect was about as challenging as a rollercoaster ride. It was another matter when films entered the difficult territory of sexual violence. And it was unfortunate that decisions on films such as *Straw Dogs* had to be made before the completion of our public consultation and research programme, and the new Guidelines.

I shared the reservations of the Board's President and Vice Presidents, and some of the examiners, about the central rape scene in *Straw Dogs*. The Video Recordings Act required the Board to have 'special regard' to any harm that may be caused to viewers or, through their actions, to society more generally. From that perspective, a portrayal of rape as ultimately consensual (reinforcing the old male 'rape myth' that women like it really) was legally problematic; particularly given the potential for the material to be viewed in the home repeatedly and out of context. Accordingly, after the distributor declined to make some cuts to the film, it was refused a classification.

By 2001, however, when the company returned once more to the fray, matters had moved on significantly.

Monica Bellucci starred in *Irreversible* (2002). The lengthy rape scene could be accommodated at '18'

At the time, the Board was preparing for a VAC appeal on that old 'video nasty', *The Last House on the Left*. The Board had required sixteen seconds of cuts to be made in order to render it suitable for an '18' classification on DVD. The distributor (concerned that he would be at a

disadvantage compared with overseas competitors whose uncut copies might be purchased on the internet) had declined to make them.

The Board commissioned focus-group research into the acceptability of scenes of sexual violence in a number of high-profile films, including both *The Last House on the Left* and *Straw Dogs*. Of all the films in the exercise, the former was the least acceptable. However, most respondents considered the rape scene in *Straw Dogs* to be justified by the wider narrative and the quality of the film.

The distributor of *The Last House on the Left* duly lost his appeal. Indeed, the VAC, finding unanimously against him, indicated that the BBFC might have cut even more deeply.

But the research outcomes on *Straw Dogs* had prompted us to reconsider it. The company this time had submitted the uncut version released in UK cinemas in 1971. Unlike the American edit of the film – the version rejected in 1999 – this included a sequence that gave a different context to the problematic scene, and in particular showed the woman as hostile to rape. As a further exercise, the complete film was viewed by clinical psychologists who concluded that harmful messages were unlikely to be taken from it. And so – in 2002 – the film was at last given its '18' classification, without cuts.

But by then, research and professional and expert advice had become a normal part of the Board's decision-making process – especially where the issues were complex or the outcome likely to be controversial. The range of advice stretched from consultant psychologists (on *Irréversible* [*Irreversible*, 2002], where the Board needed to be clear that a rape scene had no transgressive appeal to a viewer) to Scotland Yard (on *Gone in Sixty Seconds* [2000], where we needed confirmation that the film provided no useful information about how to steal a car). Such professional advice was to provide assistance not only in making individual decisions but also in reformulating and updating various aspects of BBFC policy and practice which had marked time over the years.

Those autocratic (and more exciting) days of Trevelyan and Ferman seemed already a long way behind us.

* * *

The *Daily Sport* may not have been so far off the mark with that 1998 headline. Though sexual portrayal as graphic as that in *Last Tango in Paris* had been permitted as long ago as 1972, there had, if anything, been a retrenchment during the Ferman era.

Even the exceptions tended to prove the rule. Brief explicit detail was permitted in *The Lovers' Guide* – but provided that only as much was shown as was required to make the 'educational' point. The Japanese *In the Realm of the Senses* (1976) was at last granted cinema classification in 1991 but its video use in the home continued to be prohibited.

As the twentieth century drew towards its close, explicit sex in arthouse movies was still extremely rare – and in mainstream popular cinema virtually unknown. The 'R18' débâcle had of course further muddied the waters. It was difficult then to see how real sex might be permitted at all at '18' if it remained unacceptable at the less restrictive 'R18'.

Nevertheless, two new films, both containing the kind of material previously banned (and currently unacceptable for 'R18'), arrived on my desk even as I was settling in behind it. One was Lars von Trier's *Idioterne* (*The Idiots*, 1998); the other Gaspar Noé's *Seul contre tous* (*I Stand Alone*, 1998). Both were looking for cinema release, uncut, at '18'.

In the case of *The Idiots* it was clear what, in common sense, our decision should be. Finding a means of presenting that decision publicly was (again) more difficult. The Board argued that this was a film with serious points to make and in which the exceptionally brief moment of real sex was justified by its context. In other words, they were clearly integrated within the film's narrative and thematic development and that of the film's characters. The important distinction with an 'R18' work was that the context was not one of seeking to cause viewer arousal.

So the film was passed uncut at '18'. But an important precedent had been set: explicit detail could be accepted at this level provided the material was appropriately brief, with clear contextual justification.

Seul contre tous presented an even more taxing challenge. On the surface, the two films had a number of similarities. Both were well-made European arthouse works likely to attract a culturally limited adult audience, both had important points to make, and both featured a single scene of real sex. But there were important differences. The images in *Seul contre tous* were far more graphic, of much greater duration, and more clearly foregrounded than those in *The Idiots*, in which the

The BBFC classified *The Idiots* (1998) '18' uncut, despite the film's brief moment of real sex

penetration was almost a blink-and-you'll-miss-it moment. But the most obvious difficulty with *Seul contre tous* was that the fleapit cinema images viewed by the main character were extended clips from an actual porn video. There was no way of reconciling this material with current obscenity standards and the prohibition of similar or less explicit stuff in 'R18's.

Seul contre tous was not, strictly speaking, cut to achieve its '18' classification; but the more explicit details on the porn cinema screen were optically blurred. From an audience perspective this was hardly satisfactory, particularly given that – had the film been submitted after the resolution of the 'R18' issue – there might have been a different outcome. Timing is everything....

Thus, with the greater explicitness permitted by the new Guidelines, some of the steam went out of sex issues in European arthouse movies. The Board's new-found ability to defend its classification policy evidentially meant that media attention began to dwindle.

But there were still a few landmark cases to come. One of these was *Baise-moi* (2000).

This was a film about two abused women taking violent revenge upon society. It was written and directed by women; and embedded within it, though not necessarily apparent to every viewer, was an unusual and challenging perspective on gender roles. But it contained more explicit material than any the Board had passed hitherto. Most troublingly, it included a rape scene into which the film-makers had inserted a ten-second close-up shot of vaginal penetration.

The Board concluded that the scene, taken as a whole, took a responsible view of the act of rape, which was portrayed as brutal, and deeply unpleasant and aversive. However, the insertion of the penetration shot brought with it an element of porn-movie erotica. The combination of extreme violence and graphic sexual imagery was unacceptable and the Board insisted on the removal of the shot.

Even so, we were acutely aware that the film might be a step too far for public opinion; and we awaited any reaction to the cinema release before proceeding towards video classification. In the event, the Board's position was accepted by the public and it was possible also to pass the video – though with one further cut. The standard of acceptability for material likely to be viewed in the home was always higher, because of the scope for it to be taken out of context and viewed repeatedly. Consequently a brief shot of a gun being pushed into a man's anus – mirroring the (already cut) penetration shot in the earlier rape scene – was removed.

Le Pornographe (*The Pornographer*, 2001) was about a retired – and rather naïve – porn director who had returned to the industry in the new millennium. It showed him shocked by the level of explicitness and crudity now expected, and by the increasing depersonalisation and humiliation of the performers. This was most clearly illustrated by a graphic scene in which a man ejaculated over a woman's face.

This scene from *Baise-moi* (2000) was subject to a cut for '18' on video, adding to the cut made to an earlier scene for theatrical release

The arguments were well poised. On the one hand, it was clear that the scene served an important purpose within the film: it was, arguably, not gratuitous. On the other, it was expressly the kind of material confined by the Guidelines to the 'R18' category. In terms of general public acceptability, it was more shocking – perhaps considerably so – than anything previously passed at '18'. The context, moreover, was not conventionally that of a narrative: the image arose within the context of actual pornography. There were obvious echoes here of the decision on *Seul contre tous*, and the need to maintain a clear boundary between 'explicit images' and 'pornographic images'.

The film was accordingly cut to achieve an '18' classification for cinema and video release, although the distributor also opted to take an uncut 'R18' classification. In the event, however, no sex shop could be persuaded to stock a subtitled French arthouse movie, explicit moments notwithstanding; and the unreleased 'R18' copies of *The Pornographer* gathered dust in a warehouse.

The Board – in my time – had always been a little sensitive to the charge that it only permitted explicit sex in 'arty foreign films'. The problem of course was that American and British film-makers rarely entered this territory, except in a fairly half-hearted way. But in 2001, the Board had an opportunity to challenge that too familiar canard, with the submission of *Intimacy*.

Here was a film in English, with well-known actors – including the Artistic Director of the Shakespeare Globe Theatre – having sex comparable with that previously passed in, for instance, *The Idiots*. It was classified without cuts – in line with the public consensus reflected in the Guidelines for adults at '18' – and we sat back to bask in the revelation of our consistency. Sadly, after a brief flurry of interest, the Board's critics concluded that *Intimacy* didn't qualify: the director was French, the money was French and German, and at best it was that rare phenomenon, a continental-style British arthouse movie.

* * *

For most other classification issues – violence and bad language, for example – the clarity of the new Guidelines greatly simplified the Board's task. Of particular significance was the Board's acceptance of the general view that adults should be allowed to choose for themselves at the level of '18'. At lower levels, however, where the Board's restrictions continued to impose censorship upon younger people, there were still important arguments to be had.

The case for relaxing the prohibition on under twelves viewing a '12'-rated cinema film was well made by Andreas Whittam Smith in his introduction to the *Annual Report of 2000*. He pointed *inter alia* to the wide differences between young children, and to the ability and responsibility of parents –

The BBFC classified
Spider-Man (2002) '12'
just before the '12A' was
introduced. The film was
subsequently reclassified
at the new category

rather than the Board – to judge whether their offspring were robust enough for a particular film. Should the '12' certificate, in short, be advisory rather than mandatory?[5]

The Board took its time, with a lengthy public consultation process and a pilot scheme in Norwich. It became clear that, providing effective consumer advice was made available, and children were accompanied by a responsible adult, the public favoured the relaxation.

The industry, while welcoming the initiative for obvious economic reasons, took some persuading that it was necessary to provide Board-generated advice about content on their posters, at the box office, in television commercials, in local advertisements and in press coverage generally. But the BBFC left it in no doubt that the necessary quid pro quo for an advisory '12A' was clear and consistent consumer information.

Andreas retired in August 2002 to take on another life challenge (managing the finances of the Church of England), before the new '12A' was up and running. He was succeeded as President by Sir Quentin Thomas. In the event, the Board's initiative was a considerable success and the '12A' continues to this day.

As a consequence, it was unnecessary to restrict *Harry Potter* or the Bond films to a twelve-plus audience, or to cut them for the lower 'PG'. The first significant beneficiary, however, was *Spider-Man* (2002), previously considered too violent for 'PG'. It returned for reclassification and achieved the longed-for '12A'.

Of course, the agenda immediately moved on to the possibility of an advisory '15A' or even '18A'. But I took the view that these were inappropriate because – unlike '12A' where the issue was simply material that some parents might deem unsuitable – the higher categories would include material that might actually be harmful to younger children.

* * *

(left) Julie Walters and Jamie Bell in *Billy Elliot* (2000), which, because of its frequent strong language, had to be a '15'; (right) Actor Martin Compston and director Ken Loach filming *Sweet Sixteen* (2002), an '18' due to its frequent use of very strong language

Some problems, though, remained an issue to the end of my time. At the head of my own personal list was strong language.

Whatever may have been the preferences of the examiners, the Presidential team or myself, the British public made it resoundingly clear in successive surveys that certain expletives and expressions were unacceptable at lower classification levels. As a problem, this remains unique to the English-speaking peoples (and a source of consistent bewilderment to European colleagues).

It was not open to the Board to sweep such clear public guidance to the side. Two successful British films highlighted the difficulties.

Billy Elliot (2000) straddled the boundary between 'PG' and '12' in all respects but one: there were some fifty uses of 'fuck' and its variants. The film had obvious appeal to young people down to the age of ten or less. But the lowest classification possible – without breaking faith with the public – was a '15'. Even at '12' (or later '12A') the Guideline limit was a reluctant – and pragmatic – single use of 'fuck'. Pragmatic because that was what Hollywood routinely permitted for the mass of popular films aimed at this age group.

Sweet Sixteen (2002) a couple of years later concerned a troubled Scottish teenager. This time there were some twenty 'cunt's – the public's most offensive expletive – including several extremely aggressive uses. The film's celebrated director, Ken Loach, invited me to tea and argued at great length that it should be rated '15' because the language would be familiar to a young audience. But '18' it had to be.

Different sets of difficulties arose when the Board applied the requirements of various Acts of Parliament.

The Cinematograph Films (Animals) Act 1937 made it illegal to distribute a film in the UK if an animal on screen was being cruelly mistreated. Historic film practice (tripwire horse falls in old Westerns) or national customs (Spanish bullfighting) were no defence in law. In my time, a South Korean film, *The Isle* (2000), had to lose sequences in which a fish was kept alive while actors took slices from its side to eat as sushi. But we were not required to intervene with the same country's *Oldboy* (2003), in which a man ate a live octopus, because invertebrates were not covered by the legislation.

Under the Protection of Children Act 1978 it was illegal to make, distribute or even possess indecent images of children. The Sexual Offences Act in 2003 then raised the relevant age by two years to eighteen. As a result, certain films involving sixteen- and seventeen-year-old actors, which we had previously classified, had to be examined again. Fortunately, our legal advisors were clear that a common-sense sliding scale could be applied so that something that might be indecent if it involved a fourteen- or fifteen-year-old might not be so in the case of a sixteen- or seventeen-year-old.

In *À ma soeur!* (*Fat Girl*, 2001), a twelve-year-old girl was pinned to the ground and raped by a man. The Board called in an eminent QC for his opinion. He advised that the scene was not – under the law – indecent, and that the brief and shadowy display of the girl's breasts, which had concerned examiners, was 'incidental'. After further careful consideration, we passed the film uncut for cinema release. None of this prevented the *Evening Standard*'s veteran film critic Alexander Walker storming into the BBFC's reception to express his outrage.

That was not the end of the story. Even if the material was not legally indecent, we were still concerned about its possible effect on video. Two clinical psychologists viewed the film and advised that the scene might be used as a 'grooming' tool and shown to children to disinhibit them

Oldboy (2003): the scene in which Oh Dae-su (Choi Min-sik) eats a live octopus did not require cuts

from sexual acts. This would not have been possible in the cinema, where the '18' rating would have excluded any child. But it was a risk we could not take in the domestic environment. The film was therefore cut for video release.

* * *

A final few words about two other topics that passed through major changes during my period.

I had struggled to understand the inherited rationales for Board policy on weapons and drugs.

There was a sound argument, which I recognised, for bearing down in child-rated films on any glamorisation of knives – because of their accessibility to younger viewers. The BBFC's policy for more 'exotic' weapons such as nunchaku (chainsticks) and throwing stars was more difficult to justify. Since the 1970s, when 'kung fu' mania was at its height, the Board had responded to apparent police concern by removing all sight of them, however anodyne. Thus, one of the more bemusing cuts in the late 1980s was to a string of sausages being twirled in a threatening manner.[6]

A thoroughgoing review in 1999 took in, among other advice, the current views of Metropolitan Police specialists with experience of weapons misuse. As a result, a more accurately targeted policy was introduced. Bruce Lee was restored in all his uncut glory to his legion of ageing followers; and the predicted outbreak of nunchaku-wielding violence failed to materialise. We continued to maintain a strict position on more common weaponry, especially in films aimed at children. And *Lara Croft: Tomb Raider* (2001) was cut for '12' in order to remove glamorised images of knives.

Also in need of overhaul was the Board's policy on drugs, which had become similarly inflexible and decontextualised. We needed a much better understanding of the effects of drug portrayal on young people and adults. The public's own views on what might be acceptable were relevant too. An opportunity arose for a joint piece of research with the Broadcasting Standards Council, canvassing the views of drug users, non-drug users, and experts in the field. We supplemented this with a wider public consultation exercise, including questions to Citizens' Juries. The view that emerged was that it was the glamorisation of drugs which caused the most concern, rather than any particular details on screen. Realistic – and aversive – depictions might be acceptable; much more attention needed to be given to context. Historic cuts were accordingly waived for *The Panic in Needle Park*, *Christiane F.* (see case studies), *Bad Lieutenant* (1992) and *Trainspotting*.

* * *

The theme of constant review, advice and appraisal had become embedded in the BBFC's process. Even the 2000 Guidelines, notwithstanding the weight of information underpinning their final form, were not immune. By early 2004, we were already launching a new programme of consultation including public questionnaires, 'hall tests', focus groups, a nationwide survey, contributions from individuals, experts, interested groups and the industry. All our classification principles were placed under a forensic microscope, the final outcome of which was a revised set of Guidelines published (after I had left) in February 2005. And the process continues to this day.

By 2004, the Board had become a very different creature from the troubled body whose last rites Channel 4 had proclaimed six years before. It was time to move on. Time also for a change of gear to assure it of the successful future it deserved. In the autumn of that year, I was able with great pleasure to hand the BBFC over to the shrewd and safe pair of hands that was David Cooke.

Particular thanks are due to Craig Lapper, without whose Total Recall this chapter would have been Mission Impossible.

CASE STUDY: ICHI THE KILLER (2001) Murray Perkins

Directed by Takashi Miike (who also made, among numerous other films, the violent and challenging *Audition*, 1999) and based on the Japanese manga series *Koroshiya 1* (1998–2001), *Ichi the Killer* tells the story of a young man manipulated into acting as an assassin by an older man pulling strings in the world of the yakuza.

It was first viewed for theatrical release on 28 March 2002. Between April and May, there were three further screenings during which almost the entire examining team viewed and commented on the film.[7]

Ichi the Killer contains scenes in which a female character is brutally beaten and raped while Ichi (Nao Ohmori) watches, intercut with a flashback to a schoolgirl being raped, before suggesting Ichi has found the rape sexually exciting. In the second such scene, Ichi kills both the rapist and his victim, the latter indicating that she derives pleasure from the pain inflicted. Continuing this theme of pain and sexual pleasure, a female character is shown apparently experiencing an orgasm as she tortures a man by stretching his cheek. Issues of sexual and sexualised violence continue as a woman pretends to be a rape victim and tells a confused Ichi that she wanted to be raped. In response, he slices off her leg. Another female

character has her nipple sliced off. And in an earlier scene of violence unrelated to sex, a gangster is strung up on meat hooks before having a long needle skewer his jaw and hot oil poured over his back.

The brutality of these scenes and the combination of sex and violence raised challenges for classification and it was apparent that it would be difficult to pass the film without intervention. At the time *Ichi the Killer* was submitted, the BBFC's Guidelines stated, '[t]he BBFC has a strict policy on rape and sexual violence. Where the portrayal eroticises or endorses sexual assault, the Board is likely to require cuts at any classification level.'[8] On the one hand, *Ichi the Killer* had little typically eroticising detail in the rape sequences, with limited nudity and little in the way of sexual mechanics. Instead the scenes were primarily presented as brutal assaults. On the other hand, the film contained ambiguous messages about rape, with one character in particular suggesting she enjoyed being beaten and sexually assaulted.

The film was viewed by the BBFC's Director, Robin Duval, the President, Andreas Whittam Smith, and the two then Vice Presidents. The Board gave serious consideration to all the possible outcomes, including the case for refusing *Ichi the*

Ichi the Killer: the violence against women in the film was of particular concern

Killer a certificate altogether.[9] However, it was felt that adequate cuts could be made to allow the film to be passed at '18'.

Duval arranged for trial cuts to be made to scenes of torture and sexual and sexualised violence so that the effect of the proposed interventions could be judged. In particular, the cuts sought to address concerns about sexual and other violence directed at women. As far as violence between men was concerned, the opinion was expressed that this was unrealistic and grotesque in a manga/Grand Guignol style and so difficult to take seriously.

Before the details of the cuts list were finalised, Whittam Smith stepped down as President. Sir Quentin Thomas, the new BBFC President, took over and he too recognised the problems that *Ichi the Killer* posed. He shared the view that cuts were required.

When the final agreed cuts list was sent to the distributor, on 5 September, it required reductions to the beating and rape of one woman in two individual scenes, the impression of another woman gaining sexual pleasure from her part in a violent assault, sight of a woman's nipple being stretched and a blade being run across it, and subsequent focus on the same woman's semi-naked and mutilated body.[10] Altogether the cuts amounted to three minutes, fifteen seconds and three frames. With these edits made, the cut version of *Ichi the Killer* was given an '18' certificate on 12 November 2002.

In December 2002, the distributor submitted a pre-cut edit of the film for video release. With cuts having been made in line with the theatrical release, this pre-cut version of *Ichi the Killer* was classified '18' for video on 1 May 2003. An identically pre-cut English dubbed version also received an '18' certificate that day.

In the years since *Ichi the Killer* was considered, the BBFC has maintained a strict policy on sexual violence. Current Guidelines on the issue are little changed from 2002, stating that '[c]ontent which might eroticise or endorse sexual violence may require cuts at any classification level'.[11]

Ichi the Killer remains cut in the UK.

CASE STUDY: LILO & STITCH (2002) Jason Green

When classifying films and DVD works specifically aimed at a young audience, the BBFC needs to be vigilant that there is no content that encourages children to engage in potentially dangerous behaviour. BBFC Guidelines make this point clear at both the 'U' and 'PG' categories.[12] What may seem self-evidently dangerous and inadvisable to older viewers may look exciting and fun to the very young. This is especially the case if the work features characters popular with children, or who would carry a strong appeal for younger audiences, behaving in dangerous ways without being harmed by the activity or criticised for their behaviour. This concern is further heightened when the activity is portrayed as both fun and harm-free and without appropriate warning of the dangers, or taking place within a clearly precautionary context.

Sometimes even in the most child-friendly films from the most child-friendly film-makers, these issues can arise. Potentially harmful behaviour ranges from the obvious, such as playing with fireworks[13] or trying to cut live electric cables,[14] to dangers that are less immediately apparent. For example, in 2004, an episode of the popular Welsh-language children's cartoon, *Sali Mali*, showed young Sali Mali skating on a frozen pond unaccompanied and unsupervised by any adult. The series was aimed at pre-school children and was usually classified 'Uc',[15] indicating its particular suitability for very young audiences. The lack of any adult presence or clear warning of the dangers of such behaviour was raised by the examining team as problematic for securing the 'Uc' category.[16] When apprised of this concern, the distributor chose to withdraw the episode from the classification process.

A similar, but higher-profile, illustration of this consideration of harmful behaviour in children's works arose in the 2002 Disney film *Lilo & Stitch*. *Lilo & Stitch* is an animated tale of a lonely and troubled young girl called Lilo who befriends a blue alien, naming him Stitch. Overall, *Lilo & Stitch* was considered by the Board as suitable for the 'U' category and had plenty of appeal to young audiences with its likeable pairing and comic slapstick action and humour characteristic of many Disney films. However, one short sequence in the film gave the Board pause for thought. After hiding from her elder sister, Lilo is caught emerging from a washing machine. While Lilo is never seen climbing into the machine or actually hiding inside, and the machine is never activated, this action on the part of a child character in a children's work was judged as potentially problematic for viewing by a very young audience. The Board's concern was that some very young children are unaware of the dangers of climbing into kitchen appliances such as fridges, tumble driers or washing machines.[17] Despite her loneliness, Lilo is an irrepressible and funny character with whom many young viewers would engage and identify. The fact that she is caught could, it was noted, suggest that a washing machine is not such a good hiding place. Nevertheless, this was not considered sufficiently overt criticism of her behaviour and the

Lilo (right) and Stitch.
Even animated children's
characters can cause
classification issues

danger inherent in it.[18] In the film, Lilo is berated by her sister for causing trouble but the dangers of hiding in a washing machine are never brought to her attention or that of the audience. Although injuries to – and in extreme cases the death of – children who have become trapped in domestic appliances are thankfully rare in the UK, they are not unheard of. The BBFC therefore takes a highly precautionary view of easily imitable dangerous behaviour which is presented as harm-free.

Accordingly, the BBFC issued a cut to remove this sequence from *Lilo & Stitch* in order for it to be classified at 'U'. Disney, once alerted to the risks this sequence could pose to a young audience, decided to substitute the entire scene rather than edit it. In the new version, Lilo is now seeing hiding – harmlessly – in an unlockable cupboard rather than a washing machine. The BBFC was content that this fully addressed its concerns and the film was duly classified 'U'. *Lilo & Stitch* became one of the big summer films of 2002, and spawned a number of sequels.

10 THE DIRECTOR'S COMMENTARY

David Cooke

When I arrived at the BBFC in September 2004, I was fortunate to be able to build on the legacy left by my immediate predecessor, Robin Duval. Robin had overseen a huge increase in the productivity and efficiency of the Board's decision-making, as well as a significant improvement in the consistency and openness of BBFC decisions. The effect of this had been a significant reduction in the amount of controversy that had attached to the Board's work under the regime of Robin's own predecessor, James Ferman. Nonetheless, the period from 2004 to the Board's centenary year has presented its own issues and challenges, which I will set out in this chapter.

Real Sex at '18'

One of the first film decisions I was confronted with was Michael Winterbottom's *9 Songs* (2004). It tells the story of the development and deterioration of a couple's relationship, set against a backdrop of nine concert performances attended by the protagonists. The story of their relationship is illustrated in part through a series of relatively frank and explicit sex scenes, during the making of which the two main actors engaged in actual intercourse. Of course, this was not the first time the Board had been presented with a feature film, as opposed to a pornographic film, that included explicit real sex. What did seem new, to the press at least, was that this was a British film made by a British director, in contrast to the handful of European and other arthouse films that had hitherto included such content. What was also new, at least arguably, was that the film seemed to feature more explicit sex than many previous films, including a quite graphic male ejaculation.

The classification Guidelines I had inherited from Robin Duval stated that, in line with the expectations of the public, the Board would intervene only rarely with '18'-rated cinema films, although we reserved the right to cut 'the more explicit images of sexual activity – unless they can be exceptionally justified by context'.[1] It seemed to us that the sex scenes in question were indeed justified by context. First of all, *9 Songs* was not a pornographic film, in that the explicit scenes were not being shown primarily in order to titillate the audience. It wasn't shot like porn and it doesn't look like porn. Rather, the film tells its story through sex: the manner in which the sex is portrayed, scene by scene, mirrors the developments in the couple's relationship. The explicit images – which were actually relatively brief and carefully shot – illustrated something about the development of the couple's relationship and contributed to the narrative. Of course, some critics argued that Winterbottom could have chosen to be more discreet. However, it is not the Board's role to make aesthetic decisions of that nature – we can only assess

David Cooke, the BBFC's Director since 2004

what we are presented with and judge whether it accords with the requirements of the law and the wishes of the public, as expressed through our classification Guidelines. In our view, the film did meet those requirements and it was passed '18' uncut (see case study).

What the decision on *9 Songs* illustrated was the key importance of intention in terms of deciding whether explicit sexual images might be permissible at '18'. This notion has its origin in the regulatory environment within which the Board operates. The Local Government (Miscellaneous Provisions) Act 1982 set up a licensing regime for sex shops (and, at the time, sex cinemas) which would allow the more explicit forms of pornography to be supplied in segregated premises to which only adults were admitted. The idea was that adults would be able to obtain such material if they chose to do so, without such material being on general public display, where children, or those who would be offended, might encounter it. The BBFC responded to this, in 1982, by introducing a new 'R18' classification for films to be shown in licensed sex cinemas. That special category for more explicit pornography was extended to video by the VRA. Of course, the 'R18' category only has utility in confining the more explicit forms of pornography to sex shops (or, formerly, sex cinemas), whereas it is considerably less useful when one is dealing with a non-pornographic film that happens to feature explicit content, such as *9 Songs*.

The distinction the Board made between so-called 'softcore' and 'hardcore' pornography was challenged in 2005 when a group of sex distributors, irritated by the fact that 'R18' videos could only be supplied in sex shops, took their case to the VAC. Their contention was that sex shops and the 'R18' category should be reserved for the most extreme forms of pornography, including strong fetish activities such as sadomasochism, but that straightforward explicit depictions of real sex should be permitted at '18' and therefore available to be sold in high street shops and via mail order. The Board undertook a very specific piece of public opinion research in order to prepare for that appeal, in which members of the public were shown softcore (i.e. apparently simulated) '18' porn films, unsimulated hardcore 'R18' porn films, explicit sex education videos (generally classified by the BBFC at '18' since the early 1990s), and some feature films that included explicit real sex. The results were clear: the public understood and appreciated the distinction between '18' and 'R18' and did not feel that hardcore pornography should be made available at '18'. Equally importantly, however, they understood the Board's distinction between works whose primary intention was sexual arousal (which we refer to as 'sex works') and works that served another purpose, such as *9 Songs*. The appeal was dismissed unanimously by the VAC, which recognised that Parliament's intention in setting up sex shop licensing was to restrict the more explicit forms of pornography to such premises.

The distinction between 'sex works' and other works that simply make use of explicit images was nicely illustrated by the documentary *Inside Deep Throat* (2005). On one level, the documentary was about the making of the notorious US porn film *Deep Throat* (1972). However, it was also far broader in its scope, taking in the social and cultural climate of the times and the impact the film had on popular culture. In order to illustrate what all the 'fuss' was about, a single brief clip from *Deep Throat* was shown, through which the audience was presented with the precise meaning of the film's title. The Board concluded that, although this brief moment was taken from something that was unquestionably a 'sex work', its purpose in this documentary context was quite different to its purpose in the original film. The clip here was purely for illustration and the presence of a few seconds of 'deep throat' activity did not in itself turn the whole documentary into a 'sex work'. Accordingly, we passed it '18' uncut. The brief moment of explicit real sex was, in the words of the Guidelines, 'exceptionally justified by context'.[2] By contrast, when the distributor of the documentary decided that it would be an interesting idea to accompany certain screenings with retrospective showings of the original 1972 film, we were very clear that *Deep Throat* itself was still a 'sex work' and we classified the feature at 'R18'. At least one London cinema obtained the necessary permission from its local authority to operate as a sex cinema for one night only, permitting the intended double bill to go ahead.[3]

The conceptual distinction between 'pornographic' images and 'explicit' images was searchingly questioned and interrogated by *Destricted* (2006). This comprises seven short films by a variety of artists and film-makers, including Sam Taylor-Wood, Matthew Barney, Gaspar Noé and Larry Clark. The directors in question had been commissioned to explore 'the fine line where pornography and art intersect', as the explanatory notes informed us.[4] It seemed quite clear to us that the purpose of *Destricted*, taken as a whole, was not sexually to arouse the audience. Nor was that the likely effect. The work was too far removed from pornography, in terms of the manner in which it presented sexual activity, to function as an effective aid to masturbation. Matthew Barney's film was too bizarre to be a sex work, featuring as it did a man rubbing his penis against a spinning

engine axle with some kind of root vegetable hanging from his backside. It reminded us of the kind of thing one might see at the ICA or other venues as a form of 'performance art'. Sam Taylor-Wood's film showed a man masturbating to climax in long shot in a desert location. The manner of filming was cold, detached and clinical, rather than the sort of shots familiar from porn films. (The previous sentence illustrates that, while the Board tries to avoid value judgments, that is not always realistic.) Gaspar Noé's film used disorienting camerawork and sinister noises and sound effects to produce an alienating rather than an attractive or arousing effect. Where the most significant difficulty arose was with Richard Prince's short film, *House Call*.

Prince is well known for using appropriated pop culture images in his artworks. He is particularly well known for his controversial photographic work *Spiritual America* (1983), in which he used one of Garry Gross's notorious pictures of a naked Brooke Shields. In the case of *House Call*, Prince had opted to film a scene from a dated pornographic film, apparently off a TV screen or other monitor. On one level, Prince was simply showing us a porn film, and one that certainly would have been classified 'R18' had it been submitted in its own right. However, the bleached-out look of the footage, with the image regularly flaring up owing to his filming directly from the monitor, provided a distancing effect, as did his overlaying of the film with other music. He had also edited the scene in such a way as to show only the key – and very generic – moments that make up a typical porn scene, rather than focusing on the most explicit moments in the protracted way that is normal in actual pornography. This produced a result that invited the viewer to consider what was being shown – and why – rather than to engage with it in a direct and sexual fashion. Of course, some people may reject the manner in which Prince chose to respond to the commission laid down by the producers of *Destricted*. However, as the BBFC is not appointed as an arbiter of aesthetics or as a judge of artistic worth or merit, it seemed wrong to us to reject Prince's artistic response to the initial commission while accepting those of the other artists and film-makers. His method of responding to the question posed about the line between art and pornography seemed as valid as any of the other contributions, certainly if one bought into the overall concept of the piece. It's probably true to say that we would have had more difficulty classifying *House Call* purely in isolation. However, as one element of a wider work investigating the nature of pornography and art, this seemed to be a useful contribution to the debate, not least in terms of giving an impression of what pornography was. In addition, Prince had deliberately chosen a very dated and rather light piece of conventional pornography, rather than anything abusive or unusual. Given that there was no credible risk of harm and given that there was nothing illegal in the footage, we decided that *Destricted* could be issued with the requested '18' certificate.

This increasing emphasis on the underlying intention of a work, particularly when taken as a whole, was eventually incorporated into our 2009 Guidelines. (Of course, the notion of authorial intention is itself contested, but one has to start somewhere!) Whereas the 2005 Guidelines had merely stated that explicit images may be permitted at '18', provided they were exceptionally justified by context, the new Guidelines stated that explicit images may be accepted at '18' provided the film was not a 'sex work' and that the images were justified by context.[5] The dropping of the word 'exceptionally' was significant because it had come to be regarded internally as an extremely subjective and arguable test. What was the difference between an explicit image being 'justified by context' and another image being 'exceptionally justified by context'? However, the question of whether a work was a 'sex work' or not proved to be more complicated than it might have initially seemed.

We had an inkling of what a fraught issue this could be when we were asked to take another look at *Caligula* (1979). This notorious film had been cut quite heavily by the BBFC for cinema release and only a severely truncated

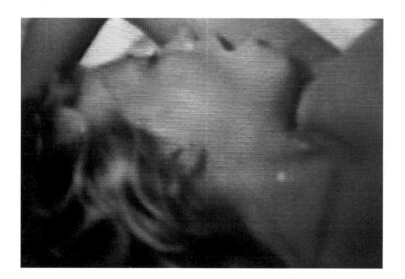

Richard Prince's *House Call* segment from *Destricted* (2006) gave the Board pause for thought, but the film was passed uncut

version had ever been released on video in the UK. In 2008, we were presented with the film for DVD release, with three alternative versions – the original 'uncut' version, a new 'director's cut', and the heavily edited US 'R'-rated edit. The film has a very long and complicated censorship history, which has been detailed at length elsewhere. For the BBFC, however, the main issue in the twenty-first century was the inclusion of some scenes of explicit sex that had been inserted into the film by its producer, apparently after the director had been removed from the project. Clearly we were not dealing with an aesthetic decision that had been made by the writer or director of the film. Nor were we dealing with elements that were entirely integral to the narrative or aesthetics of the film. Rather, we were viewing something that had been added as an afterthought in order to spice the whole film up. It was very clear to us that, taken as a whole, *Caligula* was not simply a 'sex work', although the finished product contained some elements that were clearly titillatory in nature and intent. It would therefore have been very easy for us simply to say that these elements should be removed. However, we took the view that it is not generally essential for the Board to consider the circumstances of a work's production (unless those circumstances were clearly illegal, for example in the case of a work featuring child pornography or animal cruelty). All we can consider is the product that is placed before us. Assessed under our Guidelines, those relatively brief scenes of explicit sex did not have the effect of turning *Caligula* into a 'sex work' and it was possible to allow that those incidental shots of penetration did serve some kind of purpose in order to illustrate the decadence of ancient Rome. They were not necessarily wholly gratuitous and it was not necessary for us to question their presence simply because we knew they had been added at a later date, apparently against the director's will.

We undertook a very detailed comparison between the real sex in *Caligula* and the real sex in *Destricted* and noted that *Caligula* contained a relatively small amount of material that exceeded the standards we would normally apply to even a sex work at '18': two minutes thirty-six seconds in total. By contrast, *Destricted* contained twenty-three minutes forty-one seconds of such material. Not that BBFC judgments are made, or should ever be made, on the basis of crude numerical comparisons of this nature. However, it did illustrate that, by present standards, *Caligula* was not at the upper limit of what had been permitted at '18' in the case of non-sex works. We also took account of the fact that *Caligula* would not have fitted in easily at the 'R18' classification because of its scenes of simulated violence and torture. Because we could not offer an 'R18' uncut option, any cuts we applied for sexual detail would have become compulsory, and therefore difficult to justify in terms of our Guidelines or the Human Rights Act. In that regard, *Caligula* is a unique case and we also accepted that it would be viewed as a historical curio today. The distributor intended to issue all three versions of the film, together with supporting documentary material explaining its convoluted and difficult production history. It would be difficult for viewers to make sense of this contextualising material if they were unable to see what had caused the interest, controversy and problems in the first place. Therefore, we passed *Caligula* '18' uncut in 2008.

However, this was not to say that such images would be acceptable in every context, as became clear when we considered a documentary work entitled *Porn Diaries* (2010). Ever since the Board had started classifying examples of real sex, back in the 1970s, the question had been put of whether the acceptance of such explicit images might serve as a loophole for pornographers. For example, what would happen if a 'documentary' were to be made about the making of pornography, and which featured illustrative clips? In fairness, *Porn Diaries* did seem to us to be a plausible documentary about the porn industry as it operates today in LA. However, it also featured a large number of graphic sequences showing porn films being made. Many of these were very explicit indeed and many of them went beyond making any kind of necessary point, unlike the short extract in *Inside Deep Throat*, discussed above. We came to the conclusion that although *Porn Diaries* was not a 'sex work' when taken as a whole, several passages in the film were essentially prurient and titillatory in nature rather than truly justified by the context. Accordingly, a number of cuts were made throughout to remove the more explicit images of sexual activity.

It is sometimes suggested to us that the BBFC seems prepared to pass images of explicit sex in 'serious' (and allegedly 'miserable'!) arthouse films but that it takes a more restrictive stance when sex is presented as fun, enjoyable or life-affirming. I don't think this is true, as can be seen from the decision to classify *Taxi zum Klo* (1980) uncut or, to take the example of a more recent film, *Shortbus* (2006). We have even permitted brief explicit images in films such as *Another Gay Movie* (2006) and *Pink Flamingos* (1972), where the main justification for such images was arguably comic intent rather than an insight into the human condition. When people say we don't permit 'fun' depictions of people enjoying real sex, I tend to believe what they're actually referring

to is sex as an aid to arousal, that is to say pornography. However, there is a key difference between showing explicit sex being enjoyed by the participants or characters and showing explicit sex merely in order to arouse the viewer. As I have explained above, the regulatory and licensing system within which we work is based on the difference between whether images are merely explicit (whether 'serious' in intention or not) or whether they are pornographic. That distinction seems to be accepted, understood and appreciated by the public.

Blockbusters and 'Mainstream' Cinema

It is easy to present a misleading impression that the Board's work is confined to assessing only the most controversial films or dealing with the upper end of what is acceptable for adult viewing. Of course, the truth is that the majority of our work involves films, DVDs and other works aimed at a broader audience, including children and families. Indeed, it is often the decisions we make at the more junior categories, and on high-profile blockbuster works in particular, that are more apparent and important to the majority of the public. Those decisions can be every bit as difficult as those on the margins of acceptability. More than anything else, the Board's central role is child protection, along with, increasingly, making available the fullest and best possible information.

The '12A' category, introduced by my predecessor, is much better understood now than it was when I arrived in 2004. It had served its original purpose quite well by allowing parents to make a decision as to whether to take their nine-, ten- or eleven-year-olds to the new Bond film or *The Lord of the Rings*.[6] On the other hand, anecdotal evidence still suggested that very young children were being taken to films with relatively little thought being given to the contents and that the '12A' was occasionally being misused as a kind of 'babysitting' service. The presence of very young children in such screenings could be disruptive and annoying to other viewers, as well as the film's contents being potentially unsuitable and upsetting for the children themselves. It was against this backdrop that the Board classified Steven Spielberg's remake of *War of the Worlds* (2005) at '12A'. I don't think the decision would have attracted much controversy had the film been classified '12' – after all, very little is seen in terms of detail and it's not very far removed from previous sci-fi blockbusters. It was the fact that children significantly under twelve could be taken to see the film that aroused some controversy in the press, particularly in the *Daily Mail*.[7] Having said that, the controversy over the classification of the film helped publicly to highlight the meaning of '12A' – i.e. that the film was suitable for twelve- to fourteen-year-olds but that parental discretion should be exercised in the case of younger viewers. It did so in a way that could never really have been achieved by a poster or advertising campaign, although we did make efforts to increase public

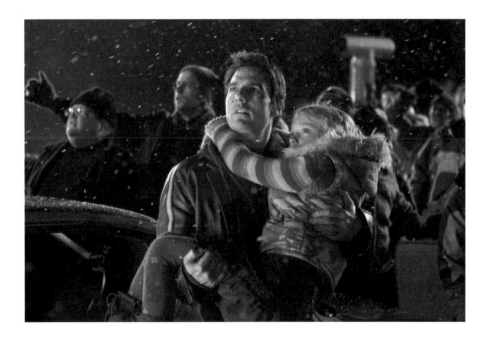

Tom Cruise and Dakota Fanning in Steven Spielberg's version of *War of the Worlds* (2005)

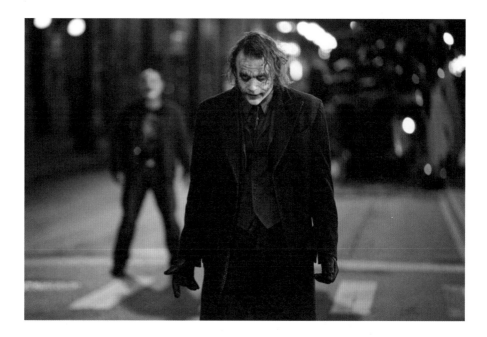

understanding of the category by introducing new on-screen black cards in 2005 that explained the precise meaning of the junior categories.

The first Harry Potter film to achieve a '12A' classification, *Harry Potter and the Goblet of Fire* (2005), highlighted the useful flexibility of the category. As most readers of the novels would have anticipated, the tone of the films became darker and more 'grown-up' as the series progressed, with the readers and viewers being invited to grow up alongside the characters. This particular instalment really went too far for an easy 'PG' classification, given the intensity of the threat in some scenes and the overall dark mood of the piece, in both visual and narrative terms. Furthermore, the death of a key character may well have proved particularly troubling for younger viewers, especially any who were unfamiliar with the novels. However, had the film been classified in such a way as to exclude the possibility of nine- or ten-year-old readers being taken along, the Board would have been faced with a very difficult dilemma and the '12A' provided the ideal solution (see case study).

A particularly notable trend since I arrived has been the increasing divergence between the BBFC and the MPAA at the '12A'/'PG-13' level. In the States, the 'PG-13' is a hugely desirable category for distributors in commercial terms. On the one hand, it suggests to teenagers that a film is more adult than a 'PG', which is often seen as something aimed at younger children. On the other hand, unlike our '12A', there is no requirement of adult accompaniment. I do not intend to criticise the MPAA at all as it operates within a wholly different cultural and regulatory environment. Indeed, its staff are excellent colleagues and I admire their work. However, it has become very noticeable over the last few years that a 'PG-13' tends to be awarded on the basis of the visual (and aural) content of a film rather than on the basis of tone. By contrast, our Guidelines place a great emphasis on the tonal aspects of a work and a film that is particularly intense or disturbing may well be pushed to '15', even if little detail is evident. This is very much in line with the findings of our public consultation exercises, which have suggested that how a film makes the audience feel can be as important as what it shows. Examples of divergence between the MPAA and ourselves have included films such as *Cloverfield* (2008) and *I Am Legend* (2007), where the sustained threat and intensity pushed the films up to a '15', in spite of the unrestricted 'PG-13's awarded in the States. In *Cloverfield* especially, there was a notable lack of resolution, with quite a downbeat and despairing ending, that suggested a '12A' would be inappropriate in spite of the visual restraint. The use of a hand-held camera also added an air of immediacy and a sense of immersion that made the experience far more unsettling than a more conventionally filmed work. *Disturbia* (2007) was another good example of a film that seemed to borrow the tropes of horror films and therefore seemed more appropriately placed at the '15' level, in spite of the 'PG-13'

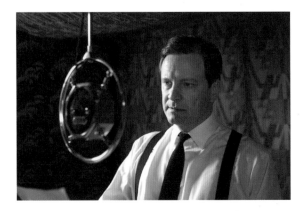

(left) Because of the exceptional context, the Board permitted the multiple uses of strong language in *The King's Speech* (2010), starring Colin Firth, at '12A'; (right) The very strong language in the '15'-rated *Closer* (2004), with Natalie Portman, took some viewers by surprise

awarded in the US. (That said, I understand the sensitivities of distributors who may not want the word 'horror' to be used in relation to films not conceived as horror films.)

That's not to say that some of the films we have passed at the top end of '12A' haven't attracted comment, in particular *The Dark Knight* (2008). Again, the film was relatively restrained in terms of what was actually shown but the dark tone led some people to question whether the film really was suitable at the upper end of '12A'. Nonetheless, we took account of the fantastical 'superhero' nature of the film and the fact that Batman was very much a known quantity, with several previous films having been passed at the '12A' or '12' level. When we consulted the public over our decision, as part of our 2009 Guidelines consultation exercise, it was reassuring to learn that 69 per cent of people felt we'd got the classification right. Some people also questioned our decision to award a '12A' to *The Lovely Bones* (2009). However, we felt that the film – which was based on a well-known and popular novel – had something to offer to the twelve–fourteen age group, who would be able to associate with some of the characters. We also felt that there were potential benefits to people in that age range in terms of teaching them important lessons about being observant and not taking risks. Additionally, it had a fairly sentimental resolution that we felt reduced the impact, provided one stayed with the film.

Of course, when the issue is one of tone it can be difficult to make cuts that will have a meaningful effect. For example, no amount of cuts would have brought *Cloverfield*'s intensity down from '15' to '12A', and one or two minor trims to *The Lovely Bones* would not have removed the concerns some people had about the film at '12A'. In other cases, however, the removal of a few explicit shots can make a significant and worthwhile difference. We made cuts to *Casino Royale* (2006), to reduce the notorious scene in which James Bond (Daniel Craig) is tortured with a whip. The scene is taken from the original Fleming novel and plays an important role in the narrative, so it couldn't be removed altogether. Of course, Bond has been captured, beaten and threatened in many previous films, although the slightly sexualised and sadomasochistic nature of this scene was unprecedented at '12A'. Accordingly, when the film was seen for advice, cuts were made to remove some of the closer detail of the whip in use and some of the more eroticised shots. Some people were still wrong-footed by the change in tone in the series, compared with the relatively more light-hearted Pierce Brosnan instalments. However, there was nothing in terms of the undetailed and highly choreographed action violence that was unprecedented in other '12A' films, such as the Bourne movies. Indeed, it has to be said that some of the violence in the early Connery movies, *Diamonds Are Forever* (1971) in particular, might well attract a '12A' rating were they made today.

In addition to violence and tone, language has continued to be a tricky issue at the '12A'/'15' border. A large number of US films, striving to get the all-important 'PG-13' rating, often insert a single use of strong language specifically for that purpose. We have similarly permitted a single use of strong language at the '12' level since 1989, when the '12' category was first introduced. However, although our public consultation exercises have revealed mixed views about the rather cynical nature of the so-called 'PG-13 f-word', there has been an increasing recognition since 2004 that context is more important than number-counting. That's not to say that people feel that strong language should be permitted at 'U' or 'PG', nor that unlimited uses should be permitted at '12A'. But the public consultation exercise in 2004 confirmed that simply stating there may be only one or two uses of strong language at '12A', regardless of context, was illogical.

Thomas Turgoose as the youngster drawn into a racist gang in *This Is England* (2006)

Since then, we have adopted a policy that generally regards four uses of strong language at '12A' as the upper limit, at least in the context of a normal feature-length film. However, there have been some cases where this was tested. Stephen Woolley, the producer of *Made in Dagenham* (2010), made a spirited and very public case for us to reconsider the '15' awarded to his film. But with seventeen uses of strong language scattered throughout the film, there was little we could do without breaching the 'infrequency' test of our own Guidelines and therefore breaching our contract with the public. By contrast, when the distributor of *The King's Speech* (2010) queried the '15' certificate awarded to its film, for a comparable number of uses of strong language, we took another look. In that particular case, the strong language occurred during two very short outbursts during speech therapy sessions. It was virtually impossible to make out the precise number of uses in real time, when the King lets off a volley of various expletives. Given the concentration of uses in such a short space of time and the very particular context within which they occurred, with no sense of aggression and no intention to insult or offend, we felt it was appropriate to award a '12A' classification, albeit with clear Consumer Advice. The distinction between the two films and our treatment of them illustrates the importance of context in all our decisions. There was simply no equivalent, in *Made in Dagenham*, to the wholly exceptional speech therapy context in *The King's Speech*.

Context is equally important in making decisions at the higher classification categories and this can also be illustrated by our treatment of bad language. Our public consultation exercises have revealed a very strong and consistent distaste for what is euphemistically called the 'c-word' and our Guidelines accordingly permit only infrequent use of the term at '15'. Aggressive or directed uses are more likely to be of concern, as are uses accompanied by violence and threat, or other aggravating factors. Fairly soon after I took up my position, we were confronted with the film version of Patrick Marber's play *Closer* (2004). The play itself included seven uses of that term, although the film only included four. Nonetheless, we decided that the film should be classified at '15', partly because the uses were never aggressively directed towards women and partly because the film used the language intelligently and with a deliberate purpose, rather than simply being crude or offensive in a gratuitous way. It seemed to us that the film should not be denied to

viewers in the fifteen–eighteen age bracket, particularly given that there was no restriction on them seeing the play on stage or reading the original text. The marketing for the film and the presence of big-name stars led some viewers, who were unaware of the nature of the play, to expect something rather different from what they got. Some people seemed to expect a romantic comedy along the lines of *Notting Hill* (1999). Nonetheless, in spite of some complaints, we felt that the correct decision had been made.

In stark contrast, we awarded an '18' classification to the powerful British film *This Is England* (2006). We did so with a certain degree of reluctance, because it was a well-made film about racism and intolerance with some potentially valuable messages for teenagers. Nonetheless, the film's four uses of very strong language were accompanied by threat, violence, other strong language and racist terms. This had the potential to create a much higher level of offence – and deliberately so – and therefore seemed more appropriately classified at '18'.

Legal Issues

As well as making assessments on the acceptability of films according to its Guidelines and broad public opinion, the Board is required to have regard to, and in some cases enforce, various pieces of legislation that apply to media content. Indeed, the number of laws we must bear in mind has increased during my time at the Board, with new pieces of legislation being introduced on the possession of 'extreme pornography', the distribution of animal-fighting videos and the possession of cartoon sexual images of children. The Board provided responses to the consultation processes leading up to the creation of a number of these new offences, ensuring that any unintended consequences were avoided. In particular, the Criminal Justice and Immigration Act 2008, which introduced the new offence of possession of extreme pornography, included a clause exempting any works classified by the BBFC. Fortunately, however, works featuring these types of new illegal content are rarely submitted to the BBFC and our concerns have largely involved more familiar forms of illegal content.

In particular, the Board has a duty to help film-makers to avoid breaches of two very specific pieces of legislation that are concerned with the manner in which participants have been treated during the production of a film, namely the Protection of Children Act 1978 and the Cinematograph Films (Animals) Act 1937. Unlike the OPA and the VRA, which are concerned with the effect of a film upon the audience, in terms of whether it might deprave or corrupt and/or cause 'harm', these pieces of legislation concern themselves, at least in part, with what happened on set. The Protection of Children Act makes it illegal to produce, distribute or possess 'indecent' images of people under eighteen and its intention is to prevent, or at least discourage, the sexual exploitation of children. The Cinematograph Films (Animals) Act 1937 makes it illegal publicly to exhibit a film, with or without a BBFC classification, if an animal was cruelly mistreated in connection with its production. Its intention, which goes back to the deliberate and cruel tripping of horses in films in the 1920s and 1930s, is to discourage film-makers from mistreating animals in a cruel fashion in order to produce a fictional feature film. It does not apply to documentary footage which might, for example, expose the mistreatment of animals in this country or abroad, but rather applies to the abuse of animals in order to produce a work of entertainment.

In the case of the Protection of Children Act, it is thankfully rare for the BBFC to be confronted with something that might be a genuinely indecent image of a child, at least in a recent film. However, during my time, we have been forced to consider previous cases where the Board had intervened, as well as where it had not intervened. In relation to the former, we were presented with Nagisa Oshima's classic *In the Realm of the Senses* for a new Blu-ray release. The film has a very long and complex classification history which need not be repeated here. It is sufficient to say that the most recent releases of the film had all been cut, or pre-cut by the distributor, to remove an extremely brief sequence in which a young boy's penis is tugged by an adult woman. The BBFC's concerns about this scene had arisen as far back as the 1970s when James Ferman had advised the distributor to cut the scene, even for private club cinema screenings, in order to avoid prosecution under the newly introduced Protection of Children Act. However, at the time, there was no real case law regarding how the Act would be interpreted by the courts and, in the absence of any such information, the Board tended to take an extremely cautious view, particularly given the vague nature of the test of 'indecency'. As time went on it became increasingly clear that 'indecent' was not the same as 'nudity', or even contact. When we were asked to consider the film for DVD and Blu-ray release, in 2011, we concluded that the scene was not sexual in nature (although the film itself is), that the nudity of the child is not eroticised or 'posed' in an eroticised

Frank Ripploh (right), the writer-director-star of *Taxi zum Klo* (1980), which the Board passed '18' uncut in 2005

manner, and that the scene was unlikely to be found legally indecent under the terms of the Act as interpreted today. Therefore the DVD/Blu-ray version was passed '18' uncut. To be clear: this was not a case of the BBFC changing the law; instead it reflected changes in the legal advice it had taken over the years on the interpretation of the child-protection legislation.

By contrast, *Sweet Sweetback's Baad Assss Song* (1971) had been classified '18' uncut by the BBFC for video release as recently as 1998. At the time, the Board had queried the age of one of the performers who appeared in the opening sequence, in which a young boy simulates sexual intercourse with an adult woman. The Board had been provided with what appeared to be details of the actor's age and the date of filming, confirming that he was over eighteen at the time. However, in 2004, the Board had examined a documentary, *Baadasssss!* (2004), about the making of the original film, in which the director's son, Mario Van Peebles, admitted that he had been the actor in the opening sequence and that he had been underage. In the light of this new evidence, the Board was presented with a problem when the original film was resubmitted for cinema and DVD re-release in 2005. Now that we knew, by the admission of the actor in the scene, that we were looking at a significantly underage boy simulating sex with an adult woman, we were forced to reconsider our earlier decision. Given the historical and cultural importance of the film, we showed the scene to our own lawyers and even went to the expense of hiring a top QC to consider whether the scene was or was not indecent at law. The unanimous and clear view was that the scene was potentially indecent, showing as it did a naked underage boy in his early teens mimicking thrusting on top of a naked adult woman. Therefore, we were forced to require the distributor to make changes to the scene in question. In the event, the film's director preferred to make the censorship apparent, scratching the emulsion off the print in the relevant shots. This created a slightly odd effect but dealt with the legal problem and the film was prefaced by an on-screen caption explaining what had happened.

A resubmission of the German film *Taxi zum Klo* raised a number of legal and policy issues. When the film was originally submitted to the BBFC in the early 1980s, the Board had required a number of cuts, to remove elements of explicit sex as well as to remove some sequences in potential breach of the Protection of Children Act and the OPA. In the event, the distributor decided not to proceed with classification and it was not until 1994 that a heavily cut version of the film was finally released on VHS. By 2005, the explicit sex was no longer an issue for us. It was presented in an entirely non-pornographic fashion and was clearly justified by context as part of the film's exploration of a gay man's lifestyle in pre-AIDS Berlin. What was more of an issue were the other previously cut scenes, one showing a man urinating into another man's mouth and

one showing a man apparently interfering with a child. In terms of the urination, we took the view that this single scene was unlikely to render the film obscene when considered as a whole, as the OPA requires. This was particularly so given the clear and significant artistic and cultural merits of the film. With regard to the other scene, in which a man apparently places his hand on a child's crotch and then places what appears to be a child's hand within his own trousers, the Board decided to seek further information about how these shots were achieved. Because the shots occur within what appears to be a genuine educational film about the dangers of paedophiles which the characters are watching, we made enquiries with the relevant German educational authorities. They were able to confirm that it was a *bona fide* informational film that had been used in German schools in the 1970s and they were also able to put us in touch with the company who had produced the film and who were still active in the making of educational videos. They provided us with a completely plausible assurance that a dummy crotch had been used instead of a real child and that the hand seen going into the man's trousers was in fact a woman's hand. Given that the evidence on screen supported this explanation, and given that it seemed highly unlikely that the German authorities would have commissioned genuine child abuse in order to produce a film for use in schools, we were able to waive the previous cuts and pass *Taxi zum Klo* at '18' uncut.

In terms of the Cinematograph Films (Animals) Act, it is virtually unheard of for a modern UK or US production to resort to animal cruelty in order to make a film. After all, CGI effects have made it possible to replicate virtually every form of animal cruelty in a lawful way. However, occasions still occur – usually with older films, or with films shot outside the UK and US – where questions have arisen. In the case of Emir Kusturica's *Life Is a Miracle* (2005), examiners noted a scene in which a pigeon was apparently attacked by a cat. On one level this is a perfectly natural occurrence. However, it seemed clear to us that the scene had been deliberately set up by the film-makers in order to produce the shot. Although the attack itself was not shown in a manner that clearly revealed cruelty, subsequent sight of the apparently injured pigeon flapping its wing in distress prompted questions under the 1937 Act and the BBFC felt obliged to raise the matter with the film's distributor. Initially, the distributor simply confirmed that 'no animals were harmed'.[8] However, this did not explain how the effect had been achieved. We therefore requested further information. At this point, the UK distributor apparently decided it had waited long enough for a certificate and that it would be far easier simply to make a short cut. But it had not consulted Kusturica and when he heard that his film had been 'censored' in the UK, for cruelty to a pigeon no less, he was furious. After some very public criticism of the BBFC by Kusturica, and a threat by him to withdraw his film from UK distribution,[9] the distributor managed to attain a written assurance that the scene in question had been achieved using a dead or dummy pigeon whose wings were being manipulated by wires to give the impression of life. Of course, the BBFC was not present on set and could not confirm or deny this, but the explanations seemed plausible in terms of what was shown on screen and the cut was waived.

By contrast, a number of films from East Asia have required cuts over the years because of the cruel manner in which horses have been caused to trip by means of wires. In some cases, the makers have come back to the Board assuring us of the precautions that were taken. However, consultations with the American Humane Association, which monitors animal action in the US, as well as with UK veterinarians, have confirmed that more often than not the precautions taken have been inadequate. Therefore, small but significant cuts have been required to recent productions such as *House of Flying Daggers* (2004), *The Warlords* (2007) and *The Good the Bad the Weird* (2008).

The intention behind the legislation is to discourage producers from mistreating animals because, should they do so, their film will not be released (or at least not released intact) in the UK. Whether such a purpose is genuinely served by cutting much older films, such as John Wayne Westerns from the 1930s, is perhaps more questionable, not least given the difficulties of investigating the circumstances of filming in the case of very old films. However, it seems to be the case that the British, as a 'nation of animal lovers', prefer not to see such action on their screens and generally support the tough line taken by the BBFC. Nonetheless, in the case of very old films where it is not obvious that cruelty has occurred, or where it is particularly likely that the film-makers made use of pre-existing documentary footage, the Board has tended to take a pragmatic line. Similarly, it is a little-known fact that the legislation only permits the Board to intervene when pain is cruelly being inflicted on an animal or where an animal is being cruelly goaded to fury. These are reasonably high tests and are not the same as saying an animal cannot be annoyed or mildly irritated or experience limited discomfort. Furthermore, the Act does not actually prohibit the killing of animals for filming purposes, provided the killing is quick and humane. It was this latter point that allowed us to pass a reissue of the classic Buñuel film *Los Olvidados* (*The Young and*

the Damned, 1950) at '12A' uncut. Although a chicken is actually killed, the killing is quick and clean and therefore not in breach of the legislation. By contrast, more obviously cruel and protracted killings, such as the killing of a small mammal in Cannibal Holocaust (1980), where it was clear the animal was suffering distress, have been cut.

Policy Matters

With increasing convergence in the media world, especially the transfer of some content to the online environment, it was particularly important for the Board to review its internal structures and processes in order to ensure it was in a strong position to respond to future trends and challenges. Accordingly, when I arrived at the BBFC, I initiated a complete structural review of the Board, resulting in the re-ordering of the organisation into three 'pillars' – Policy, Process and Support. This created two important new positions – a Head of Process who would oversee all aspects of the classification process itself and a Head of Policy who would oversee developments in BBFC policy. Hitherto, examiners would work on internal documents regarding classification policy in their spare non-examining time, and other members of staff would be enlisted to engage in policy work on a similarly 'as and when' basis. But if the Board was to become a proactive rather than a reactive organisation, it was necessary to have a dedicated Policy department that would anticipate future developments.

As well as ensuring a more systematic approach to policy work, and liaising with external stakeholders and potential future stakeholders, it was necessary for the Board to set out clearly what it stood for and where it saw itself over the next few years. Accordingly, the Head of Policy was responsible for producing the first BBFC Vision Statement, with input from all parts of the organisation, and the Head of Process was given responsibility for the formulation of an organisation-wide business plan, with clear goals being set and reviewed within each department of the Board. These documents stressed the Board's commitment to maintaining its established reputation as a trusted guide to the media environment, as well as stressing the Board's openness to change and its readiness to take on and seek out new forms of information provision.

In order to maintain the trust of the public and the industry, it is particularly important to communicate the standards we apply, as well as to be open and transparent about the decisions we have made and why we have made them. My predecessor, Robin Duval, had taken a number of important steps in this area, most clearly through the publication of publicly tested classification Guidelines. We built on this with further large-scale public consultation exercises, one of which was already in motion when I arrived in 2004, and one of which took place five years later in 2009. Robin had also made significant strides in terms of the provision of Consumer Advice, partly through requiring its display on film advertising as a condition of the introduction of the '12A' category. However, it seemed to us that the Board needed to do more in order to clearly demonstrate the degree of consideration that goes into its decisions and to ensure that the Board would remain relevant in an age in which information provision was becoming more important and where the ability to 'censor' was becoming less straightforward. The 2004 public consultation exercise had demonstrated the public's enthusiasm for consumer information in general and for receiving further film content information in particular.

In view of this, we introduced a new feature, Extended Classification Information (ECI), on our website. Part of the attraction, to me, was that we could make greater use of the excellent but confidential reports by examiners to give the public much richer and more helpful content information. From 2007, every new cinema film and video game would have a few paragraphs published on our website, explaining in detail the reasons for the classification awarded. This would include a very brief summary of the nature of the film and its plot, an explanation of how the key category-defining issues accorded with our Guidelines for the classification given, and any additional information that might be interesting and useful to parents or guardians. As an adjunct to that, we undertook some very specific research on Consumer Advice, which indicated the public's desire for Consumer Advice to be clear and specific and to avoid meaningless or antiquated phrases, such as 'mild peril', which had been derided in some quarters. In addition to the creation of ECI, we expanded the range of websites carrying BBFC information, including a students' website, containing information on the history of the BBFC, case studies on notable historic decisions, and material relating to the national curriculum, as well as a website for parents, containing content advice enabling them to make informed decisions about what they and their families view.

One of the key policy issues during my time so far at the Board has been the issue of video games. Technically, the VRA exempts video games from the classification process, unless they

contain for example 'gross' violence or human sexual activity. Inevitably, in the early days of the VRA, most computer games were text-based and did not involve anything sufficiently credible to raise the kinds of concerns that might lead to the requirement of a BBFC classification. However, during the 1990s, as games became more realistic in nature, more and more of them forfeited their exemption and were submitted to the BBFC. When I arrived as Director, the Board had already been involved in some high-profile cases, such as *Carmageddon* (see Chapter 8), which must appear very tame today. However, increasing concerns about the content of video games had led to greater levels of public and political attention and, when I took up my post, we were in a position where far more games were being submitted by the industry for formal classification, in part as a safeguard. Apart from anything else, this obliged us to take on some additional examiners, with specific experience of games and gaming.

As the system worked at the time, the Video Standards Council assessed all games to consider whether they had lost their exemption under the VRA. They would decide whether a game could be dealt with through a system of industry self-regulation (with no statutory basis), according to the Pan-European Game Information (PEGI) model, or whether it should be submitted to the BBFC. From 2007 onwards, these arrangements came under increasing scrutiny and were examined by, among others, the Culture, Media and Sport Select Committee of the House of Commons; Dr Tanya Byron; and the government, which conducted a consultation. After much discussion, and a variety of proposals and recommendations, it was decided to end the BBFC's jurisdiction in relation to video games (with exceptions related to pornographic, and certain linear, material), although this has taken some time to put into effect.

I respect, but regret, this decision. Video games are still less well understood by the public than films or DVDs, especially in their online form, where risks such as bullying are more pronounced. The BBFC could have materially strengthened the child protection arrangements, in the interests of both the public and the games industry, through better information, context-based decisions and a more broadly based overview of content. This need not have weakened the pan-European approach which has proved feasible for games but not for films: indeed, it could have helped to bring other countries into the PEGI system, on whose Advisory Board I had the privilege of serving. Nevertheless, we wish our colleagues well with the new arrangements, and will continue to help in whatever ways we can.

The rigorous nature of the Board's examination of games was demonstrated in the case of *Grand Theft Auto IV* (2008), which appeared to contain a sequence featuring a recipe for producing the drug crystal meth. The Board showed the sequence to the police, who confirmed that there was insufficient detail for the method shown to present a viable harm risk. The BBFC has rejected only one game during my time, the controversial *Manhunt 2* (2007), in which there was a relentless emphasis on stalking and killing opponents. The Board felt that the level of sadism and brutality was unacceptable and even a toned-down version of the game, edited to avoid a more restrictive rating in the US, was felt to be potentially harmful. Although the BBFC eventually lost the case at a VAC hearing (although only on the modified version of the game, the original version remaining rejected), it did have a useful effect in terms of clarifying what is meant by 'harm'. The Board argued that the VAC had considered too narrow a definition of harm in overturning the BBFC's decision and applied for a judicial review of its judgment. The result of this was that the VAC was required to consider the case again, even though it still decided that the modified version of the game should be classified at '18'. However, it did confirm that the BBFC was entitled to take factors into account that were broader than narrow behavioural harm.

BBFC Digital Services

The BBFC is at the forefront of new technological developments and the means of getting content to consumers. As broadband truly becomes super-fast and the 4G spectrum is opened to mobile providers, we can expect to see radical changes in the way the industry provides home entertainment to its customers. That has consequences for the classification regime, and the BBFC will be involved.

In 2007, the BBFC was approached by the industry to discuss the establishment of a self-regulatory model that would allow for the BBFC's decisions – backed by its well-known symbols – to be used for the classification of online content, including that made available by video-on-demand, digital rental/sell-through, streaming and supported on mobile platforms and via connected TV. Working in close concert with the British Video Association, we established BBFC.online. The scheme is entirely voluntary, but has swiftly proven to be popular – at the time of writing, it counts all the major studios as participants together with platforms where consumers

can purchase their content. By the end of 2011, more than 200,000 online certificates had been issued. In 2011, the Board added a new 'Watch and Rate' scheme for classifying straight-to-download content.

The industry recognises the advantages of having its content kite-marked by the BBFC. It provides detailed information to consumers from a trusted source, helps parents to regulate their children's viewing, and represents a single source for assessing the impact of relevant legislation – which the BBFC has years of experience in applying. A BBFC classification on a downloaded film, video or TV content offers a guarantee that the material has been professionally assessed and the distributor and consumer can be reassured that the content is legal and not likely to be harmful to those in the age group specified.

Sexual Violence and the Portrayal of Women in Films

The issue of sexual and sexualised violence has, since the 1970s, been one that the Board has treated with particular vigilance and it is one area where its public consultations have repeatedly revealed public concern. Although the majority of the UK public feels that adults should have the right to see graphic depictions of sex and violence, subject to certain constraints such as those imposed by the law, the public become far less sympathetic when the issues of sex and violence are combined. Of course, sexual violence can be male-on-male, occasionally female-on-female (usually in the context of 'women in prison' exploitation films, largely aimed at a male audience) or, very occasionally, female-on-male. However, most depictions of sexual and sexualised violence are male-on-female and it is this type of sexual violence that has tended to cause anxiety most commonly in recent years. The Board's concerns about sexual violence have for some time centred on the idea that it is particularly harmful to make sexual violence erotic and/or to endorse sexual violence. Those are the broad tests we apply today. However, during my time at the BBFC, we have attempted to systematise those concerns into a clearer set of policy tests, in order to assist examiners and in order to explain our concerns to the public, the industry and film-makers. We have also attempted to apply our policy in a more realistic manner, asking the question of whether a scene is genuinely likely to present a harm risk in the real world, rather than simply ticking boxes and cutting examples that are hugely dated or wholly risible and lacking in any realistic potential for harm today.

As currently formulated, our sexual violence policy asks five key questions:

1. Does the scene in question eroticise sexual violence (for example, through focusing on nudity and by the manner in which the scene is presented)?
2. Does the scene in question endorse sexual violence (for example, by suggesting that the victim responds to what is happening or by focusing on the enjoyment of the abuser in a manner that might encourage audience association)?
3. Does the scene offer thrills relating to humiliation, sadism or control (for example, through suggesting such control is arousing)?
4. To what extent is the scene credible (for example, is it realistic and contemporary or is it poorly acted and filmed, incredible or very dated)?
5. To what extent is the scene contextually justified rather than purely gratuitous or exploitative?

The sexual violence policy as formulated is not a 'tick-box' exercise. It works by asking examiners to balance up the extent to which the film does or does not do the things listed above and to reach a decision on the likely harm on the basis of that analysis. This allows for a certain degree of flexibility, meaning that particularly dated examples that have been cut in the past may be allowed today – for example, we waived old cuts to *Russ Meyer's Super Vixens* (1975). By contrast, contemporary films that treat such issues in a serious and responsible fashion are more likely to be passed uncut than examples that are prurient or gloating in their presentation of sexual violence.

In terms of acceptable representations of sexual violence, Michael Winterbottom's *The Killer Inside Me* (2010) presented some brutal and distressing scenes of male-on-female violence. However, it did so without any prurient focus on nudity. The effect was achieved partly by careful editing and the clever use of sound, and partly by the manner in which the audience is invited to engage with the scene. We are invited to be horrified and to flinch at the treatment of the victim, rather than to side with the perpetrator or find it a turn-on. Harrowing and powerful though the scenes were, we were left in no doubt that the actions shown were being condemned by the film.

The 'brutal and distressing scenes of male-on-female violence' in *The Killer Inside Me* (2010), starring Casey Affleck, did not require intervention at '18'

It was also an important and a necessary element of the narrative, so we passed the film at '18' uncut. Similarly, Lars von Trier's *Antichrist* (2009) presented some scenes of sexual and sexualised violence, most notably a woman hitting her husband in the groin and then bringing his penis to a bloody climax, and the wife later cutting off a particularly intimate part of her anatomy. Again, the scenes in question were pretty shocking – and, unlike *The Killer Inside Me,* quite graphic in nature. In spite of their explicitness, however, it would be hard to imagine anything less erotic or less likely to encourage emulation. The acts in question were presented as purely horrific and played an important part in what was already a highly unreal and symbolic film. Once again, we passed the film uncut. There was no realistic prospect that the scenes in question amounted to any kind of eroticisation or endorsement of what was shown, or that there was a credible harm risk.

By contrast a number of horror films have presented difficulties for us, both original films and remakes of films that had been controversial in their own day. In particular, the remake of the 'video nasty' *I Spit on Your Grave* (2010), which featured significant elements of female nudity that tended to eroticise what was shown. With such potentially erotic details in a scene of abuse and violence, it is possible that a viewer might become aroused at the spectacle of sexual violence and thereby be harmed, either in terms of attitudinal shifts or in terms of subsequent actions. *I Spit on Your Grave* also focused on the group dynamic of the men who attack the central character, focusing on the interaction of the men, including their encouraging of one another and their obvious arousal and satisfaction at their behaviour. The gang also record their actions on a camcorder, presumably so that they can enjoy their attack again later, and some of this footage seemed to us to encourage participation in this group dynamic and the men's enjoyment of the woman's degradation. Even though the film featured less nudity than the original 1978 film, cuts were required for '18'. Difficulties also arose with *Srpski Film* (*A Serbian Film,* 2010): the Board accepted that the film was intended as a political allegory regarding recent events in Serbia; nonetheless, the manner in which the sexual violence was presented, with an emphasis on nudity and other sexual detail, raised harm concerns, as did the juxtaposition of sexual and violent images with images of children. In the cases of *I Spit on Your Grave* and *A Serbian Film* it was possible to deal with the potential harm by means of cuts. Indeed, the Board's preferred solution is always to offer cuts to the company where this is likely to produce a result that is viable in both narrative and commercial terms. However, in cases where sexual violence or abusiveness pervades a work in a potentially harmful manner, such as *Murder Set Pieces* (2004), *NF713* (2009), *Grotesque* (2009) or *The Bunny Game* (2010), it is sometimes necessary to refuse a work classification. The refusal of a classification is always a last resort and the Board leaves it open to the company to present a modified version of the film at a later date. By the beginning of 2012, I had overseen the rejection of a total of seventeen video works, usually around one or two works per year. Nine of those works were refused classification on the grounds of unacceptable and potentially harmful sexual violence.

A Serbian Film (2010): the Board considered that the film raised harm concerns in its uncut form

In 2011, the Board was asked to consider the film *The Human Centipede II (Full Sequence)* (2011), a sequel to the 2010 film about a mad doctor who sews people together to create the centipede of the title. The original film centred on a concept that many would regard as repellent, and was a high-end '18', but intervention would not have been defensible, because of the relative lack of emphasis on the detail of violence and sadism, or on eroticisation. The sequel, by contrast, was a different proposition and purported to show what might happen if a viewer were to be inspired to copy the original film. Although there were undoubtedly elements of black humour, the second half in particular focused in an unremitting manner on the physical and sexual abuse of the naked victims. For the Board, this level of sadism and sexual sadism was a concern and the atmosphere of degradation and dehumanisation made it difficult to see how cuts could be effected without damaging the film in a manner that was likely to be unacceptable to the distributor. We initially rejected the film, after which the distributor referred the matter to the VAC. Before an appeal was heard, the distributor suggested some cuts that it would be prepared to make to the most obviously sexually violent scenes. Although these cuts made some difference to the most extreme moments, they were insufficient to address the more general sense of degradation and the focus on physical and sexual humiliation. The Board required further cuts to these elements, as well as to some of the more explicit scenes of sadistic abuse. Ultimately, in the view of a majority of members of the BBFC's Board of Classification, this resulted in a film that was still unpleasant to watch but which no longer raised the kind of legal or harm concerns that would justify intervention at the adult level. One of the Board's Vice Presidents, however, Gerard Lemos, remained of the view that the film should be rejected even in its cut form.

The Human Centipede II (Full Sequence) was often discussed as 'torture porn', or as a critique of that genre. I have not found the term, which was applied to various films such as the *Hostel* (2005 onwards) and *Saw* (2004 onwards) series, to be a particularly useful or accurate one, and it is one we have tended to avoid. In many respects, the films in question were simply the latest development in the tradition of excess and ghoulishness, attempting to gross out the audience and challenge it to see how much it could take. This was particularly notable in the case of Grand Guignol works such as *Hostel Part II* (2007). The films functioned in the same way as a rollercoaster ride, allowing audiences to test their endurance. Of course, testing one's endurance is fine and it is appropriate for horror films to horrify. After all, that is what the audience is paying for. However, the Board has always drawn the line where one is encouraged to be turned on by the degradation of others and I expect it is where we will continue to draw the line in the future, in accordance with public concerns.

CASE STUDY: 9 SONGS (2004) Caitlin O'Brien

Kieran O'Brien and
Margo Stilley in *9 Songs*,
classified '18' uncut

Explicit depictions of real sex more commonly occur in the 'hardcore' pornography the BBFC passes at the 'R18' category. The classification of *9 Songs* proved to be a key decision as this feature film tested the Board's limits on explicit depictions of sex at '18'.

9 Songs is a British drama from director Michael Winterbottom about young couple Matt (Kieran O'Brien) and Lisa (Margo Stilley). The course of their year-long relationship is shown through a series of sex scenes, interspersed with them attending gigs.

The progressive phases of the relationship are illustrated by the sex scenes, starting with more emotionally involved sequences where the two seem closely connected then, as Lisa grows distant, showing her, for example, masturbating alone as Matt, unobserved, watches. There is a strong focus on sex throughout – it's the main means of communicating the story – and in several scenes, it is clear that actors O'Brien and Stilley are engaged in non-simulated real sexual activity, including cunnilingus, fellatio, vaginal penetration and ejaculation – all things which the Board would, in a sex work, consider too explicit for the '18' category and pass at 'R18' instead.

The film was submitted for an advisory viewing in June 2004, after festival screenings had led to tabloid headlines suggesting it was the '[r]udest film EVER to hit our cinemas' (emphasis in original).[10] The Board had, in fact, passed real sex in feature films a number of times before, including in the classic Japanese study of sexual obsession and

sadomasochism *In the Realm of the Senses* and French-made relationship dramas *Romance* (1999) and *Intimacy*. It had, however, also required cuts to explicit images in *Baise-moi* and *The Pornographer*. While *9 Songs* lacked the sexual violence or pornographic settings of these films respectively, it contained a greater quantity of explicit material than had been passed previously at '18' in a non-sex work. There was also a sense that audience expectation might be very different for a British film and from a director whose previous works had recently included a comic take on the Factory Records story, *24 Hour Party People* (2002), and a science-fiction thriller, *Code 46* (2003).

At the advice viewing stage of *9 Songs*, it was noted that

> it never mixes up the sex with violence and is careful to avoid looking like a pornographic work […] [There is] no reason to intervene – indeed if we do intervene we would be signing up to the oft voiced criticism that we favour arthouse product/audiences over more mainstream product/ audiences […] . This is a wonderful opportunity to make it clear that we meant it when we said that adults […] have the right to choose their own entertainment within the law.'[11]

Once it had been determined the film was not pornographic in intent,[12] with sex works defined under current BBFC Guidelines as 'works whose primary purpose is sexual arousal or stimulation',[13] there was a further issue to address.

The Board's Guidelines at the time also stated that at the '18' category, it may 'cut or reject [...] the more explicit images of sexual activity – unless they can be exceptionally justified by context'.[14] When the film was formally submitted for classification in September 2004, the Board took the view that in this case, the explicit sexual detail was unusually vital to the storytelling: 'The specific acts that are shown each make individual and subtle points about the relationship in its various stages that less explicit material would make less well'.[15] The classification of 9 Songs came during the handover period between retiring BBFC Director Robin Duval and his successor, current Director David Cooke. Both of them and the BBFC's three Presidents also viewed the film, with all in favour of passing the work uncut at '18'. It received its '18' certificate in October 2004.

The BBFC's press release emphasised the Board's opinion that adults should be free to choose whether they wished to view the film, and that 'the Board's consumer advice for the film will make clear that the film contains frequent strong real sex so that anyone who might be offended can avoid seeing the film'.[16]

Building as it did on the precedents set by previous decisions, passing 9 Songs uncut at '18' paved the way for explicit sexual activity to follow uncut at '18' in other non-pornographic works such as drama features Taxi zum Klo and Shortbus and the short-film compilation Destricted.

CASE STUDY: HARRY POTTER AND THE GOBLET OF FIRE (2005) Karen Myers

Harry Potter 'apparated'[17] into the mind of British author J. K. Rowling as she travelled on a train one day in 1990. At the time he was nothing more than a 'scrawny, black-haired, bespectacled boy who didn't know he was a wizard'.[18] Twenty-one years later, that scrawny boy wizard was the titular hero of seven books which have sold over 450 million copies[19] and the star of eight blockbuster films, numerous video games and endless merchandising, and had turned his creator into a multimillionaire.[20]

The first book, Harry Potter and the Philosopher's Stone (published in the US as Harry Potter and the Sorcerer's Stone), appeared in print in 1997 and began the saga about the orphaned boy who, on his eleventh birthday, discovers he's really a wizard. As Harry and his friends progress through the Hogwarts School of Witchcraft and Wizardry, he is also forced to confront his nemesis, the evil Lord Voldemort.

The fantasy series proved irresistible to the film world and in 1998 Rowling sold the rights to the first four books to Warner Bros. for 'a hefty seven figures in any currency'.[21] The film version of Harry Potter and the Philosopher's Stone was released in the UK in November 2001 with a 'PG' certificate for 'mild horror, violence and language'. The second film, Harry Potter and the Chamber of Secrets, also had a 'PG' classification when it hit UK cinemas in November 2002 with Consumer Advice stating that it contained 'mild language and horror, and fantasy spiders'. In June 2004, Harry Potter and the Prisoner of Azkaban was released, with a 'PG' for its 'scary scenes and mild language'. Harry Potter and the Goblet of Fire, however, didn't fit the 'PG' mould of its predecessors.

By the time this fourth book was published in July 2000, Harry Potter had become a worldwide cultural phenomenon, prompting record print runs and midnight openings of book stores around the world.[22] A much bigger volume than its predecessors, Harry Potter and the Goblet of Fire has Harry, aged fourteen, entering his fourth year at Hogwarts amid the excitement of the Triwizard Tournament. Alongside students from two other wizarding schools and Hogwarts' own beloved Quidditch captain, Cedric Diggory, Harry competes in the tournament's series of dangerous magical challenges. Meanwhile, the adults of the wizarding world are troubled by signs that evil Voldemort's power is growing. Both worlds collide in the final challenge as Harry and Cedric are transported from Hogwarts to a dark hillside where Cedric is murdered and Harry's blood used to restore Voldemort to corporeal form. Saved by the spirits of Voldemort's previous victims Harry is carried back to Hogwarts with Cedric's body and the news that the Dark Lord has returned.

Cedric's death is the first Harry witnesses himself and, at the time of the book's publication, Rowling had to defend such a dark twist to her narrative:

> I don't at all relish the idea of children in tears, and I absolutely don't deny it's frightening. But it's supposed to be frightening! And if you don't show how scary that is, you cannot show how incredibly brave Harry is.[23]

With the fourth book taking on a darker tone than its predecessors, it was understandable that the Warner Bros. film would want to follow suit. In August 2005, an unfinished version of the film was submitted to the BBFC for an advice viewing. This BBFC service gives film distributors an indication of the classification category a film is likely to get before the full and formal certificate is issued. If the category recommended at this advice stage is not the one the company

Robert Pattinson as
Cedric in *Harry Potter
and the Goblet of Fire*,
which earned the series
its first '12A' category

would prefer, it is also given suggestions as to the edits or
alterations that would be necessary to secure its ideal
certification.

When the BBFC carried out the advice viewing for *Harry
Potter and the Goblet of Fire* it recognised that there had
been an unavoidable but significant shift in this latest film:
'Given the progressive nature of the novels, it was inevitable
that at some point, with the characters reaching puberty and
the tone growing more sombre, that the film version would
require more than the established PG.'[24]

Of particular note were the film's opening, as Harry
(Daniel Radcliffe) has a nightmare about Voldemort (Ralph
Fiennes), and closing, when Cedric (Robert Pattinson) is killed
and Harry confronts Voldemort. The magical torture of Harry,
with Cedric's corpse nearby, and Voldemort's final assumption
of a menacing physical form were felt to be especially intense
and frightening in a way that might disturb younger viewers at
the 'PG' category. The sombre feel of the film throughout,
dealing with adolescent angst alongside themes of death and
betrayal, as well as the absence of the usual upbeat happy
ending were also taken into consideration: 'the dark mood that
prevails throughout the film is confirmed as it ends without
resolution and in a melancholy manner'.[25] Although the
fantastical nature of the film was noted as a mitigating factor,
the film was still felt to breach the BBFC's Guidelines at 'PG',

which, in 2005, stated that '[f]rightening sequences should
not be prolonged or intense'.[26] Warner Bros. was told that
Harry Potter and the Goblet of Fire would receive a '12A'
classification, becoming the first in the film series to do so.

Accepting that the young viewers who had swarmed to the
Potter films when they were launched in 2001 were now older
and ready to accept a darker experience, Warner Bros. did not
challenge the recommended '12A' category. When the finished
version of the film was submitted for formal classification in
October 2005, it received the same rating with the Consumer
Advice 'Contains moderate fantasy violence and threat'. The
IMAX version of the film was also classified at '12A' a month
later and the DVD release was given the '12' certificate in
January 2006. All the subsequent Harry Potter films were also
classified at '12A' with moderate threat, violence and horror
remaining the central classification issues.

While the overall tone of a work has always been an issue
that the BBFC bears in mind when classifying films, the
significant impact it had on the category decision for works such
as *Harry Potter and the Goblet of Fire*, as well as *I Am Legend*,
The Dark Knight and many more, led to it being formalised in the
2009 BBFC Guidelines. The story of the boy wizard may have
come to an end with the release of the final film, *Harry Potter
and the Deathly Hallows: Part 2*, in 2011, but his influence on
the muggle[27] world of film classification lives on.

11 ON THE BBFC IN THE DIGITAL AGE

CENSORSHIP AND CLASSIFICATION IN A FREE SOCIETY

Gerard Lemos

The unending diversity of the film industry and its audiences set against a constantly changing political and social backdrop makes being a Vice President of the BBFC, a role to which I was appointed in 2009, endlessly fascinating. Like the best films, there is never a dull moment. I undertook to brigade a collection of short essays for the last chapter of this book, looking to the future, though with all due humility about the enormous likelihood of being proved wrong. Geoffrey Hawthorn, who worked with Bernard Williams on censorship in the 1970s, reflects from philosophical and sociological perspectives; Sir Stephen Sedley applies the legal lens; John Carr's telescope is on technology; and Ann Phoenix casts a sceptical eye over the 'traditional' family, both perceived and real, while noting the many and varied changes in our understanding of children's entitlements and parents' obligations, as mandated by the state and as lived out in practice. These contributions, especially my own thoughts on censorship, are of course not expositions of the BBFC's current policies on classification, but simply personal views, in the spirit of reflection and intended as a stimulus to thought and debate. Our centenary year is a fortunate opportunity to look forward as well as back.

* * *

In a free society, censorship should always be an object of suspicion and subject to contest. The enduring intellectual bulwark against restrictive censorship was erected by John Stuart Mill. He asserted the benefits of 'absolute freedom of opinion and sentiment on all subjects, practical or speculative, scientific, moral or theological'. So film censorship's survival for 100 years in the UK more or less unchallenged is remarkable. The critics would argue, while children may need some protection (in any case that is principally the responsibility of their parents, not state-sponsored authorities), why shouldn't adults watch what they like?

Unlike this difficult notion of censorship, classification of films for their suitability for certain age groups seems to command enduring and widespread support, though how those classifications are derived and their legal status are not universally agreed upon. While valuing adult freedom, parents continue to welcome help with restraining unwary children, or protecting impressionable ones. As Ann Phoenix describes, 'traditional' family life turns out to be an evanescent concept, regularly reconstructed and redefined, along with the 'consensus' on the rights and wrongs of parenting and indeed the whole concept of childhood. Children being seen and not heard, incapable of independent thought and a blank slate for the inscription of authoritative adult opinions, are not common contemporary currency. So the sense that parents should make well-informed judgments about what their particular child should see and hear has grown, and the guidance given with classification decisions is a welcome aid to that.

But even the superficially clear defence of age classifications can apparently fall apart in the face of contemporary technological and social reality. First, as John Carr describes, the boundaries between film and other forms of content, like interactive games, television and any number of user-created found and borrowed forms, will continue to blur and melt through the advance of digital technology and the great expansion in electronic memory so characteristic of our age. Second, file-sharing, piracy and the prospect of much faster downloading of internet content means that overcoming parental, official, commercial or other restrictions on accessing films has become all too easy. The rise of the smartphone is only the latest breach of the already weakened and shaky dam that holds back the flood of online material. Third, the experience of childhood has become so individualised, it is far more difficult to generalise about what is suitable for any particular age group, never mind an individual child. One of the most obvious difficulties is that girls and boys are different and, in particular, girls and boys of the same age are also different. So even if, *a priori*, the case for age classifications across the board and censorship in certain restricted circumstances has widespread acceptance, it can only become more difficult to achieve this in practice.

Notwithstanding all these problems that seem to point in different directions, film classification by age is almost certainly here to stay but censorship needs an ongoing social justification as well as a basis in law. The most substantial justifications for intervention to cut or ban films from public distribution rest on potential harm. The Video Recordings Act 1984 requires the regulator to consider any harm that may be caused to viewers or, through their subsequent behaviour, to wider society. The BBFC must also take account of a film's compliance with a number of other laws, for example, those relating to obscenity, animal cruelty or indecent images of children. Those laws are also essentially predicated on the potential for harm, whether harm to the participants in a film (in the case of animals or children), or harm that might be caused to viewers (as in the oft-criticised 'deprave and corrupt' test of the Obscene Publications Act). However, the practical difficulties of assessing what might cause harm to viewers, and where harm and offensiveness to the general public intersect and overlap, would easily, one might think, overwhelm the feeble breakwater of the efforts of a committee.

The Ur-text on censorship in Britain was set down in the Report produced by the Committee on Obscenity and Film Censorship chaired by the philosopher Bernard Williams, so aptly described by Geoffrey Hawthorn who was there, as it were. The Report was published in November 1979 (too late for its recommendations of a new statutory basis for censorship to be accepted by the defeated Labour government that established the Committee). Re-reading it today, when the issues of obscenity are rather less controversial than Mrs Mary Whitehouse ensured they were then, one would scarcely demur from any of the highly sensitive, sophisticated analysis, and many of its conclusions. Williams argued for censorship of genuinely harmful material in films, but not in literature, and the limited restriction of material likely to cause unreasonable public offence. He also had some criticisms of the law on obscenity, which nevertheless remains in place, despite a considerable collection of dissenting opinions before and since Williams.

* * *

Mill would not have even remotely imagined when making his assertion about freedom of opinion the many ways an individual's right to define themselves and redefine themselves more or less at will have irreversibly advanced over the last hundred years and the extent to which, therefore, the freedom he argues for has become allied not just to opinion or sentiment but to *identity*. A kind of freedom of identity has been progressively acquired: the right to be who you are, even if who you are is mutable according to time and place. But, crucially, the extreme emphasis now placed on individuality has not wholly undermined the notion of a collective identity of a culture or a society. Our shared identity has mercifully not been submerged or eradicated by the kaleidoscopic weight of individual differences. The emergence of individual and group identities (in children as well as adults) challenges and changes the norms and self-image of a society, but does not remove those norms and that self-image altogether. Like the death of the nation state, the death of national identity has also been continually expected but has yet to materialise. Similarly, public opinion, like the national mood, is not only felt to exist but also perceived to change in ways that constitute discernible trends, albeit arising out of many fragments, dead ends and counter-currents. Public opinion, notwithstanding being inevitably and always plural as Geoffrey Hawthorn notes, has not spun out of control and centrifugally broken up.

An aspect of that public opinion remains that some portrayals, in particular, of sex and violence are certainly a nuisance if shown in public and may be a cause of general offence, or even harm.

Even those who argue that harm is difficult to prove and easy to avoid by the simple choice of not watching the film are not led to argue that therefore anything goes in public as well as private. Just as harm can be difficult to demonstrate in a definitive fashion, it is equally difficult to categorically demonstrate its absence – and absence of evidence is not evidence of absence, certainly where harm is concerned. The weight of this concern is added to by the nature of some of the material itself. As Williams noted,

> we feel it necessary to say to many people who express liberal sentiments about the principle of adult freedom to choose that we were totally unprepared for the sadistic material that some film makers are prepared to produce [...]. Films that exploit a taste for torture and sadistic violence do raise further, and disturbing, questions.

Nothing in the contemporary life of a film classifier in 2012, more than thirty years after that was written, makes it less true. On the contrary.

The evidence for the persistence of a reasonably general public consensus on offensiveness is rarely to be found in quantitative surveys. Instead the evidence is all around. Most would agree that people nowadays feel much less comfortable about casually expressing racist or anti-Semitic views in public than they once did. More accepting attitudes towards lesbians and gay men have taken hold perhaps more quickly than in any other social sphere of changed attitudes, to the undoubted chagrin of a minority but with an unrestrained, if slightly surprised, cheer from the majority of heterosexual people. Stephen Sedley notes how strongly notions of homosexual equality were contested only a few decades ago. As recently as 2004, the debate in the House of Lords which led to the creation of legal civil partnerships for lesbians and gay men was characterised by much opposition and lurid descriptions of 'sodomy' and 'buggery'. When the same subject came up for debate in 2011, not a single peer spoke against civil partnerships; some even humbly admitted to the welcome discovery that they had homosexual friends who had been happily partnered for decades. The only dissent was that ministers of religion, who felt morally uncomfortable performing such ceremonies in their places of worship, should not be obliged to do so, something the government was happy to concede. Even that was not pressed to a vote, for fear on the part of the minority seeking the safeguards that it might lose. The House of Lords should not perhaps be taken as an adequate or accurate proxy for public opinion, but the speed of the turnaround is nevertheless remarkable.

More tolerant attitudes towards many groups in society have found institutional expression in legal changes designed to remove lawful unfairness and enshrine to the extent possible an entitlement to fair treatment, not least in the way that the courts handle both the victims and perpetrators of rape, where the balance has long stood in need of correction towards adequate redress for the (mostly female) victims. But legal fiat, including developments in the international jurisprudence noted by Stephen Sedley, is not the only or perhaps even the most important restraint on the expression of prejudice and enactment of discrimination. Social censure expressed in the first instance in extreme embarrassment on the part of listeners or observers is just as strong, perhaps stronger. Custom or convention has great force, as Geoffrey Hawthorn notes, greater in fact than law – at least as sociologists see the world! Except in hardened, much-derided unreconstructed corners which advertise contrarian intolerance as a group-membership requirement, those attitudes are simply no longer acceptable. These are without doubt changes in attitudes that are so widespread that they could be regarded as universal for practical purposes – and that means, among others, for the purposes of censorship.

These changes point to the welcome widening shores of individual freedom, particularly for those likely to be at the wrong end of prejudice or discrimination. However, public distaste for, and legal prohibition of, sexism or racism, for example, paradoxically have not necessarily advanced the frontiers of artistic freedom. Mostly artists restrain themselves without the need for official intervention. Artistic self-restraint in the face of changing public attitudes is, as it were, a legitimate form of censorship in that it is not imposed by the authorities over a citizenry powerless to resist so much so that the artists in question would in the main not now admit to the need to restrain themselves. They would argue that the recognition and representation of the diversity of individuals is at the core of the creed of Western art, harking back to the Renaissance. Portraying individuality is an essential part, as it were, of the artistic search for truth, and it was this search for truth that motivated Mill to seek to prevent censorship and promote freedom of expression. Let people say, paint and perform what they like for 'whoever knew Truth put to the worse, in a free and open encounter?'

That claim to a great tradition may sound plausibly high-minded, but in big ways and small ones, artistic representations all too readily reflect the prejudices of the day. To take a trivial example, the dog in Michael Anderson's 1955 film *The Dam Busters* is called 'Nigger'. When the film is shown on television, that is routinely over-dubbed with 'Trigger'. Or, to take a rather more serious example, no contemporary poet careful of their reputation would write lines like 'The rats are underneath the piles./The Jew is underneath the lot./Money in furs' as T. S. Eliot did in his poem 'Burbank with a Baedeker: Bleistein with a Cigar'.

But what if the artist does not wish to restrain themselves or, for that matter, doesn't give a damn about the truth? What if their true motives are instead to provoke shock or outrage, perhaps for commercial reasons or just for the nihilistic fun of it? In theory and in practice, the public to a woman and a man may all deplore the manner and the matter of the work of the provocative 'artist' but to the liberal mind the authorities, following Mill, may only restrain the circulation of that work if its distribution can be shown to cause harm to others. In all other circumstances, regardless of the absence of artistic merit or verisimilitude, the work may travel unimpeded across culture and society gleefully trampling down fastidious finer feelings. Countering this rather pure libertarian view (which has never in fact wholly prevailed), some would argue that in these circumstances the harm has been visited on the entire culture and society, whether or not the harm immediately influences individual people's actions, hence the British crime of 'inciting' racial and religious hatred with or without causing the actual behaviour. Many feminist critics and others would argue we are *all* lowered and lessened by widespread access to portrayals of extreme sexual violence against women, for example.

And what if the work seeking a public audience is not and may have no pretensions to being art? Plenty of forms of perfectly legitimate expression are not art. The notable example here is pornography. Even those who believe that pornography should be freely distributed to adults to use in private (as it now is in effect, via the web) might still be willing to accept that the purpose of most pornography is not artistic, but arousal. Bernard Williams noted in a characteristic turn of phrase,

> any committee enquiring into this kind of subject is likely to encounter a certain amount of humbug. Perhaps the most striking example of it that came our way was the pretence that present day commercial pornography represents some fulfilment of liberal and progressive hopes.

Much less, Williams argues, is pornography a convincing advocate of Mill's 'permanent interests of man as a progressive being'.

The indictment against censorship is that it is politically abhorrent and practically impossible. Critics of censorship call in aid of that argument the number of previous censorship decisions that are overturned as time goes by. Many cuts and rejections come to seem absurd and a frequent film viewer knows that the power to shock or harm is much reduced by the ageing of the representation, even if the content remains unappealing.

With all that in mind, it might seem brave to predict that the BBFC – or anything like it – will survive another century. But the short collection of essays that completes this volume takes aim at the future and broadly reaches a conclusion which will surprise some people, that the current arrangements, however unplanned their gestation, are likely to survive and thrive in some form.

The key to unlocking the conundrum of the persistence of a regime so easily criticised and undermined lies in the difficult concept of public opinion. The problem, as Geoffrey Hawthorn and Stephen Sedley note in their fine essays, is that defining the public and knowing its opinion are fraught with difficulties. There are too many publics with too many opinions. The proxy we have is the appointment of a surprisingly small group of people by Parliament to take the decisions in line with what it can best establish to be 'broad public opinion'. That British institutional deference for the inexpert 'great and good' and their supposed grasp on wisdom and the public mood is inevitably an obvious candidate for the detoxifying effects of a healthy dose of corrective cynicism. Their decisions are readily open to challenge by a sceptical liberal media and formal appeal by film-makers – just as they should be. Should the decisions of those appointed be thought to be consistently wide of the mark, Parliament can replace them by designating someone else to do the job. Transparency is a contemporary watchword and the need for it in this sensitive territory is more marked than in many others.

And yet, paradoxically, the shifting terrain of plural public attitudes and the occasional settlement of the social sediment into a discernible consensus (which is rightly open to continual question) seem to make a limited case for intervention, even censorship. The twin mistakes are to

imagine first that there is no consensus and second that accepted received wisdom cannot be suddenly and irreversibly overturned, however durable or permanent it might seem; hence all those reversals of previous censorship decisions. That still leaves many difficulties about how the intervention should be made, by whom and up to what limits. Achievement resides in enforceable prohibition of material which has the potential to cause real harm, as well as in the clear expression of a powerful public view. It seems, in this light, that if the BBFC didn't exist, any government, in the name of society and the government's claim to represent its changing opinions, might end up inventing something like it with considerable public endorsement, even enthusiasm.

REFLECTIONS ON THE 1979 WILLIAMS REPORT

Geoffrey Hawthorn

By the time that the Home Secretary set up his Departmental Committee on Obscenity and Film Censorship in July 1977,

> to review the laws concerning obscenity, indecency and violence in publications, displays and entertainments in England and Wales, except in the field of broadcasting, and to review the arrangements for film censorship in England and Wales; and to make recommendations'.[1]

Everyone was dissatisfied. Some thought the raft of relevant statutes and common-law offences too restrictive, some not restrictive enough; those charged with administering it knew that it no longer worked as anyone could have intended; and in a few respects, not least in the devolution of responsibility for deciding whether actually to show a film, which had derived from local authorities' fire regulations, existing measures were plainly absurd.

The Home Secretary, Merlyn Rees, appointed Bernard Williams, a moral philosopher, to chair the Committee and an imaginatively wide range of members: Ben Hooberman, a solicitor; John Leonard, a judge; Richard Matthews, a former Chief Constable; David Robinson, a film critic; Sheila Rothwell, from the Equal Opportunities Committee; A. W. B. Simpson, a professor of law; Anthony Storr, a consultant psychotherapist; Jessie Taylor, a headmistress; John Tinsley, a bishop; Polly Toynbee, a journalist; J. G. Weightman, a professor of French; and Vivian White, a youth and community worker and secretary of the United Caribbean Association. Rees gave no political direction and had no preconception. He wanted the Committee to think the whole question through. It did, and its Report, crucial parts of which were drafted by Williams himself, has come to be taken in the United Kingdom and elsewhere as a model of how to think about the regulation of representations of sex and violence in a liberal society.

Moralists and conservatives feared that the Committee might be excessively progressive, even libertarian. In one sense it was. Williams was a radical about 'progressivism' itself. The word, as he wrote later, is ugly, but it captured what he disliked: the view that ethical advance lay in the consciously theoretical elaboration of a systematically connected set of general precepts about 'freedom, autonomy, inner responsibility, moral obligation and so forth' to replace inchoate convention and ground the law.[2] He knew that this dislike could sound like a call to reaction. But it was not. In contrast to the 'thin' notions of freedom, autonomy, responsibility and obligation, none of which is sufficient to guide any thought we might have about any actual circumstances or any action we might take, he argued that convention contains the 'thick' notions with which we actually live our lives. It wouldn't be what it is, of course, if it didn't have a history and, to that extent, conventions look backwards. But few are universal, and even fewer are fixed. All change as circumstances do, and none is immune to reflection.

The members of the Committee reflected well. On the basis of the films and other materials they saw, the arguments they received, the research they considered and their own discussions (as we have seen in Chapter 6, they met as a Committee thirty-five times), they argued against three existing convictions. The first was that one could define the 'indecent' or 'obscene'. Like those who had spoken against what became the first Obscene Publications Act in 1857, they took the view that there could be little agreement on what counted as either. The second was the conviction that one could classify the representations at issue according to the harm they caused. The case for harm as a limit to liberty had been made by John Stuart Mill in 1859, the Lord Chief Justice had ruled in 1868 that 'obscene' materials could be shown 'to deprave and corrupt', and

The philosopher Bernard
Williams

the Crown and much of the public had come to accept that they could. But the Committee found
no research to show that the kinds of representation at issue caused harm and argued that it was
difficult to conceive of any which might validly and reliably be able to do so.[3] This criterion too,
therefore, was unsafe. The third conviction to which the Committee objected was the view, also
enshrined in the revision of the Obscene Publications Act in 1959, that otherwise questionable
representations might contribute to 'the public good'. 'The public', it pointed out, was not easy to
specify, and public goods were as indeterminate as many of the alleged bads. In any event, the
history of what had been censored in films since 1912 plainly showed that views about what
should and should not be published change and that there was no reason to think that they would
not continue to do so.

The Committee did not, however, set itself against censorship altogether. It had no doubt that
there should be prohibitions on the depiction of sex involving people under sixteen or inflicting
physical harm on people of any age. It also agreed that the depiction of violence, sexual and not, in
some of the films that members had watched blurred the line between reality and fantasy. In any
event, it learnt that some pre-censorship of films was widely accepted, not least by the film industry
itself, which wanted to avoid the hazard and expense of being taken to law. It was for films in
particular, the Committee argued, together with certain sorts of live shows in the theatre, that the
case could be strong, and it did not accept that this could effectively be countered by arguments for
freedom of speech; despite rulings in the United States, pictorial depiction was in several important
ways both more and less than 'speech', and most of what was questionable in the kinds of
representations at issue could scarcely be said to embody an 'idea'. They also insisted that films, like
live shows on stage, have a more immediate effect than the printed word, and being exposed to
questionable representations in a cinema is involuntary in a way that encountering them in print is not.

The Committee accordingly chose to avoid criteria of content altogether and to concentrate instead on what audiences might find 'offensive'. If pre-censorship was to continue, it would have to be exercised by 'reasonable people', neither excessively upset by everything nor indifferent to all, and to rely on their judgment of how to classify what they saw and, if necessary, ask for cuts or at the limit refuse to classify it at all. From time to time, such people would disagree. But the reasons they will properly be required to give for doing so would be a natural and desirable part of coming to the conclusions they do.

The Williams Committee did not have the impact on legislation that it wished to. By the time the Report was published, in 1979, the Conservatives were in office. Willie Whitelaw, the new Home Secretary, was not unsympathetic to its recommendations, but explained that they were not now politically possible. In a poll the year before, 92 per cent of Conservative MPs had declared themselves in favour of a 'new obscenity law', and even talk of reforming the Obscene Publications Act might have divided the party. The Act is still on the statute book, and with it, the criterion of the obscene, the possibility that obscene material can deprave and corrupt, and the countervailing possibility that allowing it to be published might nonetheless serve the public good. Subsequent legislation – the Video Recordings Act 1984 (together with its amendments in 1994), the Public Order Act 1986, the Sexual Offences Act 2003, the Criminal Justice and Public Order Act 1994 and the Criminal Justice and Immigration Act 2008 – includes a range of provisions on what Parliament believes courts will be able to decide is the harm that can be caused to viewers and to 'society' more widely by the depiction of criminal behaviour, the use of illegal drugs, human sexual activity and violent or horrific behaviour. The Digital Economy Act 2010 has hopes for a degree of control over internet sites also.

The BBFC has naturally to take note of any likely conflict with the law in the material it assesses. This no doubt explains why, notwithstanding Williams, its Guidelines mention the possibility of damage to the viewer and what it calls a wider 'moral harm'. This aside, the Board embodies the spirit of the 1979 Report. It presumes that adults should in private be free to see what they wish to. Its Guidelines make it clear that it will act on anything it considers unacceptable to 'broad public opinion' for the age group in question, but it sees 'no reason in principle why most themes, however difficult, could not be presented in a way which allows classification at "18" or even "15"'.[4] And it takes care periodically to gather what evidence it can on what 'broad public opinion' might be.

But there are two evident difficulties. The Williams Committee itself was aware of the first. It cannot be sufficient to stipulate 'offensiveness' alone as grounds for restriction. There are all sorts of things that some people would balk at. Most political stances are going to offend some people at some time or another and some, like those on a government's commitment to a war or indeed on various matters of sport, could offend a majority. Religious allegiances, by contrast, and attitudes to the fact of religion itself, may now be less important; a majority in England declares no allegiance to any faith, and blasphemy is no longer prohibited by law. Yet, as the Committee itself insisted and the Human Rights Act 1998 makes clear in its stipulation of an undefined 'freedom of expression', there are arguments against persisting with what the Committee called the old 'list approach' to offensive content and in continuing to specify content in a prejudicial way. Drawing what it knew was a fine line but insisted was an important one, it instead proposed 'dimensions' of offensiveness that might be grounds for restriction and suggested those that arise 'by reason of the manner in which [the film or live show] portrays, deals with or is related to violence, cruelty or horror, or sexual, faecal or urinary functions, or genital organs'.[5] In setting these out, it had the law partly in mind.

It is now true that although it is even stronger than it was in the late 1970s, the law seems to be relatively inert. But there is a greater demand than there was thirty years or so ago for what is now called 'transparency', and in acknowledging this, the Board interestingly reveals that it works with a rather wider set of dimensions: discrimination on grounds of race, gender, religion or disability, the use of some drugs, images of horror, violence, imitable behaviour of a cruel or violent (including self-harming) kind, the use of what most would regard as bad language, portrayals of nudity, and of sex for the sole purpose of arousal. In line, however, with the Williams Committee, it is careful to say that the manner and context in which these dimensions are portrayed are relevant. If an audience can reasonably be thought to expect a certain kind of content, fantasy, say, or comedy, rather than mere reality, if the content is presented as part of a wider story or 'theme' or for an educational purpose, if the 'tone' of the whole is not too unsettling, or if the production plainly dates from a time when different standards might have applied (most obviously on discrimination by race, sex or age), a more inclusive classification might be more appropriate.

The Board is also careful to say that it takes note of the fact, of which the Committee was in the nature of the case unaware, that video recordings and games will, like the internet, be experienced at home, where although access would be more voluntary than in a cinema, and private, it could also, in homes where there were people under fifteen, be 'unrestricted'.

It would nonetheless be wrong to infer that there is an inclination now to restrict more than the Williams Committee had in mind. There is no reason to believe that the Board is not sincere in starting from the assumption that adults should be able to watch what they wish. It accordingly concentrates on what should be restricted to children and young people. Even though it has to work within legislation that is notably more restrictive and poorly framed than the Williams Committee (and perhaps the Board itself) would have wished, it still finds itself inclined to refuse to classify only one or two films or videos a year. In 2011, only the film *The Human Centipede II (Full Sequence)* and the DVD *The Bunny Game* were initially refused any classification at all. The Board concluded that both films were unsuitable for classification under the VRA because of the harm risk they posed. *The Human Centipede II* was later classified '18', one member of the Board abstaining, with cuts of just over two and a half minutes. Bad law, one might suggest, is not only convenient to those in Parliament who advocate it or see no advantage to themselves in reforming it. But both films plainly crossed the Board's own Guidelines.

The second difficulty was as evident to the Williams Committee as it is to the Board. Where, beyond the law, does one draw the lines? The pressures on the Board are clear. At the extremes of public opinion, there are the libertarian right and the liberal left, which, as the Committee noted, come together in the belief that censorship is an insult. In between are those, evident in the correspondence the Board receives but almost certainly more numerous, who are cautious. In the industry, there are directors like Tom Six, the originator of the two *Human Centipede* films, who are determined to demonstrate their seemingly ever-extending imaginations; *Centipede III*, Six has been reported to say, is going to make *Centipede II* 'look like a Disney film'.[6] The Board has to balance the views of the public and, even if only for reasons of law, be prepared for what the industry, whose imaginings are increasingly able to be realised in computer simulation, might devise. The balance is plainly the more difficult problem of the two.

The Board takes pains to discover what public opinion is, and in the interest again of transparency, publishes such research as is practicable. This research and one's own, one hopes 'reasonable', sense do not go in one direction. On the one hand, there is a much more relaxed attitude to sex and less respect for public authority. It would be next to impossible now to find the sentiment that in central Europe reacted adversely to Mozart's *The Marriage of Figaro* or in Italy to several of Verdi's operas, or that would have assented to the list of forty-three grounds for deletion in T. P. O'Connor's submission on behalf of the British Board of Film Censors to the Cinema Commission of Inquiry that had been set up in 1916 by the National Council of Public Morals. And open homosexuality is coming to be taken as much for granted as heterosexuality. On the other hand, there appears to be a greater sensitivity now than before to personal dignity and security. It would be unwise to claim that discriminations of age, sex, race, ethnicity, class, status and region have disappeared from British society, but few would disagree with the claim that they cannot politely be taken for granted in representations of relations in Britain now; more exactly, in representations that even by omission might be seen to take them for granted. And even though much of what used to be regarded as 'bad language' has become part of everyday exchange, there are still one or two taboos, and disgust, even if there is little firm evidence to show it, may be as lively as ever, if not on some matters more so. Concerns for personal liberty and personal protection do not go easily together, for adults or for children. One can imagine that collisions between the two are at least as likely to increase as not.

So also, and importantly, are the muddles, which are endemic. The Williams Committee produced arguments that are as subtle and decisive as any we are likely to hear against tests for obscenity and indecency and 'the tendency to deprave and corrupt'. Its case for trusting to 'offensiveness' was strong. It nevertheless confessed itself uncertain about what this actually consisted of. 'Distaste', as it said, put it too mildly for many, 'outrage' too strongly for all but a few. And none of these terms explains itself. The Committee speculated about the disturbance and anger, oppression even, that people felt when private matters, most obviously of sex, were made public in a film or live show. On violence, it ventured to suggest that

it is no doubt because aggressive impulses have to be contained and denied expression in actual life to an even greater extent than is the case with sexual impulses, that the reactions to sadistic and other violent material are typically stronger and more alarming than to sexual material – except

in so far as an aggressive presentation of the sexual material, very characteristic of pictorial photography, is itself expressive of sadism.

But 'the psychology of the experience of pornography', it said (and might have added, of the experience of violence also), is 'a subject which we would not feel confident in claiming that there existed any very definite knowledge, let alone that we possessed it'. It may well be that such experience includes fears of harm and destruction, and that as social judgments, as the Committee said, such fears are incorrect.

> But this does not mean that the reactions themselves, or the less violent reactions of others who find the display of such material in various degrees offensive, are incorrect. It seems to us that they can be entirely appropriate, and that the world would not necessarily be a better place if people ceased to have them.[7]

It is important analytically, as one might say, to distinguish offensiveness from demonstrations of obscenity, indecency and extreme violence, and allegations of likely harm; yet all are part of what causes offence, to the extent that it is next to impossible in practice to distinguish any of them from what offensiveness is. And although the more liberal or libertarian 'progressives' would like it not to be so, what is now fashionable to think of as 'civility' in good part depends on the fact that it is. It's accordingly difficult to resist the conclusion that, even on the radical arguments of the Williams Committee, the BBFC, like the bad law − as law − in the relevant provisions of the Obscene Publications and Criminal Justice Acts, cannot but continue tacitly to promote as well as reflect a certain picture of what it believes people should see. That, however, is not quite all. One would like to think that the decisive difference from the spirit of O'Connor and the National Council of Public Morals in 1916 and many since would not be to agree on any such picture and certainly not to rely on the law providing it, nor to give in to the libertarians' thin and vacuous 'liberty', but to welcome a vigorous, continual and open battle between the judgments of a reasonable and well-informed Board and representations to adults of life's less appetising aspects, including, of course, the less appetising aspects of imagination itself.

FUTURE TECHNOLOGIES AND HOW THEY MIGHT IMPACT ON FILM CLASSIFICATION AND CENSORSHIP

John Carr OBE

Mass censorship of film mostly worked for two straightforward reasons: first, because comparatively few producers had the capability to make the sort of materials people in authority thought needed to be vetted. Second, there was a relatively small and tightly defined number of ways of delivering their output to the populace. By and large everything was neat, tidy and manageable.

There has always been a challenging − some would say creative − fringe, a filmic samizdat. At one end of the spectrum, there are 'arthouses', particularly in university towns, London and other big cities. At the less high-minded end of the market, there is a grimy underworld of dodgy videos (which are nevertheless professionally made), aimed at small audiences with 'specialist tastes', which is sometimes a euphemism for distasteful or perhaps offensive. However, on the high street, for the film viewer on the cinematographic Clapham Omnibus, as far as censorship is concerned, all is fairly well settled most of the time. The comparative rarity of substantial challenges to the status quo or prevailing standards of taste and decency underlines the stability of the solid centre. Things do move and change, but usually slowly.

In mainstream cinema, the people who take the big decisions about the movies that get made see themselves as being in the entertainment business. They have shareholders and major investments which they are keen to protect and they need to make profits. Success is principally measured in box-office receipts, DVD sales and franchising deals. Generally that mitigates against too much overtly challenging material. Similarly, the well-known and popular celebrity actors are closely wedded to the dominant systems of production and distribution. They will therefore generally, not invariably, be careful to avoid flighty or excessively edgy projects which might tarnish their image, put them out of favour with the public or the producers and hence shorten their careers. However, sometimes being controversial or different can be profitable. It's all a question of striking the right balance.

Most of the time everyone knows the rules and sticks to them on classification and censorship. The parameters are known and accepted. From time to time, the BBFC has to negotiate a clip here, an edit there. The arguments are normally about what rating to give a film, up one category or down, rather than whether or not it should be shown in or sold to the public at all. However, generally the system of movie-making and distribution is substantially self-policing, self-censoring.

This is possible, in part, because everyone is working within known jurisdictions and therefore within well-known rules and understood cultural boundaries. The people the movie-makers target in the UK watch films either in cinemas near where they live or on DVDs which they buy at the local supermarket, rent from a video shop, or get delivered through the post. Watching films that are supplied over cable and satellite channels is increasingly important and, with the emergence of companies such as LOVEFILM, a market for movies on demand delivered over the internet has started up. Twenty-five per cent of all new TVs sold in the UK in 2010 were internet-enabled. Notwithstanding the new delivery channels, the BBFC is still an unavoidable part of the British landscape for the great mass of cinematic publications and is likely to remain so for some time. There appears to be no political will to abandon censorship or film classification altogether. The question is will classification and censorship, in practice, become irrelevant in the internet-driven era now upon us and growing by the hour? I don't believe it will but there are undoubtedly areas of great uncertainty.

One of the reasons the early pirate radio stations caused such a flap at the time they broke on to the scene in the UK in the 1960s was precisely because they operated extra-territorially yet still had a substantial impact within our green and pleasant land. The BBC's comfortable monopoly of 'popular music' was permanently broken. It was a sign of things to come. In our brave new digital world, could the BBFC go the way of the Home Service? In the context of the film industry, is the internet the new pirate radio? A disruptive technology that has come in from left field? A game-changer? Yes and no.

The internet is at once both a cause and an effect of change. Because of its unprecedented potential to reach vast audiences, cyberspace has directly or indirectly stimulated a tsunami of technological innovation which in turn has enriched and broadened the film product itself. Ironically a great deal, though not all, of this innovation has been driven by the porn industry, constantly striving to improve the quality of their online offerings to make it more acceptable to larger numbers of people whom they hope will be willing to pay for more. The porn industry was among the first to snap up better and cheaper high-definition digital cameras, sound-recording and music-editing software, CGI and video-editing software and in some instances was behind several technical innovations which later found their way into the mainstream industry.

Disintermediation, an ugly word, nevertheless aptly describes the many ways the internet has prompted large-scale reorganisations within various consumer industries. Disintermediation is about cutting out middle layers, typically shortening the distance between producers and consumers. Normally this makes things cheaper and much more accessible. Because prices are lower more people can afford them but also they can be called up anywhere via a screen connected to any of a still rapidly growing number of internet-enabled devices, many of them portable. More people can now become, have become, film producers. The internet provides a distribution channel which potentially frees film-makers from dependency on the UK's small number of cinema chains. As with indie bands, people are making films, putting them up on the web and selling them direct as a download to anyone and everyone anywhere in the world. Good news for creativity; good news for young film-makers trying to get noticed. But few of these new movies are ever going to make it onto a DVD on Amazon or be shown at a local multiplex. If ever they were, they would still have to go through the same classification and marketing processes as *Ben-Hur* (1959) and *Avatar* (2009). More people can make movies that are close to viewable quality but that does not mean consumers will pay to watch them, or watch them even if they are free. The film-viewing public will not embrace rubbish, however easily it can be accessed. Talent will still be important, scarce and expensive. How many Meryl Streeps are there? Possibly only one. Steven Spielbergs? Ditto. CGI and editing software is better and cheaper than ever before, but the computing power and skilled technicians needed to bring it all together do not come cheap or easy. This argues against an imminent explosion of new talent that will wipe Hollywood or the British film industry off the map as it evades the BBFC and pumps films straight into living rooms.

For all the cries of anguish from the MPAA and other groups representing rights holders about revenues lost to piracy through the internet, the film industry, unlike the music distribution industry, appears for now to be in continuing rude good health. We buy music to listen to, normally by

ourselves; the enjoyment of movies can of course be solitary but typically most of it is more communal. If it's communal and in a public place, public policy has an interest in it.

The internet *is* a game-changer but it will not change every aspect of every game. It most definitely promises important problems on the periphery, but whether or to what extent that periphery encroaches on and changes the mass market, the centre ground, is moot. People's appetite for being entertained by a broad spectrum of adventure stories, romances, historical dramas, science-fiction films and other familiar genres seems to be hard-wired into the culture and is unlikely to vanish. The mainstream of film viewers is not going to develop a taste for an unvarying diet of ultra-violence and weird sex. But, around the edges, more of that could become available. The decision to create the Authority for Television on Demand was a recognition of that possibility.

In the early days of the internet, there was much talk about its potential to be a great equaliser. In theory, a sole trader building bicycles by hand in a suburb of Nottingham had the same possibility as Raleigh to market or supply to cyclists in Toulouse and Milwaukee. It hasn't worked out like that. Counter-intuitively the efflorescence of choice which the internet introduced has evidently worried the buying public. They are driven to and are clustering more and more solidly around established names, established brands. The internet is creating new economic and cultural giants who benefit from a natural mistrust of the new or never heard of. The French have a wonderful expression: *plus ça change, plus c'est la même chose*. The more things change, the more they stay the same. Parts of the whole movies business seem quite settled.

Will cinemas disappear altogether? Again that seems unlikely. Unless you are a Premier League footballer or a wealthy banker, few can afford gigantic screens and sound systems. Going to the pictures also has a social aspect to it. Inviting someone around to your house to watch a movie implies a level of intimacy or engagement, or involves a lot of hassle as one discharges one's obligations as a host, that may not always be desirable or appropriate.

The internet is not the only technological innovation affecting films. There have been reports of odd-looking, very large, ear-enclosing spectacles we can all wear that will create the illusion of looking at a 700-inch screen with wrap-around sound but I'm not sure how you manage the coke bottle or the popcorn, or have a quick exchange with your partner about a particularly gripping, horrible, funny or exciting segment you have both just watched. Or did you both just watch it? Maybe the glasses next door were running at a slightly different speed because a while back the wearer had stopped everything to go to the toilet.

Abraham Lincoln is supposed to have said 'It is better to remain silent and be thought a fool than to open one's mouth and remove all doubt'. He might have been talking about technology pundits. Anyone with eyes to see will realise how thickly their literature is littered with spectacularly inaccurate and embarrassing predictions. Some of my favourites include 'This "telephone" has too many shortcomings to be seriously considered as a means of communication. The device is inherently of no value to us', according to Western Union in 1876. 'Computers in the future may weigh less than 1.5 tons', says *Popular Mechanics* in 1949. Bill Gates famously acknowledged that when the internet first emerged he dismissed it as a passing fad. Within twelve months, Microsoft realised their calamitous error and proceeded to turn the company around on a sixpence. Many other firms did not have the same resources as the Seattle giant or did not wake up quite so quickly. They disappeared, killed in the techno gold rush. I have kept this one until last: the famous remark of H. M. Warner of Warner Bros. In 1927 he asked 'Who the hell wants to hear actors talk?'

Historically, innovation in the technology space has been famously volatile. The 'new' can soon die. As far as the internet is concerned, the film and computer industries have deep vested interests in sustaining the myth of constant change. It keeps legislators at bay as they repeatedly fall for the idea that intervention, regulation, may shut off imminent new inventions which will sustain or create new economic growth. Yet the truth is that the scope for wholly original technologies or applications to emerge has reduced, particularly as the individuals who were once the brave new inventors have transformed themselves into global conglomerates. Their executives may wear jeans but that's only to hide the suits. These companies have a strong vested interest in key parts of the status quo; real challenges are likely to be resisted by those who once challenged others.

In the short term, the most likely future pathway for new technologically driven developments in film will be ones which impact most on distribution. Piracy is solvable and annoying but not that important. If it were truly important, studios would be folding. Fewer films would be made. That is not happening, certainly not on any noticeable scale.

Many studios, or the companies that now own what we used to call studios, are sitting on huge archives of finished films and other content that hitherto has been inaccessible to everyone except academic researchers who wheedled their way in. This archive and associated materials

constitute a 'long tail' that could breathe new life into or help enlarge the number of small independent cinemas or clubs, which could pipe the pictures cheaply via the internet, or even have them beamed down from a satellite. Expensive projection equipment and transportation costs eliminated at a stroke. *That* would be disintermediation.

If I were to stick my neck out and predict where things were going, two ideas constantly jump off the page: becoming more feature-rich and creating greater interactivity, or a combination of the two. 'Two-screen' environments are already becoming more common. It has now become commonplace to watch the news or the football on TV while running ticker tape with the scores in other games or carrying unrelated breaking news from other parts of the world. If something in a movie puzzles you or intrigues you, a smaller screen or console in the armrest or on the seat in front will offer additional information or insights. Will the BBFC have to see all that and classify it? Probably.

However, while this is an example of film becoming more feature-rich, it still represents a low level of interactivity; moreover it is definitely doable soon. What about things that may be a bit further down the track? To quote William Gibson, 'The future is already here – it's just not very evenly distributed'. The really wild innovations will coalesce around human beings' increasing engagement with computers and electronics that become integrated into our bodies and perform a wide range of functions. A lot will be to do with monitoring or improving our health or enhancing our memory but Mr Showbiz will be looking to get in on it.

An erudite professor recently revealed that he had had a number of electrodes implanted into his arm. When these were connected to a particular piece of apparatus, it enabled him to *feel* things that were simultaneously being depicted on a screen. With my vertigo I had difficulty watching *Up* (2009) in 3D. If I were also able to experience the sensation of floating high above the ground, I could only go to cinemas that either had an ambulance permanently on standby or were conveniently close to hospitals that specialised in treating sudden cardiac arrests.

And quite what such technology would do for movies depicting sex scenes, horror scenes or any number of other types of drama is a troubling thought. What would have to be certificated by the BBFC? Not only what you were watching on the screen but how it made you feel? How could anyone else know the intensity of someone else's feelings? Again to take myself as a pathetic example: I have a very strong aversion to seeing people being injected by or using hypodermics. The context is irrelevant: a sanitary and sanitised hospital scene or *Trainspotting* – it's all the same. Would individual audience members be able to choose whose point of view, or whose feelings, they adopted and experienced? Maybe there would be a dial allowing you to switch? I definitely would not want to be the guy who was eaten by the dinosaur.

Research is also being carried out into what can only be described as *mind reading*. I am not referring here to Madame ZaZa's celebrated psychic powers, demonstrated nightly for only £2.50 on Brighton Pier. These are clinical trials where, again using implanted electrodes, individuals were able to *do* things, or cause things to be done, simply by thinking about them. A computer reads the patterns of brain activity and interprets them. You could send that email to your mother without your hands ever touching the keyboard. Again, this opens up many possibilities. We already have computer games with alternative endings the player can choose from. Might we have movies that respond to our then emotional state, or which allow us to interact in some way with what is going on on the screen?

A MARGIN OF APPRECIATION

Stephen Sedley

Beside me, as I write this, are two small books, each one adapted from a Danish version and published in the United Kingdom in 1971. One is *The Little Red Schoolbook*; the other is *The Little White Book*. Both are written for children and young adults with the aim of helping them to get their bearings in the adult world.[8]

The Little Red Schoolbook says this about masturbation:

Some girls, and a very few boys, don't masturbate. This is quite normal. It's also normal to do it. Some do it several times a day, some several times a week, some more rarely. Grown-ups do it too. If anybody tells you it's harmful to masturbate, they're lying. If anybody tells you you mustn't do it too much, they're lying too, because you can't do it too much. Ask them how often you ought to do it. They'll usually shut up then.

The Little White Book says this about it:

> It is only in the last few years that this subject, which is of a very personal nature, has been given great prominence. All this publicity provokes curiosity and perhaps experimentation which might never have otherwise arisen.
>
> This being the situation, we feel we must say a few words here.
>
> You live in a sex-mad world, and we know this makes it difficult for you. We only want to help you not to become a slave to this habit.
>
> God created you not to be dominated by your passions, but to rule over them. It is worth remembering that sex as God gave it is for sharing between male and female in a life-long partnership.
>
> There is only one way in which you can emerge through this sexual propaganda which is raging against you day and night – by continually following Jesus Christ.

Evangelists were handing out free copies of *The Little White Book* outside the Inner London Quarter Sessions – now the Inner London Crown Court – in October 1971 as, inside the building, John Mortimer QC argued the appeal of Richard Handyside, the publisher of *The Little Red Schoolbook*, against his conviction by a stipendiary magistrate for obscenity. The prosecution had been brought largely at the instigation of the promoters of *The Little White Book*. Handyside could not believe that his conviction would be upheld; but it was.

My own memory of the appeal, as Mortimer's junior, is of something resembling a mumming play, as a parade of vicars, bishops, public moralists, doctors, headteachers and psychologists passed through the witness box either denouncing or defending the book, while a wigged judge and two magistrates listened solemnly. The unscripted part was when Mortimer's clerk slipped in to tell him that his wife Penny, who had just given birth to their first child, was haemorrhaging. John, who was cross-examining a bishop, turned to me, said 'Carry on' and shot out of court. He returned two hours later to find me still grappling with the bishop.

The case went on to the European Court of Human Rights in Strasbourg,[9] which sat in plenary session to hear it. Here, surely, a stand would finally be made for the right of free expression guaranteed by Article 10 of the Convention. And a reader of the eventual judgment of the Grand Chamber would have been justified in feeling optimistic as he or she read the Court's stirring vindication of the importance of free speech and the need for tolerance in a democratic society.

Article 10, you will recall, starts by saying: 'Everyone has the right to freedom of expression. This right shall include freedom to hold opinions and to receive and impart information and ideas without interference by public authority and regardless of frontiers.'

By the time the case reached Strasbourg, *The Little Red Schoolbook* had been published without reprisal not only in Denmark but in Belgium, Finland, France, Germany, Greece, Iceland, Italy, the Netherlands, Norway, Sweden and Switzerland, to name only states subscribing to the European Convention. It was circulating freely elsewhere within the member states of the Council of Europe, including the part of the UK north of the border, where a Glasgow bookseller who stocked it had been acquitted by the sheriff court of selling an obscene publication.

Article 10 of the Convention goes on to permit restrictions and penalties on the exercise of the primary freedom if these are prescribed by law and necessary in a democratic society in the interests of – among other things – the protection of morals. This, said the Court, 'leaves to the Contracting States a margin of appreciation', a margin which is enjoyed both by the national legislature and by the courts which apply the legislation. It was also by then well established, however, that what was 'necessary' was not a matter of local judgment: it required the member state to establish the objective existence of a pressing social need.

The English words 'margin of appreciation' have no discernible meaning. They are a literal translation of the French phrase (French being the ECtHR's other official language) *marge d'appréciation*, meaning scope for judgment. That is more or less how the expression has come to be understood since it first appeared in an early judgment of the Court. It signifies a grey area in which states may legitimately differ as to what interference with a fundamental but conditional human right is necessary in a democratic society. But it is subject, the Court stressed, to 'European supervision'.

So stated, the doctrine appears unobjectionable; and, as I shall suggest later, it is capable of taking on a valuable role as a matrix of dialogue between the courts of member states and the Court of Human Rights itself. But in the Handyside case and other relatively early cases of obscenity and blasphemy, the margin of appreciation was arguably used more nearly as a means of ducking difficult questions of free speech.

Handyside v. *United Kingdom* illustrates the paradox. The judgment resonantly limits what it calls 'the power of appreciation' by recalling that 'freedom of expression constitutes one of the essential foundations' of a democratic society, and that no such society can exist without pluralism, tolerance and broadmindedness. To these qualities, said the Court, its supervisory functions required it to pay 'the utmost attention'.

The Court's reason for stepping back, having noted the conditions to which the primary right was subject, was put in this way:

> [I]t is not possible to find in the domestic law of the various Contracting States a uniform European conception of morals. The view taken by their respective laws of the requirements of morals varies from time to time and from place to place, especially in our era, which is characterised by a rapid and far-reaching evolution of opinions on the subject. By reason of their direct and continuous contact with the vital forces of their countries, State authorities are in principle in a better position than the international judge to give an opinion on the exact content of these requirements as well as on the 'necessity' of a 'restriction' or 'penalty' intended to meet them.

It may be fairly said that this passage overlooks one crucial variable: as well as differing from state to state and from time to time, moral standards differ from individual to individual. And it is to the protection of the individual's right to speak according to his or her own lights that Article 10 is principally directed. The Article goes on to allow a societal restriction where this is objectively necessary 'for the protection of morals'. But whose morals? Both the Convention and the Court assume, without apparently recognising the paradox inherent in it, that the morals requiring protection are a consensual, or at least a majoritarian, set of values of which the domestic courts are the best judges. It is at least arguable that to assume this is to exclude the very thing that Article 10 exists to protect: the right, even shockingly, to contest conventional wisdom.

Close behind the moral excoriation of *The Little Red Schoolbook*, there may have lurked a political agenda. The book had taken its name from the booklet in which the thoughts of Chairman Mao were being circulated worldwide. But although *The Little Red Schoolbook* presented itself as a parallel gesture of defiance, its content was a great deal less abstract than Mao's. It encouraged children to stand up for themselves against adults but took great trouble to explain the difficulties under which adults themselves – teachers, for example, and parents – functioned. It gave sane and accurate advice about drugs, sex and contraception. It counselled honesty in relationships. It explained that homosexuality was not abnormal but that homosexuals 'in our Christian culture […] are considered sick, abnormal or even criminal' – an assertion which, if proof were needed, could be readily confirmed from the pages of *The Little White Book*:

> The danger for you is that practising homosexuals are very aggressive, not only in order to get equal rights, but also in order to satisfy sexual desire by seducing people into this way of life who were not born homosexual. […] Jesus Christ can deliver the homosexual. Instead of excusing his tendencies the homosexual must turn away from his sin.

And a page later: 'It is questionable whether it is not abnormal and artificial for young people to feel compelled to take sides about the situations in Vietnam, South Africa, Pakistan, Czechoslovakia, or the Middle East.'

The Handyside case continues to throw up a concern that the book's real offence was to encourage young people to think unofficial thoughts, to defy conventional wisdom and to take responsibility for themselves. It is inconceivable that it could be successfully prosecuted in England today. There remains a corresponding worry that the Strasbourg court, in deferring to the judgment of the Inner London Quarter Sessions, failed to stand up for the right to contest accepted moral standards, albeit within a legal regime that seeks to protect morals.

Handyside was followed during the 1990s by two comparably problematic cases. One[10] arose out of the seizure by the Austrian authorities of a satirical film on a charge of disparaging religious doctrines. The other,[11] not long afterwards, arose out of the refusal by the BBFC of a classification certificate for a video, *Visions of Ecstasy* (1989), which from a Christian standpoint was blasphemous. Both cases were found by the Strasbourg court to involve no violation of the Convention, in each instance by reason of the state's margin of appreciation.

The Otto-Preminger-Institut had scheduled a showing of a satirical film, *Das Liebeskonzil* (*Council of Love*, 1982), to persons seventeen years of age or over. Proceedings were brought under a section of the Austrian penal code which criminalised disparagement or insult directed at

objects of veneration or belief and 'likely to arouse justified indignation'. According to the Regional Court which ordered forfeiture of the film, in it 'God the Father is presented […] as a senile, impotent idiot, Christ as a cretin and Mary Mother of God as a wanton lady […]'. But the Austrian basic law guaranteed 'freedom of artistic creation', and the Institut contended that the forfeiture violated Article 10 of the Convention. The government contended that it was aimed at protecting the rights of others and the prevention of disorder.

The Court this time acknowledged that, as to the significance of religion, 'even within a single country […] conceptions may vary':

> For that reason it is not possible to arrive at a comprehensive definition of what constitutes a permissible interference with the exercise of the right to freedom of expression where such expression is directed against the religious feelings of others. A certain margin of appreciation is therefore to be left to the national authorities […].

The Court went on to reiterate that the margin was not unrestricted: 'The necessity for any restriction must be convincingly established' – as it was by the fact that 87 per cent of the local population was Catholic and by the need to 'ensure religious peace' and prevent the giving of religious offence. The fact that nobody was obliged to watch the film seems to have been overlooked by both courts.

The second case, *Wingrove* v. *United Kingdom*, by contrast involved a permissible assumption that the video, if released, would be watched. It was an eighteen-minute sequence reimagining the ecstasy of St Teresa of Avila in terms which, while not wholly different in kind from much Catholic martyrology, were overtly erotic in presentation. The British Board of Film Classification, in the exercise of its statutory powers, refused the video a classification certificate and thereby prevented it from being distributed. It considered the video to be blasphemous according to the common-law definition which effectively limited hostile publications about Christianity to 'decent and temperate' criticism.

In Strasbourg, this view was held to sit within the UK's margin of appreciation and so to have caused no breach of Article 10. Whereas, the Court said, the scope for restricting political speech was very limited, 'a wider margin of appreciation is generally available to Contracting States when regulating freedom of expression in relation to matters liable to offend intimate personal convictions within the sphere of morals or, especially, religion'. This, moreover, would vary significantly from time to time and from place to place. But in UK law, 'the high degree of profanation that must be attained constitutes in itself a safeguard against arbitrariness'.

So it was that a visual commentary on what some quite rational people consider to be the sado-eroticism of much Catholic martyrology was denied an airing.

* * *

What the margin of appreciation has arguably enabled the Court to do in these cases, touching as they do raw nerves of embarrassment and credence, is to uphold intolerant and populist decisions without the responsibility of forming its own judgment on what are *par excellence* Convention questions. That, at least, is one view. The other is that the Court has been doing in these cases something it ought to have been doing much more widely – leaving member states, and especially the older democracies, to do things their way unless a clear and inexcusable departure from the Convention has been established.

The second of these models of Convention adjudication has received increasingly vocal support, first from the UK's right-wing press and politicians, but most recently from one of the engineers of the Human Rights Act, Blair's first Lord Chancellor, Lord Irvine. In December 2011, Derry Irvine came out of retirement to argue that the United Kingdom's courts had been slavishly following Strasbourg jurisprudence instead of having no more than a decent regard to it (as mandated by the Human Rights Act) in the course of developing their own human rights jurisprudence.

Among a number of criticisms to which Irvine's thesis is open is the fact that there has been no consistent history of slavish adherence to Strasbourg. It was evident to the UK judges, for example, that the Court had made a serious mistake in the *Saunders* case[12] on the admissibility of self-incriminating evidence obtained in the course of a statutory inquiry, a mistake which had led to the gutting of a large number of crime-fighting statutes. So when, following Scottish devolution, the Privy Council had to deal with the case of a visibly drunk woman in a Dunfermline supermarket

who had told police officers, as she was legally obliged to do, that it was she who had driven her car there, it refused to follow the *Saunders* decision and held that the woman had been lawfully convicted of drunk driving on her own admission.

But the abscess was lanced the day after Irvine's speech by a groundbreaking decision of the Strasbourg court in *Al-Khawaja and Tahery* v. *United Kingdom*.[13] The British President of the Court, Sir Nicolas Bratza, had already trailed the change of position in a published article.[14] He now led the Court in establishing a fresh paradigm: not the top-down supervision of national decisions by an international tribunal – albeit allowing a margin of local judgment in certain cases – but a 'judicial dialogue between national courts and the European Court on the application of the Convention'.

The metaphor of dialogue is not new: it has been used for many years to describe the relationship (or at least the hoped-for relationship) between the courts and the legislatures of Canada in implementing the 1983 Charter of Rights and Freedoms. But its application in the *Al-Khawaja* case to the relationship between the supranational court and the national ones is a radical departure. For many years, the Court had held that a criminal trial was not fair if it produced a conviction based solely or decisively on hearsay testimony. In a Europe with widely divergent criminal processes, one size was not going to fit all, and in no case more so than that of the United Kingdom, with a system of jury trial unlike any other in Europe. The Supreme Court had said as much in *R* v. *Horncastle*,[15] declining to follow Strasbourg's jurisprudence on the issue, not only because it is often impossible to know whether a particular piece of evidence has been decisive in the jury's thinking, but also because decisiveness is itself an elusive concept.

'I share the view of the majority', said the President, 'that to apply the [Court's] rule inflexibly, ignoring the specificities of the particular legal system concerned, would run counter to the traditional way in which the Court has, in other contexts, approached the issue of the overall fairness of criminal proceedings.'

It is not entirely helpful that this change of position is taking place under the shadow of xenophobic and nationalistic attacks on the competence of a court which those who know it consider to be of generally high calibre. But it is sufficient for the present to observe that the latitude which member states can now expect is not the old margin of appreciation. It was one thing to defer to a local judgment as to whether a book or a film breached an accepted legal standard which incorporated an indeterminate moral standard. It is another to recognise that, while due process is an unyielding requirement of the Convention and its fairness a matter of objective judgment for the Court, it has in practice to accommodate widely differing legal systems, none of which can be classed as inherently unfair.

That, it might be thought, is a very different thing, not least because the margin is now located not in the member state but in Strasbourg. In other words, rather than merely allowing each member state to do certain things, albeit they impinge on human rights, in its own way, the Court has now undertaken the task of differentiating between national legal systems and coming to different conclusions about them.

HOW THE WORLD HAS CHANGED FOR CHILDREN AND PARENTS, 1912–2012

Ann Phoenix

The Georgian, post-Victorian UK of 1912 which saw the advent of the BBFC was a world in the process of change. The lives of working-class children had already been ameliorated by late-nineteenth-century legislation that prevented children under the age of ten from working underground in coal mines or in factories and reduced the working day for all children to no more than ten hours. With the 1870 Education Act, schools were set up in each village and town to provide a moral and religious education at a small cost that was, nonetheless, prohibitive for poor children. By 1880, however, all five- to ten-year-olds had to go to school. Concern with children's health led to the provision of free school meals in 1906, but councils often ignored this because of the cost until it was made compulsory in 1914 when the government realised that many of the British soldiers in World War I, as in the earlier Boer War, were undernourished. This is one reason that Debórah Dwork makes the apparently paradoxical suggestion that 'war is good for babies and other young children'.[16]

There were other ways in which the lot of children improved early in the twentieth century. In 1907, the number of free scholarship places in secondary schools was increased, so that the most academic working-class children could stay at school until fifteen. At the same time, some 'young offenders' began to be placed on 'probation' in the community rather than being sent to prison and, in 1908, the Children and Young Persons Act imposed punishments for child neglect, for selling children tobacco, alcohol and fireworks or for using them for begging.[17]

Legislation at the start of the twentieth century thus afforded children more protection than previously and more than adults. In addition, the state made efforts to promote children's health and education. These changes both resulted from, and had consequences for, how children and their parents were viewed and for their experiences. That state policies have an impact on children's identities is evocatively illustrated by Liz Heron who, speaking of a post-World War II girlhood, says,

> Along with the orange juice and the cod-liver oil, the malt supplement and the free school milk, we may also have absorbed a certain sense of our own worth and the sense of a future that would get better and better.[18]

In creating the conditions of possibility for children to take an optimistic view of their self worth and future possibilities, legislation can be said to be psychosocial, having both psychological and social impact.

The discussion below takes a broad view of changes for children and parents over the last century that are central to the issues with which the BBFC has to grapple in classifying films and videos. Three of these are of particular note. First, 'childhood' has come to be recognised as a definable state and an important site of government policy. Second, transformations in our understanding of childhood are inextricably linked with transformations in the expectations of parents. Where once it was often taken for granted that they (and fathers in particular) should be figures of distant universal authority, they are now expected to be warm, affectionate attachment figures, who guide, educate and protect their children. In practice, private realities were always more complex and differentiated than such a typification would suggest. As the state has become more concerned with children and parenting, parents have also been increasingly subjected to intervention. Families have, however, long been viewed as amenable to state intervention. Third, the context of 'the family', in which parents are supposed to perform parenting roles, has been in constant flux, with the result that there are often contradictions between normative ideas of children and parents and the multiplicity of ways in which they live.

Changes in Orientation to Childhood

The constellation of legislative changes on children and families was accompanied by, and produced, marked changes in thinking about children and childhood. These are illustrated by the rise of the sociology of childhood in the 1980s and 1990s. Sociologists of childhood self-consciously resisted what they saw as the marginalisation of childhood by advocating that children should be studied in their own right, paying attention to their agency, perspectives, cultures, rights and impact on others in their social worlds, including their parents. This shift in academic understanding does not mean that the nature of childhood has changed. Children have always been active in their own development and frequently contributed to the maintenance of their families, but there has been a paradigm shift in perceptions of children and childhood, and hence of parents, whose socially sanctioned roles have become less authoritarian and more educative over the last century. Instead of contributing economically to their households, many children began receiving pocket money between the World Wars. This meant that children could attend cinema matinées and buy sweets and comics for themselves.

As the age of compulsory education rose to fifteen with the 1944 Education Act and young people increasingly needed educational qualifications to secure employment, the transitional period between childhood and adulthood lengthened. At the same time, the economic boom of the 1950s and full employment enabled those young people leaving school to find jobs easily. Many had economic power in the marketplace (where young men were paid more than young women) and could afford newly available mass-produced goods. As a result, young people became a group defined by their leisure consumption, peer-group identity and style. In the 1960s, 'youth' and 'teenagers' increasingly became a focus of media moral panics as groups of young men, defined by certain styles, sometimes met for agonistic displays. There were also moral panics about

changes in both sexual mores and young people's behaviour following the development of the contraceptive pill, the legalisation of abortion and reduced stigma for lone motherhood and cohabiting couples from the 1970s onwards. Young women as well as young men gained new sexual freedoms that were only partially curtailed as AIDS came to be understood in the 1980s and this was accompanied by increased sexualisation of media.

Moral panics about young people were far from new. For example, G. Stanley Hall called adolescence a period of 'storm and stress' in 1904,[19] an idea that gained support from the 1940s in psychoanalytic theory, which predicts emotional volatility, depressed mood and parent–adolescent conflict in adolescence.[20] In the 1960s, the psychoanalyst Erik Erikson theorised adolescence as central to identity formation and a period of normative 'crisis'.[21] This view, of young people as turbulent and stressful, is highly influential. However, the research available makes clear that it is not so turbulent or such a period of confrontation with parents as often thought.

Consumption is, however, an area where there continues to be popular concern about young people. A UNICEF-funded study of materialism and inequality in the UK, Sweden and Spain found that children in all three countries said that they most enjoyed spending time with their parents and doing activities, especially outdoors, rather than owning technology or branded clothes. Parents in the UK, however, said they felt tremendous pressure from society to buy material goods for their children and this was particularly the case in low-income homes.[22]

In the second decade of the twenty-first century, consumption constitutes a crucial site for conflict, contradiction and deliberation about the nature of childhood and how it should be regulated and supported. It lies at the heart of gendered contradictions (and racialised differentiation) that are germane to film production.[23] For example, anxiety about the sexualisation of childhood is in effect a gendered concern focused on girls that starts from the premise that children are innocent and disregards the widespread sexualisation of society and preoccupation with women's bodies (at least partly responsible for increases in cosmetic surgery for young women). Such concern also ignores the ways in which girls use agency in making complex negotiations between portraying themselves as 'sexy' (a socially powerful identity) and resisting sexualised slurs on their moral reputation.

Consumption is also centrally implicated in masculinities and the ways in which boys and young men are increasingly subject to media images of the perfect male body and have to negotiate constructions of masculinity as 'hard', sporty, powerful and too 'cool' to be seen doing too much schoolwork. Concerns about boys and young men focus on boys' poorer educational attainment in comparison with girls' and on the fact that young men are more likely than any other age/gender group to commit suicide.

Continuities in Viewing of Families as a Crucial Site of Social Policy Intervention

Perhaps the most obvious continuity between 1912 and current thinking about families is the construction of families as the central site for social policy intervention in the interests of social welfare and the eradication of poverty. For example, the foundation of the Beveridge/Keynes reforms was predicated on gendered notions, with fathers being expected to take responsibility for economic provision of families. Eleanor Rathbone, a social reformer and MP, who influenced the Beveridge reforms, considered that family allowances should not be paid to lone mothers because that would encourage other, less capable young women to have children without being married. She was not censorious of illegitimacy on moral grounds, but perspectives like Rathbone's served to construct lone, unmarried mothers as undeserving.[24]

There has, however, been a marked increase in the percentage of all households with dependent children that consist of children with a lone mother. At any one time, more than a million women are lone mothers, and since it is not a static state, many more women will have been, or know that they are likely to become, lone mothers. Many men are the fathers of the children being reared by lone mothers, and stepfathers and stepmothers are common. In addition, cohabitation is increasingly common. These demographic changes have both gender and economic implications that have been dealt with in different ways by different governments. However, attempts to construct lone mothers as 'feckless' have, to a large extent, been unsuccessful, partly because lone mothers now constitute a large category.

The establishment of the Child Support Agency by the Conservative government (in April 1993) was predicated on notions of the importance of the family as a site for social policy

intervention and of specific contributions by fathers and mothers as well as beliefs that families should be self-sufficient. The then Prime Minister Margaret Thatcher's oft-quoted statement that 'there is no such thing as society, only family life' suggested that families had to take individual responsibility for themselves. In the late 1990s, the New Labour government was keen to establish that they were as concerned about the family and family policy as was the Conservative Party.

The idea of the family being 'the cornerstone of society' is not simply due to this being the structure in which many people choose to live. Instead, the pronouncements of politicians make clear that 'the family' is a civil institution of importance to the state. It is arguably when 'the family' changes in ways that conflict with a state's political aims that concerns about threats to 'the family' are expressed. Parents are expected to provide economic support and care for their children as well as teaching them appropriate and acceptable behaviour. If parents do not provide for their children, the state (at least in liberal democracies) incurs a responsibility to intervene.

It can be argued that the family has become overloaded with expectations and responsibilities and that this has led to parents being blamed for the faults of their children. From a BBFC perspective, it is also because families are a site of social policy intervention that the regulation of what children are allowed to hear and watch is of interest to governments of different political persuasions.

Contradictory Thinking about Families

'The family' has often been defined as 'nuclear'. The 'nuclear family' consists of a man and woman who are cohabiting (and preferably legally married) and their children, living in the same household. It is bound together through mutual ties of affection, common identity and relationships of care and support. The rearing of children is supposed to be the major task of the nuclear family. In northern societies, this stereotype of 'the family' is a very strong one and it is often assumed to be the natural and normal form of social organisation.

Yet, anthropologists point out that 'the traditional family' is not as widespread as often thought and, even in the north, the 'traditional', nuclear family is of relatively recent creation and continuously changing. Linda Nicholson argues that it dates from the post-World War II period. The economic boom of the 1950s increased real wages and allowed government spending so that it became possible for the working classes to copy middle-class divisions of household labour with most men going out to employment and many women staying at home to rear children. At the same time, massive housing construction made possible the possession of 'a home of one's own' for nuclear family living. Since the 1950s, there has been a marked increase in the number of married women who are employed outside their homes. Government policies on employment as the way to end social exclusion and child poverty have built on feminist campaigns to open up the labour market to women.[25]

There are other ways in which what are viewed as 'traditional families' have changed over time. For example, Ann Dally points out that it was only in the middle of the twentieth century that women could be relatively confident that each pregnancy would result in both a live birth and a live mother. Before this, there had been a fair amount of reconstituting of families following maternal deaths (and, indeed, fathers' deaths).[26] The construction of the traditional 'nuclear family' as normal and the norm is also being challenged by diversity as increasing numbers of lesbian and gay couples form partnerships, have children and, since the UK civil partnership law was enacted in 2005, view civil partnerships as equivalent to marriage. Age, social class and the number of family members in a household also differ between families. 'Extended families' are commonplace, particularly as economic recession makes intergenerational living increasingly necessary for some families. At the same time, an increasing number of households have no children and so do not fit notions of the traditional nuclear family.

The emotional expectations of families have also changed. The ideal of the 'companionate marriage' where a loving heterosexual couple are good friends who support each other and their children is a recent construction. Marriage used to be more widely accepted as being contracted for economic, status or political reasons, such as to bring estates together or to make provision for a family.[27] While economic reasons are still important, many people in northern societies (but by no means all) consider that love and friendship should be central.

Traditional nuclear families are, therefore, not at all traditional and they have become more diverse over the last century.

Dynamic Social Divisions, Parental Responsibilities and the Twenty-First-Century BBFC

The changes and continuities discussed above are only intelligible within a framework that recognises social differences between children and families that were central when the BBFC came into existence and continue to be important, albeit in different ways. The differences were particularly noticeable between children from affluent families and those from impoverished families, and boys and girls had very different childhoods. Children from families living in poverty would generally have to contribute to their family incomes much earlier than would be expected for children from more affluent households, and education was gender-differentiated, with girls being expected to learn the skills involved in home-making and boys being taught skills suited to their probable employment.

Social class and racialisation and ethnicisation continue to be central to society and the lives of parents and children. Social class, for example, continues to be the major factor that differentiates experiences and outcomes for families. While children from poor families no longer go to work at twelve years old, they continue to get far lower educational qualifications than their middle-class peers and many are involved in part-time economic activity. Similarly, while the constitution of British society has changed enormously since 1912 with migration from the 'Commonwealth' and from the EU, racialisation and ethnicisation continue to have marked impacts on parents and children's life chances and experiences.

These social divisions and social changes place parents in a contradictory position. On the one hand, they are increasingly held responsible for their children's educational, moral and social outcomes, and on the other, they have to negotiate gendered, social class and individual differences and the increasing pressures of commercialisation while taking a more democratic approach to child-rearing than was expected a century ago. These contradictions make the work of a dynamic and future-oriented twenty-first-century BBFC relevant to parents and children in new ways. Many parents are likely to welcome help from film classification as a starting point for making and enforcing their own decisions about what their children are permitted to watch at home and outside the cinema and for drawing the (un)suitability of films they do not know to their attention. A national classificatory system also provides parents with an external authority on which to 'blame' prohibitions unpopular with children, allowing parents to impose regulation while taking a democratic stance in interaction with their children. Many also welcome attempts to enforce prohibitions on young people who are frequently outside parental supervision in their leisure time and who are negotiating gendered contradictions of consumption and sexualisation. It is also worth reflecting that children and young people themselves sometimes prefer to blame external regulation for prohibiting them from doing things they do feel (un)comfortable about. Increasingly, then, an important role for the BBFC is likely to be providing expert advice in ways that support parental attempts to regulate their children's leisure and children's negotiations of their social worlds

The BBFC issues age rating information for platforms to use on their video-on-demand services. Here, a black card co-branded with BT Vision

NOTES

Notes to Preface

1. Derived from British Board of Film Censors, *Annual Report for Year Ending December 31ˢᵗ 1915* (London: BBFC, 1916), pp. 7–9.
2. *The BBFC Student Guide 2005/06*, p. 4, http://www.bbfc.co.uk.

Notes to Chapter 1

1. The projection speed for silent films varied, but around sixteen to eighteen frames per second were more or less standard. Sound speed is twenty-four frames per second.
2. Jon Burrows, 'Penny Pleasures: Film Exhibition in London During the Nickelodeon Era – Part One', *Film History* vol. 16 no. 4, 2004, p. 72.
3. Cecil Court was known as 'Flicker Alley' because of the number of early film companies located there. For more on the history of Cecil Court, see Simon Brown, 'Flicker Alley: Cecil Court and the Emergence of the British Film Industry', *Film Studies* no. 10 (Manchester: Manchester University Press, 2007), pp. 21–33.
4. David R. Williams, 'The Cinematograph Act of 1909: An Introduction to the Impetus Behind the Legislation and Some Early Effects', *Film History* vol. 9 no. 4, 1997, pp. 341–50; pp. 342–3.
5. Ibid., p. 343.
6. Ibid., p. 345.
7. *Bioscope*, 21 January 1909, p. 7.
8. Memoranda on the History of Film Censorship, 3 May 1923, The National Archives (TNA): Public Record Office (PRO) HO 45/11191 Home Office: Entertainments: Cinematograph – Censorship of Films 1918–23.
9. Ibid.
10. Copy of Note of Deputation of Representatives from the Film Trade to Reginald McKenna, 22 February 1912, TNA: PRO HO 45/10551/163175 Home Office: Entertainments: Film Censorship 1912–14.
11. Annette Kuhn, *Cinema, Censorship and Sexuality 1909–1925* (London: Routledge, 1988), p. 22.
12. Neville March Hunnings, *Film Censors and the Law* (London: Allen & Unwin, 1967), p. 52.
13. Home Office memo, 'Development of the Film Censorship', 1922, TNA: PRO HO 45/22906 Home Office, p. 5.
14. Notes from Trade Deputation to the Home Office, 13 November 1912, TNA: PRO HO 45/10551/163175 Home Office.
15. Hunnings, *Film Censors and the Law*, p. 131.
16. British Board of Film Censors, *Report of the British Board of Film Censors for Year Ending December 31st, 1913* (London: BBFC, 1914).
17. Ibid.
18. Indeed, a set of model conditions circulated to licensing authorities in 1916 by the Home Office included the stipulation that '[e]very part of the premises to which the public are admitted shall be so lighted during the while of the time it is open to the public as to make it possible to see clearly over the whole area'. This measure

was suggested specifically to try to discourage immoral behaviour in the darkened auditoria. See Hunnings, *Film Censors and the Law*, p. 64.

19. BBFC, *Report 1913*.
20. Memoranda on the History of Film Censorship, TNA: PRO HO 45/11191 Home Office.
21. Letter from BBFC to Pathé, 15 August 1913, TNA: PRO HO 45/10551/163175 Home Office.
22. *Bioscope*, 7 May 1914, p. 571.
23. TNA: PRO HO 45/10551/163175 Home Office.
24. M. Delevigne, Home Office to J. Brooke Wilkinson, BBFC, 5 February 1914, TNA: PRO HO 45/10551/163175 Home Office.
25. Brooke Wilkinson to Delevigne, 7 February 1914, TNA: PRO HO 45/10551/163175 Home Office.
26. British Board of Film Censors, *Annual Report for Year Ending December 31st, 1914* (London: BBFC, 1915), p. 3. Following on from the lukewarm support given by the Home Office in the 1913 Report, in 1914, the Report states that the BBFC is grateful for the 'kindly assistance' of the Home Office.
27. TNA: PRO HO 45/10551/163175 Home Office.
28. Memoranda on the History of Film Censorship, TNA: PRO HO 45/11191 Home Office.
29. *Bioscope*, 21 October 1915, p. 245; 25 November 1915, p. 849.
30. BBFC, *Annual Report 1914*, p. 2.
31. British Board of Film Censors, *Annual Report for Year Ending December 31st, 1915* (London: BBFC, 1916), p. 4.
32. Colonel Cockerill to Home Office, 1 April 1915, TNA: PRO HO 139/6 Home Office Portf. No. 12, British Board of Film Censors – Official Press Bureau files.
33. Cockerill to Sir Edward Cook, 13 December 1915, TNA: PRO HO 139/6 Home Office.
34. John Simon, Home Secretary to Cockerill, 13 December 1915, TNA: PRO HO 139/6 Home Office.
35. Memoranda on the History of Film Censorship, TNA: PRO HO 45/11191 Home Office.
36. Ibid.
37. Hunnings, *Film Censors and the Law*, p. 63.
38. Ibid.
39. Ibid., pp. 63–7.
40. Quoted in ibid., p. 67.
41. Home Office minute, 5 November 1916, quoted in ibid., p. 66.
42. Francis Fytton, 'The Legacy of T. P. O'Connor', *Irish Monthly* vol. 83 no. 969, May 1954, pp. 169–73.
43. National Council of Public Morals, *The Cinema: Its Present Position and Future Possibilities* (London: Williams and Norgate, 1917), p. vi.
44. Kuhn, *Cinema, Censorship and Sexuality 1909–1925*, p. 38.
45. Memoranda on the History of Film Censorship, TNA: PRO HO 45/11191 Home Office.
46. Ibid.
47. National Council of Public Morals, *The Cinema*, p. xxx.
48. Ibid., pp. 254–5.
49. Hunnings, *Film Censors and the Law*, p. 69.
50. Memoranda on the History of Film Censorship, TNA: PRO HO 45/11191 Home Office.

51. Ibid.
52. Hansard HC Deb 22 June 1920 vol. 130 cc 1999–2000. http://hansard.millbanksystems.com/commons/1920/jun/22/cinemas-censorship.
53. Hansard HC Deb 17 February 1921 vol. 138 cc 256–8. http://hansard.millbanksystems.com/commons/1921/feb/17/cinema-films-censorship.
54. TNA: PRO HO 45/11191 Home Office.
55. James C. Robertson, *The Hidden Cinema: British Film Censorship in Action 1913–1975* (London: Routledge, 1989), pp. 14–16.
56. Kuhn, *Cinema, Censorship and Sexuality 1909–1925*, p. 19.
57. Memoranda on the History of Film Censorship, TNA: PRO HO 45/11191 Home Office.
58. Hunnings, *Film Censors and the Law*, p. 75.
59. Ibid., pp. 76–7.
60. TNA: PRO HO 45/11191 Home Office.
61. Circular from the Home Office, 6 July 1923, TNA: PRO HO 45/11191 Home Office.
62. Ibid.
63. Hunnings, *Film Censors and the Law*, p. 77.
64. Hansard HL Deb 18 May 1927 vol. 67 cc 345–66. http://hansard.millbanksystems.com/ lords/1927/may/18/censorship-of-films.
65. Ibid.
66. Hansard, HL Deb 15 March 1928 vol. 70 cc 468–93. http://hansard.millbanksystems.com/ lords/1928/mar/15/censorship-of-films.
67. British Board of Film Censors, *Report: Year Ended December 31st, 1929* (London: BBFC, 1930), p. 2.

Case Study: BATTLESHIP POTEMKIN

68. Cited in David Bordwell and Kristin Thompson, *Film Art: An Introduction* (New York: McGraw-Hill, 1993), p. 468.
69. V. I. Pudovkin, *Film Technique and Film Acting* (New York: Grove Press, 1958), p. 73.
70. British Board of Film Censors, *Report – Year Ended December 31st, 1926* (London: BBFC, 1927), p. 8.
71. For example, the Board rejected *Bolshevism on Trial* (1922).
72. Review in *Variety*, 8 December 1926.
73. Clerk to the Council, London County Council to J. Brooke Wilkinson, BBFC, 8 April 1935, BBFC file: *Battleship Potemkin*.
74. London County Council, Report of the Inspection of Films Sub-Committee, 29 March 1935.
75. Brian Winston, *Claiming the Real: The Documentary Film Revisited* (London: BFI, 1995), p. 37.

Notes to Chapter 2

1. Cited in Jeffrey Richards, *The Age of the Dream Palace: Cinema and Society in Britain 1930–1939* (London: Routledge & Kegan Paul, 1984), p. 11.
2. H. Llewellyn Smith (ed.), *New Survey of London Life and Labour, Volume 9* (London: P. S. King and Son, 1935), pp. 43 and 47. See also Robert James, *Popular Culture*

and *Working-Class Taste in Britain, 1930–39: A Round of Cheap Diversions?* (Manchester: Manchester University Press, 2010), Chapter 1.

3. Simon Rowson, 'A Statistical Survey of the Cinema Industry in Great Britain in 1934', *Journal of the Royal Statistical Society* vol. 99 no. 1 (1936), pp. 67–129. Sidney Bernstein's questionnaires, conducted in 1932, 1934 and 1937, also revealed that nearly 50 per cent of filmgoers visited the cinema twice weekly; some made as many as seven visits a week. Bernstein's questionnaires are held at the British Film Institute Library, London.

4. Louis Moss and Kathleen Box, 'The Cinema Audience: An Inquiry Made by the Wartime Social Survey for the Ministry of Information' (1943), republished in J. P. Mayer, *British Cinemas and Their Audiences* (London: Arno, 1948), pp. 251–75.

5. See Margaret Dickinson and Sarah Street, *Cinema and State: The Film Industry and the Government, 1927–84* (London: BFI, 1985); Julian Petley, 'Cinema and State', in Charles Barr (ed.), *All Our Yesterdays: 90 Years of British Cinema* (London: BFI, 1986), pp. 31–46.

6. The National Archives (TNA): Public Record Office (PRO) HO 45/15248 Home Office: Sunday Opening of Cinemas; report by Oswald H. Davis, 29 October 1932.

7. Hansard HL Deb 4 May 1932 vol. 84 cc 291–305; c 292. http://hansard.millbanksystems.com/lords/1932/may/04/importance-of-british-films.

8. See 'Perils of Popular Education', *Publishers' Circular*, 9 May 1931.

9. Ibid.

10. Hansard HL Deb 28 November 1927 vol. 69 cc 271–305; c 284. http://hansard.millbanksystems.com/lords/1927/nov/28/cinematograph-films-bill.

11. Ibid.

12. TNA: PRO HO 45/15206 Home Office: Entertainments: Film Censorship in the United Kingdom, 9 November 1931.

13. Tom Dewe Mathews, *Censored: The Story of Film Censorship in Britain* (London: Chatto & Windus, 1994), p. 80.

14. TNA: PRO FO 371/21530 Foreign Office: United States Film Industry: British Film Legislation, memo from Bevin, 10 January 1938.

15. Noreen Branson and Margot Heinemann, *Britain in the Nineteen Thirties* (London: Weidenfeld & Nicolson, 1971), p. 253.

16. Hansard HL Deb 28 November 1927 vol. 69 cc 271–305; cc 289–90.

17. Petley, 'Cinema and State', p. 41.

18. See TNA: PRO HO 45/15207 Home Office: Entertainments: Film Censorship in the United Kingdom. The file contains letters of correspondence between the Board and government officials regarding the exhibition of foreign films in Britain and British films in the British Empire, 3 February and 7 December 1933; see also, in the same file, Memorandum, 1 November 1933.

19. See, for example, TNA: PRO HO 45/15208 Home Office: Entertainments: Film Censorship Consultative Committee, in which the Home Secretary, Sir Herbert Samuel, remarks:

> The Home Office, of course, is not responsible for the Board of Film Censors and does not desire to assume any responsibility at all […]. At the same time, it is necessary that the Home Office should keep in close touch with the Board of Film Censors and with this Consultative Committee, 1 December 1931.

For a more detailed discussion of this close relationship see Jeffrey Richards, 'The British Board of Film Censors and Content Control in the 1930s: Images of Britain', *Historical Journal of Film, Radio and Television* vol. 1 no. 2, 1981, pp. 95–116.

20. Jeffrey Richards and James C. Robertson, 'British Film Censorship', in Robert Murphy (ed.), *The British Cinema Book* (London: BFI, 2009), pp. 67–77; p. 68.

21. TNA: PRO INF 1/178 Central Office of Information: Film Censorship, 17 September 1938.

22. TNA: PRO INF 1/178 Central Office of Information: 14 April 1939, correspondence between Mr Woodburn and Mr Waterfield.

23. *Kinematograph Year Book* 1935, p. 10.

24. *Kinematograph Year Book* 1932, p. 13.

25. Robert James, '*Kinematograph Weekly* in the 1930s: Trade Attitudes Towards Audience Taste', *Journal of Popular British Cinema and Television* vol. 3 no. 2, 2006, pp. 229–43.

26. TNA: PRO HO 45/15207 Home Office: 24 August 1932.

27. Ibid., correspondence between Lord Bledisloe and Sir Herbert Samuel, 6 September 1932. Bledisloe argued: 'Any movement deserves encouragement which by developing a healthier and more critical public opinion can bring pressure to bear on the cinematograph trade itself towards the production of a better type of film.'

28. TNA: PRO HO 45/15206 Home Office: House of Commons, Deputation from the Parliamentary Film Committee in regard to the censorship of films, 17 March 1932.

29. 'Discussion on Mr Rowson's Paper', in Rowson, 'A Statistical Survey', p. 123. Rowson was Chairman of the British Film Institute's Entertainment Panel and President of the Renters' Society.

30. Ibid., p. 128.

31. Annette Kuhn, 'Children, "Horrific" Films and Censorship in 1930s Britain', *Historical Journal of Film, Radio and Television* vol. 22 no. 2, 2002, pp. 197–202; pp. 197–8.

32. Ian Conrich, 'Traditions of the British Horror Film', in Murphy, *The British Cinema Book*, pp. 96–105; p. 97.

33. Richards and Robertson, 'British Film Censorship', p. 69.

34. Richards, 'The British Board of Film Censors', p. 96.

35. James C. Robertson, 'British Film Censorship Goes to War', *Historical Journal of Film, Radio and Television* vol. 2 no. 1, 1982, pp. 49–64; p. 49.

36. Dewe Mathews, *Censored*, p. 50. Miss Shortt was the daughter of the Rt Hon Edward Shortt, the BBFC's President from 1929 until his death in 1935.

37. Ibid., p. 49.

38. Sarah Smith, *Children, Cinema and Censorship: From Dracula to Dead End* (London: I. B. Tauris, 2005), p. 47.

39. Ibid.

40. Robertson, 'British Film Censorship Goes to War', p. 49.
41. The BBFC scenario reports are held in Special Collections, British Film Institute, London.
42. Richards, 'British Board of Film Censors', p. 96.
43. BBFC scenario report: *Water Gypsies*, 16 April 1931; BBFC scenario report: *Cuckoo in the Nest*, 10 July 1933.
44. Richards, 'British Board of Film Censors', p. 102.
45. BBFC scenario report: *Hindle Wakes*, 22 April 1931.
46. Sylvia Harvey, 'The "Other Cinema" in Britain: Unfinished Business in Oppositional and Independent Film, 1929–1984', in Barr, *All Our Yesterdays*, pp. 225–51; p. 227.
47. F. Thorpe and Nicholas Pronay, *British Official Films in the Second World War* (Oxford: Clio Press, 1980), p. 16.
48. Juliet Gardiner, *The Thirties: An Intimate History* (London: Harper Press, 2010), pp. 441–6.
49. *The White Captive* was opposed because '[t]he sight of a white man drifting to degradation through drink in native surroundings is always unpleasant'. BBFC scenario report, 22 April 1931. *Tiger Bay* was prohibited because '[t]he whole story is an exact replica of the worst type of American gangster films with the scene laid in London, amidst very low and sordid surroundings'. BBFC scenario report, 14 June 1933.
50. BBFC scenario report: *Dreamer Awake*, 28 June 1937.
51. Ibid.
52. The film referred to is *The Red Light*. BBFC scenario report, 15 December 1931.
53. BBFC scenario report: *Red Square*, 22 February 1934.
54. See BBFC scenario report: *Soviet*, 24 July 1933 and BBFC scenario report: *Knight without Armour*, 18 February 1935 respectively. *Soviet* was initially opposed (BBFC scenario report, 11 March 1933) but production was allowed after amendments were made.
55. BBFC scenario report, 12 April 1934. The quote is taken from a report for Gaumont-British's film *Machines*, which the censor believed 'savours much too strongly of political propaganda'.
56. BBFC scenario report: *Tidal Waters*, 29 March 1932.
57. BBFC scenario report: *Sitting on Top of the World*, 19 August 1935.
58. BBFC scenario report: *Strike Down*, 18 May 1937.
59. BBFC scenario report: *The Navvy*, 4 December 1934.
60. Cited in Petley, 'Cinema and State', p. 44.
61. Robertson, 'British Film Censorship Goes to War', p. 62.
62. Ibid.
63. BBFC scenario reports: *The Mad Dog of Europe*, 1 November 1934 and 19–21 November 1939.
64. Robertson, 'British Film Censorship Goes to War', pp. 53–4.
65. James Chapman, *The British at War: Cinema, State and Propaganda, 1939–1945* (London: I. B. Tauris, 1998), pp. 116–17.
66. Dewe Mathews, *Censored*, p. 110.
67. BBFC scenario report: *The Sign of Colonel Britton*, 20 July 1941.
68. BBFC scenario reports: *It's in the Bag*, 28 July and 2 August 1943.
69. BBFC scenario report: *See How They Run*, 18 May 1945.
70. BBFC scenario report: *Kiss the Bride Goodbye*, 27 January 1944.
71. BBFC scenario report: *Easy Money*, 14 August 1947.
72. BBFC scenario report: *Love on the Dole*, 15 March 1936; Richards, 'British Board of Film Censors', p. 112.
73. BBFC scenario report: *Raid of Heligoland*, 7 January 1942.
74. BBFC scenario report: *Royal William*, 4 July 1941.
75. Ibid.
76. Sue Harper, *Picturing the Past: The Rise and Fall of the British Costume Film* (London: BFI, 1994), p. 12.
77. Richards, 'British Board of Film Censors', p. 112.
78. BBFC scenario report: *Boys in Uniform*, 8 July 1942. The report noted: 'Major Maguire's statement that the casualties in the Charge of the Light Brigade at Balaclava were only 2 men and 14 horses is certainly inaccurate!'
79. BBFC scenario report: *The Private Life of the Virgin Queen*, 25 February 1947.
80. Ibid.
81. BBFC scenario report: *I'll Marry the Girl*, 21 August 1941.
82. BBFC scenario report: *Somewhere in the Camp*, 7 October 1941.
83. BBFC scenario report: *The Lone Wolf Goes High Hat*, 29 August 1941.
84. Ibid.
85. BBFC scenario report: *Flying Fortress*, 22 October 1941.
86. Ibid.
87. Conrich, 'Traditions of the British Horror Film', p. 98.
88. *Today's Cinema*, 29 May 1940, p. 16, quoted in ibid.
89. BBFC scenario report: *Murder in Whitechapel*, 18 April 1947.
90. BBFC scenario report: *The Tober and the Tulpa*, 13 November 1947.
91. BBFC scenario report: *One of Us*, 4 September 1941.
92. BBFC scenario report: *Fire in the Night*, 14 September 1942.
93. BBFC scenario report: *Blitzkrieg*, 9 February 1943.
94. BBFC scenario report: *Green for Danger*, 3 October 1945.
95. Richards, 'British Board of Film Censors', pp. 109–10.
96. BBFC scenario report: *The Interloper*, 26 May 1944.
97. Juliet Gardiner, *Wartime Britain 1939–1945* (London: Headline, 2004), pp. 683–5.
98. BBFC scenario report: *The Snake Pit*, 30 April 1946.
99. BBFC scenario reports: *The Eminent Dr. Deeves*, 4 May 1946 and 6 May 1946.
100. BBFC scenario report: *The House of Doctor Belhome*, 9 April 1947.
101. BBFC scenario report: *Dead on Time*, 21 October 1947.
102. Dewe Mathews, *Censored*, pp. 51–2.
103. Richards, 'British Board of Film Censors', p. 106. The escalation of the gangster film cycle caused extreme anxiety in America too, leading to the formalisation of the Hays Code to combat the threat. See John Springhall, *Youth, Popular Culture and Moral Panics: Penny Gaffs to Gangsta-Rap, 1830–1996* (New York: Palgrave, 1999), p. 100.
104. BBFC scenario report: *The Anatomist*, 27 May 1944.
105. BBFC scenario report 88, *No Orchids for Miss Blandish*, 3 July 1944.

106. Ibid.
107. Ibid., 11 October 1944.
108. Ibid., 12 October 1944.
109. BBFC scenario report: *The Business of Death*, 5 July 1944.
110. BBFC scenario report: *Uncle Harry*, 11 December 1944.
111. BBFC scenario report: *Jim the Penman*, 13 March 1947.
112. Ibid.

Case Study: ISLAND OF LOST SOULS

113. For a useful discussion, see D. Tacium, 'A History of Antivivisection from the 1800s to the Present', *Veterinary Heritage*, Part I, May 2008, vol. 31 no. 1, pp. 1–9; Part II, November 2008, vol. 31 no. 2, pp. 21–5; Part III, May 2009, vol. 32 no. 1, pp. 1–5.
114. H. G. Wells, *The Island of Doctor Moreau* (London: Penguin, 2011 [1896]).
115. See www.imdb.com/title/tt0241582.
116. Tom Johnson, *Censored Screams: The British Ban on Hollywood Horror in the Thirties* (Jefferson, NC: McFarland, 1997), p. 71.
117. British Board of Film Censors, *Report: Year Ended December 31st, 1933* (London: BBFC, 1934), p. 7.
118. See, for example, Johnson, *Censored Screams*, p. 71 and James C. Robertson, *The Hidden Cinema: British Film Censorship in Action, 1913–1975* (London and New York: Routledge, 1993), p. 56.
119. See Johnson, *Censored Screams*, p. 75 and Robertson, *The Hidden Cinema*, p. 56.
120. See David J. Skal, *The Monster Show: A Cultural History of Horror* (London: Plexus, 1993), p. 171 and Robertson, *The Hidden Cinema*, p. 56.
121. Arthur Watkins, BBFC to distributor, 6 July 1951, BBFC file: *Island of Lost Souls*. All remaining citations in this case study come from the same file.
122. Examiner's report, 5 July 1951.
123. Distributor to G. Nicholls, BBFC, 11 October 1957.
124. BBFC to distributor, 29 October 1957.
125. Ibid.
126. Distributor to Nicholls, 29 November 1957.
127. BBFC internal memo, 3 December 1957.
128. Ibid.
129. Record of meeting between a representative from the distributor and the President and Secretary of the BBFC, 23 December 1957.
130. BBFC exception form no. 15225, 17 December 1957.
131. Examiner's report, 22 April 1996.

Notes to Chapter 3

1. BBFC scenario report 36, *Pick-Up Girl*, 7 October 1946.
2. 'He was courteous and kind, and his life was throughout influenced by the Christian standards of morality. He had as much integrity as anyone I have ever known', was John Trevelyan's judgment. *What the Censor Saw* (London: Michael Joseph, 1973), p. 50.
3. See his profile in *Kinematograph Weekly*, 29 July 1948, p. 6.
4. 'I wasn't much of a filmgoer in India', he later commented. 'To be perfectly honest, I thought all their films were much too long.' Quoted in Philip Oakes, 'Mister Bluenose', *Sunday Times Magazine*, 3 July 1966, pp. 16–17.
5. Madge Kitchener commented: 'Horror piled on horror, does not, in my opinion, constitute healthy entertainment.' BBFC scenario report 47, *Eyes That Kill*, 27 January 1947.
6. BBFC scenario report: *The Private Life of the Virgin Queen*, 25 February 1947
7. BBFC scenario report 78, *Saraband for Dead Lovers*, 25 July 1947.
8. See for example BBFC scenario reports 79, *The Tender Years*, 31 July 1947 and 35, *Double Alibi*, 22 September 1946.
9. BBFC scenario report 37, *Cat-Astrophe*, 28 October 1946. One of the films complained about had been *Goldwyn Follies* (1938).
10. BBFC scenario report 1, *Grand National Night*, 6 January 1949.
11. BBFC scenario report 28, *They Walk Alone*, 23 October 1946.
12. BBFC scenario report 30, *Irene*, 13 June 1949.
13. Madge Kitchener added: 'Although it is known that there may have been cases of English women living in Eastern bazaars, it is unlikely to have been by their husband's orders. The whole theme and details of this story are tainted.' BBFC scenario report 27, *The Street of Painted Lips*, 3 May 1949.
14. BBFC scenario report 9, *For Them That Trespass*, 22 April 1946.
15. BBFC scenario report 73, *Idol of Paris*, 20 June 1947.
16. *Kinematograph Weekly*, 9 February 1950, p. 4.
17. A. T. L. Watkins, 'Film Censorship in Britain', *Penguin Film Review 9* (London: Penguin, 1949), pp. 61–6.
18. Ibid.
19. Ibid.
20. Guy Phelps, *Film Censorship* (London: Victor Gollancz, 1975), p. 37.
21. James C. Robertson, 'The Censors and British Gangland, 1913–1990', in Steve Chibnall and Robert Murphy (eds), *British Crime Cinema* (London: Routledge, 1999), pp. 16–26; Robert Murphy, *Realism and Tinsel: Cinema and Society in Britain 1939–49* (London: Routledge, 1989), pp. 146–67.
22. BBFC scenario report 2, *999, Appointment with Crime*, 17 January 1946. They took up an even more permissive stance towards *The Hangman Waits*, the tale of the murder and dismemberment of a girl by a cinema organist. BBFC scenario report 12, 2 May 1946.
23. BBFC scenario report 42, *South East Five*, 18 December 1946.
24. BBFC scenario report 41, *A Convict Has Escaped*, 23 December 1946.
25. BBFC scenario report 55, *Brighton Rock*, 4 March 1947.
26. BBFC scenario report 89, *A Gunman Has Escaped*, 29 September 1947.
27. BBFC scenario report 88, *No Orchids for Miss Blandish*, 3 July 1944. See also James C. Robertson, *The Hidden*

Cinema: British Film Censorship in Action, 1913–1975 (London: Routledge, 1989), pp. 92–7.

28. *Monthly Film Bulletin*, April 1948, p. 47.

29. *Sunday Times*, 18 April 1948.

30. Sir Sidney Harris, BBFC to Under-Secretary of State, Home Office, 21 April 1948, The National Archives (TNA): Public Record Office (PRO) HO 495.

31. Harris to BFPA, KRS and CEA, 19 April 1948, Home Office file, TNA: PRO HO 495.

32. Sydney Box, 'Sadism – It Will Only Bring Us Disrepute', *Kinematograph Weekly*, 27 May 1948, p. 18.

33. See, for example, Town Clerk of Bury Council to Under-Secretary of State, Home Office, 11 October 1948, TNA: PRO HO 495.

34. *Kinematograph Weekly*, 29 July 1948, p. 6. The findings of the Wheare Committee and the Board's relationships with local authorities are discussed more fully in Sue Harper and Vincent Porter, *British Cinema in the 1950s: The Decline of Deference* (Oxford: Oxford University Press, 2007), pp. 218–22.

35. BBFC scenario report 24, *The Blue Lamp*, 12 April 1949.

36. See Metropolitan Police file, TNA: PRO MEPO 44 2/8342.

37. BBFC scenario report 24, *The Blue Lamp*, 15 April 1949.

38. Ibid.

39. Watkins, BBFC to Joseph I. Breen, 18 November 1949. The detailed guidelines are published verbatim in Harper and Porter, *British Cinema in the 1950s*, p. 242.

40. 'Censorship – A Revolution in the System Is Taking Shape', *Kinematograph Weekly*, 9 November 1950, p. 6.

41. Roger Manvell, *Film* (London: Penguin, 1946), p. 173.

42. 'Circuits "X" Fears', *Kinematograph Weekly*, 4 October 1951, p. 39.

43. Examiner's note, 13 November 1950, BBFC file: *Amelia*. See also Robertson, *The Hidden Cinema*, pp. 100–3.

44. '[T]he "X" category may very well prove a first breach in the family tradition upon which the prosperity of the film industry is founded', warned *Kinematograph Weekly*, 20 July 1950, p. 4.

45. See Phelps, *Film Censorship*, p. 40.

46. *Kinematograph Weekly*, 29 November 1951.

47. Miles Byrne, MD, County Theatre, Hereford to *Kinematograph Weekly*, 11 October 1951, p. 10.

48. 'These "X" Censors Judge Only by Synopses', *Kinematograph Weekly*, 17 September 1953, p. 12.

49. Secretary, Public Morality Council to Watkins, 15 June 1951, BBFC file: *La Ronde*.

50. *Evening Standard*, 31 March 1951. *What's On in London* (6 April 1951) even regarded the opportunity to see 'one of the most star-laced French movies of the decade' as justification for the 'X' certificate.

51. Cyril Kersh, 'Would You Let Your Daughter See This?', *People*, 6 April 1952.

52. *Sunday School Chronicle*, 1 May 1952.

53. Watkins to Nottingham Watch Committee, 8 July 1952, BBFC file: *La Ronde*.

54. Reed to Watkins, 13 July 1952, BBFC file: *La Ronde*.

55. Examiners' reports, 1 July 1953, BBFC file: *Trois Femmes*.

56. See for example Martin Barker, *A Haunt of Fears: The Strange History of the Horror Comics Campaign* (London: Pluto Press, 1984), Steve Holland, *The Mushroom Jungle: A History of Post-War Paperback Publishing* (Westbury: Zeon Books, 1993) and Alan Travis, *Bound and Gagged: A Secret History of Obscenity in Britain* (London: Profile Books, 2001), pp. 92–127.

57. Examiner's report, 16 December 1953, BBFC file: *Miss Sadie Thompson*.

58. *Daily Mirror*, 18 December 1953. See also E. N. Shapiro, 'Rita's Sadie Shocks the Censor', *Picturegoer*, 23 January 1954.

59. Watkins to distributor, 21 December 1953, BBFC file: *Miss Sadie Thompson*. Another notorious dance sequence by a leading sex symbol would cause problems in *Et Dieu … créa la femme* (*And God Created Woman*, a.k.a. *And Woman Was Created*, 1956) not least because of Brigitte Bardot's erotic proximity to 'negroes' in her audience. BBFC, *Minutes of Exceptions 1957* (March).

60. Cohn to Bell, 22 January 1954, BBFC file: *Miss Sadie Thompson*.

61. Watkins to Bell, 5 February 1954, BBFC file: *Miss Sadie Thompson*.

62. Bell to Thorpe, 16 February 1954, BBFC file: *Miss Sadie Thompson*.

63. Bell to Watkins, 16 February 1954, BBFC file: *Miss Sadie Thompson*.

64. Watkins to Thorpe, 12 April 1954, BBFC file: *Miss Sadie Thompson*.

65. Dilys Powell, for example, complained about 'a script determined that Mr. Maugham shall not have his final devastating word'. *Sunday Times*, 31 May 1954.

66. BBFC, *Minutes of Exceptions 1954* (July).

67. Woolf to Watkins, 21 April 1954, BBFC file: *Tea and Sympathy*.

68. Reader's report, 26 April 1954, BBFC file: *Tea and Sympathy*. The Board's problems with 'Mr. Dent' will be discussed shortly.

69. Note by Watkins, 3 May 1954, BBFC file: *Tea and Sympathy*.

70. Note by Harris, 6 May 1954, BBFC file: *Tea and Sympathy*.

71. *Observer*, 6 October 1957. There are close parallels between the Board's treatment of *Tea and Sympathy* and that of a British play adaptation dealing with accusations of homosexuality, *Serious Charge*, in 1955. See Anthony Aldgate, 'From Script to Screen: *Serious Charge* and Film Censorship', in Ian MacKillop and Neil Sinyard (eds), *British Cinema in the 1950s: A Celebration* (Manchester and New York: Manchester University Press, 2003), pp. 133–42.

72. Watkins to distributor, 25 January 1954, BBFC file: *The Wild One*.

73. Watkins to distributor, 23 July 1954, BBFC file: *The Wild One*.

74. Harris to Sir David Griffiths, President of the Kinematograph Renters' Society, 7 January 1955, BBFC file: *The Wild One*. Dilys Powell, who had publicly criticised the BBFC for passing *No Orchids*, this time offered her support in resistance to *The Wild One*. *Sunday Times*, 1 May 1955.

75. Watkins to distributor, 31 March 1955, BBFC file: *Cell 2455 Death Row*.

76. Watkins to Thorpe, 6 May 1955, BBFC file: *Rebel without a Cause*.

77. The Board initially rejected *Blackboard Jungle* on 15 March 1955 due to sensitivity surrounding the film's theme of the perceived ineffectiveness of authority figures in the face of unruly teenagers in a school setting, before passing it 'X' on 15 August that year with cuts.

78. Unsigned note, BBFC file: *Rebel without a Cause*.

79. Watkins to distributor, 17 October 1955, BBFC file: *Rebel without a Cause*.

80. Distributor to Watkins, 25 October 1955; distributor to Watkins, 8 November 1955, BBFC file: *Rebel without a Cause*.

81. Watkins to Harris, 21 November 1955, BBFC file: *Rebel without a Cause*.

82. Harris to Watkins, 22 November 1955, BBFC file: *Rebel without a Cause*.

83. Distributor to Watkins, 30 November 1955, BBFC file: *Rebel without a Cause*.

84. Nicholas Ray to Watkins, 10 December 1955, BBFC file: *Rebel without a Cause*.

85. Watkins to Ray, 15 December 1955, BBFC file: *Rebel without a Cause*.

86. Examiner's report, 12 April 1976, BBFC file: *Rebel without a Cause*.

87. Watkins to distributor, 23 May 1956, BBFC file: *Crime in the Streets*.

88. BBFC, *Minutes of Exceptions 1957* (February).

89. Ibid. (March).

90. Ibid. (June).

91. Examiner's report, 28 November 1956, BBFC file: *Runaway Daughters*.

92. See for example Nicholls to E. W. Newberry, Public Control Dept, LCC, 22 August 1957, BBFC file: *Runaway Daughters*. Fellow exploiteer E. J. Fancey was not as successful with the American thriller *City Jungle*, which had been unanimously rejected by the Board when originally submitted as *Violated* four years earlier (3 September 1953). It was again refused a certificate by the BBFC and later (28 March 1958) by the LCC when the Council read the examiner's report stating:

 [I]ts obvious emphasis on sex-mania, exemplified by leering men, half-naked dancers, prostitutes and rapists, with sex-murder by a hair-fetishist pervert, whilst law and order were represented by a bullying and inefficient police force and a psychiatrist who sides with the maniac, made this film totally unsuitable for public exhibition in this country.

 Nicholls to Fancey, 10 November 1957.

93. Nat Miller to BBFC, 12 January 1959, BBFC file: *Runaway Daughters*.

94. BBFC to Nat Miller, 16 January 1959, BBFC file: *Runaway Daughters*.

95. Miller would have been aware of the way International Film Distributors had enjoyed partial success with the same tactic after *Chained for Life* (1952) – based on the extraordinary story of conjoined twins Daisy and Violet Hamilton, one of whom had escaped punishment for the murder of the other's husband because it would have entailed the suffering of her innocent sibling – had been branded by a BBFC's examiner's report (23 July 1952) as 'sensationalism of the lowest kind' and denied a certificate. Although rejected by many local authorities, it was given 'U' certificates in Glasgow and Newcastle.

96. BBFC to local authorities, various dates, BBFC file: *Garden of Eden*.

97. These statistics are derived from correspondence in the BBFC file for *Garden of Eden*.

98. Secretary's note, 14 February 1957, BBFC file: *Garden of Eden*. Circular to local authorities, March 1957. For press and public reaction, see: John Champ. 'The Biggest Censor Chaos Yet', *Picturegoer*, 5 January 1957; 'Inconsistency Brings Censorship into Contempt', *Kinematograph Weekly*, 24 January 1957; 'No Sin in Eden', *South Wales Evening Post*, 18 July 1957.

99. Examiner's note, 12 February 1957, BBFC file: *Garden of Eden*.

100. Ibid.

101. He qualified this assertion by arguing that the cinema provides 'entertainment to which parents take their children' and this 'fact governs the approach of the Board to censorship questions'. *Financial Times*, 23 September 1957. Watkins by this time was safely ensconced in an executive role at the British Film Producers' Association.

102. Trevelyan to licensing authorities, 29 July 1958, BBFC file: *Garden of Eden*.

103. Daniel Angel to Watkins, 26 September 1951, BBFC file: *Women of Twilight*.

104. Watkins to Angel, 2 October 1951, BBFC file: *Women of Twilight*.

105. President's note, 30 April 1952, BBFC file: *Women of Twilight*.

106. *Daily Mirror*, 16 January 1953. See also: *Evening News*, 15 January 1953; *Daily Telegraph*, 19 January 1953.

107. The third was J. Lee Thompson's *The Yellow Balloon* (1953), a child-in-danger thriller for which Associated British eventually managed to negotiate a reclassification to the 'A' category. Unfortunately the BBFC file on this film no longer survives.

108. Reader's report, 25 May 1952, BBFC file: *Cosh Boy*.

109. Reader's report, 26 May 1952, BBFC file: *Cosh Boy*.

110. Ibid.

111. Ibid.

112. Memo from Watkins to BBFC President, 4 June 1952, BBFC file: *Cosh Boy*.

113. Watkins to Angel, 6 June 1952, BBFC file: *Cosh Boy*.

114. Angel to Watkins, 9 September 1952, BBFC file: *Cosh Boy*.

115. *Sunday Dispatch*, 11 January 1953. The influential critic Jympson Harman also called for a total ban. '*Cosh Boy* Is No Laughing Matter', *Picturegoer*, 2 May 1953.

116. *Evening Standard*, 5 February 1953, and *News Chronicle*, 7 February 1953 respectively.

117. Member of the public to BBFC, 19 February 1953, BBFC file: *Cosh Boy*. See also the correspondence between

Watkins and representatives of Council of Women's Kindred Societies, 12–16 March 1953.

118. Watkins to Clerk of Cumberland County Council, 3 March 1953, BBFC file: *Cosh Boy*. He did at least have the support of the *Sunday Graphic*, which warned against allowing the outcry against *Cosh Boy* to turn movies into 'nursery fodder, full of a never-never purity that is both sticky and false'. 'Films Don't Make Thugs', *Sunday Graphic*, 8 February 1953.

119. Harris to distributor, 18 March 1953, BBFC file: *Cosh Boy*.

120. *Beckenham Journal*, 22 April 1953. Letter from Desmond Davies to *Birmingham Mail*, 17 March 1953.

121. *Luton News*, 26 June 1953.

122. See for example '"Cosh Boy" Film Must Not Be Shown in Nottingham', *Nottingham Evening News*, 6 May 1953, and 'Coventry Bans Film: "Slurs Youth Clubs"', *Birmingham Gazette*, 18 May 1953.

123. For discussion of other notable censorship cases such as *Spare the Rod* (1961) and *I Am a Camera* (1955), see Anthony Aldgate, *Censorship and the Permissive Society: British Cinema and Theatre 1955–1965* (London: Clarendon Press, 1995); and Harper and Porter, *British Cinema in the 1950s*, pp. 229–31.

124. Examiner's report, 26 February 1952, BBFC file: *Intimate Relations*.

125. Examiner's report, 26 February 1952, BBFC file: *Intimate Relations*.

126. Distributor to Watkins, 5 April 1952, BBFC file: *Intimate Relations*.

127. Watkins to David Dent, 28 April 1952, BBFC file: *Intimate Relations*.

128. President's note, 22 May 1952, BBFC file: *Intimate Relations*.

129. D. Dent to Breen, 27 August 1952; Breen to Dent, 15 September 1952, BBFC file: *Intimate Relations*.

130. D. Dent to Watkins, 2 October 1952; Watkins to Dent, 15 October 1952, BBFC file: *Intimate Relations*.

131. Arthur Dent to Watkins, 17 October 1952, BBFC file: *Intimate Relations*.

132. 'Mother-love and the Censor', *Evening News*, 9 December 1952.

133. Ibid.

134. Examiners' reports, 17 and 22 February 1953, BBFC file: *Intimate Relations*.

135. Watkins to A. Dent, 20 January 1954, BBFC file: *Intimate Relations*.

136. Reader's report, 2 November 1954, BBFC file: *Yield to the Night*. Sidney Harris commented: 'This seems to me so brilliant a tour-de-force in imaginative thinking that I could wish that Joan Henry had devoted her obvious literary gifts to a less morbid subject.' President's note, 6 November 1954.

137. Watkins to Kenneth Harper, 11 November 1954, BBFC file: *Yield to the Night*.

138. Steve Chibnall, *J. Lee Thompson* (Manchester: Manchester University Press, 2000), pp. 70–5.

139. Examiner's report, 15 January 1955, BBFC file: *Yield to the Night*.

140. Watkins to Harper, 27 January 1955, BBFC file: *Yield to the Night*.

141. See particularly Harper to Watkins, 8 November 1955; and Watkins to Harper, 9 November 1955, BBFC file: *Yield to the Night*: '[A] great deal can be done, and should be done, by your people to prevent and damp down an undesirable association of the film with a certain case.'

142. Wayne Kinsey, *Hammer Films: The Bray Studio Years* (London: Reynolds and Hearn, 2002).

143. Reader's report, 21 June 1956, BBFC file: *The Curse of Frankenstein*.

144. Watkins to Hammer production manager Tommy Lyndon-Haynes, 10 September 1954, BBFC file: *The Quatermass Xperiment*. See also Kinsey, *Hammer Films*, p. 34.

145. Reader's report, 2 May 1956, BBFC file: *Quatermass 2*.

146. Reader's report, 24 November 1955, BBFC file: *X the Unknown*.

147. Reader's report, 14 October 1957, BBFC file: *Dracula*.

148. President's note, 30 November 1955, BBFC file: *X the Unknown*. See also Kinsey, *Hammer Films*, pp. 41–3.

149. Anthony Hinds to Watkins, 6 December 1955, BBFC file: *X the Unknown*.

150. James Carreras to Watkins, 13 June 1956; Watkins to Carreras, 14 June 1956, BBFC file: *The Curse of Frankenstein*.

151. President's note, 16 October 1956; Field to Hinds, 19 October 1956, BBFC file: *The Curse of Frankenstein*. See also Kinsey, *Hammer Films*, pp. 62–3.

152. Hinds to Watkins, 24 October 1956, BBFC file: *The Curse of Frankenstein*.

153. As Audrey Field put it on reading the script for *Dracula*: 'The curse of the thing is Technicolor blood: why need vampires be messier feeders than anyone else?' Reader's report, 14 October 1957, BBFC file: *Dracula*.

154. Carreras to Nicholls, 14 February 1958, BBFC file: *Dracula*.

155. For example, this is from the cuts list for *20 Million Miles to Earth*: 'Delete shot of man driving pitchfork into monster's back and of monster's reaction in both sound and picture. [...] Remove sound of monster screaming when net is dropped on him.' BBFC, *Minutes of Exceptions 1957* (July).

156. See, for example, Trevelyan's note, 10 April 1958, BBFC file: *Dracula*.

157. Nicholls to Raymond Stross, 20 June 1957, BBFC file: *The Flesh Is Weak*. It was still usual to remove references to prostitution from 'A' films at this time.

158. 'Local Censors', *Tit-Bits*, 16 November 1957.

159. Ibid.

160. *Kinematograph Weekly*, 29 December 1955.

Case Study: THE SNAKE PIT

161. Arthur Watkins, BBFC to distributor, 19 April 1949, BBFC file: *The Snake Pit*. All other citations in this case study come from the same file.

162. J. Brooke Wilkinson, BBFC to distributor, 14 August 1946.

163. Watkins to distributor, 18 February 1949.

164. Watkins to the Film Control Commission, Brussels and to Statens biografbyrå, Stockholm, 1 March 1949.

165. Note on file by Watkins, 3 March 1949.

166. Note on file by Watkins, 8 March 1949.
167. Note on file by Watkins, 11 March 1949.
168. Ibid.
169. Note on file by Watkins, 15 March 1949.
170. Note on file by Watkins, 18 March 1949.
171. Note on file by Watkins, 1 April 1949.
172. Note on file by Watkins, 4 April 1949.
173. Note on file by Watkins, 11 April 1949.
174. Examiner's report, 22 July 2004.

Case Study: CAGED

175. Lizzie Francke, *Script Girls: Women Screenwriters in Hollywood* (London: BFI, 1994), p. 73.
176. Examiner's report, 11 May 1950, BBFC file: *Caged*. All remaining citations in this case study come from the same file unless otherwise stated.
177. Arthur Watkins, BBFC to distributor, 18 May 1950.
178. Examiner's report, 11 May 1950.
179. Watkins to distributor, 18 May 1950.
180. Examiner's report, 11 May 1950.
181. Note on file, 12 May 1950.
182. Watkins to distributor, 18 May 1950.
183. Distributor to Watkins, 23 May 1950.
184. Watkins to distributor, 25 May 1950.
185. Watkins to distributor, 12 June 1950.
186. Watkins to distributor, 22 June 1950.
187. Distributor to Watkins, 10 July 1950.
188. Watkins to distributor, 21 July 1950.
189. 'Screen Sensationalism: Need for Category "X"', *The Times*, 29 September 1950.

Notes to Chapter 4

1. Review of *A Kind of Loving*, *John o'London's*, 19 April 1962.
2. Matt Houlbrook, *Queer London: Perils and Pleasures in the Sexual Metropolis, 1918–1957* (London and Chicago, IL: University of Chicago Press, 2005), p. 242.
3. John Sutherland, *Offensive Literature: Decensorship in Britain, 1960–1982* (Totowa, NJ: Barnes and Noble, 1982).
4. John Trevelyan, 'Film Censorship in Great Britain', *Screen* vol. 11 no. 3, 1970, pp. 19–30; p. 25.
5. Alexander Walker, Preface, in John Trevelyan, *What the Censor Saw* (London: Michael Joseph, 1973), p. 13.
6. Alexander Walker, *Sex in the Movies: The Celluloid Sacrifice* (Harmondsworth: Penguin, 1968), p. 161.
7. Anthony Aldgate, *Censorship and the Permissive Society: British Cinema and the Theatre 1955–1965* (Oxford: Clarendon Press, 1995), p. 41.
8. John Woolf recalled all these details in a letter to the historian Arthur Marwick, 4 June 1984, BBFC file: *Room at the Top*.
9. Tony Richardson, *Encounter* vol. 15 no. 3, 1960, p. 65.
10. John Trevelyan's handwritten note (15 October 1958) appended to a letter from John Woolf, 14 October 1958, BBFC file: *Room at the Top*.
11. Woolf to Trevelyan, 14 October 1958, BBFC file: *Room at the Top*. The American National Legion of Decency criticised the film: 'The treatment involves gross suggestiveness in costuming, dialogue and situations. It moreover tends to arouse undue sympathy for an adulteress.' Unidentified press clipping attached to letter, BBFC file: *Room at the Top*.
12. Woolf to Trevelyan, 14 October 1958. Alexander Walker's description of 'moral compensation' explains Woolf's position: '[E]very sin the characters commit must be compensated for by their punishment or repentance, or both.' *Sex in the Movies*, p. 169.
13. Claire Langhamer, 'Adultery in Post-War England', *History Workshop Journal* vol. 62 no. 1, 2006, pp. 86–115; p. 99.
14. Walker, *Sex in the Movies*, p. 165.
15. Aldgate, *Censorship and the Permissive Society*, p. 41.
16. Trevelyan to distributor, 19 September 1958, BBFC file: *Look Back in Anger*.
17. Adrian Bingham, *Family Newspapers? Sex, Private Life and the British Popular Press 1918–1978* (Oxford: Oxford University Press, 2009), p. 86.
18. Ibid., p. 87. Along with Marjorie Proops, Bingham lists Anne Allen (*Sunday Mirror*), Dee Wells (*Daily Herald*), Monica Furlong (*Daily Mail*), Anne Batt (*Daily Express*), Lena Jeger (*Guardian*) and Katherine Whitehorn (*Observer*), pp. 86–7.
19. Alan Sillitoe, *Life without Armour* (London: Robson Books, 2004), p. 258.
20. Ibid., p. 259.
21. Trevelyan to Harry Saltzman, 24 November 1959, BBFC file: *Saturday Night and Sunday Morning*. The BBFC's response to *Alfie* in 1966 was different altogether: writing to the Department of Education in Bermuda, Trevelyan told D. J. Williams that 'we all felt that [*Alfie*] was very moral in its message and would show young people that "sleeping around" produces nothing of permanent value'.
26 September 1966, BBFC file: *Alfie*. To the Reverend Alan Stephens, he suggested that

> I should emphasise that in its abortion scene, which is played with great sincerity, it does bring home to the young that abortion is not a casual business and that it involves the taking of a tiny human life, an incident which shocks our young hero into the realization of what he has caused.

29 March 1966, BBFC file: *Alfie*. Trevelyan was responding to a letter to the Editor that the Reverend Stephens had sent to the *Evening Standard*.
22. Trevelyan to Bryan Forbes, 11 April 1962, BBFC file: *The L-Shaped Room*.
23. Examiner's report, 30 April 1964, BBFC file: *The Pumpkin Eater*.
24. Member of the public to BBFC, 28 October 1965, BBFC file: *Darling*.
25. Trevelyan to member of the public, 3 November 1965, BBFC file: *Darling*.
26. Trevelyan to Stephens, 29 March 1966, BBFC file: *Alfie*.
27. Guy Hamilton to Trevelyan, 9 September 1963, BBFC file: *The Party's Over*.

28. Trevelyan to Hamilton, 16 September 1963, BBFC file: *The Party's Over*.
29. Examiner's report, 20 November 1959, BBFC file: *Saturday Night and Sunday Morning*.
30. Examiner's report, 24 September 1964, BBFC file: *Darling*.
31. BBC Written Archives Centre, VR/57/643, *Lifeline*, 'The Problem of the Homosexual', 26 November 1957. Eirene White, MP for East Flint, also described homosexuality as 'baffling'. Hansard HC Deb 29 June 1960 vol. 625 cc 1453–514. http://hansard.millbanksystems.com/commons/1960/jun/29/wolfenden-report-part-two.
32. Trevelyan to Janet Green, 1 July 1960, BBFC file: *Victim*.
33. Trevelyan to Michael Relph, 18 May 1960, BBFC file: *Victim*.
34. Hansard HC Deb 29 June 1960 vol. 625 cc 1453–514.
35. Relph to Trevelyan, 12 May 1960, BBFC file: *Victim*.
36. For a broader discussion about the Wolfenden Report and the kinds of privileged testimonials he received, see Houlbrook, *Queer London*, pp. 241–63.
37. Trevelyan to Relph, 18 May 1960, BBFC file: *Victim*.
38. This was in relation to *A Taste of Honey*: 'I don't think [Geoff] can help his character being "betwixt and between": the young man in *I Am a Camera* was much the same, and that was before we had opened our doors to "homos".' Undated examiner's report, BBFC file: *A Taste of Honey*.
39. Examiner's report, 29 June 1960, BBFC file: *Victim*.
40. The cut is listed in the BBFC *Minutes of Exceptions 1960* (May).
41. Trevelyan to Green, 1 July 1960, BBFC file: *Victim*.
42. Examiner's report, 16 May 1960, BBFC file: *Victim*.
43. John Coldstream, *Victim* (London: BFI, 2011), p. 15.
44. Reader's report, 29 June 1960, BBFC file: *Victim*.
45. Hansard HC Deb 29 June 1960 vol. 625 cc 1453–514.
46. Examiner's report, 8 November 1988, BBFC file: *A Kind of Loving*.
47. Examiner's report, 12 May 1961, BBFC file: *Victim*.
48. Trevelyan to Relph, 15 May 1961, BBFC file: *Victim*.
49. Examiner's report, 12 May 1961, BBFC file: *Victim*.
50. Coldstream cites Green's letter to Relph and Dearden: 'Our experience with you both on this subject has been one of destroy, experiment, experiment, destroy again.' *Victim*, p. 31. Green to Trevelyan, 12 September 1961, BBFC file: *Victim*.
51. Trevelyan to Green, 13 September 1961, BBFC file: *Victim*.
52. This was reported in both the *Daily Mail* and the *Daily Telegraph*, 17 November 1961.
53. *Films and Filming*, October 1961.
54. Derek Hill, 'The Habit of Censorship', *Encounter* vol. 15 no. 1, 1960, pp. 52–62; p. 59.
55. The MP Stephen Swingler had asked for an enquiry:

 In view of the concern about horror films and the abuse of the X certificate, the anomaly of continuing censorship of cinemas and having no censorship of television, and in view of the ridiculous farce of so-called censorship of plays, surely the time has come to have some form of general enquiry about the future of censorship in the country?

 Hansard HC Deb 14 July 1960 vol. 626 cc 1569–70. http://hansard.millbanksystems.com/commons/1960/jul/14/censorship. Hill, 'The Habit of Censorship' was the article cited.
56. John Osborne, *Encounter* vol. 15 no. 3, 1960, p. 64.
57. Hamilton to Trevelyan, 9 September 1963; Trevelyan to Hamilton, 16 September 1963, BBFC file: *The Party's Over*. Trevelyan explained to Hamilton that the *News of the World* had linked *The Party's Over* with a film based on the Profumo scandal, *The Keeler Affair* (1963):

 I merely suggested this kind of publicity, especially illustrated as it was in each case by a most undesirable 'still', would be likely to provoke critical and adverse reactions. There was certainly no idea in my mind, or at the Board, that your film attacked the establishment. Honestly, this never occurred to me, and if it had I would not have worried about it.

58. Trevelyan, 'The Censor's Reply', *Encounter* vol. 15 no. 3, 1960, p. 63.
59. Trevelyan, *What the Censor Saw*, p. 20.
60. Sutherland, *Offensive Literature*, p. 36.
61. Trevelyan to Albert Zugsmith, 29 February 1964, BBFC file: *Fanny Hill*.
62. Trevelyan to the Town Clerk, Worcester, 9 August 1965, BBFC file: *Fanny Hill*.
63. Trevelyan correspondence, 8 July 1965, BBFC file: *Fanny Hill*.
64. Examiner's report, 17 August 1964, BBFC file: *Fanny Hill*.
65. Trevelyan to Philip Ridgeway, 21 August 1964, BBFC file: *Fanny Hill*.
66. Trevelyan to David Pelham, 18 September 1964, BBFC file: *Fanny Hill*. The name echoed that of Lord Denning, who produced the report on the Profumo affair.
67. Trevelyan outlined a full list of objections in his letter to Pelham, 18 September 1964, BBFC file: *Fanny Hill*.
68. Trevelyan handwritten note, 18 September 1964, BBFC file: *Fanny Hill*.
69. Sutherland, *Offensive Literature*, p. 30.
70. Ibid., p. 37.
71. Trevelyan, 'Film Censorship', p. 27.
72. Ibid.
73. Trevelyan internal memo, 24 November 1960, BBFC file: *Lolita*.
74. Examiner's report, 31 August 1962, BBFC file: *Ulysses*.
75. Examiner's report, 30 August 1962, BBFC file: *Ulysses*.
76. Examiner's report, 21 June 1962, BBFC file: *Ulysses*.
77. Undated examiner's report for the first draft of the Joseph Strick/Fred Haines script, originally presented to the Board in 1962, BBFC file: *Ulysses*.
78. Strick to Trevelyan, 2 June 1965, BBFC file: *Ulysses*. He reiterated the point in a letter to Trevelyan in 1969, accusing Trevelyan of implying that his version of Molly's monologue 'was not wholly from Joyce' and asking whether the BBFC would consider passing the film uncut with an 'X'. Trevelyan replied that Lord Harlech, President of the Board, was 'not prepared to reopen the matter'. 9 January 1969, BBFC file: *Ulysses*.

79. Examiner's report, 7 June 1965, BBFC file: *Ulysses*.
80. Confidential memo, 16 February 1967, BBFC file: *Ulysses*.
81. Ibid.
82. Ibid.
83. Trevelyan private memo, 9 March 1967, BBFC file: *Ulysses*.
84. Anne Scott-James, *Daily Mail*, 23 February 1967.
85. Trevelyan to Anne Scott-James, 28 February 1967, BBFC file: *Ulysses*.
86. Trevelyan to distributor, 28 March 1967, BBFC file: *Ulysses*.
87. *Brighton and Hove Herald*, 26 April 1968, BBFC file: *Ulysses*.
88. Trevelyan to the Editor, *Brighton and Hove Herald*, 7 May 1968, BBFC file: *Ulysses*.
89. Trevelyan to O. J. Silverthorne, 20 March 1967, BBFC file: *Ulysses*.
90. Examiner's report, undated, BBFC file: *The Killing of Sister George*.
91. BBFC *Minutes of Exceptions 1961* (March).
92. Trevelyan to Forbes, BBFC file: *The L-Shaped Room*.
93. Trevelyan to distributor, 24 February 1969, BBFC file: *The Killing of Sister George*.
94. Ibid.
95. Tom Dewe Mathews, *Censored: The Story of Film Censorship in Britain* (London: Chatto & Windus, 1994), p. 183.
96. Trevelyan to the Clerk of the County Council, Beverley, 8 October 1969, BBFC file: *The Killing of Sister George*.
97. The distributor's draft statement for the press was sent with correspondence from the distributor to the BBFC. 13 March 1969, BBFC file: *The Killing of Sister George*.
98. Trevelyan to distributor, 1 July 1970, BBFC file: *The Killing of Sister George*.
99. Walker, *Sex in the Movies*, p. 175.
100. Trevelyan. *What the Censor Saw*, p. 116.
101. Ibid., p. 118.
102. Sian Barber '"Blue is the Pervading Shade": Re-examining British Film Censorship in the 1970s', *Journal of British Cinema and Television* vol. 9 no. 3, 2009, pp. 349–69; p. 355.
103. Trevelyan to Larry Kramer, 13 August 1968, BBFC file: *Women in Love*.
104. Kramer to Trevelyan, 8 July 1969, BBFC file: *Women in Love*.
105. Trevelyan letter, 27 February 1970, BBFC file: *Women in Love*.
106. Dewe Mathews, *Censored*, p. 193.
107. Julian Wintle to Trevelyan, 16 January 1963, BBFC file: *This Sporting Life*.
108. Trevelyan to Lindsay Anderson, 1 July 1968, BBFC file: *If….*
109. Anderson to Trevelyan, 25 August 1968, BBFC file: *If….*
110. Ibid.
111. Examiner's note, 6 November 1968, and Trevelyan to Michael Medwin, 28 November 1968, BBFC file: *If….*
112. Trevelyan to Anderson, 1 July 1968; Anderson to Trevelyan, 25 August 1968, BBFC file: *If….*
113. Trevelyan letter, February 1970, BBFC file: *Women in Love*.
114. Trevelyan to Harlech, 26 November 1968, BBFC file: *If….* There was a precedent: in his memoir, Trevelyan noted that the Swedish film *Puss & kram* (*Hugs and Kisses*, 1967)

had been the first film screened to have full frontal nudity in it. Trevelyan, *What the Censor Saw*, p. 102.
115. Trevelyan to Rank, 6 April 1967, BBFC file: *Blowup*.
116. Trevelyan to distributor, 24 January 1968, BBFC file: *I Am Curious (Yellow)*.
117. Ibid.
118. John Johnston, *The Lord Chamberlain's Blue Pencil* (London: Hodder and Stoughton, 1990), p. 29.
119. Cited in Robert Hewison, *Too Much: Art and Society in the Sixties 1960–1975* (London: Methuen, 1986), p. 26.
120. Trevelyan, *What the Censor Saw*, p. 178.
121. Scott-James, *Daily Mail*, 23 February 1967.
122. Harlech to Michael Jopling, 17 June 1969, responding to a constituent's complaint about Satanism in *Rosemary's Baby*, BBFC file: *Rosemary's Baby*.
123. Trevelyan, *What the Censor Saw*, p. 203.
124. Dewe Mathews, *Censored*, p. 147.

Case Study: CAPE FEAR

125. Examiner's report, 19 March 1962, BBFC file: *Cape Fear*. All other citations in this case study come from the same file unless otherwise stated.
126. Examiner's report, 19 March 1962.
127. Expert opinion, 27 March 1962.
128. John Trevelyan to distributor, 3 April 1962.
129. Distributor to Trevelyan, 4 April 1962.
130. Cablegram from J. Lee Thompson to Trevelyan, 12 April 1962.
131. Trevelyan, *What the Censor Saw*, p. 73.
132. Trevelyan to Lee Thompson, 4 May 1962.
133. Lee Thompson to Trevelyan, 11 May 1962.
134. Trevelyan, *What the Censor Saw*, p. 73.
135. Lee Thompson to Trevelyan, 11 May 1962.
136. Lee Thompson to Trevelyan, 24 May 1962.
137. Roderick Mann, 'Mr. Peck Finds Hollywood A Dull Town Now', *Sunday Express*, 16 December 1962.
138. Trevelyan to distributor, 31 May 1962.
139. Examiner's report, 4 July 1991.

Case Study: BLOWUP

140. In an earlier Antonioni film, *I vinti* (*The Vanquished*, 1953), which was a trio of short films united by a common theme, one of the stories had been in English. Incidentally, the Board had rejected this film (though there is no file to explain its reason for doing so).
141. See, for example, 'Vanessa [Redgrave] Film Banned in America', *Daily Mail*, 30 December 1966.
142. See, for example, 'Vanessa's "Sexy" Film Is Banned', *Daily Mirror*, 30 December 1966; 'Antonioni film condemned', *Catholic Herald*, 6 January 1967.
143. See, for example, 'Vanessa Faces up to the Stark Facts of Art for Art's Sake …', *London Life*, 15 October 1966; 'A London Nobody Knows', *Daily Telegraph*, 13 January 1967.
144. 'A London Nobody Knows'.
145. 'Vanessa Film Banned in America'; 'Like I Loathed It, Man …', *Daily Mirror*, 15 March 1967; 'Stoical Antonioni', *Evening Standard*, 18 March 1967.

146. 'Like I Loathed It, Man …'.
147. 'BLOW-UP: Imagine "Darling" – Masculine Style', *Daily Express*, 20 January 1967.
148. Trevelyan, *What the Censor Saw*, p. 115.
149. Examiner's report, 13 January 1967, BBFC file: *Blowup*.
150. Cited in ibid.
151. Trevelyan, *What the Censor Saw*, p. 115.
152. See, for example, Roger Ebert, 'Blow-Up (1966)', rogerebert.com, 8 November 1998, http://rogerebert. suntimes.com/apps/pbcs.dll/article?AID=/19981108/ REVIEWS08/401010304/1023; David Thomson, *'Have You Seen …?': A Personal Introduction to 1,000 Films* (London: Allen Lane, 2008), p. 108.
153. Examiner's report, 13 January 1967, BBFC file: *Blowup*.
154. Note from Trevelyan, BBFC, 17 January 1967, BBFC file: *Blowup*.
155. Ibid.
156. Ibid.
157. Trevelyan to Bosley Crowther, 13 February 1967, BBFC file: *Blowup*.

Notes to Chapter 5

1. The chapter title is borrowed from the 1973 album by the Grateful Dead.
2. John Trevelyan, BBFC to Greater London Council, 19 November 1969, BBFC file: *The Wife Swappers*.
3. Examiner's report, 23 October 1987, BBFC file: *The Wife Swappers*.
4. Staff at the Board nickname the *Minutes of Exceptions* the 'Blue Books' after their navy blue covers.
5. Thanks to Heather Graves for help with archive and database research.
6. John Trevelyan, *What the Censor Saw* (London: Michael Joseph, 1973), p. 64.
7. For *The Devils*, see James C. Robertson, *The Hidden Cinema: British Film Censorship in Action, 1913–1975* (London: Routledge, 1989), Chapter 4 and Guy Phelps, *Film Censorship* (London: Gollancz, 1975), Chapter 4; for *A Clockwork Orange*, see Peter Krämer, *Controversies: A Clockwork Orange* (Basingstoke: Palgrave Macmillan, 2011); for *Straw Dogs*, see Stevie Simkin, *Controversies: Straw Dogs* (Basingstoke: Palgrave Macmillan, 2011).
8. Tom Dewe Mathews, *Censored: The Story of Film Censorship in Britain* (London: Chatto & Windus, 1994), p. 189.
9. Amy C. Whipple, 'Speaking for Whom? The 1971 Festival of Light and the Search for the "Silent Majority"', *Contemporary British History* vol. 24 no. 3, September 2010, pp. 319–39, p. 319.
10. From an article in the *Sunday Telegraph*, 27 February 1972, BBFC file: *Straw Dogs*.
11. Trevelyan, *What the Censor Saw*, p. 214.
12. Stephen Murphy, BBFC to member of the public, 7 February 1972, BBFC file: *Straw Dogs*.
13. Murphy to member of the public, 10 June 1974, BBFC file: *The Canterbury Tales*.
14. Cited in Trevelyan, *What the Censor Saw*, p. 221.
15. Phelps, *Film Censorship*, p. 179.
16. Ibid., pp. 210–11.
17. Trevelyan, *What the Censor Saw*, p. 204.
18. Robertson, *The Hidden Cinema*, pp. 135–6.
19. Ibid., p. 148.
20. Krämer, *Controversies: A Clockwork Orange*, pp. xi–xvi.
21. Fergus Cashin, 'Terror Films Shock Critics', *Sun*, 7 January 1972.
22. Margaret Hinxman, 'Blood and Blunder' (*Straw Dogs* review), *Sunday Telegraph*, 28 November 1971.
23. Alexander Walker, 'After This, Anything Goes …' (*Straw Dogs* review), *Evening Standard*, 26 November 1971.
24. Cited in Mathews, *Censored*, p. 205.
25. Walker, 'After this …'.
26. Krämer, *Controversies: A Clockwork Orange*, p. 93.
27. Dilys Powell, 'The Cinema in Danger' (*Straw Dogs* review), *The Times*, 28 November 1971.
28. Cited in Phelps, *Film Censorship*, p. 81.
29. 'The Rising Tide of Violence', *Sun,* 7 January 1972, pp. 16–17.
30. Cited in Phelps, *Film Censorship*, p. 78.
31. Murphy & Lord Harlech, BBFC to *The Times*, 20 December 1971.
32. Robertson, *The Hidden Cinema*, pp. 150–1.
33. Michael Winner to BBFC, 28 April 1972, BBFC file: *Chato's Land*.
34. Murphy to Winner, 16 May 1972, BBFC file: *Chato's Land*.
35. Murphy to distributor, 1 June 1973, BBFC file: *Bloody Friday*.
36. Ibid.
37. Mark Patterson, cited in Phelps, *Film Censorship*, p. 76.
38. Press book, copy in BBFC file: *Love Variations*.
39. Trevelyan to member of the public, 9 April 1970, BBFC file: *Love Variations*.
40. Halifax County Council to BBFC, 8 December 1970, BBFC file: *Love Variations*.
41. Trevelyan to Halifax County Council, 10 December 1970, BBFC file: *Love Variations*.
42. Letter from BBFC to local authorities, undated draft, probably November 1970, BBFC file: *Love Variations*.
43. Phelps, *Film Censorship*, p. 76.
44. Robertson, *The Hidden Cinema*, pp. 140–1.
45. GLC to distributor, 10 April 1974, BBFC file: *The Bloody Fists*.
46. Murphy to Brighton Borough Council, 19 October 1972, BBFC file: *Daddy Darling*.
47. It should be noted that all the tables in this chapter refer to the number of films cut for particular kinds of controversial material; in this sense, the statistics are indicators, and not strictly quantitative, since they do not take account of the *amount* of material, or how 'offensive' it might have been deemed at the time.
48. Murphy to distributor, 11 May 1973, BBFC file: *A Bay of Blood*.
49. Murphy to distributor, 19 September 1974, BBFC file: *Arabian Nights*.
50. The examiner's report remarks, 'The drawing of a jug of blood is pretty disgusting, and all the shots of bits of human carcass are prohibitive.' 14 June 1973, BBFC file: *A Candle for the Devil*.

51. Exception form, 14 January 1974, BBFC file: *The Living Dead at the Manchester Morgue*.
52. BBFC, *Minutes of Exception 1971* (May)
53. BBFC, *Minutes of Exception 1975* (March).
54. *Enter the Dragon* was cut for its 1973 release and was recalled in 1979 to remove another scene featuring chainsticks (or nunchaku). For home video in 1988, some cuts were waived but the chainstick sequences remained unacceptable to the Board; some footage was restored in 1993, but a twenty-one-second cut of footage which the Board felt glamorised the use of the weapon still applied. An uncut version would finally be passed in 2001.
55. Exception form, February 1974, BBFC file: *The Big Boss*.
56. Murphy to distributor, 31 August 1973, BBFC file: *The Bloody Fists*.
57. BBFC, *Minutes of Exception 1974*. A note from examiners on an earlier martial-arts movie, *The Lady Hermit* (1971) is instructive: 'Because all the principal characters die in such a welter of blood and nasty detail […] we cannot, without establishing dangerous precedents, pass the picture X uncut and cuts would destroy continuity'. 22 June 1972, BBFC file: *The Lady Hermit*. The film was therefore rejected.
58. *Vampire Circus* (1972), for example, was passed at '18' for home video in 1987 and 2002, and at '15' in 2011; *Hands of the Ripper* was granted a '15' in 1987; *Dr. Jekyll & Sister Hyde* (1971), cut for cinema release, was given an '18' certificate uncut in 1990 and a '15' in 2004.
59. When James Ferman came to reconsider the film in the late 1970s, he would endorse Murphy's decision, pinpointing the extended scenes where women were targeted and subjected to prolonged terrorisation: 'Ferman described the film as "the pornography of terror", in that its intention seemed to be to invite the audience to revel in a vulnerable woman's distress, and concluded that the film could not be classified'. BBFC case study: *The Texas Chain Saw Massacre*, http://www.bbfc.co.uk.
60. Cited in Alexander Walker, *National Heroes: British Cinema in the Seventies and Eighties* (London: Harrop, 1985), p. 33.
61. Cited in Richard Maltby, *Hollywood Cinema – Second Edition* (Oxford: Blackwell, 2003), p. 177.
62. Lewis J. Rachmil, memo to Peckinpah and Melnick, 20 April 1971, from the Sam Peckinpah Collection, Margaret Herrick Library, Los Angeles, CA, folder 28-f.44.
63. In the 'Blue Books', exception reports and other documents, explicit sex is most often signalled by the term 'close copulation', or references to the male character 'between the legs' of a female character.
64. Phelps, *Film Censorship*, p. 127.
65. The context reveals that the reference is to a scene depicting heterosexual, not homosexual, mutual oral sex.
66. Examiner's report, 12 February 1973, BBFC file: *Love Play*.
67. It is worth noting that the Board's reluctance to pass scenes of anal sex was in part due to the fact that heterosexual buggery was still technically against the law at this time.
68. BBFC to distributor, 27 August 1974, BBFC file: *The Case of the Smiling Stiffs*.
69. Exception form, 21 March 1974, BBFC file: *The Naughty Stewardesses*. A note in the file indicates that the company wished to change the title to *The Naughty Sex Stewardesses;* the request was denied by the examiner and Murphy ('No – it's overkill').
70. Member of the public to BBFC, 4 March 1972, BBFC file: *Naughty*.
71. Sian Barber, '"Blue Is the Pervading Shade": Re-examining British Film Censorship in the 1970s', *Journal of British Cinema and Television* vol. 6 no. 3, 2009, pp. 349–69; p. 356.
72. Cited in ibid., pp. 353–4.
73. BBFC, *Minutes of Exception 1970* (June).
74. Exception form, 11 September 1974, BBFC file: *Eskimo Nell*.
75. See Simkin, *Controversies: Straw Dogs*, especially pp. 53–69.
76. The original note is dated 3 November, but the quoted addendum is undated. From BBFC file: *Straw Dogs*.
77. James Ferman would, after careful consideration, conclude that the rape scene was impossible to cut effectively, and choose instead to refuse the film a home-video certificate. The examiner viewing it on 27 May 1987 remarked,

 What is clear on re-viewing [from 1974] is that it's way beyond the current standards of sexual violence to women that we're currently using at the Board, even in the adult category. I don't think that there's any doubt that we've tightened up on sexual assault and violence to women in the last ten years, or at least since I've been at the Board, and it may well be that this film was stretching the limits of what we thought acceptable even in 1974. […] I hope what we have removed is the exploitative nudity and degradation to women, while leaving in enough of the rape to show how brutal and horrific it actually is.

78. Murphy to Winner, 16 September 1974, BBFC file: *Death Wish*.
79. Winner to Murphy, 12 September 1974, BBFC file: *Death Wish*.
80. Murphy to Winner, 16 September 1974, BBFC file: *Death Wish*.
81. *Death Wish* disappeared in the UK in its uncut form until 2006 (although a version with twenty-nine seconds of cuts would appear on VHS in 2000).
82. Murphy to distributor, 3 January 1972, BBFC file: *Wild Riders*.
83. BBFC to distributor, 7 January 1974, BBFC file: *The Candy Snatchers*.
84. BBFC to distributor, 20 November 1974, BBFC file: *The Last House on the Left*.
85. Examiner's report, 8 December 1975, BBFC file: *Bamboo House Dolls*.
86. The slap remained problematic on home-video submission in 1982. The examiner commented,

 I would still quite definitely demand a cut in Reel 4 where Mario slaps a girl twice round the face and then

immediately forces her head down to his crotch to fellate him, which he does off-camera. This is humiliating & degrading for the girl – dialogue over says 'you bitch' – & without question a sexual turn-on for men got at the expense of brutal humiliation. As a model of how to treat women it is deplorable.

Examiner's report, 9 November 1982, BBFC file: *Blood for Dracula*.

87. BBFC, *Minutes of Exception 1975* (April).
88. BBFC, *Minutes of Exception 1972* (January).
89. Cited in Robertson, *The Hidden Camera*, p. 137.
90. For proof of this, we need look no further than the report on the home-video submission of *Arabian Nights,* where the examiner remarks,

As, for the past decade at least, the Board has not been so ready to treat arthouse movies like Fiona Cooper tapes and to cut, mechanically, when a certain level of genital exposure is noted and, especially post-AI NO CORRIDA, I am suggesting that we pass this '18'.

91. Examiner's report, 23 March 1973, BBFC file: *The Demons*. It was, although a number of local authorities passed it, including the GLC, Birmingham, Coventry, Liverpool, Newcastle upon Tyne, Bristol, Coventry and Sheffield.
92. James Ferman, BBFC to distributor, 30 September 1976, BBFC file: *Ilsa, She Wolf of the SS*.
93. Trevelyan to distributor, 15 June 1970, BBFC file: *Bloody Mama*.
94. Murphy to GLC, 14 February 1974, BBFC file: *Bloody Fists*.
95. Murphy to distributor, 8 July 1974, BBFC file: *The Last House on the Left*.
96. Murphy to distributor, 1 June 1973, BBFC file: *Bloody Friday*.
97. As an indicator that recalibration could move in different directions over time, four years later, *Emmanuelle* would be hauled back in for further cuts in order to avoid falling foul of the OPA's 'deprave and corrupt' test (see Chapter 6).
98. Trevelyan to distributor, 15 June 1970, BBFC file: *Bloody Mama*. In the report prepared for home video certification, the examiner scrutinising *Bloody Mama* commented that '[i]t is […] salutary for censors to read the file and apprehend how pompously out of date our then utterances now seem' (30 April 1985).

Case Study: THE PANIC IN NEEDLE PARK

99. Examiner's report, 16 June 1971, BBFC file: *The Panic in Needle Park*. All other citations in this case study come from the same file unless otherwise stated.
100. John Trevelyan, BBFC to distributor, 16 June 1971.
101. Ibid.
102. Note added to examiner's report, 21 February 1972.
103. Ibid.
104. Stephen Murphy, BBFC to distributor, 22 February 1972.
105. *Trash* would be passed 'X' with cuts on 9 November 1972.
106. Handwritten note on file, 21 November 1974.
107. Examiner's report, 21 April 1987.
108. Examiner's report, 22 March 2002.

Case Study: WR – MISTERIJE ORGANIZMA (WR – MYSTERIES OF THE ORGANISM)

109. Distributor to John Trevelyan, BBFC, 11 June 1971, BBFC file: *WR – Mysteries of the Organism*. All other citations in this case study come from the same file unless otherwise stated.
110. Examiner's report, 21 June 1971.
111. Trevelyan to distributor, 22 June 1971.
112. Distributor to Trevelyan, 29 June 1971.
113. Examiner's report, 6 July 1971.
114. Stephen Murphy, BBFC to Lord Harlech, BBFC, 13 July 1971.
115. Internal note by Murphy, 11 August 1971.
116. Video submission form for BBFC classification from Stablecane Limited, 24 January 1986.
117. Internal note (unsigned), 28 January 1986.
118. Examiners' reports, 28 January 1986.
119. Raymond Durgnat, *WR – Mysteries of the Organism* (London, BFI, 1999), pp. 12–13.
120. Examiners' reports, 2 March 1995.

Case Study: A CLOCKWORK ORANGE

121. BBFC to studio, 2 June 1967, BBFC file: *A Clockwork Orange*.
122. Ibid.
123. Krämer, *Controversies: A Clockwork Orange*, p. 76.
124. Stephen Murphy, BBFC to Director of Administration, City of Leeds, 26 April 1974, BBFC file: *A Clockwork Orange*.
125. Ibid., p. 93. For a full discussion of the controversy surrounding the film in the US see Krämer, *Controversies: A Clockwork Orange*, pp. 94–100.
126. Whipple, 'Speaking for Whom?', pp. 319–39.
127. Murphy, to *The Times*, 2 May 1973, BBFC file: *A Clockwork Orange*.
128. Murphy to Dermot Breen, Irish Film Censor, 31 August 1973, BBFC file: *A Clockwork Orange*.
129. Derek Godfrey, 'Mugging Murder in Church Porch', *Evening News* (London) as quoted in Krämer, *Controversies: A Clockwork Orange*, p. 106.
130. Krämer, *Controversies: A Clockwork Orange*, p. 107.
131. Murphy to Breen, 31 August 1973, BBFC file: *A Clockwork Orange*.
132. Krämer, *Controversies: A Clockwork Orange*, p. 117.
133. Kathy Marks, 'Trial Fuels "Clockwork Orange" Controversy', *Independent*, 5 February 1993, http://www.independent.co.uk/news/uk/trial-fuels-clockwork-orange-controversy-1471070.html.
134. Heather Mills, 'Channel 4 to Use "Clockwork Orange" Scenes', *Independent*, 23 October 1993, http://www.independent.co.uk/news/uk/channel-4-to-use-clockwork-orange-scenes-appeal-court-ruling-on-banned-kubrick-film-may-have-wide-implications-reports-heather-mills-1512450.html.
135. Colin Blackstock, '"Clockwork Orange" Ban to Be

Challenged', *Independent*, 14 March 1999, http://www.independent.co.uk/news/clockwork-orange-ban-to-be-challenged-1080491.html.

Notes to Chapter 6

1. See discussions of legislation in the previous chapters.
2. James Ferman, 'Film Censorship and the Law', 1977–8, *Poly L Review*, pp. 5–12; p. 5.
3. John Trevelyan, *What the Censor Saw* (London: Michael Joseph, 1973), p. 229.
4. Julian Petley, *Film and Video Censorship in Modern Britain* (Edinburgh: Edinburgh University Press, 2011), p. 51.
5. This short history of Ferman's career is taken from a variety of sources including obituaries such as Dennis Barker, 'James Ferman. Film Censor in an Age of Growing Tolerance', *Guardian*, 27 December 2002. http://www.guardian.co.uk/news/2002/dec/27/guardianobituaries.filmcensorship. In addition, see Michael Brooke, 'James Ferman (1930–2002)', *BFI Screenonline*. http://www.screenonline.org.uk/people/id/458174/index.html.
6. Ferman, 'Film Censorship and the Law', p. 9.
7. See the 'Resolution of the Cinema Consultative Committee for Forwarding to the Home Secretary', in British Board of Film Censors, 'Evidence to the Home Office Committee on Obscenity and Film Censorship', February 1979, BBFC file, Appendix A, Clause 4. More broadly, on theatre censorship, see David Thomas *et al.*, *Theatre Censorship: From Walpole to Wilson* (Oxford: Oxford University Press, 2007).
8. See generally here Geoffrey Robertson, *Obscenity* (London: Weidenfeld & Nicolson, 1979).
9. See here Craig Lapper, '*Salò* and Censorship: A History', 2000, BFI. http://www.bfi.org.uk/features/salo/history.html.
10. Graham Zellick, 'Obscene or Pornographic? Obscenity and the Public Good', *Cambridge Law Journal*, 1969, pp. 177–81.
11. On this, see, for example, the account of Graeme Turner, *British Cultural Studies: An Introduction* (London: Routledge, 1996), especially Chapter 2.
12. The Law Commission, *Criminal Law. Report on Conspiracy and Criminal Law Reform*, London: HMSO, Law Com No. 76, 1976.
13. Ibid., p. 84.
14. Ibid., p. 85.
15. The Law Commission, *Codification of the Criminal Law Conspiracies Relating to Morals and Decency*, Working Paper No. 57, 1974.
16. See the arguments below on LA control on this.
17. Law Commission, *Criminal Law*, p. 93.
18. Quoted in Geoffrey Robertson, 'The Future of Film Censorship', *British Journal of Law and Society* vol. 7 no. 1, Summer 1980, pp. 78–94; p. 82.
19. James Ferman, 'Poacher Turned Gamekeeper', undated, BFI file: JF/64. See also '"The Tenor of the Times": An Interview with James Ferman', in Petley, *Film and Video Censorship in Modern Britain*, pp. 55–62 (originally published in *AIP & Co*, January/February 1986).
20. BBFC, 'Evidence to the Home Office Committee on Obscenity and Film Censorship', p. 22, paragraph 56.
21. Ferman, BBFC to distributor, 27 February 1976, BBFC file: *Salò*.
22. Lord Harlech, BBFC to Ferman, 30 July 1976, BBFC file: *Salò*.
23. British Board of Film Censors, *Monthly Report for February 1976* (London: BBFC, 1976), p. 19.
24. Hugh Wittow, *Evening News*, 28 July 1977.
25. Ferman to Sir Thomas Hetherington, DPP, 6 June 1979, BBFC file: *Salò*.
26. Statement taken by dictation over the phone from Mr Kranz (Cinecenta solicitor), 19 October 1978, BBFC file: *Salò*.
27. Ferman to Hetherington, 6 June 1979, BBFC file: *Salò*.
28. DPP to BBFC, 14 June 1979, BBFC file: *Salò*.
29. Ferman to Hetherington, 6 June 1979, BBFC file: *Salò*.
30. Ibid.
31. For the later history of *Salò*, including its life on VHS and DVD, see Gary Indiana, *Salò or The 120 Days of Sodom* (London: BFI, 2000).
32. Lord Denning, in *R* v. *Greater London Council ex parte Blackburn* [1976] 1 WLR 550, p. 554.
33. Cited in letter issued by the Nationwide Festival of Light, 3 September 1979, p. 2.
34. Cited in ibid., p. 3.
35. See the letter from member of the public to the BBFC, 12 November 1979, BBFC file: *Life of Brian*. As with many of the complaints, it is prefaced with the unwitting disclaimer that 'I write, as a Christian, to protest that this film, which I have never seen nor do I intend to see […]'.
36. *R* v. *Lemon* (1979) AC 617.
37. Nationwide Festival of Light to BBFC, 19 February 1979, BBFC file: *Life of Brian*.
38. 'Opinion', John Mortimer and Michael Grieve, 11 July 1979, BBFC file: *Life of Brian*.
39. See summary in BBFC file: *Life of Brian*.
40. Questionnaire in letter from BBFC to local authorities, 31 July 1980, BBFC file: *Life of Brian*.
41. While technically it could have been exhibited as an 'X' during this period, the distributors insisted it could not be shown unless it was unedited and carrying the original BBFC certificate. Richard Savill, 'Monty Python's The Life of Brian Film Ban Lifted after 28 Years', *Telegraph* online, 24 September 2008. http://www.telegraph.co.uk/news/3073308/Monty-Pythons-The-Life-Of-Brian-film-ban-lifted-after-28-years.html.
42. See Beverley Brown, 'A Curious Arrangement. Beverley Brown Interviews the Secretary of the British Board of Film Censors, James Ferman', *Screen* vol. 23 no. 5, 1982, pp. 2–25; p. 11.
43. Robertson, 'The Future of Film Censorship', p. 78.
44. Home Office, *Report of the Committee on Obscenity and Film Censorship* (the Williams Report), Cmnd 7772, 1979, p. 1, paragraph 1.1.
45. See Geoffrey Hawthorn, this volume, Chapter 11, for more discussion of the Committee.
46. John Stuart Mill, *On Liberty* (originally published 1859).

47. See here the commentary of Brown, 'A Curious Arrangement', p. 2, and Robertson, 'The Future of Film Censorship', p. 83.
48. *Report of the Committee on Obscenity and Film Censorship*, 12.10, p. 145.
49. Ibid., 12.15, pp 146–7.
50. Ibid., p. 147.
51. Ibid.
52. Ibid., p. 151.
53. Brown, 'A Curious Arrangement', p. 3.
54. BBFC, 'Evidence to the Home Office Committee on Obscenity and Film Censorship', p. 59.
55. Robertson, 'The Future of Film Censorship', p. 79.
56. Brown, 'A Curious Arrangement', p. 23.
57. The Hayward Gallery in London removed *Rosie* and another print *Marty and Hank* from its Mapplethorpe retrospective on police advice in 1996. A work by Richard Prince entitled *Spiritual America* (1983) which itself used one of the Brooke Shields photos was also removed from the Tate Modern exhibition *Pop Life* in 2009, again after intervention from Scotland Yard.
58. See s3, which imposed a duty on licensing authorities to place restrictions on the admission of children to cinemas.
59. Stanley Cohen, *Folk Devils and Moral Panics: The Creation of the Mods and Rockers* (London: Blackwell, 1980 [1973]).
60. Ibid., p. 204.
61. Steve Redhead, *Unpopular Cultures: The Birth of Law and Popular Culture* (Manchester: Manchester University Press, 1995). On new forms of moral panics see, for example, Chas Critcher, *Moral Panics and the Media* (Milton Keynes: Open University Press, 2003) and Ian Marsh and Gaynor Melville, 'Moral Panics and the British Media – A Look at Some Contemporary "Folk Devils"', *Internet Journal of Criminology*, 2011. http://www.internetjournalofcriminology.com/Marsh_Melville_Moral_Panics_and_the_British_Media_March_2011.pdf.
62. See, for example, the review provided by Kristen Zgoba, 'Spin Doctors and Moral Crusaders: The Moral Panic behind Child Safety Legislation', *Criminal Justice Studies* vol. 17 no. 4, December 2004, pp. 385–404. On child pornography more specifically, see Suzanne Ost, 'Children at Risk: Legal and Societal Perceptions of the Potential Threat That the Possession of Child Pornography Poses to Society', *Journal of Law and Society* vol. 29 no. 3, September 2002, pp. 436–60.
63. For example, in Petley, *Film and Video Censorship in Modern Britain*.
64. *Report of the Committee on Obscenity and Film Censorship*, 2.28.
65. Brown, 'A Curious Arrangement', p. 5.
66. Application for Censorship from CIC UK, with total to be paid calculated at £263.83, 28 March 1978, BBFC file: *Pretty Baby*.
67. Ferman to distributor, 28 April 1978, BBFC file: *Pretty Baby*.
68. Ibid.
69. Leeds City Council to Ferman, 1 June 1978, BBFC file: *Pretty Baby*.
70. BBFC Press Release, 2 June 1978, BBFC file: *Pretty Baby*.
71. Ferman to member of the public, 8 July 1978, BBFC file:

72. *Pretty Baby*.
72. Exception form, 16 August 1978, BBFC file: *Pretty Baby*.
73. Ferman to Louis Malle, 10 November 1978, BBFC file: *Pretty Baby*.
74. Quoted in Brown, 'A Curious Arrangement', p. 10.
75. Distributor to Ferman, 30 October 1979, BBFC file: *Pretty Baby*.
76. Ferman to Peter Barnes, Deputy DPP, 5 November 1979, and Ferman to distributor, 5 November 1979, BBFC file: *Pretty Baby*.
77. Ferman to Chief Executive, Cardiff City Hall, 24 September 1980, BBC file: *Pretty Baby*.
78. R. T. H. Stone, 'Out of Sight, Out of Mind? The Indecent Displays (Control) Act 1981', *Modern Law Review* vol. 45 no. 1, January 1982, pp. 62–8; p. 63. See also Hansard HL Deb 10 June 1981 vol. 421 cc 273–308; c 299. http://hansard.millbanksystems.com/lords/1981/jun/10/indecent-displays-control-bill.
79. Ferman, Protection of Children Act 1978, memorandum dated February 1979 in BBFC, 'Evidence to the Home Office Committee on Obscenity and Film Censorship', Appendix B, p. 2.
80. Ibid.
81. Exception form no. 22914, 26 November 1981, BBFC file: *Christiane F.*
82. Philip French and Julian Petley, *Censoring the Moving Image* (London: Seagull Books, 2007), p. 27.
83. Working Paper, Home Office Working Party on Vagrancy and Street Offences (London: HMSO, December 1974).
84. Stone, 'Out of Sight, Out of Mind?', pp. 62–8.
85. St John A. Robilliard, 'Law or Licence? Local Government (Miscellaneous Provisions) Act 1982, Schedule Three and Cinematograph (Amendment) Act 1982', *Modern Law Review* vol. 45 no. 6, November 1982, pp. 676–82.
86. Robilliard, 'Law or Licence?', p. 682.
87. See Chapters 8 and 9, as well as Petley, *Film and Video Censorship in Modern Britain*, p. 83.
88. Quoted in Petley, *Film and Video Censorship in Modern Britain*, p. 107.
89. Ferman, 'Poacher Turned Gamekeeper'.

Case Study: SHIVERS

90. Examiner's report, 9 September 1975, BBFC file: *Shivers*. All other citations in this case study come from the same file unless otherwise stated.
91. British Board of Film Censors, *Monthly Report for December 1975* (London: BBFC, 1975), p. 15.
92. BBFC to member of the public, 15 June 1976.
93. BBFC to member of the public, 13 July 1976.
94. James Ferman, BBFC to Doncaster Metropolitan Borough Council, 11 September 1976.
95. Leeds City Council to BBFC, 27 January 1977.
96. Examiner's report, 29 January 1992.
97. Examiner's note, 7 February 1992.
98. Chris Rodley (ed.), *Cronenberg on Cronenberg* (London: Faber and Faber, 1997), p. 58.
99. Distributor to BBFC, 20 November 1984, BBFC file: *Videodrome*.

Case Study: DIE BLECHTROMMEL (THE TIN DRUM)

100. Cuts list, 18 March 1980, BBFC file: *The Tin Drum*. All other citations in this case study come from the same file unless otherwise stated.
101. Examiner's report, 17 March 1980.
102. Ibid.
103. Letters, *Evening Standard*, 3 April 1980.
104. James Ferman, BBFC to the Editor, *Evening Standard*, 14 April 1980.
105. Franz Seitz Filmproduktion to distributor, 20 March 1980.
106. Expert opinion to Craig Lapper, BBFC, 16 May 2003.

Case Study: CHRISTIANE F. – WIR KINDER VOM BAHNHOF ZOO (CHRISTIANE F. – WE CHILDREN FROM ZOO STATION)

107. Examiner's report, 8 September 1981, BBFC file: *Christiane F*. All other citations in this case study come from the same file.
108. Cuts list, 26 November 1981.
109. Examiners' reports, 28 December 1983–5 January 1984.
110. Expert opinion, 'Notes on "*Christiane F.*" – Video', 16 January 1984.
111. Examiner responses to trial edits, 15 February 1984.
112. Legal opinion, 17 February 1984.
113. Handwritten note from James Ferman, BBFC, 27 February 1984.

Notes to Chapter 7

1. Quote taken from BBFC website timeline on legislation. http://www.bbfc.co.uk.
2. The Board had previously suggested this name change in its response to the Report of the Williams Committee. BBFC, 'Evidence to the Home Office Committee on Obscenity and Film Censorship', February 1979, BBFC file, p. 70.
3. Lester D. Friedman, 'Preface to the First Edition', in Lester D. Friedman (ed.), *Fires Were Started: British Cinema and Thatcherism – Second Edition* (London: Wallflower Press, 2006), pp. xi–viii; p. xii.
4. Graham Thompson, *American Culture in the 1980s* (Edinburgh: Edinburgh University Press, 2007), p. 9.
5. John Hill, *British Cinema in the 1980s: Issue and Themes* (Oxford: Oxford University Press, 1999), p. xi.
6. Jane Pilcher and Stephen Wagg (eds), *Thatcher's Children? Politics, Childhood and Society in the 1980s and 1990s* (London: Falmer Press, 1996), p. 4.
7. *Manchester Guardian Weekly*, 4 December 1983, p. 4.
8. Martin Barker and Julian Petley, *Ill Effects: The Media/ Violence Debate – Second Edition* (London: Routledge, 2001).
9. James Ferman to Ellis Hillman, 16 January 1976, James Ferman Papers Box JF4, BFI Special Collections.
10. Quoted in Beverley Brown, 'A Curious Arrangement. Beverley Brown Interviews the Secretary of the British Board of Film Censors, James Ferman', p. 16.
11. Calls for a certificate that addressed the teenage audience can be found in the BBFC files for *Carrie* (1976), *Saturday Night Fever* (1977), *Quadrophenia* (1979) and *Alien* (1979).
12. Examiner's report, 30 June 1989, BBFC file: *Batman*.
13. Examiners' reports, 4 May 1989 and 30 June 1989, BBFC file: *Batman*.
14. BBFC response to letter of complaint, 26 June 1987, BBFC file: *My Beautiful Laundrette*.
15. BBFC files for *The Wicked Lady* and *Indiana Jones and the Temple of Doom*.
16. Kate Egan, *Trash or Treasure?: Censorship and the Changing Meaning of the Video Nasties* (Manchester: Manchester University Press, 2007), p. 3.
17. Julian Petley, *Film and Video Censorship in Modern Britain* (Edinburgh: Edinburgh University Press, 2011).
18. Examiner's report, 23 August 1982, BBFC file: *The Evil Dead*.
19. Examiner's report, 24 August 1982, BBFC file: *The Evil Dead*.
20. Ibid.
21. For a full discussion of *The Evil Dead* see the detailed case study provided on the BBFC's website http://www.bbfc.co.uk.
22. Examiner's report, 28 December 1984, BBFC file: *The Driller Killer*.
23. Ibid.
24. Ibid.
25. Examiners' reports, 1 December 1983 and 19 September 1984, BBFC file: *I Spit on Your Grave*.
26. Ibid.
27. Ibid.
28. Ibid.
29. For a full history of the BBFC's changing attitudes to sexual violence over the years, see the timeline on their website. See also Sian Barber, *Censoring the 1970s: The BBFC and the Decade That Taste Forgot* (Newcastle: Cambridge Scholars Publishing, 2011) for a fuller discussion of on-screen rape in the 1970s.
30. Transcript of talk given by James Ferman, 'Censorship Today', at an industry seminar sponsored by the AIC, 1979, p. 9.
31. Examiner's report, 27 October 1988, BBFC file: *The Accused*.
32. Ibid.
33. Ibid.
34. For a full history of the BBFC's changing attitudes to sexual violence over the years, see the timeline on their website.
35. Examiner's report, 21 December 1981, BBFC file: *Death Wish*.
36. Ibid.
37. Examiners' reports, 20 and 21 December 1982, BBFC file: *Class of 1984*.
38. Ibid.
39. Examiner's report, 1 March 1985, BBFC file: *The Breakfast Club*.
40. Examiner's report, 27 October 1989, BBFC file: *Drugstore Cowboy*.

41. Examiner's report, 10 November 1989, BBFC file: *Drugstore Cowboy*.

42. Examiner's report, 27 October 1989, BBFC file: *Drugstore Cowboy*.

43. *Saving Private Ryan* would pose similar problems for the BBFC before being classified '15' in 1998. See British Board of Film Classification, *Annual Report 1998* (London: BBFC, 1999), p. 23.

44. Examiner's report, 22 January 1987, BBFC file: *Platoon*.

45. Examiner's report (#2), 22 January 1987, BBFC file: *Platoon*.

46. Examiner's report, 17 February 1987, BBFC file: *Platoon*. For further discussion of the issue of film's power to educate and inform, see examiners' reports within the BBFC files for *Christiane F.*, *Gandhi* and *The Last Temptation of Christ* (1988).

47. Examiners' report, 7 August 1987, BBFC file: *Full Metal Jacket*.

48. Examiner's report (#2), 30 July 1987, BBFC file: *Full Metal Jacket*.

49. Ibid.

50. Video versions were classified '18' as well, until in 2007, when a DVD submission received a '15' classification on 15 August of that year.

51. Examiners' reports, 28 September 1987, BBFC file: *Fatal Attraction*.

52. Ibid.

53. Ibid.

54. Ibid.

55. Examiner's report, 4 November 1988, BBFC file: *Scandal*.

56. Examiner's report, 11 November 1986, BBFC file: *Personal Services*.

57. Examiners' reports, 30 March 1987, BBFC file: *Rita, Sue and Bob Too*.

58. Quoted in Brown, 'A Curious Arrangement', p. 16.

59. Samantha Lay, *British Social Realism: From Documentary to Brit-Grit* (London: Wallflower Press, 2002), p. 85.

60. Examiner's report, 30 January 1984, BBFC file: *Another Country*.

61. Examiner's report (#2), 30 January 1984, BBFC file: *Another Country*.

62. Examiner's report, 30 November 1984, BBFC file: *Another Country*.

63. Examiner's report, 12 September 1985, BBFC file: *My Beautiful Laundrette*. A useful discussion of this film can be found in Christine Geraghty, *My Beautiful Laundrette* (London: I. B. Tauris, 2005).

64. Examiner's report, 13 June 1987, BBFC file: *The Living Daylights*.

65. James Chapman, *Licence to Thrill: A Cultural History of the James Bond Films* (London: I. B. Tauris, 1999), p. 200.

66. Examiners' reports, 10 April 1981, BBFC file: *For Your Eyes Only*.

67. Examiners' reports, 15 March 1983, BBFC file: *Octopussy*.

68. Ibid.

69. Ibid.

70. Examiners' reports, 19 March 1985, BBFC file: *A View to a Kill*.

71. Ibid.

72. Examiner's report, 6 February 1987, BBFC file: *Indiana Jones and the Temple of Doom*.

73. For further discussions of masculinity in the 1980s, see Yvonne Tasker, *Spectacular Bodies: Gender, Genre and Action Cinema* (London: Routledge, 1993) and Thompson, *American Culture in the 1980s*, pp 89–122.

74. Examiners' reports, 29 December 1986, BBFC file: *Raiders of the Lost Ark*.

75. Ibid.

76. File note (undated), BBFC file: *Raiders of the Lost Ark*.

77. Examiners' reports, 6 May 1980, BBFC file: *The Empire Strikes Back*.

78. Examiner's report, 12 May 1983, BBFC file: *Return of the Jedi*.

79. Ibid.

80. Ibid.

Case Study: INDIANA JONES AND THE TEMPLE OF DOOM

81. Examiners' reports, 30 April 1984, BBFC file: *Indiana Jones and the Temple of Doom*. All other citations in this case study come from the same file unless otherwise stated.

82. James Ferman, BBFC to distributor, 15 May 1984, p. 1.

83. Ibid.

84. Ibid., n. p.

85. Jim Windolf, 'Q&A: Steven Spielberg', in *Vanity Fair*, 2 January 2008 (online only). http://www.vanityfair.com/culture/features/2008/02/spielberg_qanda200802. *Indiana Jones and the Temple of Doom* remained a 'PG' in the US.

86. Distributor to Ferman, 15 May 1984.

87. As noted in, for example, BBFC to member of the public, 10 August 1984.

88. Members of the public to BBFC, 20 June 1984 and 8 August 1984.

89. Examiner's report, 22 June 1984, BBFC file: *Gremlins*.

90. Examiner's report, 30 April 1984.

Case Study: LICENCE TO KILL

91. A 1954 production of *Casino Royale*, made for the US TV series *Climax!* and starring Barry Nelson as Bond, received its first classification from the Board in 1995, for video release. The category was 'U' uncut.

92. For example, considering *From Russia with Love* (1963) for video classification in 1987, an examiner wrote 'Whether this violence would be acceptable in another context is one of those imponderables about which we regularly ponder at the Board. In this context [...] I would judge this acceptable.' Examiner's report, 6 July 1987, BBFC file: *From Russia with Love*.

93. Examiner's report, 20 June 1977, BBFC file: *The Spy Who Loved Me*.

94. One examiner referred to it as 'a hard-hitting, sadistic revenge movie'; another talked of it as 'sadism on offer as entertainment'. Examiners' reports, 27 February 1989, BBFC file: *Licence to Kill*. All remaining citations in this case study come from the same file.

95. Examiners' reports, 23 February 1989 and 23 March 1989.
96. Note on file, 27 February 1989.
97. Examiners' reports, 23 March 1989; note on file, 23 March 1989.
98. Handwritten note, 23 March 1989; BBFC to distributor confirming cuts list for the soundtrack, 7 April 1989.
99. Note on file, 15 May 1989.
100. The running time of the classified version was two hours, twelve minutes, sixteen seconds and fourteen frames, roughly three and a half minutes longer than the rough cut (two hours, eight minutes, forty-two seconds and nine frames), due largely to the addition of the completed credits sequence. The Board's records unfortunately do not indicate how much footage had been removed since the rough-cut stage.
101. Note on file (undated).
102. Note on file (undated).
103. Internal note to Ferman, 10 July 1989.
104. Distributor to Ferman, 18 August 1989.
105. Technical comparison reports, 13 October 2000 and 19 May 2005

Notes to Chapter 8

1. The chapter title is inspired by a quote from J. G. Ballard's novel *Crash* (London: Harper Perennial, 2008 [1973]), p. 2: 'In his vision of a car-crash with the actress, Vaughan was obsessed by many wounds and impacts – by the dying chromium and collapsing bulkheads of their two cars meeting head-on in complex collisions endlessly repeated in slow-motion films'.
2. This quote was widely reported on 25 November 1993. For an example, see 'Judge's Remarks Prompt MPs' Horror Video Curb Call', *Guardian*, p. 4.
3. Julian Petley, *Film and Video Censorship in Modern Britain* (Edinburgh: Edinburgh University Press, 2011), pp. 87–108.
4. Martin Barker and Julian Petley, *Ill Effects: The Media/Violence Debate* (London: Routledge, 1997).
5. British Board of Film Classification, *Annual Report 1993* (London: BBFC, 1994), p. 1.
6. *Criminal Justice and Public Order Act 1994, Part VII*.
7. Ibid.
8. British Board of Film Classification, *Annual Report 1994–95* (London: BBFC, 1995), p. 1.
9. Home Affairs Committee, *Video Violence and Young Offenders* (London: HMSO, 1994), p. 3.
10. Ibid., p. 9.
11. British Board of Film Classification, "BBFC Guide: Obscenity Law and Video Violence", in British Board of Film Classification, *BBFC Annual Report for 1985* (London: BBFC, 1986), Appendix V, pp. xxxi–iii.
12. Cited in ibid., p. xxxi.
13. Cited in ibid.
14. Cited in ibid.
15. Cited in ibid.
16. Cited in ibid., p. xxxii.
17. Ibid.
18. BBFC, *Annual Report 1993*, p. 4.
19. Ibid., p. 1.
20. BBFC, *Annual Report 1994–95*, p. 1.
21. British Board of Film Classification, *Annual Report 1996–97* (London: BBFC, 1997), Appendix II, p. 4.
22. Ibid.
23. BBFC, *Annual Report 1996–97*, Appendix IV, p. 5.
24. Ibid., p. 16.
25. British Board of Film Classification, *BBFC Annual Report for 1992* (London: BBFC, 1993), p. 12.
26. BBFC, *Annual Report 1993*, p. 4.
27. Home Affairs Committee, p. 7.
28. Ibid., p. 10.
29. BBFC, *Annual Report 1996–97*, p. 3.
30. BBFC, *Annual Report 1994–95*, p. 2.
31. British Board of Film Classification, *Annual Report 1998* (London: BBFC, 1999), p. 7.
32. Ibid., p. 6.
33. British Board of Film Classification, *BBFC Annual Report for 1990* (London: BBFC, 1991), p. 10.
34. Ibid., p. 11.
35. Ibid.
36. British Board of Film Classification, *BBFC Annual Report for 1991* (London: BBFC, 1992), p. 11.
37. BBFC, *BBFC Annual Report for 1990*, p. 9.
38. Ibid.
39. Examiner's report, 18 April 1997, BBFC file: *Carmageddon*.
40. Ibid.
41. Ibid.
42. Ibid.
43. Examiner's report (#2), 18 April 1997, BBFC file: *Carmageddon*.
44. Examiner's report, 25 April 1997, BBFC file: *Carmageddon*.
45. Examiner's report (#2), 25 April 1997, BBFC file: *Carmageddon*.
46. Ibid.
47. See distributor to BBFC, 29 May 1997, BBFC file: *Carmageddon* and BBFC press release, 'Video Game: Carmageddon', *BBFC Annual Report 1996–97*, Appendix V: 'Press Releases 1996/97', n. p.
48. James Ferman, BBFC to distributor, 19 June 1997, BBFC file: *Carmageddon*.
49. BBFC, *Annual Report 1996–97*, Appendix VI, p. 5.
50. Ibid., pp. 5–6.
51. This information is derived from British Board of Film Classification, *Annual Report 1997-98* (London: BBFC, 1998), Appendix IV, n. p.
52. BBFC press release, 13 November 1997.
53. BBFC, *Annual Report 1996–97*, p. 8.
54. Examiner's report, 12 August 1991, BBFC file: *The Lovers' Guide*.
55. Press release, 3 October 1991, BBFC file: *The Lovers' Guide*.
56. BBFC, *BBFC Annual Report for 1991*, p. 9.
57. 'Woolies Pull Plug on Too-Blue Video', *Daily Star*, 9 September 1991.
58. Press release, 3 October 1991, BBFC file: *The Lovers' Guide*.
59. BBFC, *BBFC Annual Report for 1992*, p. 14.

60. BBFC, *Annual Report 1998*, pp. 38–9.
61. See, for example, Guy Cumberbatch and Dennis Howitt, *A Measure of Uncertainty: The Effects of the Mass Media* (London: John Libbey, 1989) and David Gauntlett, *Moving Experiences, Second Edition: Media Effects and Beyond* (Eastleigh: John Libbey, 2005).
62. BBFC, *Annual Report 1994–95*, pp. 20–1.
63. BBFC, *BBFC Annual Report for 1992*, p. 14.
64. BBFC, *Annual Report 1994–95*, p. 21.
65. Ibid.
66. Ibid.
67. The 2010 submission of *Bare behind Bars* was also a more explicit version than that which was rejected in 1994.
68. BBFC, *Annual Report 1994–95*, p. 21.
69. BBFC, *Annual Report 1996–97*, pp. 17–18.
70. Quoted in Petley, *Film and Video Censorship*, pp. 130–1.
71. Linda Williams, *Hard Core: Power, Pleasure and the 'Frenzy of the Visible'* (Berkeley and Los Angeles: University of California Press, 1999), p. 49.
72. Quoted in Petley, *Film and Video Censorship*, p. 136.
73. It is told in detail in Petley, *Film and Video Censorship*, pp. 129–57.
74. Julian Petley, 'No Redress from the PCC', *British Journalism Review* vol. 8 no. 4, 1997, pp. 66–73; Petley, *Film and Video Censorship*, pp. 115–28; Julian Petley, *Controversies: Crash* (Basingstoke: Palgrave Macmillan, forthcoming 2013).
75. 'Ban This Car Crash Sex Film', *Daily Mail*, 9 November 1996.
76. Westminster City Council Licensing Sub-Committee to BBFC, 21 November 1996, BBFC file: *Crash*.
77. Note on registration form, 22 October 1996, BBFC file: *Crash*.
78. Examiner's report, 11 December 1996, BBFC file: *Crash*.
79. Examiner's report (#2), 11 December 1996, BBFC file: *Crash*.
80. Examiner's report (#3), 11 December 1996, BBFC file: *Crash*.
81. Examiner's report, 13 December 1996, BBFC file: *Crash*.
82. Examiner's report (#2), 13 December 1996, BBFC file: *Crash*.
83. British Board of Film Classification, *Annual Report 1995–96* (London: BBFC, 1996), p. 1.
84. Ibid.
85. Ibid., p. 3.
86. BBFC, *Annual Report 1996–97*, Appendix II, p. 5.
87. BBFC, *Annual Report 1994–95*, p. 1.
88. Ibid., Appendix II, n. p.
89. Ibid.
90. BBFC, *Annual Report 1995–96*, p. 5.
91. Ibid., p. 1.
92. BBFC, *Annual Report 1994–95*, p. 11.
93. BBFC, *Annual Report 1993*, Appendix III, n. p. This can also be found in Home Affairs Committee, *Video Violence and Young Offenders*, p. 67.
94. Ibid.
95. Lord Birkett, BBFC to Chairman, School Curriculum Assessment Authority, 6 October 1994, *Annual Report 1994–95*, Appendix III, n. p.

Case Study: INTERNATIONAL GUERILLAS

96. For further information on the reaction to *The Satanic Verses*, see Daniel Pipes, *The Rushdie Affair: The Novel, the Ayatollah, and the West* (New York: Birch Lane, 1990).
97. VAC judgment, 3 September 1990, BBFC file: *International Guerillas*. All remaining citations in this case study come from the same file.
98. Examiners' reports, June 1990.
99. Examiner's report, 20 June 1990.
100. BBFC press release, 22 July 1990.
101. BBFC registration form, 5 July 1990.
102. VAC judgment, 3 September 1990.
103. Notice of Appeal, 25 July 1990.
104. Statement of Salman Rushdie, 15 August 1990.
105. VAC judgment, 3 September 1990.

Case Study: MIKEY

106. Examiners' reports, 11 November 1992, BBFC file: *Mikey*. All other citations in this case study come from the same file.
107. Note on file, 28 April 1993.
108. BBFC to experts, 18 August 1995.
109. BBFC to distributor, 20 December 1996.
110. BBFC to experts, 18 August 1995.
111. BBFC to distributor, 20 December 1996.
112. James Ferman, BBFC to experts, 18 August 1995.
113. Expert opinion to Ferman, 15 September 1995.
114. Ibid.
115. Expert opinion (#2) to Ferman, 17 September 1995.
116. Ibid. This figure of 10 per cent was not sourced in the letter. Nevertheless, it was reproduced in the letter of rejection to the distributor, 20 December 1996.
117. Distributor to Ferman, 19 July 1995.
118. Ibid.
119. Ibid.
120. BBFC to distributor, 20 December 1996.
121. Ibid.

Notes to Chapter 9

1. 'Channel 4 Liberal Is New Censor', *Daily Mail*, 7 November 1998.
2. 'Will This Man Give You the Sexual Freedom You Deserve?', *Daily Sport*, 10 November 1998.
3. National Centre for Social Research, 'British Social Attitudes Survey, 1999' (London: National Centre for Social Research, 2001).
4. The footage appeared in the BBC documentary *Time Shift – Dear Censor …: The Secret Archive of the British Board of Film Classification* (2011).
5. Andreas Whittam Smith, 'President's Introduction', *BBFC Annual Report 2000* (London: BBFC, 2001), p. 3.
6. The film was *Teenage Mutant Ninja Turtles II: The Secret of the Ooze* (1991).

Case Study: ICHI THE KILLER

7. Examiners' reports, 11 April, 3, 7, 16, 17 May 2002, BBFC file: *Ichi the Killer*.
8. British Board of Film Classification, *BBFC Classification Guidelines* (London: BBFC, 2000), p. 9.
9. Minutes of Presidents' meeting, 9 May 2002.
10. Cuts list, 5 September 2002, BBFC file: *Ichi the Killer*.
11. British Board of Film Classification, *BBFC – The Guidelines* (London: BBFC, 2009), p. 15.

Case Study: LILO & STITCH

12. British Board of Film Classification, *BBFC – The Guidelines* (London: BBFC, 2009), p. 21 ; p. 23.
13. Examiner's report, 25 September 2007, BBFC file: *Tony Hawks in Boom Boom Sabotage*.
14. Examiner's report, 26 July 2000, BBFC file: *O Christmas Tree*.
15. The 'Uc' category was a video-only certificate introduced in 1985. It indicated that a work was particularly suitable for very young unsupervised audiences. It was used primarily for works aimed at pre-school children. The category was abandoned in 2009, when research revealed that there was actually very little knowledge of the rating among the public. The BBFC now assigns the 'U' category to such works, with the Consumer Advice 'Particularly Suitable for Pre-school Children'.
16. Examiner's report, 25 April 2002, BBFC file: *Lilo & Stitch*.
17. British Board of Film Classification, *BBFC Annual Report 2002* (London: BBFC, 2003), p. 40.
18. Examiner's report, 25 April 2002, BBFC file: *Lilo & Stitch*.

Notes to Chapter 10

1. British Board of Film Classification, *BBFC Classification Guidelines* (London: BBFC, 2000), p. 16.
2. Ibid.
3. The screening took place at the Everyman Cinema in Hampstead on 10 June 2005. 'After 33 Years, Deep Throat, the Film That Shocked the US, Gets Its First British Showing', *Guardian*, 11 June 2005.
4. See http://www.destrictedfilms.com/uk/about.htm.
5. British Board of Film Classification, *BBFC – The Guidelines* (London: BBFC, 2009), p. 29.
6. The second and third films in the trilogy, *The Lord of the Rings: The Two Towers* (2002) and *The Lord of the Rings: The Return of the King* (2003), were both classified '12A'. The first film, *The Lord of the Rings: The Fellowship of the Ring* (2001), had received a 'PG'.
7. Melanie Phillips, 'Transparent Unaccountability', *Daily Mail*, 1 July 2005.
8. Note forwarded by distributor to BBFC, 7 March 2005, BBFC file: *Life Is a Miracle*.
9. Emir Kusturica, 'I Will Not Cut My Film', *Guardian*, 4 March 2005.

Case Study: 9 SONGS

10. *Daily Mirror*, 18 May 2004.
11. Examiner's report, 9 June 2004, BBFC file: *9 Songs*.
12. The importance of contextual justification for a work being considered non-pornographic is illustrated very well by the fact that some DVD extra material for *9 Songs*, submitted separately as a standalone work, received an 'R18' certificate. The material comprised extended versions of some of the feature's sex scenes. Appearing outside of the narrative context of the feature, it was felt that these scenes on their own looked very much like pornographic material featuring explicit sexual detail and they were classified accordingly. BBFC file: *9 Songs – DVD Extras*.
13. British Board of Film Classification, *BBFC – The Guidelines* (London: BBFC, 2009), p. 29.
14. British Board of Film Classification, *BBFC Classification Guidelines* (London: BBFC, 2000), p. 16.
15. Examiner's report, 1 September 2004, BBFC file: *9 Songs*.
16. Press release, 'BBFC Passes 9 SONGS Uncut for an Adult Audience', 18 October 2004.

Case Study: HARRY POTTER AND THE GOBLET OF FIRE

17. 'Apparate – To transport oneself instantly to any destination.' *Harry Potter Book Glossary*, http://harrypotter.bloomsbury.com/books/glossary/a.
18. Biography on www.jkrowling.com.
19. 'Rowling Looking into Harry Potter E-Books', *ABC News*, 4 April 2011, http://abcnews.go.com/Entertainment/wireStory?id=13292040.
20. Joanne (J. K.) Rowling, Forbes.com, 8 December 2011, http://www.forbes.com/profile/joanne-jk-rowling/.
21. 'Books: Cover Stories at the Frankfurt Bookfair', *Independent*, 10 October 1998, http://www.independent.co.uk/arts-entertainment/books/books-cover-stories-at-the-frankfurt-book-fair-1177247.html.
22. See www.jkrowling.com, http://www.jkrowling.com/en/index.cfm.
23. '"Harry" Up!', EW.com, 7 September 2000, http://www.ew.com/ew/article/0,,20431232_85524,00.html.
24. Examiner's report, 23 August 2005, BBFC file: *Harry Potter and the Goblet of Fire*.
25. Ibid.
26. British Board of Film Classification, *BBFC – The Guidelines* (London: BBFC, 2005), p. 14.
27. 'Muggle – Person totally without magical powers'. *Harry Potter Book Glossary*.

Notes to Chapter 11

'Reflections on the 1979 Williams Report'

1. The Report was published in 1979 as Cmnd. 7772. It was republished without its eight Appendices on such matters as the history of criminal law in these areas and of film censorship, the law in other countries, and bibliographical and statistical matters, as Bernard Williams (ed.), *Obscenity and Film Censorship: An Abridgement of the Williams Report* (Cambridge: Cambridge University Press, 1981). The relevant law and the actions to date of what is now the British Board of Film Classification are set out on the Board's website, www.bbfc.co.uk, which also contains an illuminating history, with cases, of opinion and action since 1912.
2. Bernard Williams, *Shame and Necessity* (Berkeley: University of California Press, 1993), pp. 4–7.
3. There are similarly sharp criticisms of the relevant research in Special Committee on Pornography and Prostitution, *Pornography and Prostitution in Canada* (Ottawa: Canadian Government Publication Centre, 1985).
4. BBFC, *The Guidelines* (London: BBFC, 2009), p. 14.
5. Williams, *Obscenity and Film Censorship*, §9.31, p. 122.
6. In 'Empire Online' at http://www.empireonline.com/news/story.asp?NID=31758.
7. Williams, *Obscenity and Film Censorship*, §§7.8–10, p. 98.

'A Margin of Appreciation'

8. Søren Hansen and Jesper Jensen, *The Little Red Schoolbook*, trans. Berit Thornberry (London: Stage 1, 1971); Johannes Facius, Johny Noer and Ove Stage, *The Little White Book*, trans. Penelope Howell *et al.* (Bromley: White Book Publications, 1971).
9. *Handyside* v. *United Kingdom* (1976) 1 EHRR 737.
10. *Otto-Preminger-Institut* v. *Austria* (1995) 19 EHRR 34.
11. *Wingrove* v. *United Kingdom* (1997) 24 EHRR 1.
12. *Saunders* v. *United Kingdom* (1997) 23 EHRR 313.
13. *Al-Khawaja and Tahery* v. *United Kingdom* [2011] ECHR 2127, application nos. 26766/05 and 22228/06, 15 December 2011. On 7 February 2012, the Court confirmed its policy in an important decision, *Von Hannover* v. *Germany* (No. 2), which spelt out a mechanism for invigilating national courts without second-guessing them.
14. 'The Relationship between the UK Courts and Strasbourg' [2011] EHRLR 505.
15. *R* v. *Horncastle and Ors* [2009] UKSC 14.

'How the World Has Changed for Children and Parents, 1912–2012'

16. Déborah Dwork, *War Is Good for Babies and Other Young Children: A History of the Infant and Child Welfare Movement in England 1898–1918* (London: Taylor & Francis, 1987).
17. See http://en.wikipedia.org/wiki/Liberal_welfare_reforms – cite_note-10.
18. Liz Heron (ed.), *Truth, Dare or Promise: Girls Growing Up in the Fifties* (London: Virago, 1985), p. 6.
19. G. Stanley Hall, *Adolescence: Its Psychology and Its Relations to Physiology, Anthropology, Sociology, Sex, Crime and Religion (Vol. 1)* (New York: D. Appleton and Company, 1904), p. xi.
20. See, for example, Anna Freud, 'Adolescence', *Psychoanalytic Study of the Child* no. 13, 1958, pp. 255–78.
21. Erik Erikson, *Identity, Youth and Crisis* (New York: W. W. Norton, 1968).
22. Ipsos MORI and Agnes Nairn, *Children's Well-Being in UK, Sweden and Spain: The Role of Inequality and Materialism* (London: Ipsos MORI/UNICEF, 2011), p. 24.
23. See, for example, Estella Tincknell, *Mediating the Family: Gender, Culture and Representation* (London: Edward Arnold, 2005).
24. Eleanor Florence Rathbone, *The Case for Family Allowances* (Harmondsworth: Penguin, 1940).
25. Linda Nicholson, 'The Myth of the Traditional Family', in Hilde Lindemann Nelson (ed.), *Feminism and Families* (London: Routledge, 1997), pp. 27-42.
26. Ann Dally, *Inventing Motherhood: The Consequences of an Ideal* (New York: Schocken Books, 1982).
27. See, for example, Diana Gittins, *The Family in Question* (London: Macmillan, 1985).

INDEX

List of Illustrations

While considerable effort has been made to correctly identify the copyright holders, this has not been possible in all cases. We apologise for any apparent negligence and any omissions or corrections brought to our attention will be remedied in any future editions.

A Clockwork Orange, © Warner Bros./Polaris Productions; *The Life of Charles Peace*, Sheffield Photo Company; *Where Are My Children?*, National Council of Public Morals/The Universal Film Manufacturing Company; *Auction of Souls*, First National Pictures/Selig Studios for the American Committee for Armenian & Syrian Relief; *Battleship Potemkin*, First Studio Goskino; *Dracula*, © Universal Pictures Corporation; *Frankenstein*, Universal Pictures Corporation; *A Cuckoo in the Nest*, Gaumont–British Picture Corporation; *Hindle Wakes*, Gaumont–British Picture Corporation; *Jarrow March* by David Savill/Stringer, Getty Images *Knight Without Armour*, London Film Productions; *It's in the Bag*, Butcher's Film Service; *Love on the Dole*, Pathe Pictures Limited; The ruins of Addle Street by William Vandivert, Time & Life Pictures/Getty Images; *Island of Lost Souls*, © Paramount Productions; *No Orchids for Miss Blandish*, Tudor Films/Alliance Film Studios Limited; *The Blue Lamp*, ©STUDIOCANAL/Ealing Studios; *Detective Story*, Paramount Pictures; *La Ronde*, Sacha Gordine; *Dial M for Murder*, © Warner Bros.; *Tea and Sympathy*, © Loew's Incorporated; *Rebel Without a Cause*, © Warner Bros. Pictures Inc.; *Cosh Boy*, © Daniel Angel Films; Derek Bentley driven away from Croydon court, 10 November 1952, Popperfoto/Getty Images; *Yield to the Night*, Kenwood Films; *The Flesh is Weak*, Raystro Films Ltd; *The Snake Pit*, © Twentieth Century-Fox Film Corporation; *Caged*, Warner Bros.; *Room at the Top*, Remus Films; *The L-Shaped Room*, Romulus Films/Beaver Films; *Victim*, © Parkway Films; *Ulysses*, Ulysses Film Production; *The Killing of Sister George*, © Palomar Pictures International/The Associates and Aldrich; *Women in Love*, © Brandywine Productions; *If....*, © Paramount Pictures Corporation; *Cape Fear*, © Melville Productions/Talbot Productions; *Blowup*, © Metro-Goldwyn-Mayer; Mary Whitehouse at the Festival of Light Rally, 25 September 1971, J. Wilds/Stringer, Getty Images; *The Devils*, © Warner Bros.; *Straw Dogs*, © AMB Pictures Corp.; *Love Variations*, Oppidan Film Productions; *Bonnie and Clyde*, © Warner Bros./Seven Arts/Tatira Productions/Hiller Productions; *A Bay of Blood*, Nuova Linea Cinematografica; *Enter the Dragon*, Warner Bros./Concord Productions; *The Texas Chain Saw Massacre*, Vortex; *Vampyres*, © Essay Films; *Death Wish*, Dino De Laurentiis Corporation/Paramount Pictures Corporation; Film Censors Censured, Lord Harlech and Stephen Murphy by David Ashdown, Getty Images; *The Last House on the Left*, © The Night Company; *Emmanuelle*, Trinacra Films/Orphée Productions; *The Panic in Needle Park*, Gadd Productions; *WR – Mysteries of the Organism*, Neoplanta Film/Telepool; *Sàlo*, P.E.A.; *Monty Python's Life of Brian*, Python (Monty) Pictures/HandMade Films; *Pretty Baby*, © Paramount Pictures Corporation; *Shivers*, Cinépix/Canadian Film Development Corporation; *The Tim Drum*, Franz Seitz Filmproduktion/Munich Bioskop-Film/Hallelujah-Film/GGB 14 KG/Argos-Films/Jadran Film/Film Polski; *Christiane F.*, Solaris Film/Maran-Film/Popular-Film/Hans K. Kaden/CLV Filmproduktion; *The Driller Killer*, © Rochelle Films; *The Accused*, Paramount Pictures Corporation; *Drugstore Cowboy*, Avenue Entertainment; *Platoon*, Hemdale Film Corporation/Orion Pictures Corporation; *Full Metal Jacket*, © Warner Bros.; *Fatal Attraction*, Paramount Pictures Corporation; *Personal Services*, Zenith Productions; *My Beautiful Laundrette*, © Channel Four; *Octopussy*, © Danjaq S.A.; *Return of the Jedi*, © Lucasfilm Ltd; *Indiana Jones and the Temple of Doom*, © Lucasfilm Ltd; *Licence to Kill*, © Danjaq S.A./© United Artists Company; *Terminator 2*, © Carolco Pictures/Carolco International; *Carmageddon*, Stainless Software; *The Lovers' Guide*, Lifetime Vision; *Crash*, Alliance Communications Corporation/Téléfilm Canada/TMN – The Movie Network/Recorded Picture Company; *International Guerillas*, Evernew Pictures; *Mikey*, Constantin Film; *The Exorcist*, © Warner Bros./Hoya Productions; *Irréversible*, © Nord-Ouest Productions/© STUDIOCANAL; *The Idiots*, © Zentropa Entertainments2 ApS/La Sept Cinéma; *Baise-moi*, © Pan-Euriopéenne Production/Ciné Valse; *Spider-Man*, © Columbia Pictures Corporation; *Billy Elliot*, © Tiger Aspect; *Sweet Sixteen*, © Sixteen Films/© Road Movies Filmproduktion GmbH/© Tornasol Films/© Alta Films; *Oldboy*, © ShowEast; *Ichi the Killer*, © Hideo Yamamoto/Shogakukan Inc./'Ichi the Killer' Production Committee; *Lilo & Stitch*, © Disney Enterprises Inc.; *House Call* (*Destricted*), OffHollywood Pictures; *War of the Worlds*, © Paramount Pictures/© DreamWorks Pictures; *The Dark Knight*, © Warner Bros. Entertainment Inc.; *The King's Speech*, © UK Film Council/Speaking Film Productions Ltd; *Closer*, © Columbia Pictures Industries Inc.; *This Is England*, © Warp Films/© UK Film Council in association with Film Four/EM Media/Screen Yorkshire; *Taxi zum Klo*, Filmwelt; *The Killer Inside Me*, © LLC Kim Productions; *A Serbian Film*, Contrafilm; *9 Songs*, Revolution Films; *Harry Potter and the Goblet of Fire*, © Patalex IV Productions Ltd; Bernard Williams by Steve Pike, Getty Images.